D1398345

# CONVERSION to MODERNISM

APR - - 2012

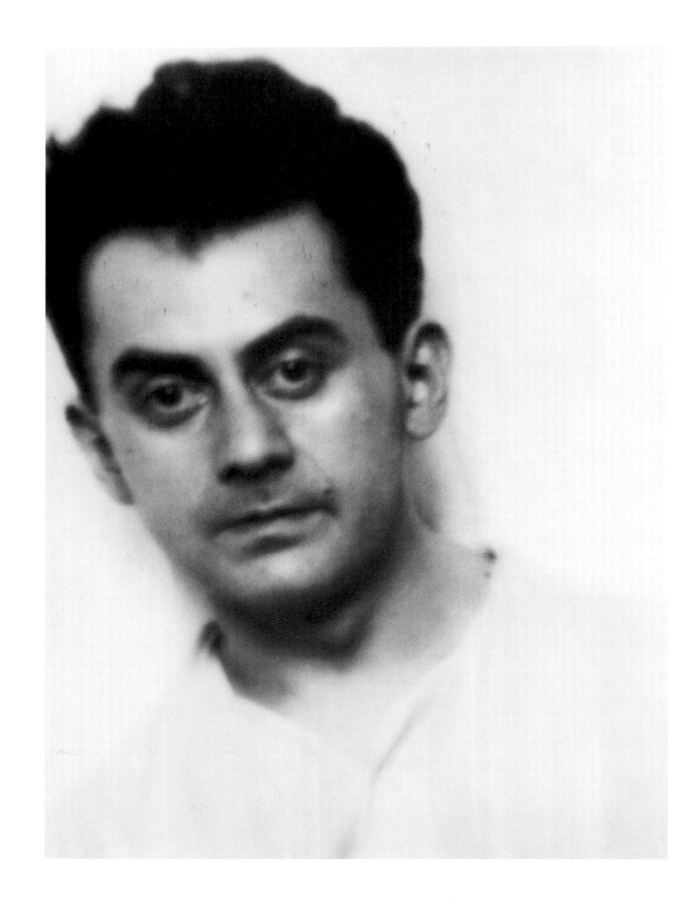

# CONVERSION to MODERNISM

## THE
## EARLY WORK
## OF
## MAN RAY

Francis M. Naumann

With an essay by Gail Stavitsky

RUTGERS UNIVERSITY PRESS
New Brunswick, New Jersey, and London

MONTCLAIR ART MUSEUM

APR - - 2012

Published on the occasion of the exhibition *Conversion to Modernism: The Early Work of Man Ray,* organized by Montclair Art Museum, Montclair, New Jersey.

 NEW JERSEY COUNCIL FOR THE HUMANITIES

The publication of this catalogue has been made possible, in part, by generous grants from the New Jersey Council for the Humanities, a state partner of the National Endowment for the Humanities; The Karma Foundation; Judith Targan; Adrian Shelby in memory of Elizabeth Van Wie Penick Schmitz; Mr. and Mrs. Frank Martucci; Hollis Taggart Galleries; the Society for the Preservation of American Modernists; and anonymous donors.

Funding for all Museum programs is made possible, in part, by the New Jersey State Council on the Arts/Department of State, a partner agency of the National Endowment for the Arts, and Montclair Art Museum members.

ITINERARY

Montclair Art Museum, New Jersey
    February 16, 2003–August 3, 2003
Georgia Museum of Art, Athens
    September 20, 2003–November 30, 2003
Terra Museum of American Art, Chicago
    January 23, 2004–April 4, 2004

Frontispiece. *Portrait of Man Ray,* ca. 1915. Gelatin silver print, 11 x 8 in. (Photograph attributed to Alfred Stieglitz.) Collection of the Tokyo Fuji Art Museum, Tokyo, Japan.

This collection copyright 2003 by the Montclair Art Museum

All rights reserved

No part of this book may be reproduced or utilized in any form or by any means, electronic or mechanical, or by any information storage and retrieval system, without written permission from the publisher. Please contact Rutgers University Press, 100 Joyce Kilmer Avenue, Piscataway, NJ 08854-8099. The only exception in this prohibition is "fair use" as defined by U.S. copyright law.

BOOK DESIGN BY JENNY DOSSIN
Manufactured in Singapore

LIBRARY OF CONGRESS CATALOGING-IN-PUBLICATION DATA
Naumann, Francis M.
    Conversion to Modernism: the early work of Man Ray/Francis M. Naumann; with an essay by Gail Stavitsky.
    p. cm.
    Itinerary, Montclair Art Museum, New Jersey, February 16, 2003–August 3, 2003 and others.
    Includes bibliographical references and index.
    ISBN 0-8135-3147-0 (cloth: alk. paper)—ISBN 0-8135-3148-9 (pbk.: alk. paper)
    1. Ray, Man, 1890–1976—Exhibitions. I. Montclair Art Museum. II. Title.
N6537.R3 A4 2003
759.13—dc21                                    2002020162

British Cataloging-in-Publication information is available from the British Library.

All works by Man Ray Copyright © 2003 Man Ray Trust/Artists Rights Society (ARS), New York/ADAGP, Paris.

Unless otherwise noted in the captions, all photographs were provided by Francis M. Naumann.

# CONTENTS

# ILLUSTRATIONS

An asterisk (*) indicates a work represented in the exhibition.

Known as a glamorous and nearly legendary pioneer of Manhattan modernism, a Paris sophisticate and high-style innovator in photography, an alluring Hollywood art world émigré in the 1940s, Man Ray has seldom been thought of as a New Jersey artist. Yet, the Garden State played a pivotal role in his shift from an academic to an avant-garde artist. His Ridgefield respite and the surprisingly lively artists' camaraderie there remind us that country, no less than city, is vital to even the most forward-thinking artistic figures. Once again we see that for artistic creativity, bucolic life is the productive partner to the ferment and energies of New York City.

The genesis and presentation of *Conversion to Modernism: The Early Work of Man Ray* reflects the Montclair Art Museum's long-standing commitment to developing exhibitions and publications that address overlooked aspects of American art. In 1998 the Museum's chief curator, Gail Stavitsky, approached her colleague Francis M. Naumann about the possibility of collaborating on an exhibition devoted to the colony of artists active in

Ridgefield, New Jersey, during the early twentieth century. She was aware of Dr. Naumann's outstanding record as an esteemed scholar of American modernism and his reputation as the leading Man Ray expert. His dissertation, "Man Ray and America: The New York and Ridgefield Years, 1907–1921," has served as the foundation for this project. The pioneering studies of William H. Gerdts, Professor Emeritus of Art History, Graduate School of the City University of New York, on artists in New Jersey were also of great assistance in the genesis of the project. Drs. Stavitsky and Naumann decided to co-curate the exhibition, which Dr. Naumann proposed should focus upon Man Ray, certainly the most innovative visual artist to be associated with the town of Ridgefield. As the project developed, with helpful input from various colleagues, they broadened the range of works beyond the period of 1912 to 1915, when Man Ray resided in Ridgefield, to encompass his paintings, watercolors, drawings, and aerographs from 1907 to 1920. An immediate outgrowth of the project was the Museum's acquisition of the centerpiece in

this exhibition, Man Ray's superb *Ridgefield Landscape* (1913). In addition to their generous gift of this work, Naomi and David Savage of Princeton, New Jersey, have made several key loans to the exhibition. A full list of lenders follows this foreword.

.     .     .

This exhibition and its accompanying publication provide the first comprehensive study of the early American years of Man Ray's long career. It makes clear that his years in New Jersey were seminal for his development as a leading modernist. Over the last three years Dr. Naumann's avid, scholarly intelligence and lengthy experience have framed the vision and realities of this show. In August 2001, following the organizational and loan negotiation phase of this project, Dr. Naumann launched Francis M. Naumann Fine Art, a gallery in New York City specializing in the art of the Dada and Surrealist periods.

The work of Dr. Naumann has been complemented by Gail Stavitsky, the Museum's chief curator, who contributed a well-researched essay on artists and writers in Ridgefield from the late nineteenth century to the present, which provides a context for understanding Man Ray's attraction to this hillside community that had emerged during the 1890s as a noteworthy locale for growing numbers of creative artists (painters and poets), many of whom sought a quiet, bucolic retreat from the noise and crowds of Manhattan. She was ably assisted in her research by intern Joshua McConnell. Dr. Stavitsky also negotiated the exhibition's numerous loans and coordinated myriad curatorial details of the show's organization.

Leslie Mitchner and Marlie Wasserman, respectively editor-in-chief and director of Rutgers University Press, quickly saw the significance of this project. They have done an outstanding job in producing this attractive book. Thanks are also extended to India Cooper, the copyeditor, and the book designer, Jenny Dossin.

Others who played instrumental roles in the successful realization of this project include Sylvia Yount, former chief curator of the Museum of the Pennsylvania Academy of the Fine Arts, who is now curator of American Art of the High Museum of Art in Atlanta. She was an early supporter of this show. Our heartfelt thanks are also extended to the following individuals at the other venues at which the show will be seen: William U. Eiland, Georgia Museum of Art, Athens; Elizabeth Glassman, Stephanie Mayer, and Cathy Ricciardelli, Terra Museum of American Art. The following other individuals greatly contributed to the research for this project: John Dublania, assistant principal, Ridgefield High School; Nancy Ellis and Jane Forti, Ridgefield Public Library; Peter J. Sampson and Maggie Hutchinson, the *Record;* Mike Merse, Ann Temkin, Michael Taylor, and Ann Percy, Philadelphia Museum of Art; Gary Garrels, Kristin Helmick-Brunet, and Cora Rosevear, Museum of Modern Art; Barbara Haskell and library staff, Whitney Museum of American Art; Julie Mellby, Toledo Museum of Art; Nannette V. Maciejunes, Columbus Museum of Art; Daniel Shulman, Art Institute of Chicago; Robert Berman, Robert Berman Gallery, Santa Monica, California; Joann Moser and Riche Sorenson, Smithsonian American Art Museum, and John Boos.

Among the many Montclair Art Museum staff members who contributed to this project, Renee Powley, associate registrar, Rosemary Vence, curatorial assistant, Tom Shannon, director of facilities planning and exhibit design, Anne-Marie Nolin, director of communications, Elyse Reissman, deputy director for institutional advancement, Nancy Pinella, former grants writer, and Susana

Sabolcsi, librarian, deserve special thanks. The role of New Jersey as a creative inspiration for artists, so thoroughly documented by the Montclair Art Museum in the life and art of George Inness, is again affirmed in this project on a previously underknown chapter of Man Ray's life.

PATTERSON SIMS, DIRECTOR
*Montclair Art Museum*

# LENDERS TO
# THE EXHIBITION

Ackland Art Museum, University of North Carolina
    at Chapel Hill
Addison Gallery, Phillips Academy,
    Andover, Massachusetts
Albright-Knox Art Gallery, Buffalo, New York
Art Institute of Chicago, Illinois
Timothy Baum, New York
Baltimore Museum of Art, Maryland
Beinecke Library, Yale University,
    New Haven, Connecticut
Alexander and Cynthia Bing
David Ilya Brandt and Daria Brandt
Jeffrey and Lucinda Cohen
Columbus Museum of Art, Ohio
Gale and Ira Drukier
Forum Gallery, New York
Paula and Joel Friedland
Galerie 1900–2000, Marcel and David Fleiss, Paris, France
David Goldwater
Hirshhorn Museum and Sculpture Garden,
    Smithsonian Institution
Teruo Ishihara
The William H. Lane Collection
Mr. and Mrs. Meredith J. Long

Man Ray Trust, Hicksville, New York
Metropolitan Museum of Art, New York
Betsy Wittenborn Miller
Montclair Art Museum, Montclair, New Jersey
Munson Williams Proctor Institute, Utica, New York
The Museum of Modern Art, New York
National Museum of American Art, Washington, D.C.
Francis M. Naumann, Fine Art, New York
A & R Penrose Collection, England
Philadelphia Museum of Art, Pennsylvania
Phillips Collection, Washington, D.C.
Agnes Rein
Dr. and Mrs. David J. Rose
Naomi and David Savage
Michael Senft, East Hampton, New York
Fiona and Michael Scharf
M. Schecter
Estate of Natalie Davis Spingarn, Washington, D.C.
Hollis Taggart Galleries, New York
Alain Tarica
Tokyo Fuji Art Museum, Japan
Whitney Museum of American Art, New York
Constance and Albert Wang

Man Ray (1890–1976) has long been considered one of the most versatile and innovative artists of the twentieth century. As a painter, writer, sculptor, photographer, and filmmaker, he is best known for his intimate association with the French Surrealist group in Paris during the 1920s and '30s, particularly for his highly inventive and unconventional photographic images. These remarkable accomplishments, however, have tended to overshadow the importance of his earlier work—not only significant for an understanding of Man Ray's future artistic development but also of extreme importance in any effort to gain a thorough understanding of the visual arts in America during one of the most important and crucial phases of the modernist evolution.

*Man Ray: Conversion to Modernism* is intended to fill this lacuna. It is the underlying purpose of this study to satisfy a desire expressed by the artist's widow, Juliet Man Ray, a few years before her death. "I want to see Americans recognize Man Ray as a major American artist," she said, "who chose to live in Europe."[1] It is only through a com-

prehensive examination of the artist's work produced during his early years in New York and Ridgefield, New Jersey (before his departure for Paris in 1921), that his preeminent position in the history of American modernism can be securely established. If these paintings and drawings are arranged into the approximate chronological sequence of their making, and if these works are then subjected to a rigorous formal analysis—a method that Man Ray understood, and indeed one that guided his creative efforts in these years— we can begin to understand the path he himself embarked upon in his gradual attainment of a more vanguard and, ultimately, conceptual vision.

Until recently, Man Ray's contribution to the history of American modernism has been largely overlooked. The majority of critics have found his work derivative or, for those with an even more myopic vision, little more than a pastiche of work by more accomplished painters and sculptors. The issue of influence is one that Man Ray was well aware of, and for which he had established a simple defense. "I had never worried about influ-

ence," he later explained. "There had been so many—every painter whom I discovered was a source of inspiration and emulation . . . sufficient that I chose my influences—my masters."[2]

Indeed, there can be little doubt that Man Ray's paintings of this period represent the product of a search, but not the sporadic search of an unthinking imitator "in quest of modernism," as a recent study might have us think.[3] Rather, as the present examination of his work will reveal, each successive style he embraced developed methodically, from the formal concerns that dominate his paintings and writings of the mid-teens to a more conceptually oriented approach, in which the medium he employs is considered subordinate to the message he attempts to convey.

It is only after this particular aspect of his work is understood—where an idea takes precedence over the method used to express it—that one can begin to comprehend the importance of Man Ray's artistic production in this period. It is this very concept, however, that is most consistently overlooked in historical evaluations of his work. Three noteworthy exceptions are the monographic studies of Carl Belz, Roland Penrose, and Arturo Schwarz.[4] These authors shared a very valuable resource, one that is—regrettably—absent from the present study: Man Ray himself. All three of these scholars met and interviewed the artist. Fortunately, his reminiscences are accurately recorded in their respective publications, but the single most important and reliable source of information on the artist and his work is provided in his autobiography: *Self Portrait.*

Although written in the early 1960s—some forty years after the New York and Ridgefield period—his recollection of this particular episode in his life is remarkably vivid and detailed. While he was composing this portion of his text, the artist's keen memory was aided by two very

important resources: a card file he kept of works produced in this early period (see document C) and a good number of the original works themselves, many of which were then still safely housed in the artist's studio in Paris.

The impressive quantity of work that Man Ray produced in New York and Ridgefield would serve him well in years to come, even after he departed for Paris. Not only was he able to bring many of these paintings and drawings with him to Europe—where they would represent his contribution to a variety of exhibitions—but he considered the ideas they contained to be timeless and therefore, whenever the need arose, capable of infinite repetition. These were precisely the sentiments he attempted to express when, in 1966, he began a statement about his lifework with the words: "I have never painted a recent picture."[5]

.     .     .

In October of 1976—while in the process of compiling information for my doctoral dissertation on the subject of New York Dada—I wrote a general letter of inquiry to Man Ray, who was then eighty-six years old and living in Paris. I asked him about his early years in New York, but, because I had earlier worked as an artist, I also seized the opportunity to inform him of my high regard for his painting. "I shall always regard your Dada-related paintings as a remarkable achievement," I wrote. "You are in my humble opinion (and I might add as well, that of many young historians) America's greatest artist from those pioneering years." Within weeks of the receipt of my letter, Man Ray died. Years later, I was informed by his widow, Juliet Man Ray, that, due to a debilitating illness, her husband was unable to respond to my letter, but he had genuinely appreciated my comments about his early paintings.

In the years that followed, I have gained an even greater appreciation of Man Ray's early work. I am not certain that I would any longer describe him as "America's greatest artist" from those years, but I would certainly rank him among the most innovative and creative individuals working in America during the early years of the twentieth century. My understanding of the artist's work was enhanced through the lectures of Robert Pincus-Witten, who, in the spring of 1976, taught a course on New York Dada at the Graduate School of the City University of New York. Having thoroughly researched the subject of my dissertation, I began its writing, only to encounter the most serious writing block of my entire career. After months of agonizing attempts to begin on the first page, I was advised by William Camfield, a good friend and a professor of art history at Rice University, to begin somewhere in the middle of the text, on a subject that I felt particularly comfortable writing about. So I began with the chapter on Man Ray, only to discover that his work from this period was so complex and intriguing that it merited a separate study of its own. After nearly six years, I completed "Man Ray and America: The New York and Ridgefield Years, 1907–1921," a two-volume, nearly one-thousand-page manuscript on the artist's early work. I eventually went on to complete a book on New York Dada—which included a chapter on Man Ray—but I have always wanted to return to the subject of my dissertation, for over the years I have discovered new material on Man Ray that caused me to reevaluate my original thesis, information that I have long been anxious to incorporate into the original text.

Coincidentally, it was an article by Gail Stavitsky, co-curator of the present exhibition, that led me to one of these discoveries. In 1991 she published an article on the American art critic John Weichsel. Any new information on Weichsel was of interest to me, for in November of 1915 Man Ray wrote to Weichsel saying that he had enjoyed reading an article the critic had written about his work, but he did not mention the name of the magazine, so I was never successful in locating a copy. Stavitsky did not cite this particular article, but in her notes she did refer to a thesis on the dealer Edith Gregor Halpert, and since I was interested in the paintings of her husband, Samuel Halpert (Man Ray's friend and colleague during his early years in Ridgefield), I contacted the author, Diane Tepfer. Tepfer informed me that she had organized an exhibition on Halpert, which was about to open in Washington, D.C. I attended the exhibition and purchased a little brochure that Tepfer had written about the paintings, where I discovered in one of her notes that in January of 1916 Weichsel had written an article on Halpert for a magazine called *East and West*. Equipped with this information, I rushed to the microfilm division of the New York Public Library and finally located Weichsel's "New Art and Man Ray," a fully illustrated, seven-page article on the artist. This publication not only represented the first serious attempt to evaluate Man Ray's paintings from this period, but it contained a transcription of the artist's prescient theories of formalism (see document A), which he would later revise and publish under the title *A Primer of the New Art of Two Dimensions* (see fig. 155 and my discussion of the article in chapter 6, pages 148–151).

Another discovery came when I was examining an important early watercolor by Man Ray entitled *Ramapo Hills* (fig. 80), which was then in the collection of Naomi Savage, Man Ray's niece. In my thesis, as well as in a number of articles that were derived from it, I identified this watercolor as the very image he was working on when he announced to friends that he would no longer paint from nature, a decision that was among the most crucial steps in his gradual but certain

"conversion to modernism." Since the watercolor was not dated, I carefully followed the sequence of events in the artist's autobiography and determined that his trip to the Ramapo Hills took place in the fall of 1914. It was only when I was given an opportunity to examine the verso of this watercolor that I discovered an inscription in Man Ray's hand that read "September 1913." This new information caused me to revise my thinking about the work that immediately followed, particularly the paintings, drawings, and watercolors from 1914. Clearly they differed in conception and style from the previous work, but now I was in a position to inform my readers exactly why. When mistakes enter into the literature, they are almost impossible to eradicate, and since I caused this one to exist, I was naturally anxious to revise my text. (For more on this mistake, see chapter 4, note 14, herein.)

Over the years, my work on Man Ray has been facilitated by the support and encouragement of many individuals. Leo Steinberg and Stan Jernow prodded me periodically on the progress of my dissertation, and Robert Pincus-Witten, acting in the capacity of my dissertation advisor, would regularly ask, "Where's the big book report?" I also enjoyed the benefit of discussing Man Ray's early work and ideas with a number of friends and colleagues—in particular, Anne d'Harnoncourt, Paul Avrich, William Camfield, Jack Flam, Rose-Carol Washton Long, and John Rewald—each of whom, in varying ways, contributed to my understanding of the artist and his work. I also learned a great deal from Neil Baldwin's thoroughly researched and well-written biography of the artist, *Man Ray: American Artist* (Clarkson N. Potter, New York, 1988), for, as his title suggests, we both understand the work as the product of Man Ray's American heritage. I should also like to acknowledge the patience and understanding of several good friends, whose for-bearance and understanding went beyond the bounds of a casual friendship. To this list of dubious though well-earned distinction, I should like to include the following: Kristina Amadeus; John Cauman; Roger Conover; Mark and Georgina Kelman; Frank, Patti, and Johanna Kolodny; Otto, Heidi, Tristan, Ambrose, and Siena Naumann; Robert Reiss; Martica Sawin; Michael Sgan-Cohen; Girolamo De Vanna; and Beatrice Wood. Last but certainly not least are my wife, Marie T. Keller, and children, Béa, Roland, and Alexei, who are right in feeling that the time I spent on this book would have been better spent with them.

Finally, my research could never have been completed without the generous assistance of literally hundreds of individuals. There are countless secretaries, assistants, and other staff members, working in museums, galleries, and libraries all over the world, whose names I may never know but without whose help this project might never have been realized. I am particularly indebted to Juliet Man Ray, who spent many hours with me discussing Man Ray and his work. Her able assistant, Jerome Gold, who then served as administrative and curatorial consultant to the Man Ray Trust, tirelessly answered a seemingly endless barrage of questions, supplied me with page after page of xerographic documentation, and provided many of the photographs of previously unpublished paintings, watercolors, and drawings that are reproduced in the present catalogue. Additional photographs were provided by the various institutions and collectors whose names are provided in the captions, to which I should like to add the following individuals, each of whom not only gave generously of their time but in many cases fulfilled my request for photographs without cost: Merry Foresta, Naomi Savage, Giorgio Marconi, Arturo Schwarz, and Lucien Treillard.

FRANCIS M. NAUMANN

# CONVERSION to MODERNISM

# ONE

## YOUTH AND FIRST ARTISTIC IMPULSES

### (1907–1911)

"My mother told me that I made my first man on paper when I was three."[1]

This sentence stands alone as a separate paragraph and begins Man Ray's nearly four-hundred-page autobiography, a lighthearted, delightful excursion through a career that spanned nearly a half century and, at least in its author's mind, went on to establish a reasonably complete and accurate record of his important contributions to the Dada and Surrealist movements.

The book was written in the early 1960s, by which time Man Ray had passed his seventieth birthday and was internationally renowned for his accomplishments as a highly skilled and talented photographer. In writing his autobiography, above all else, Man Ray wanted to set the record straight, to tell the world that he was not only a photographer but, first and foremost, an artist, someone who painted and drew instinctively throughout his entire life. Even though he could not recall the event firsthand, the first sentence of his autobiography makes clear the importance he attached to putting his first "man" on paper. As author, the

"man" he places on paper is, of course, Man Ray himself, who, as he tries to convince readers, simply could not prevent himself from becoming the artist he was.

Man Ray goes on to explain that his first experience as a painter had nothing to do with brushes and canvas. At the age of five, in the absence of parental supervision, he coerced several friends to place their hands into wet house paint and smear the pigment all over their faces. When their mothers came home, they jumped out from behind the front door of the house and scared them. Their mothers were not amused, and they reacted by promptly scrubbing the children's faces with hot water and laundry soap. As unpleasant as this experience may have been, it was the reprimand of the father that was never forgotten: "He gave us a methodical, cold-blooded whipping."[2]

Of course, in any autobiographical account, it is natural for a writer to recall specific events from childhood that, in retrospect, are felt to be significant in explaining events in the life that follows. Man Ray wants readers to know that his first

memory of touching paint, an activity he had engaged in to attain pleasure, only resulted in severe punishment for his indulgence. Even when he recalls his first serious attempt to make a naturalistic image, he tells his readers that it was greeted with criticism from his family and peers. With a box of crayons given to him by a cousin for his seventh birthday, the young artist freely added colors to a drawing he had made of the battleship *Maine,* the famous American cruiser that was sunk in Havana harbor in 1898. The drawing was based on a black-and-white reproduction of the sunken vessel that appeared in a local newspaper. When the picture was completed, his family and friends quickly praised its accuracy and detail, but they objected to the young artist's arbitrary application of color, selected at random from the full spectral range available in his box of colors. Whereas the boy may have lacked the facility to properly defend himself at the age of seven, some sixty-five years later the mature artist was ready to explain: "I felt that since the original pictures were in black," he reasoned, "I was perfectly free to use my imagination."[3]

In retrospect, much could be made of the precociousness of these events, particularly in light of the long and unconventional artistic career that would follow. Man Ray's lifelong dedication to painting and penchant for bright colors could be gleaned from these accounts; more important, we are provided with an early indication of the artist's innate sense of defiance, directed against both parental authority and artistic convention. Throughout his life, Man Ray would instinctively question the traditional notions of art, continuously seeking alternatives to accepted practice and rarely allowing the criticism of others to interfere with the final realization of his creative efforts. At a very early age, he adopted a guiding principle that was to serve him well in years to come: "I shall

from now on," he declared, "do the things I am not supposed to do."[4] When confronted with a particular problem—aesthetic or intellectual—Man Ray never provided his viewer with the most convenient or most logical solution. Instead, we are more often provided with only alternatives, solutions "stripped bare," so to speak, and selected arbitrarily, like the colors in his drawing of the battleship. And finally, although Man Ray's account of this incident appears to be little more than a casual recollection drawn from his youth, he must have intended his tacit dismissal of criticism at such an early age to serve as a representative sampling of his unerring nonchalance, an attitude that forms the basis of his artistic wit and would, in later years, underlie the production of his most innovative and successful Dada objects.

Toward the end of his life, Man Ray attempted to provide his audience with a rather simplistic explanation of his working method: "Mystery," he wrote, "this was the key word close to my heart and mind—and everyone loved a mystery; but did he not also want the solution? Whereas I always began with the solution."[5] Of course, this explanation relies in good measure on the oft-quoted aphorism of his lifelong friend and Dada co-conspirator Marcel Duchamp, who provided a similar solution to those who insisted upon explanations: "There is no solution," he remarked, "because there is no problem."[6]

.    .    .

Michael [Emmanuel] Radnitzky was born to Russian-Jewish parents in Philadelphia on August 20, 1890. On his birth certificate the artist's first name is given as "Michael," but his name was actually "Emmanuel," and close friends and relatives called him "Manny."[7] He was the firstborn in a family of four, sharing a relatively strict upbring-

ing with a brother and two sisters. His father worked in their home as a tailor, while his mother usually occupied herself with more domestic chores around the house. Dorothy, his younger sister, recalls that their home was always cluttered with remnants from their father's profession: cloth samples and scraps of material, which their mother often stitched together to make carriage blankets and quilts. The children also became involved in the making of these items, and at a very early age they—boys included—were taught to piece together material, sew, and embroider.[8] As we shall see, this domestic experience appears to have had a particularly lasting effect on young Emmanuel, for he would later employ similar techniques in the making of his mature paintings and collages.

In 1897 the Radnitzky family moved to Brooklyn, New York, where the boy was forced to pursue his artistic inclinations in secrecy, for his parents did not think that the pursuit of an artistic life was a worthwhile endeavor. In high school, however, Emmanuel's talents were quickly put to use in the design of illustrations and headings for the local student paper (figs. 1, 2, 3). Featuring himself the class artist, he expanded his repertoire to include outdoor subjects, preparing, on one occasion, an ink drawing that recalled the events of a vacation he took with his cousin Rose at a New Jersey resort during the summer of 1907 (fig. 4). "We row and bathe," he wrote to his brother, Sam, "and I sketch."[9]

During his junior year in high school, Emmanuel was able to take courses in art and mechanical drawing, acquiring at an early age the

4, right. *Vacation Memories*, 1907. Pen and ink, 17 1/4 x 13 1/2 inches (9 in. in diameter). Private Collection (on long-term loan to the Patrick and Beatrice Haggerty Museum of Art, Marquette University, Milwaukee, Wisc.).

1. *Untitled* [*Still Life: Violin*], ca. 1907. Pen and ink, 5 x 8 1/2 in. Private Collection.

2. *Societies*, 1907. Pen and ink, 3 1/2 x 7 1/2 in. Private Collection.

3. *Athletics*, 1907. Pen and ink, 5 x 7 in. Private Collection.

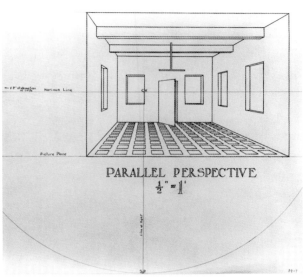

5. *Parallel Perspective*, 1907. Pencil and pen on paper, 9 3/8 x 15 in. Present whereabouts unknown (formerly Estate of the Artist, Paris).

6. *Parallel Perspective*, 1907. Pencil and pen on paper, 10 7/8 x 11 5/8 in. Present whereabouts unknown (formerly Estate of the Artist, Paris).

7. *Untitled* [*Perpetual Motion*], 1908. Pen and ink with pencil, 8 3/4 x 7 1/8 in. The Museum of Modern Art, New York; Gift of Sylvia Pizitz.

skills that would serve him well in the future. He especially excelled in the mechanical drawing class, where, he remembers, he admired the teacher for his ability to combine "everything that was practical with a wonderful sense of the graphic."[10] These very qualities are apparent in his numerous perspective studies from these years (figs. 5, 6). The diagram of a so-called perpetual motion machine (fig. 7) is one of several mechanical drawings by the young artist to have survived from this course. Not only does this work display a certain degree of technical aptitude, but the drawing also documents an early interest in recording the mechanics of a given operation—in this case, the belt-driven transfer of motion from vertical to horizontal displacement. Later, Man Ray would apply this same keen sense of precision to determine the arrangement and mechanical execution of shapes in his numerous collages, drawings, and paintings of the mid- to late teens.

One of many assignments in this high school course appears to have been to design an alphabet, as well as a series of fanciful letters for an illustrated book (figs. 8, 9), an experience the artist would also feel free to draw upon in later years

(particularly in his *Alphabet for Adults,* a book he designed and published while living in Hollywood some thirty years later).[11] Apparently, students in this high school course were expected to gain a greater understanding of the proportions inherent in Greek and Gothic art by preparing detailed diagrams of architecture, as well as selected examples of sculptural form (figs. 10, 11). He also made a colorful tempera-and-ink drawing of a castle perched at the edge of a mountain cliff that was supposed to serve as a design for a stained glass window (fig. 12). Nearly every one of these drawings would—in one way or another—serve the artist's

10. *Discobolus,* ca. 1908. Pencil on paper, 6 x 4 1/4 in. Private Collection.

8. *Untitled [The Letter "A"],* 1908. Ink on paper, 6 1/2 x 5 1/8 in. Present whereabouts unknown (formerly Estate of the Artist, Paris).

9. *Untitled [The Ornate Letters "S" and "O"],* 1908. Ink on paper, 9 1/2 x 12 3/16 in. (overall). Present whereabouts unknown (formerly Estate of the Artist, Paris).

11. *Untitled [Gothic Window],* 1908. Pencil and ink on paper, 10 1/2 x 8 in. Present whereabouts unknown (formerly Estate of the Artist, Paris).

12. *Untitled* [*Stained Glass Window*], ca. 1908. Tempera and ink on paper, 14 x 10 13/16 in. Private Collection.

needs in years to come; not only do they preserve a documentary record of his first serious artistic inclinations, but the disciplined line and precise mechanical execution they readily exhibit are qualities that would remain integral to Man Ray's artistic sensitivities throughout his life.

The series of early works that perhaps best harbors the essential characteristics of the artist's more mature artistic development is contained in a group of drawings based on a study of mechanical forms and their projected shadows. The drawing entitled *Triangles* (fig. 13), for example, composed of six mechanically produced images of draftsman's triangles, each of which is rendered as if in suspension and casting shadows against either curved or angular wall surfaces, bears an uncanny resemblance to the basic imagery and procedural method utilized in Man Ray's series *The Revolving Doors* (fig. 162), particularly the panel entitled *Shadows* (fig. 164). Indeed, the general theme of shadows can be seen to run throughout Man Ray's mature work, exhibiting itself so often and with such consistency that, from this point onward, objects and their projected images can be seen to attain the relevance of a consciously inspired leitmotif.

Upon his graduation from high school in 1908, it was announced that Emmanuel had been awarded a scholarship in architecture at Columbia University. But because he had already decided to become a painter, he declined. "His parents were bitter and heartbroken," reported one of his relatives. "For an immigrant family's child to attain such a high standard and then throw it away was a dreadful thing. And so, they denied themselves almost everything and saved from their meager finances to buy Manuel paints and brushes and canvases."[12] Thus properly equipped, immediately upon the close of school, the determined young artist devoted his summer to the pursuit of his

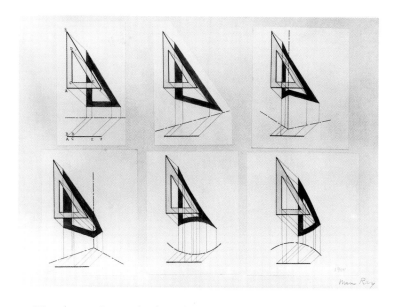

13. *Triangles,* 1908. Pencil, ink, and watercolor on paper, 10 1/4 x 13 3/4 in. (overall; six separate pieces of paper). Francis M. Naumann Fine Art, New York.

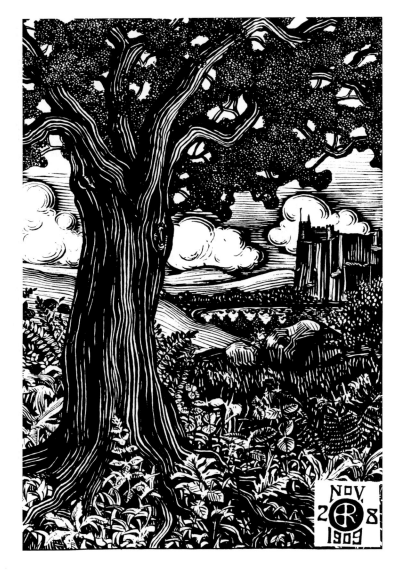

14. *Untitled* [*Tree and Castle*], 1909. Pen and ink on paper, 8 3/4 x 6 in. Collection of Helen Ray Faden, Pasadena, Fla.

newly chosen profession. Few works from this period have survived: a consciously stylized illustration of a tree and distant castle evoking a medieval setting (fig. 14); the drawing of a classical building under construction, probably the Brooklyn Museum (fig. 15); and the portrait of a friend from high school (fig. 16). The portrait records the intense gaze of a young boy, his pensive features recorded in muted brown tonalities, as if in emulation of contemporary American Realist painters, who themselves sought inspiration in the dark pictures of the Dutch and Flemish masters of the seventeenth century.

In this highly experimental period—which continued for several years after his graduation from high school—it appears that the prodigious young painter took his new career quite seriously. On sunny afternoons, he would even try his hand at landscape painting, setting up his easel in Prospect Park, located near his home in Brooklyn. Or, when he sought more rural surroundings, he took the elevated train to the outskirts of the city, which was then still open countryside with a few scattered farmhouses, grazing fields, and livestock. Among the landscapes that survive from this period, few exhibit more than the untrained hand of an inexperienced young painter, trying diligently to emulate the broad and quickly applied brushstrokes of the Impressionists. Others show that he sought inspiration from specific paintings that he may have been familiar with from trips to the New York museums or from prints and repro-

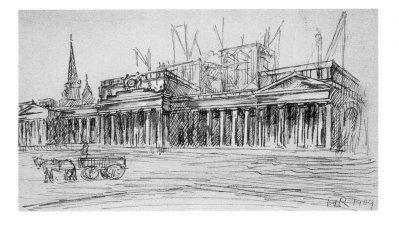

15. *Untitled* [*Classical Building under Construction* (possibly the Brooklyn Museum)], 1909. Pen and ink with watercolor on paper, 5 x 8 1/2 in. Private Collection.

ductions he had seen in art books. Man Ray himself admitted years later that the paintings he produced in this period—all signed with his initials, *ER,* usually fused in the form of a monogram—failed to communicate what he was trying to express.[13] Undaunted, however, he continued to paint at home in his bedroom, which by this time he had transformed into an artist's studio.

In a photograph from this period, we find the artist hard at work in his Brooklyn studio (fig. 17), where he occupied himself primarily with the painting of portraits and still lifes. At one time or another, practically every member of the family posed for him. Most of his portraits took less than a half hour to complete, and he became so proficient at capturing the sitter's likeness that he genuinely entertained aspirations of becoming a fashionable New York portrait painter (see, for example, his *Woman with Hat,* which is a portrait of Madeleine, a friend of his sister Elsie, fig. 18).[14] One of his favorite subjects was his sister Dorothy, whom he had painted a few years earlier while still in high school (fig. 19). Man Ray recalls that she "was quite a beauty with raven black hair, white skin, and big black eyes."[15] Originally he offered to paint her in a slightly more revealing pose, but she only acknowledged her brother's compliments and politely declined his offer. Nevertheless, we know that on at least one occasion the artist, with an intensity and curiosity matched only by his irrepressible ingenuity, employed a professional model to pose naked in his bedroom, the expenses for her services and experience to be shared by a few friends. When his parents discovered what was going on, however, the entire enterprise was quickly abandoned.[16]

In the years after high school, Man Ray worked at a variety of jobs while pursuing his desire to become a painter. After an attempt to work at a newspaper stand lasted only a week, he

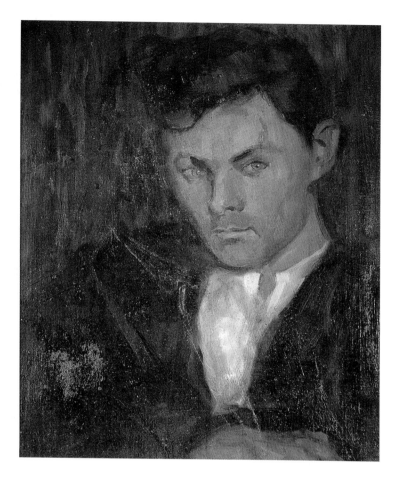

16. *Untitled* [*Portrait*], ca. 1909. Oil on canvas, 18 1/8 x 14 15/16 in. Present whereabouts unknown (formerly Estate of the Artist, Paris).

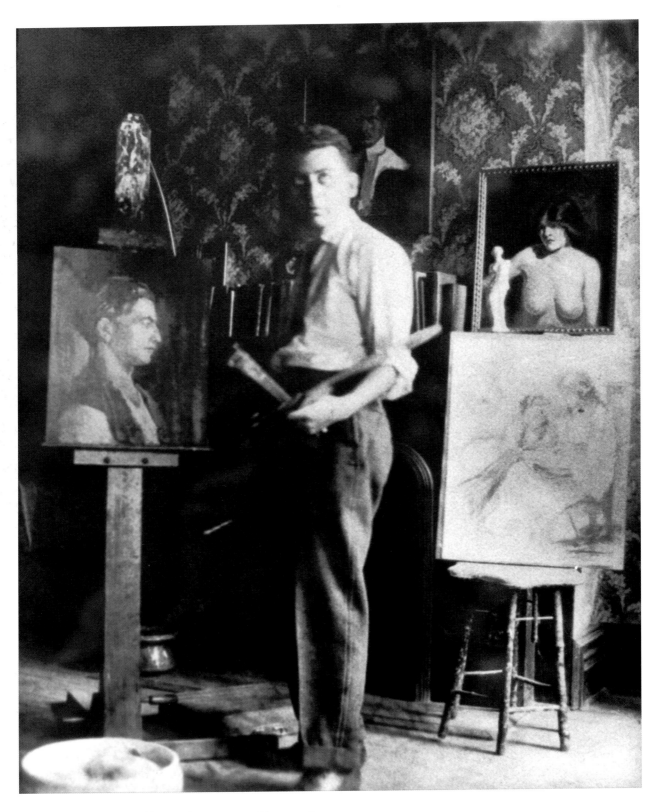

17. Man Ray in his Brooklyn studio, ca. 1910. Photograph, dimensions unknown. Collection of Joan Hofheimer, Bethesda, Md.

secured his first art-related employment as an engraver's apprentice. This job did not last long either, but within a few weeks he was able to secure a lettering and layout position for an advertising firm in Manhattan. With this experience and his commercial skills behind him, the artist was later equipped to support himself throughout his early twenties, working at a variety of art-related jobs, ranging from mechanical drafting for a publishing house to handling the artistic production of a map and atlas publisher. This professional experience would find application in the various techniques utilized by the artist in his more experimental work from these years, although throughout his life the mature artist would consistently caution observers against the pitfalls of admiring a particular work of art solely on the basis of its technical excellence.[17]

It was not only for the purpose of improving the technical quality of his paintings and drawings that Man Ray enrolled in life drawing classes at the National Academy of Design and, later, the Art Students League in New York. "I wanted to see a nude woman," he later confessed, and it was for this reason as much as any other that he attended the drawing classes in these academic institutions.[18] Aside from the obvious opportunity to satisfy certain sexual curiosities, it is safe to assume that Man Ray had probably also hoped that the instruction he received in these courses might lead to a more rapid attainment of his goal of becoming a professional painter. The young student, however, was very quickly disillusioned. The time-consuming and laborious method of drawing stipulated by the academic approach strained his patience and only served to stifle his creative impulses. For the brief period when he attended these classes, Man Ray appears to have been exposed to the full gamut of working methods required by the academy: sketching models in

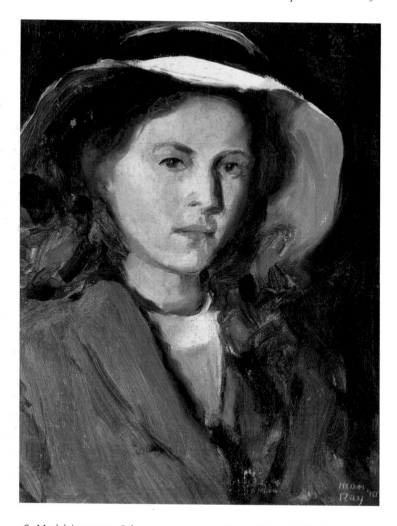

18. *Madeleine,* 1910. Oil on canvas, 12 x 9 1/2 in. Private Collection.

19. *Portrait of Dorothy, 1908.* Oil on canvas, dimensions unknown. Destroyed (Photo: Artist's Card File; see document C).

various costumes, making drawings of antique plaster casts, and executing detailed studies of human anatomy, prepared not only from models but also from dissected cadavers and skeletons.

The artist's first exposure to the rigors of academia occurred in the fall of 1910, during the time of his application for admission to classes at the National Academy of Design. One of the Academy's most important entrance requirements was that every candidate complete a drawing from the antique, on the premises, directly before the watchful eyes of his or her prospective teacher; the drawing then had to be evaluated by a group of instructors selected from the Academy's staff. Over the course of several evenings, Man Ray carefully prepared a detailed drawing from a plaster cast of the Greek god Apollo (fig. 20). Working more quickly, he then sketched the figure of a standing nude male model (fig. 21). Both drawings exhibit an obvious technical proficiency and, one could say, even reveal an exceptional talent for a beginning student. Foreshortening and anatomical proportions are accurately rendered, while select details are more carefully studied in the surrounding areas of the page.

But the rigid dictates of such a slow and methodical working method have resulted in the creation of relatively cold, lifeless figures, an impression that forms a sharp contrast to the small, quickly sketched figure of a man with arching back and upraised arms that can be seen in the right margin of the nude figure study. Apparently, the young artist was not accustomed to such a laborious method, so, in an effort to relieve his impatience, he made a quick sketch of the model stretching after an exceptionally long pose. Even Man Ray's instructor remarked that this little sketch was more interesting and showed more life than his academic studies, and he advised his new student to drop out of the course and work inde-

20. *Apollo*, ca. 1910. Charcoal on paper, 24 1/4 x 19 in. Present whereabouts unknown (formerly Estate of the Artist, Paris).

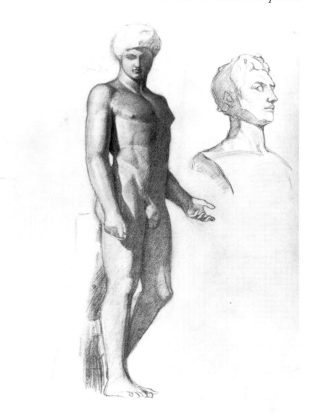

pendently on things he found more interesting.[19]

Man Ray followed his instructor's advice, only to enroll in yet another academic institution. In October of 1911, he signed up for a six-month course in life drawing at the Art Students League. The instructor was George B. Bridgman, one of the best-known teachers of human anatomy in his time.[20] In the very first class, Man Ray recalled, the model was "a huge naked woman" who posed openly on a platform in the center of the classroom. While most of the students carefully studied the model's proportions and worked for days on their individual drawings, Man Ray remembered having sketched the general pose of the nude very quickly, with heavy black lines, working and reworking his image until the drawing "was a complete mess of black charcoal out of which emerged a strange primitive-looking figure."[21] The drawing produced in this first class may very well have been the charcoal sketch of a half-length nude reproduced here (fig. 22), which, indeed, is so heavily overworked that the figure barely emerges from the muddle of dark lines defining her form. In spite of such relatively awkward handling, this very sketch appears to have served as the subject of a more sophisticated rendering of the half-length nude in paint, with the figure positioned, rather curiously, behind a plaster statuette of the Venus de Milo (see painting propped above a drawing on the upper right in fig. 17).

"Between 1908 and 1912," Man Ray later remarked, he studied at "most of the art schools in New York."[22] It soon became clear, however, that

21. *Untitled* [*Standing Male Nude*], ca. 1910. Charcoal on paper, 24 1/4 x 18 3/4 in. Present whereabouts unknown (formerly Estate of the Artist, Paris).

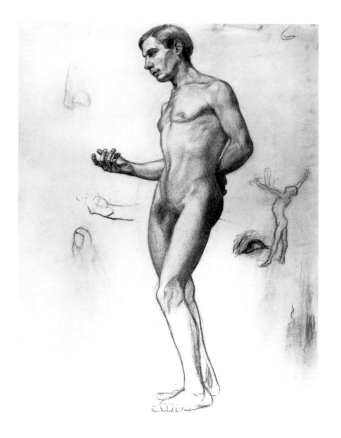

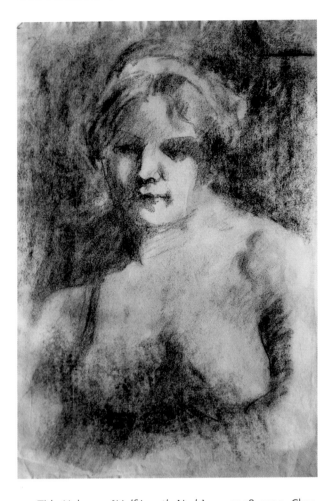

22. *Title Unknown [Half-Length Nude]*, ca. 1908–1910. Charcoal on paper, 19 x 12 1/2 in. Private Collection.

the restrictive atmosphere fostered by these academic institutions provided little freedom for such an imaginative young painter. By this time Man Ray was clearly looking for a change, a new direction that would represent not only a break from the artistic conventions of the past but something even deeper, something that would allow him to reinvent himself and chart a course for the future.

In 1912 two events occurred in Man Ray's life that contributed significantly to facilitating this change. In accordance with a suggestion provided by his younger brother, Sam, in the spring of 1912 the Radnitsky family changed its name to Ray, leaving Emmanuel with the name Manny Ray, or, as he ingeniously shortened it, Man Ray.[23] It was under this new name that, in the fall of 1912, he enrolled in classes at the Ferrer Center, a new educational institution in Manhattan. It was here that he would encounter many young artists who, like himself, not only believed that breaking the rules of convention served as a guiding philosophy of life but were convinced that a pursuit of the new and innovative in art could—in and of itself—serve as a perfectly legitimate approach on which to base all future artistic expression.

# TWO

---

## THE FERRER CENTER: Formulating the Aesthetics of Anarchism (1912)

The Ferrer Center, or Modern School, as it was also called, was located at 63 East 107th Street in Harlem. A liberal school of child and adult education, the Ferrer Center was organized and run by a number of free-spirited individuals who came from highly diverse cultural and professional backgrounds, men and women whose pedagogical talents were allied by a common commitment to the ideological tenets of anarchism. Just as the members of this organization sought to abolish the oppression of political authority, as teachers at the Ferrer Center they attempted to create an atmosphere of complete freedom for the students, providing an alternative to the structured and often inhibiting approach imposed in a more traditionally disciplined classroom.[1]

Shortly after it was established in 1911, the Ferrer Center became known as the gathering place for a number of New York's most celebrated cultural and political radicals—Leonard Abbott, Alexander Berkman, Will Durant, Emma Goldman, Margaret Sanger, Upton Sinclair, Lincoln Steffens, and a host of others—each of whom either lectured or offered courses at the school. The art classes were an especially important part of the curriculum, for here, rather than follow the slow and methodical approach stipulated through academic training, students were strongly encouraged to explore the impetus provided by their own fertile imaginations. This open and unrestricted atmosphere was promoted by Man Ray's teachers Robert Henri and George Bellows and enthusiastically shared by his fellow students Ben Benn, Samuel Halpert, Abraham Walkowitz, Max Weber, Adolf Wolff, and William Zorach, all of whom would become better known for their artistic accomplishments in the years to come.

Upon his first visit to the life drawing class at the Ferrer Center, Man Ray recalled, he was particularly impressed by the sketching technique taught to the students, for they were instructed to rapidly execute their drawings and color sketches from the posing model within twenty minutes, an approach that differed sharply from the slower, more studied method he had been familiar with from the academic institutions he had attended.

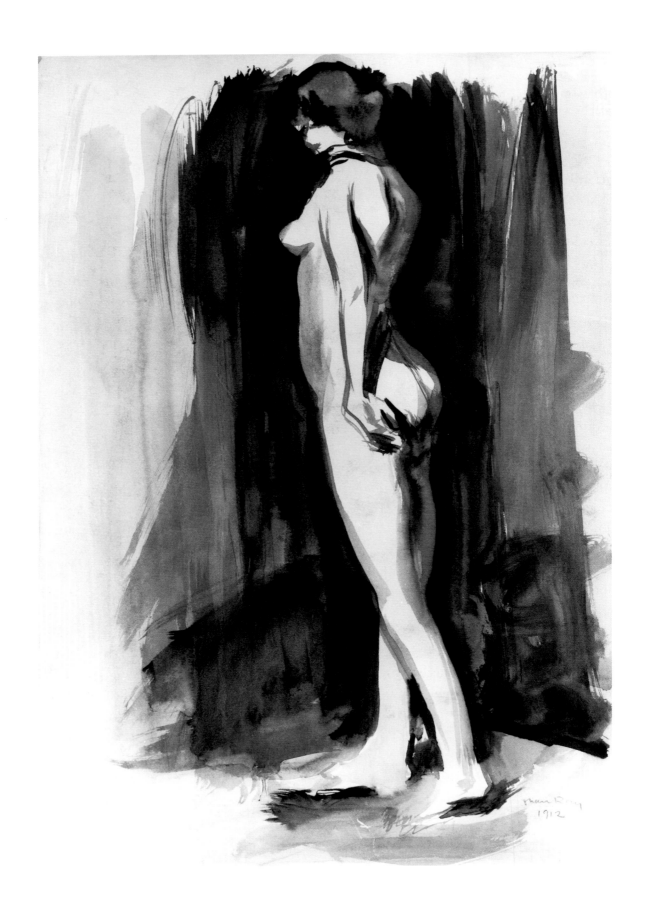

23, facing page. *Untitled [Standing Nude in Profile]*, 1912. Ink and ink wash on paper, 21 1/2 x 14 3/4 in. (inscribed on verso: "20 min. sketch/Ferrer Center 1912"). Present whereabouts unknown (formerly Estate of the Artist, Paris).

Robert Henri, for example, his most memorable teacher at the Center, instructed him to assert his individuality, even at the risk of being misunderstood. Years later, Man Ray recalled that Henri's ideas were even more stimulating than his artistic criticism: "He was against what most people were for, and for what most were against."[2]

While Henri's rebellious and pioneering position in the history of American painting has been well established, until recently his more radical, anarchist sympathies have been either overlooked or suppressed by historians and biographers.[3] His interest in social reform dates from his family's support for the Democratic Party, but his humanitarian concerns were more definitively aroused as a result of the government's poor treatment of the American Indian and by the injustices of the Homestead steel strike in 1892. As the leader of the Eight, he encouraged his fellow painters to seek inspiration in the dynamism of the city, whose ethnic groups and lower-class inhabitants succinctly embodied the vitality of life in its most dignified and uncorrupted state. But even more than his socialist inclinations, it was the dynamic preaching of Emma Goldman that drew Henri to the Ferrer Center in 1911 and converted him to the cause of anarchism, a philosophical doctrine he embraced and supported until his death in 1929.

Henri taught without pay at the Ferrer Center for nearly seven years and also managed to enlist the talents of his friend and former pupil George Bellows, whose anarchist leanings were quickly replaced by patriotic instincts when America entered the war in 1917 (at which time Bellows quit teaching and joined the military).[4] Together,

Emma Goldman later noted, Henri and Bellows "helped to create a spirit of freedom in the art class which probably did not exist anywhere else in New York at that time."[5]

This "spirit of freedom" is clearly reflected in the numerous sketches Man Ray produced in the life drawing classes at the Ferrer Center (figs. 23–27). Independent of medium—whether he was working in charcoal, ink wash, or a densely applied watercolor pigment—his results were always consistent: the model is given visual definition by means of a rapid, though confident and fluid, application of line or color. Since the drawings in this course had to be completed within the twenty-minute time limitation set by the instructor, there was little opportunity for the students to render details precisely in the fashion customarily demanded by more academic approaches. Consequently, with few exceptions, Man Ray's figure studies are characterized by a lack of definition in the extremity of their appendages (fingers and toes), though—as in the example of a skillfully rendered, slightly foreshortened figure of a reclining nude (fig. 24)—these details were sometimes worked out in the surrounding space on the drawing page.

Most of the sketches of nudes that survive from this period record the same buxom, young female model—probably fourteen-year-old Ida Kaufman, who at age fifteen married the school's director, Will Durant, and later, as co-author of many books with her husband, became well known under the name Ariel. "Her figure, quite stocky, with firm, fully developed breasts," Man Ray recalled some fifty years later, "resembled one of Renoir's nudes."[6] While his subjects may very well recall the works of an Impressionist, the technique Man Ray adopted for the application of paint was far more dependent upon the bravura brushstroke and intense palette of Fauvism. The

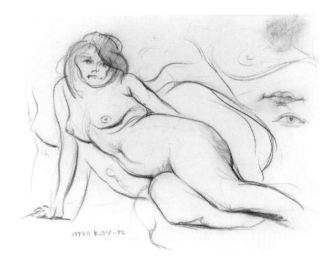

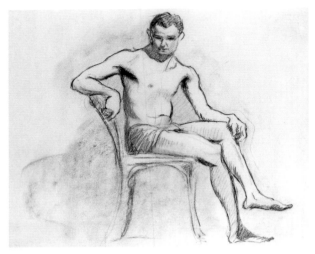

24. *Untitled* [*Reclining Nude*], 1912. Charcoal on paper, 14 x 17 in. Private Collection.

25. *Untitled* [*Man in Shorts Seated in a Chair*], 1912. Pencil on paper, 13 7/8 x 17 in. Collection of Beatrice Nina Naumann, Yorktown Heights, N.Y.

artist frequently accentuated his figure studies with open washes of bright, near-luminous pigment, where flesh tones can range from pale rose to fiery orange (fig. 27). In some cases, it almost appears as if Man Ray has consciously reacted against the adverse criticism he received as a child for his arbitrary application of color, for most of these figure studies, when painted, are highlighted with an assortment of bright, sometimes unmixed hues, seemingly selected from his palette in a random fashion and applied in quick, expressionistic gestures of pure color.

Occasionally, Man Ray would direct his attention away from the model to subjects in his immediate environment. These works—usually rendered with brush and ink and probably intended as illustrations—provide a sampling of the activities that took place in life drawing classes at the Ferrer Center. One drawing documents the great variety of individuals who took advantage of classes there: a middle-aged woman, an elderly man, and a young boy are shown diligently at work on their drawings (fig. 28). Another sketch shows a woman drawing at a makeshift easel, her sketch pad propped up

against the back of a stool (fig. 29). Finally, a more ambitious drawing depicts two older men reviewing drawings as their students attentively look on (fig. 30). The mustachioed gentlemen in the foreground was probably meant to represent Robert Henri, while the bearded man to his right may have been based on the features of Adolf Wolff, a sculptor and friend of Man Ray's who was distinguished by his sharply trimmed beard and gruff

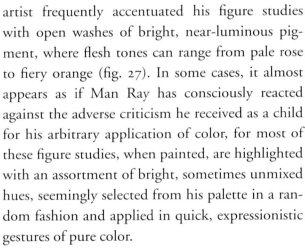

26. *Female Nude*, 1912. Charcoal on paper, 10 3/4 x 15 in. Collection of Roland Archil Naumann, Yorktown Heights, N.Y. Photo courtesy of Francis M. Naumann.

appearance.[7] The scene probably records one of Henri's "quiet" critiques. "Passing around from drawing to drawing," Man Ray recalled years later, "he made gentle, encouraging remarks, but never touched the drawings nor criticized adversely."[8]

The year 1912 marked a period of intense activity for Man Ray at the Ferrer Center. By the winter he was ready to participate in the first group exhibition organized by the artists associated with the Modern School, held at the Ferrer Center from December 28, 1912, through January 13, 1913. It is difficult to establish with precision the works by Man Ray that were shown in this exhibition, although a painting entitled *A Study in Nudes* (fig. 31)—signed and dated 1912—was reproduced in a review of the show that appeared in *The Modern School,* a magazine published by the Ferrer Association.[9] Despite the poor quality of this black-and-white illustration, it can be seen that the harsh delineation usually associated with more academic modeling has been entirely replaced by a softer, more color-oriented approach to the definition of form.

The seven female figures in this painting (as well as a small baby clutching the thigh of the kneeling figure on the right) are reminiscent of the postures and compositional arrangement given to several paintings in the bather series of Cézanne, an artist whose works were just then becoming associated with the most advanced developments of modern painting on both sides of the Atlantic.[10] That the works Man Ray showed in this exhibition did not conform to a unified stylistic approach, however, is confirmed by the comments published by his friend and fellow exhibitor Adolf Wolff: "Man Ray is a youthful alchemist forever in quest of the painter's philosopher's stone," he wrote. "May he never find it, as that would bring an end to his experimentations which are the very condition of living art expression."[11]

27. *Female Nude,* 1912. Watercolor on paper, 15 1/4 x 11 1/8 in. Private Collection.

28. *Untitled* [*People Drawing*], 1912. Pencil and ink on paper, 10 x 7 7/8 in. Collection of the Tokyo Fuji Art Museum, Tokyo, Japan.

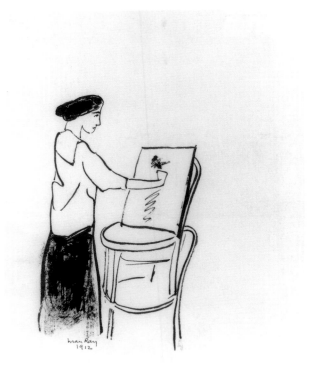

29. *Untitled* [*Woman Drawing*], 1912. Ink on paper, 15 3/4 x 11 1/8 in. Francis M. Naumann Fine Art, New York.

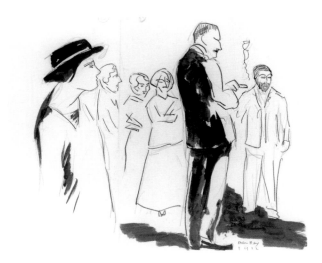

30. *Untitled* [*People Looking at Art*], 1912. Pencil, pen, and ink on paper, 9 7/8 x 13 3/16 in. Collection of the Tokyo Fuji Art Museum, Tokyo, Japan.

Man Ray's stylistic oscillations in this period were aptly matched by the diversity of subjects incorporated in his work, evidenced in part by the range and variety of titles given to the paintings and drawings he showed in the next group exhibition at the Ferrer Center—held only four months after the first, from April 23 to May 7, 1913. This second showing appears to have been a more ambitious undertaking, for over sixty-five works were exhibited and virtually every art student associated with the school participated, including the children, whose works were exhibited alongside those of the adults. The show was even accompanied by a small catalogue (fig. 32), containing a brief introduction by Max Weber and a simple list of the works' titles.[12]

It is difficult to securely identify with known

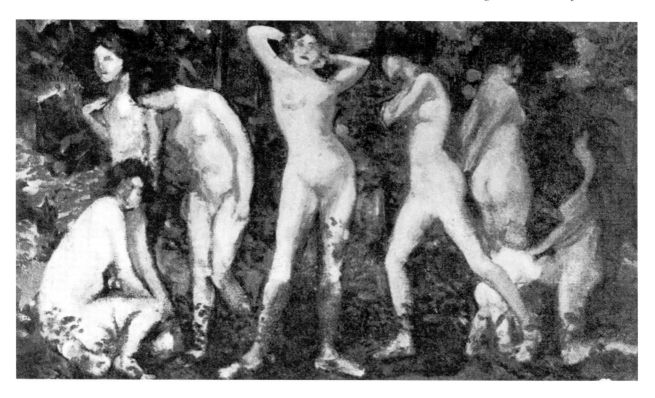

31. *A Study in Nudes,* 1912. Oil on canvas, dimensions unknown. Lost or destroyed (reproduced in *The Modern School,* Spring 1913).

works any of the paintings, drawings, or watercolors shown by Man Ray in this exhibition. Their titles, however, indicate that the subjects were not always derived from tangible elements in the artist's immediate environment and faithfully recorded in a traditional, representational method. Indeed, certain titles suggest that at this time Man Ray was becoming increasingly aware of the potential inherent in a less figuratively dependent approach. Along with works simply entitled *Nude, Portrait, Bridge, New York,* and *The Copper Pot,* for example, he showed works with such diverse titles as *Amour, Fantasy, Decoration,* and *Tschaikowsky* (the

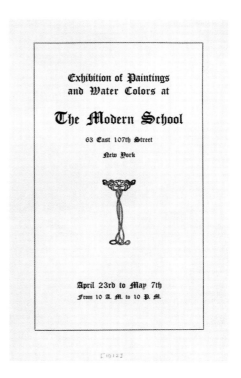

Exhibition of Paintings and Water Colors at

**The Modern School**

63 East 107th Street

New York

April 23rd to May 7th
From 10 A. M. to 10 P. M.

32. *Exhibition of Paintings and Water Colors at the Modern School,* April 23–May 7 [1912], catalogue. Collection of Teruo Ishihara.

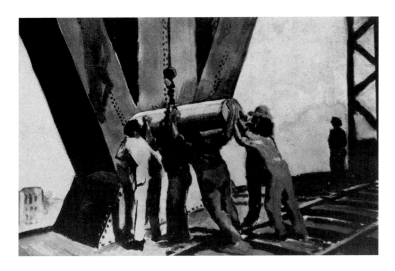

33. *Bridgebuilders*, 1912. Oil on canvas, 24 x 28 in. Lost or destroyed (photo: Artist's Card File; see documet C).

latter of which was most likely an abstract or "abstracted" composition meant to represent the music of the composer, rather than a portrait likeness of the composer himself).[13]

Even before his introduction to the Ferrer Center, Man Ray recalled, he had engaged in many long conversations with an unnamed friend, an aspiring young musician, who argued that music was superior to painting because it was "more mathematical, more logical and abstract." Man Ray remembered complying with this notion, but he claimed that at the time he did not know quite how this principle could be applied to his work, though he acknowledged that it was the germinating factor that later led to his involvement with abstraction. "I agreed," he remarked, "but intended later to paint abstractedly [*sic*]."[14]

At the Ferrer Center, Man Ray could hardly have avoided continuing conversations along these lines, for the interrelationship of music and art was a favored topic of his friend Manuel Komroff, who was both an artist and a musician. Komroff not only participated in most of the exhibitions held at the Center but also, on Monday evenings, held piano recitals at the school, playing "selections from the great masters."[15] Komroff was the only artist to be represented by more works than Man Ray in the 1913 exhibition at the Ferrer Center, and most of the titles he gave to his paintings and watercolors invoked an analogy to music: *Etude in F Minor, Study in C Sharp Minor, Study in the Key of C,* etc. In fact, at the time when the exhibition was being held at the center, Komroff published in the school's magazine an article entitled "Art Transfusion," by which term he meant that sculpture, painting, and literature were becoming more and more like music while, at the same time, modern music was increasingly sharing qualities with the visual arts. "As each art is striving to include all the others," he observed, "they are all becoming one." He further postulated that "Nature and art have very little in common," concluding that "true art . . . is as far removed from earth as space itself."[16]

The potential inherent in abstraction was further expounded upon in Max Weber's introductory essay in the catalogue. One of the older, more established artists who began frequenting the Center in 1912, he was to have a pronounced influence on Man Ray's earliest experiments with modern art. By the time of this exhibition at the Ferrer Center, Weber's familiarity and understanding of the Cubist and Futurist movements in Europe was considerably more advanced than his contemporaries', and he had already begun to experiment with the principles of abstraction in his own work. In his introduction to the catalogue, Weber indicated that he and his fellow painters were on the threshold of a new artistic reality. "Surely there will be new numbers, new weights, new colors, new forms, new odors, new sounds, new echoes, new rhythm of energy, new and bigger range of our sense capacities," he wrote. "We shall paint with the mind eye, the thought eye. . . . We shall not be bound to visible objects. . . . We shall put together

34. *In Dock,* ca. 1912. Watercolor on paper, 6 x 4 1/4 inches. Collection of Helen Ray Faden, Pasadena, Fla.

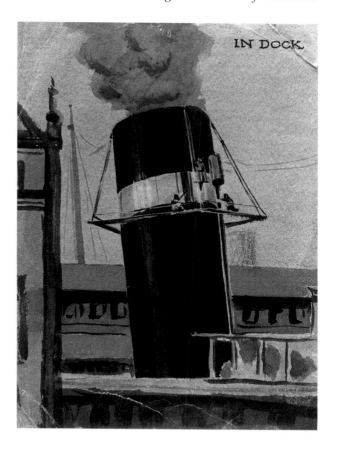

that which in a material sense is quite impossible."[17] Weber later recalled that he also urged his fellow students "to take time off from the life-class" and, like Henri, suggested that if they wished to capture the energy and heroism of modern times, they should "go out among the people who toil in the mills and shops, go to scenes of bridge construction, foundries, excavation."[18]

On at least one occasion, Man Ray appears to have taken Weber's advice literally. In a lost painting from 1912 entitled *Bridgebuilders* (fig. 33), the artist has faithfully recorded a group of workmen in the process of hoisting a large cylindrical mass during the construction of a bridge. An equally representational approach was adopted for a small watercolor entitled *In Dock* (fig. 34), which shows workmen on a suspended scaffold painting the smokestack of a steamship. If we can judge solely by the titles given by Man Ray to works shown in this exhibition at the Ferrer Center, the artist seems to have relied upon themes drawn from city life in a number of other paintings and drawings from this period. Although the work that was entitled *New York,* for example, cannot be securely identified with an extant painting by the artist, a semblance of its spirit and perhaps even its style might be garnered from a small pen-and-ink drawing from 1912 entitled *Skyline* (fig. 35), which, as its title suggests, depicts the many bridges and skyscrapers of Manhattan.

*Skyline* is not a straightforward, naturalistic cityscape but rather a quickly executed sketch that captures the dynamism of a thriving metropolitan center with its overcrowded streets and elaborate

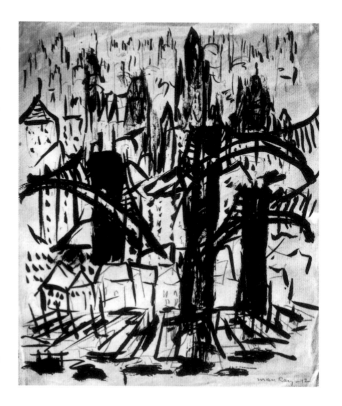

35. *Skyline,* 1912. Pen and ink on paper, 10 x 8 in. Collection of Arnold Crane, New York.

transportation network. A series of rectangular piers fans out at the base of the image, and the city's many bridges are shown as if uprooted from their moorings and embedded within its architecture, serving to join the low-lying houses near the piers in the foreground with the towering skyscrapers at the upper center of the image.

The Ferrer Center exhibition received sparse critical acclaim, although Arthur Hoeber, art critic for the *New York Globe,* mentioned it in his weekly column. In a letter to the newspaper, Man Ray reproached Hoeber for having published an insufficiently prepared review of the show. Among his objections, he accuses the critic of never having actually seen the exhibition, further asserting that Hoeber's entire review was based only on his reading of the catalogue introduction, which Man Ray felt was not intended to express the full variety and diversity of ideas that were represented in the exhibition. "Mr. Hoeber's notice proves," he amusingly concluded, "that even a critic can become creative if only he neglect natural representation."[19]

In the stimulating environment of the Ferrer Center, Man Ray was exposed to the most progressive and revolutionary ideologies of his day; even more than the artistic instruction of his teachers, these ideas would serve to nurture the rebellious attitude already assumed by this young painter. But the artist who would have the greatest effect on the formation of his political ideologies, as well as a profound impact on his personal life, was the Belgian-born anarchist Adolf Wolff, self-proclaimed "poet, sculptor and revolutionist" and, as he himself emphasized, "mostly revolutionist."[20]

Man Ray met Wolff (or "Loupov," as he is thinly disguised in Man Ray's autobiography) at the Ferrer Center. Like Man Ray, after only a few months of exposure to the workings of the school, Wolff became one of its most active participants. In the evenings he gave a course in French for adults, while on Thursday afternoons he taught art to the children. Learning that Man Ray was unhappy living at home, Wolff offered his young friend a place in which to work, in a small studio he rented on Thirty-fifth Street in Manhattan. Man Ray accepted his friend's invitation, but he did not find the space very conducive to work, for Wolff left the floor wet and dirty, and the studio was filled with his sculptures, drawings, and oil paintings. Moreover, one morning Man Ray entered the small studio only to discover the older artist and a young woman lying together on the studio couch. Wolff laughingly explained that the woman was a model and that they were only trying out a new pose for a sculpture. Man Ray accepted the explanation but realized that he would soon need to find a new place in which to work.

During the mid- to late teens Wolff participated in a number of anarchist demonstrations, several of which resulted in his arrest and imprisonment. This dedication to anarchism was succinctly incorporated in his poems and sculpture of this period. Like his personality, Wolff's poetry was characterized by a crude, unrefined power that reflected his militant temperament, while his sculpture clearly paralleled the most advanced sculptural expressions of the day. The more figuratively dependent works of ca. 1913–1914 are characterized by a basic reduction and simplification of form (fig. 36), doubtlessly inspired by Cubist painting and sculpture, examples of which Wolff would have known from the Armory Show or from exhibitions of progressive European and American art in the New York galleries (Man Ray's response to these exhibitions is discussed in the following chapter). We know that Wolff attended these exhibitions during the 1913–1914 gallery season, for at that time he served for a brief period as an art reviewer for the socialist magazine *The*

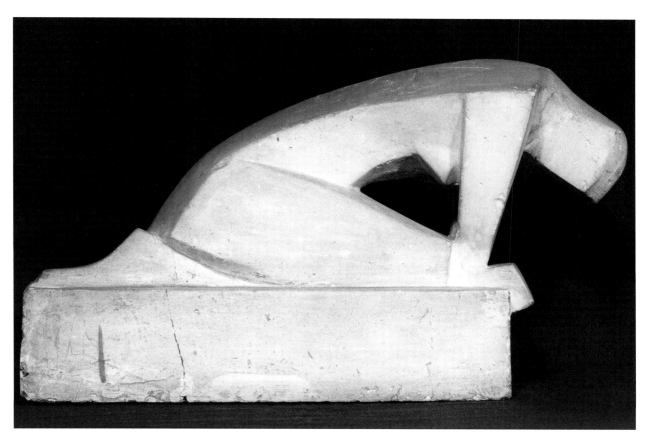

36. Adolf Wolff, *The Suppliant,* 1914. Plaster, 12 x 20 1/2 x 9 in. Francis M. Naumann Fine Art, New York.

*International.* To this monthly publication he contributed a series of articles entitled "Insurgent Art Notes," presenting his somewhat unorthodox and prosaic reviews of current exhibitions, from the small inaugural show at the Ferrer Center to important, larger exhibitions of modern art at the better-known galleries in Manhattan.

In the same period when Wolff was writing for *The International,* Man Ray provided the cover illustration for at least three numbers of this socialist review (fig. 37), a design that is repeated with different colored backgrounds on the March, April, and May 1914 issues. Within the circular frames defined by the outstretched and supporting arms of three symmetrical, architectonic figures (somewhat reminiscent of Wolff's Cubist-inspired sculpture), Man Ray has supplied two ink draw-

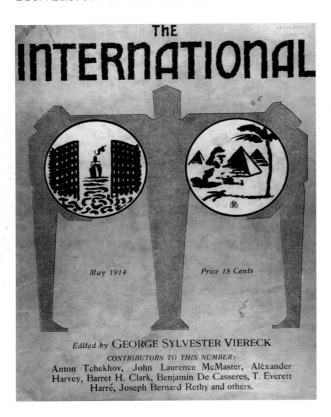

37. *The International,* cover (with ink drawings of a lift lock and pyramids by Man Ray), May 1914. Butler Library, Columbia University, New York.

ings, one of an ocean steamer about to pass through the opening doors of a lift lock, and the second of pyramids and a sphinx in the shadow of a sun-drenched palm. These two seemingly unrelated views may in fact have been a subject of some political importance in 1914, for it was in that year that the Panama Canal, the most important man-made waterway in the Western Hemisphere since the Suez Canal in 1869, was informally opened; together, these two canals created a single round-the-world sea passage, regarded strategically as an especially important transportation route during the war.[21]

In addition to these covers for *The International,* Man Ray's only other known contribution to leftist politics came in the form of two political cartoons he designed for covers of *Mother Earth,* the radical periodical edited by Emma Goldman and Alexander Berkman, whose offices were just a few blocks away from the Ferrer School.[22] The first of these covers (fig. 38) shows a giant two-headed dragon tugging at opposite ends of a figure labeled HUMANITY, while the separate heads of the monstrous beast are identified by the labels CAPITALISM and GOVERNMENT. The illustration makes it clear that Man Ray considered the individual powerless against the larger ideological forces that ultimately control man's destiny. It should be noted that this drawing appeared on the cover of the August 1914 issue of the magazine, precisely the month when it became clear that the European war would reach worldwide proportions. This issue also carried, on its title page, a poem by Adolf Wolff entitled simply "War," where, in a strongly anarchist tone, law and order are denounced as the very causes of death and destruction.

The next issue of *Mother Earth* carried Man Ray's drawing of two prisoners in striped garb (fig. 39), positioned in such a fashion that their uniforms complete the stripes of an American flag.

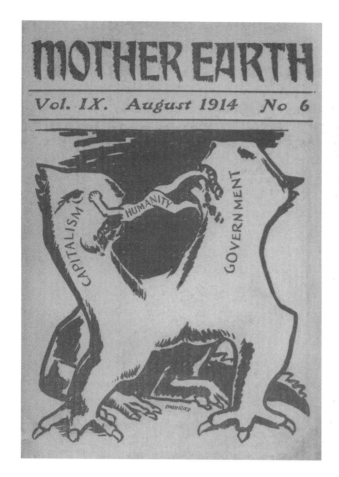

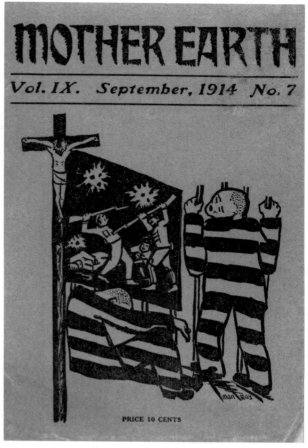

38. *Untitled* [*Humanity Caught between Capitalism and Government*], 1914. Pen and ink on paper (?), dimensions unknown. Lost or destroyed (reproduced on the cover of *Mother Earth,* August 1914). Collection of the Tokyo Fuji Art Museum, Tokyo, Japan.

39. *Untitled* [*Prisoners of War*], 1914. Pen and ink on paper (?), dimensions unknown. Lost or destroyed (reproduced on the cover of *Mother Earth,* September 1914). Collection of the Tokyo Fuji Art Museum, Tokyo, Japan.

The staff of the flag is comprised of a crucifix, while the stars are composed of mortar blasts in a violent battle scene. More than the obvious reference to the plight of political prisoners evoked by this image, it is the visual pun incorporated in its design that lends the drawing such strength.

Throughout his life, Man Ray would frequently acknowledge the importance of the anarchist ideals he had been exposed to while taking classes at the Ferrer Center. But by the time he had been asked to contribute illustrations to *The International* and *Mother Earth,* he had already been introduced to the most advanced artistic manifestations of his day, providing him with the means by which to express—both verbally and visually—his commitment to the aesthetics of modernism.

# THREE

## STIEGLITZ, RIDGEFIELD, AND THE ASSIMILATION OF A MODERNIST AESTHETIC

### (1913: Part 1)

The socially radical spirit Man Ray encountered at the Ferrer Center coincided with his first exposure to modern art. During lunch hours he would frequently rush from work over to Stieglitz's 291 Gallery; he recalls having seen most of the important exhibitions held there, beginning with the Cézanne watercolors show, mounted in March 1911.[1] On occasion, Stieglitz would invite Man Ray to lunch, where they were often joined by some older painters, artists whom Man Ray suspected of tagging along just for the free meal. Even though they usually dined at some of the finer midtown restaurants, Stieglitz never left without picking up the tab, reconfirming Man Ray's admiration for the dealer's altruistic spirit.

Although Stieglitz asked to see examples of Man Ray's work, he never offered to display it, either in group or one-man shows in his gallery. Nevertheless, Man Ray continued to speak highly of the man and his efforts to promote modern art. When asked by Stieglitz to record his impressions of 291 for a special issue of the gallery's magazine, *Camera Work,* Man Ray wrote one of the more poignant and expressive tributes to the gallery and

its founder. "The gray walls of the little gallery are always pregnant," he wrote, a remark he backed up with a series of aphoristic statements on the artists Stieglitz exhibited:

> Cézanne the naturalist; Picasso the mystic realist; Matisse of large charms and Chinese refinement; Brancusi the divine machinist; Rodin the illusionist—Picabia surveyor of emotions—Hartley the revolutionist—Walkowitz the multiplier; Marin the lyrist; De Zayas insinuating; Burty the intimate; the children, elemental.[2]

His words of praise for Stieglitz openly acknowledged his respect for the man who selected and courageously displayed the work of these artists. "A Man," he went on to say (intentionally capitalizing the *M,* as if to imply the deification of his subject), "the lover of all through himself stands in his little gray room. His eyes have no sparks—they burn within. The words he utters come from everywhere and their meaning lies in the future. The Man is inevitable. Everyone moves

him and no one moves him. The Man through all expresses himself."

On one particularly eventful visit to the gallery, Stieglitz asked Man Ray to pose before his camera (see frontispiece).[3] The photographer made it a casual practice to take pictures of various artists, friends, and other individuals who frequented the gallery. On this occasion, he asked Man Ray to support himself against one of the gallery walls, for he had planned to take an exceptionally long exposure. With the shutter held open, Man Ray stood as still as possible while Stieglitz waved a screen of stretched cheesecloth about the head of his subject, allowing the light-sensitive film to record the imagery in a muted, soft-focus fashion. In the resultant print, the artist looks directly into the camera lens, locked into a timeless gaze with the viewer, his deep-set eyes, dark curly hair, and rounded facial features emerging gently from the subtle, soft-gray diffusion of the photographic image. While this experience would kindle the artist's interest in photography, it would be some years before he considered the possibility of utilizing the camera as a tool for his own artistic expression. In this period, his purpose for visiting the gallery was to see examples of the most recent developments in his chosen profession—namely, painting—selected, as these examples were, from the most advanced manifestations of the visual arts to be found on both sides of the Atlantic.[4]

Although Man Ray was certainly impressed by the work of American painters that he saw at 291 —particularly Marin, Dove, Hartley, and Weber— he claimed to have felt an even greater attraction to the European artists, whose work he said was more mysterious. The mystery that drew him to these works was their unfinished quality, their tendency not to present imagery in a fully resolved and finished state (later he would even claim to possess "an aversion to paintings in which nothing is left to speculation").[5] In this regard, he was especially impressed by the exhibition of Cézanne watercolors. "I admired the economical touches of color and the white spaces which made the landscapes look unfinished but quite abstract," he remarked, "so different from any watercolors I had seen before."[6]

The sparse, though highly refined and elegant, watercolors by this nineteenth-century French painter—regarded already by many to be the "Father of Modern Art"—were of such inspiration to Man Ray that, shortly after viewing them at Stieglitz's gallery, he went home and began experimenting with the medium himself. One of his earliest surviving watercolors is a portrait of his sister Dorothy (fig. 40), who, we shall recall, had served as the subject of a more representational portrait just a few years earlier (fig. 19).[7] Comparing these two highly diverse approaches to the same subject, it is clear that the artist's style has dramatically changed. The very fact that he begins working in watercolor at this time may indicate the influence of Cézanne, but the colorful and somewhat chaotic brushstrokes lack the delicacy and finesse of this venerated French artist. Nevertheless, Man Ray still manages to capture his sister's heavy-set eyes and, at the same time, conveys something more. From now on, he will no longer be content to simply render the objects of this world in a strictly representational manner (if for no other reason than to demonstrate his proficiency at the medium) but wants his viewers to know that he is committed to the new aesthetics of modernism.

Another European artist whose work was a great influence on Man Ray in this period was Rodin, whose watercolors were first shown at 291 in January 1908—though Man Ray probably first became familiar with his work through subsequent exhibitions or through various examples of his drawings retained by Stieglitz for private viewing at the gallery. "Rodin's unanatomical watercolor sketches of nudes," Man Ray later remarked,

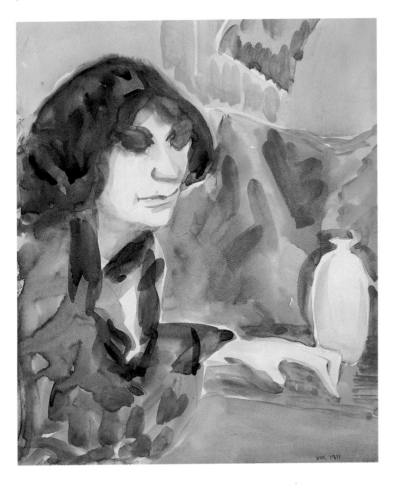

40. *Portrait of Dorothy,* signed 1911 but ca. 1912. Watercolor on paper, 14 x 11 in. Man Ray Trust.

"pleased me immensely and justified my abandon of academic principles."[8] The truth in this remark is evident in a comparison of Man Ray's numerous sketches of nudes (figs. 23–27) with the figure studies by Rodin (particularly the examples reproduced in *Camera Work,* which we can be relatively certain were exhibited at 291 and likely seen there by Man Ray).[9] In his watercolors (fig. 27), Man Ray appears to have consciously emulated the fluid motion and line contour that characterize the drawings of Rodin. But perhaps even more significant, Man Ray has allowed himself to be openly guided by the freedom and general spirit inherent in the Frenchman's unbridled and spontaneous interpretation of the nude female form.

The work of Rodin and Cézanne may have inspired the style (but clearly not the subject) of Man Ray's *Metropolis* (fig. 41), a watercolor from 1913 that depicts New York's elaborate transportation network. The viewpoint taken in this image —a somewhat detached, distant view of a metropolitan center—is logical for a Brooklynite who commuted into Manhattan every day. In *Metropolis,* an oval-shaped ferryboat nestled against the skyline in the lower left corner of the image appears to be making its way upriver behind two large steamships docked between piers in the harbor. Issuing forth from a large, low-lying brick building in the right corner—probably meant to represent the central train station—is a series of commuter lines disappearing into the center of the composition, while a sole trolley car makes its way over a viaduct above them. The most prominent element of this composition takes the form of a large woman's head looming above the entire ensemble in the upper left corner of the work. The sharply juxtaposed scale and detached positioning of this head—along with its cold, expressionless features—suggest the possibility of a symbolic interpretation: Man Ray may have intended this

head to represent some kind of mythic goddess of metropolitan life. Finally, the most prophetic element of this intriguing watercolor comes in the form of seven abstract planes of color, rendered as two-dimensional strips winding their way through the center of the composition. The first plane begins as a single blue rectangle emerging from the depths of the river in the central foreground, while the last two planes are rendered as olive-green shapes merging with cloud-like formations in the sky above. At this point, these abstract patterns were probably meant as nothing more than indicators of the step-by-step process necessary in negotiating such a complex transportation network.

Compositionally, *Metropolis* is loosely based on the pen-and-ink sketch of lower Manhattan that Man Ray made a year earlier (fig. 35). This technique—of using an earlier work as the basis for something new—is an approach that Man Ray employed more than once during these years, for some of the details in *Metropolis* reappear in an untitled ink drawing (or woodcut?) reproduced in the *Modern School* magazine in the fall of 1913 (fig. 42).[10] In this work a large crouching figure is shown bending into the confines of an overcrowded rectangular space. On the lower left is a series of parallel lines reminiscent of the train cars in *Metropolis*, and below the skyscrapers on the right we see again a pair of steamships berthed at their piers. Finally, the entire image is unified by means of a heavy black crescent-shaped line, zigzagging through the center of the composition in the shape of an irregular S-curve, assuming a position equivalent to that of the rectangular planes interwoven through the center of *Metropolis*.

The possible significance of these abstract

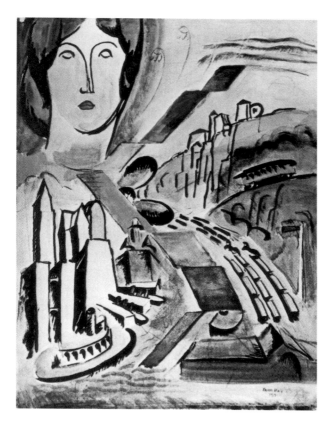

41. *Metropolis*, 1913. Watercolor on paper, 20 x 18 1/8 in. Galerie Alphonse Chave, Vance.

42. *Untitled*, ca. 1913. Pen and ink on paper (?), dimensions unknown. Present whereabouts unknown (reproduced in *The Modern School*, Autumn 1913).

43. *Tapestry Painting,* 1913. Oil on canvas, 9 x 4 ft. Present whereabouts unknown (photo: Artist's Card File; see document C).

shapes is made clearer in the enlargement and elongation of this image in *Tapestry Painting* (fig. 43), a large (nine feet high) oil-on-canvas composition, which, if we can judge by the title, was meant to be displayed in the fashion of a wall hanging. In this version of the image, it becomes clear that the large figure in the center of the composition is playing a guitar, the upper neck of which is represented by one of the many dark crescent shapes. Their repetition throughout the image, then, may have been meant to symbolize the sound emanating from this musical instrument, a detail that unites the theme of this picture with other musical analogies that preoccupied Man Ray and his friends at the Ferrer Center—one among many concerns, as we shall see, that eventually led Man Ray to explore the potential inherent in more abstract imagery.

## RIDGEFIELD

With Man Ray's interest in modern painting reaffirmed through periodic visits to Stieglitz's gallery, and his commitment to anarchism firmly established through his involvement with the Ferrer Center, the restricting conditions of living at home with his family and the discomfort of sharing a small studio in Manhattan with Adolf Wolff necessitated a major change in his living situation. In the fall of 1912, the opportunity presented itself in the form of an invitation from Samuel Halpert, a somewhat older painter whom Man Ray had befriended at the Ferrer School who had recently returned from a trip to Paris, where he studied for a brief period with Matisse.[11]

Halpert asked Man Ray to join him on a Sunday afternoon visit to an artists' colony just across the Hudson River from Manhattan, in Grantwood, New Jersey. The remote atmosphere of this

44. The town of Ridgefield, ca. 1921. Photograph. The building in the center distance is the former Public School No. 1, which burned down in 1955. It is now the site of the Ridgefield Public Library. Photo courtesy of the Man Ray Trust and Ridgefield Public Library.

small community—which was then still relatively undeveloped, with only a few isolated houses situated along the heights overlooking the small town of Ridgefield (fig. 44)—was exactly what Man Ray was looking for. "It was open country without any house," Man Ray recalled of his first view of the terrain. "In the foreground, scattered here and there, stood a few simple picturesque little houses with fruit trees in between. To the right, among taller trees, could be seen more substantially built rustic stone houses. It certainly looked like my idea of an artists' colony."[12] A journalist who visited the community a few years later described the locale as follows:

> Ridgefield, or rather the poet's part of
> Ridgefield, for they are some distance from
> the village of that name, is unique and
> charming. The houses are clustered together

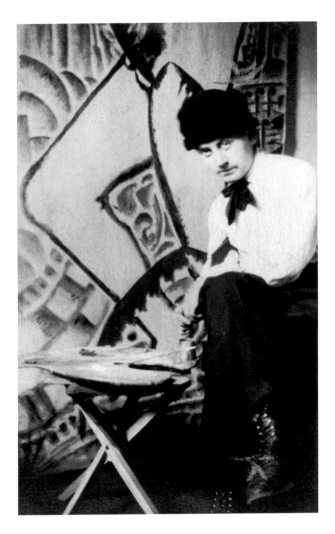

45. Man Ray before his *Tapestry Painting* (see fig. 43), ca. 1913. Photograph. Collection of Constance and Albert Wang.

on the side of the long hill which slopes down from the Palisades, overlooking the Hackensack Valley, and a few miles beneath the Hackensack River flows like a silver thread in the blue haze. The locality is hardly more than a half hour's trolley and ferry ride from New York, but the atmosphere is that of a peaceful island village, as separated from the din and bustle of the city as though it were in the mountains.[13]

Almost immediately, Man Ray began sharing the twelve-dollar monthly rent on a sparsely furnished shack with Halpert and decided that he would eventually move out there permanently. Within a few weeks the two painters were joined by the young experimental poet Alfred Kreymborg, a friend of Halpert's who would soon leave his mark on the development of the modern poetry movement in New York.

Halpert and Kreymborg planned on using their rooms only on weekends, so at first Man Ray was left to paint in relative isolation. He set up a studio for himself, tacking to one wall his large *Tapestry Painting*. With a Brownie camera—which he used to take various documentary snapshots during his years in Ridgefield—Man Ray took a picture of himself in these new surroundings (fig. 45), his large palette resting on a three-legged table as he looks up at the viewer, seemingly caught in the act of painting. But a closer examination of the image reveals that it was probably a carefully posed picture, staged in order to reveal the artist's dual identity: a loose-fitting white shirt and somewhat flamboyant bow tie suggest his profession as a painter, while the winter cap and hiking boots that he also wears give the impression that he has taken only a momentary break from the more rugged demands of his remote rural environment.

Not long after Man Ray moved to Ridgefield,

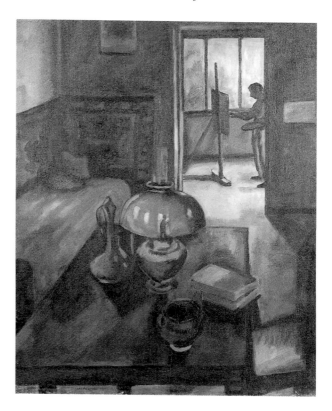

46. Samuel Halpert, *Interior with Man Ray*, ca. 1914–1915. Oil on canvas, 36 x 28 3/8 in. Rose Art Museum, Brandeis University, Waltham, Mass.; Gift of Mrs. Edith Gregor Halpert, New York, 1961.50.

Halpert painted a picture of him at work in a brightly lit room on the main floor of the shack (fig. 46), the artist standing before his easel likely working on an outdoor scene visible through the glass window directly behind him. (In a reflection on the shade of a lamp positioned on the table in the center of the composition, Halpert depicts himself painting the picture.) Since Man Ray's first months in Ridgefield were spent during the winter of 1912–1913 (fig. 47), we can imagine that in Halpert's painting the artist may have been working on a scene of the surrounding countryside, bedecked, as it often was in the cold winter months, with a blanket of freshly fallen winter snow (figs. 48, 49).[14]

The technique used to record snow in both of these landscapes is unusual. When painting winter scenes, students are normally instructed to apply the required layers of white pigment as a background, allowing it to dry before adding the finishing details. Man Ray, however, followed quite the contrary procedure. Working directly onto the surface of unprimed canvas, he quickly sketched the outline of trees, houses, and the profile of a large hill located in the distance across the valley. Only as a final step did he elect to apply the uneven patches of white paint, taking care not to cover those details in the landscape he had just painted. The results are surprisingly convincing. The exposed areas of unprimed canvas are interpreted as sections of uncovered ground, while at the same time they provide the paintings with an

47. Man Ray in Ridgefield, winter 1913. Photograph. Collection of Helen Ray Faden, Pasadena, Fla.

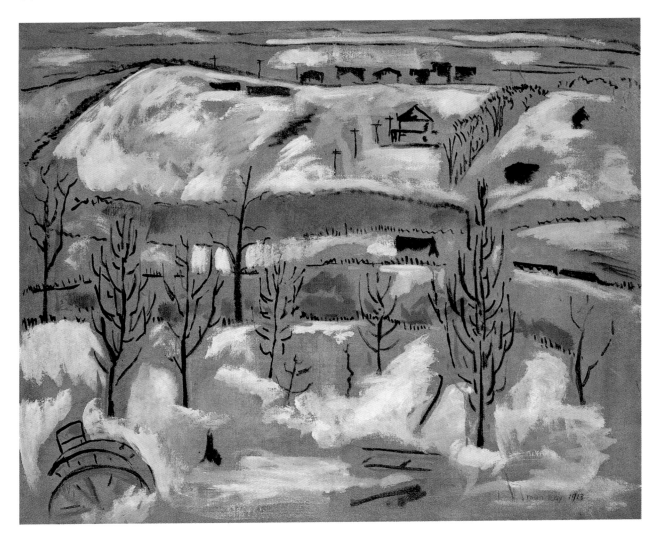

48. *The Hill*, 1913. Oil on canvas, 20 1/8 x 24 1/8 in. Hirshhorn Museum and Sculpture Garden, Smithsonian Institution; Gift of Joseph H. Hirshhorn, 1966.

unfinished quality—an effect the artist doubtlessly intended, in emulation of the watercolors of Cézanne.

When the cold weather did not permit painting outdoors, Man Ray worked inside, sketching anything he came into contact with in his immediate environment, from interior views of various rooms in the cottage (fig. 50) to still lifes based on whatever happened to be lying about: from an old teapot (fig. 51) to a stray cat (fig. 52). These drawings and watercolors were tacked up on the walls of his little shack in order to give it, as he said, "a more lived-in appearance." The last of these draw-

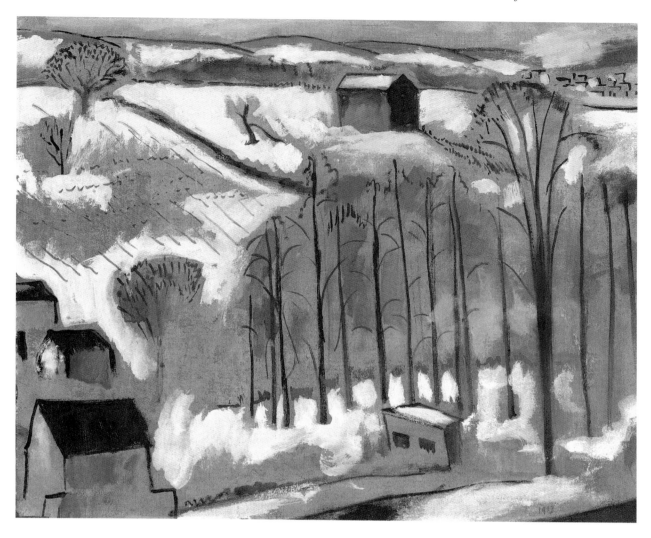

49. *Landscape*, 1913. Oil on canvas, 19 1/2 x 23 1/2 in. Estate of Natalie Davis Spingarn.

ings may have served as the inspiration for a painting depicting a cat sleeping on a pillow next to various still life elements (fig. 53), a work that caused Halpert to accuse Man Ray of stealing his material and—to a certain extent—even his style.

The disagreement between these artists involved the glazed black vase pictured in the center of the composition. Apparently, this vase belonged to Halpert, and he wanted to use it for the first time in one of his paintings. "When Halpert turned up the next week and saw my painting, he frowned," Man Ray recalled. "He recognized the vase he had brought for his projected still-life and

51, above. *Teapot*, 1913. Brush and ink, 9 3/4 x 7 1/2 in. Collection of David Ilya Brandt and Daria Brandt, New York.

50, above. *Untitled [Interior]*, 1912. Watercolor on paper, dimensions unknown. Present whereabouts unknown. Photo courtesy Lucien Treillard, Paris.

52. *Untitled [Cat]*, 1913. Ink on paper, 14 3/4 x 18 3/4 in. Collection of Jeffrey and Lucinda Cohen.

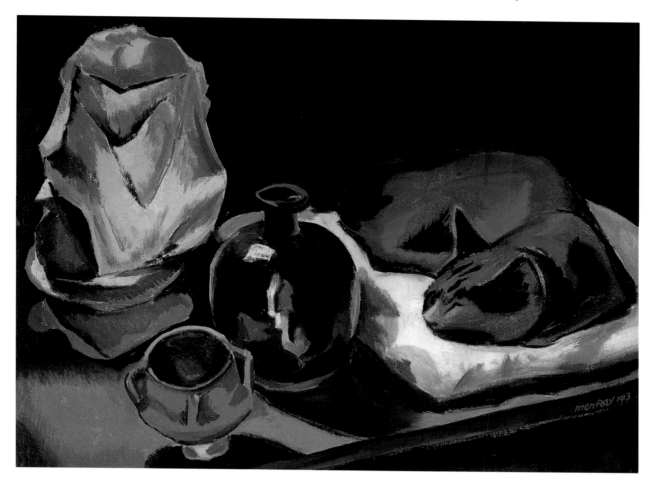

53. *Still Life No. 1*, 1913. Oil on canvas, 18 x 24 in. Columbus Museum of Art, Ohio; Gift of Ferdinand Howald, 1931.257.

considered my work an act of piracy." Man Ray apologized to his friend but later confessed that he never really understood why Halpert took such an antagonistic position. "After all," he reasoned, "he hadn't made the vase any more than the landscape before which we both sat a couple of weeks ago."[15]

Despite Man Ray's denials, there are certain details in this painting that rely upon the precedent of Halpert's unique style. Even though Halpert had recently returned from Paris, where he attended classes at the Matisse Academy, he seems to have been more deeply impressed by the work of one of Matisse's colleagues, Albert Marquet. Marquet was a lesser-known Fauve painter but an artist of considerable talent; he had himself been influenced by Matisse, but his style was char-

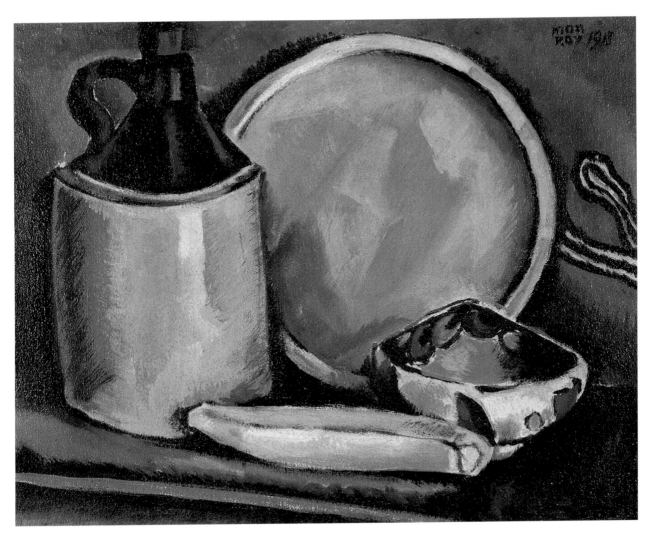

54. *Still Life*, 1913. Oil on canvas, 9 7/8 x 11 7/8 in. Ackland Art Museum, The University of North Carolina at Chapel Hill; Burton Emmett Collection.

acterized by a reduction of detail, an accentuation of form through outline, and a restrained though tonally atmospheric palette. When he returned to New York, Halpert applied a similar technique to his modeling of form, visible not only in his still lifes but also in his better-known landscapes and cityscapes.[16]

The way in which Man Ray reduces and simplifies the various components of his paintings in this period—clarifying contours with lines of black pigment—reveals an approach that is very close to Halpert's. This is especially apparent in

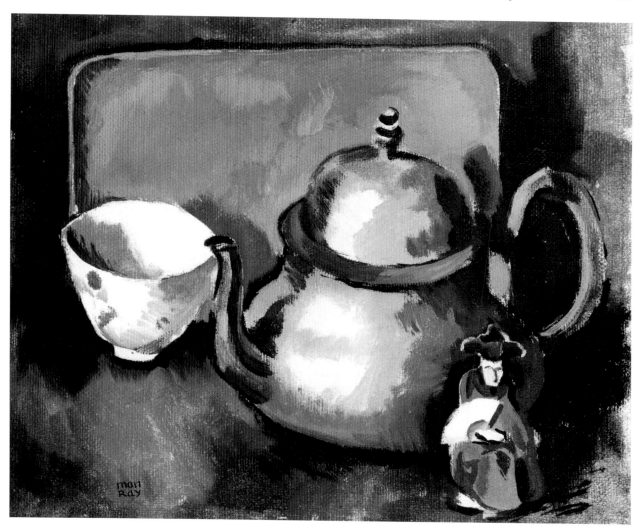

55. *Still Life with Teapot*, ca. 1913. Oil on canvas, 8 1/4 x 10 5/16 in. Philadelphia Museum of Art; Gift of Frank and Alice Osborne.

two still lifes from 1913, one that depicts a ceramic jug, a banana, and an assortment of miscellaneous tableware (fig. 54) and another that incorporates the same teapot that had been used in the earlier sketch (fig. 51), as well as a colorful Japanese figurine, which, in company with a small teacup positioned next to the pot, lends the entire composition a slightly Asian air (fig. 55). This is not a comparison Man Ray would have denied, for a few years earlier he had painted a very detailed copy of a Japanese print (just as van Gogh had done before him).[17]

Halpert may very well have been proud to name such important European artists as his teachers, yet even at this early date a number of his colleagues considered his work derivative. Writing a decade later, for example, Kreymborg regarded Man Ray's approach as far more innovative. "The slow moving convert to Post-Impressionism," he wrote of Halpert, "had a ponderous habit of repeating himself." Reaching his conclusions through hindsight, Kreymborg went on to describe the work of the younger artist quite differently: "With the ten-year younger Ray," he wrote, "one never knew what to anticipate. Man was only twenty-two at the time, but the large-eyed, curly-haired dreamer had an enviable record as a daring performer in versatile experiments."[18]

It would not be long before the comparatively straightforward, naturalistic approach that Man Ray employs in his paintings of this period would be replaced by an even deeper commitment to modernism, an approach influenced, in all likelihood, by having seen the most important and influential exhibition of modern art ever held in America.

## THE ARMORY SHOW

The works of modern art that Man Ray had seen at Stieglitz's gallery helped prepare him—and other American painters and sculptors of his generation—to view in February 1913 the single most influential grand-scale art exhibition ever held in this country: the International Exhibition of Modern Art, which, because it was held at the Sixty-ninth Regiment Armory on Lexington Avenue at Twenty-fifth Street in Manhattan, became known as the Armory Show. The large paintings by French artists shown there—particularly those by Picabia, Matisse, and Duchamp—prompted Man

Ray to begin work on a larger scale, while their abrupt departure from conventional painting affirmed and encouraged his own modernist inclinations. The show's impact was so great, however, that it overwhelmed him to the point of inactivity: "I did nothing for six months," he later told a reporter. "It took me that time to digest what I had seen."[19]

For the next two years Man Ray would experiment with the most current European movements, fusing the bright colors of Fauvism with the broken planar structures of Analytic Cubism. The specific influence of Matisse, for example, can be immediately discerned in his *Flowers with Red Background* (fig. 56), where, as Matisse did in his famous *Red Studio* (Museum of Modern Art, New York)—a painting that was exhibited in the Armory Show[20]—Man Ray surrounded the individual elements of his still life in an enveloping, brilliant red hue. As in the painting by Matisse, this uniform background coloration serves to spatially compress the pictorial elements of the composition, enhancing and reaffirming its predominantly decorative characteristics. Even the wallpaper pattern that Man Ray uses in his painting appears to have been appropriated from a specific painting by Matisse, *Harmony in Red* (State Hermitage Museum, St. Petersburg); that picture was not in the Armory Show, but Man Ray would have known it from a black-and-white photographic reproduction that was mounted and displayed a few years earlier in Stieglitz's gallery.[21]

While the impact of seeing Matisse's paintings for the first time is unmistakably evident in this picture, the influence of Picasso is felt with perhaps even greater intensity in a group of paintings by Man Ray from 1913 that have only recently been considered within the context of Cubism and its influence on American art in this period.[22] The only artist living in New York who was intimately

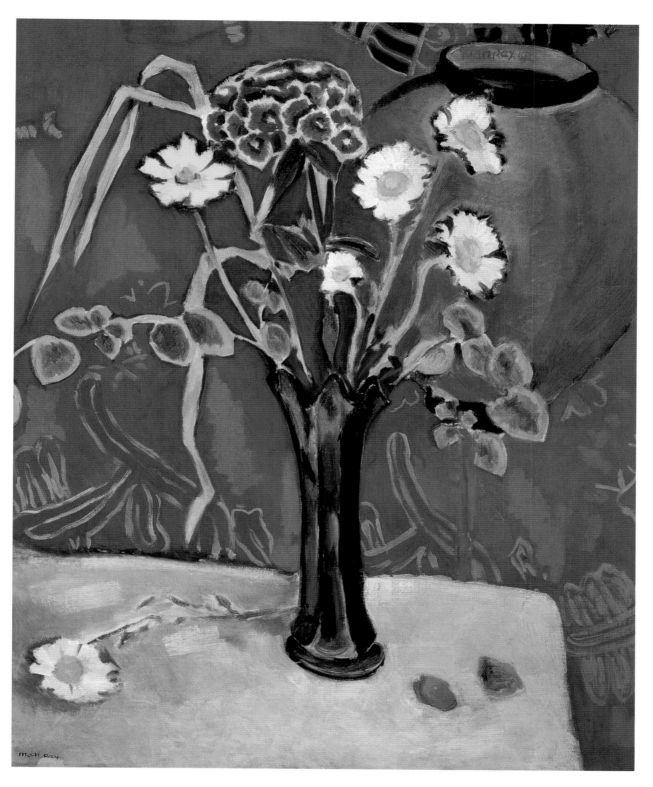

56. *Flowers with Red Background,* 1913. Oil on canvas, 24 x 20 in. Private Collection. Courtesy of Hollis Taggart Galleries, New York. Photo courtesy of Hollis Taggart Galleries.

familiar with the development of Cubism in Europe was Max Weber, who had his first one-man exhibition at 291 in February of 1911 and whom Man Ray had likely met and befriended in classes at the Ferrer School, which Weber began to frequent in 1912. Weber had spent three years in Europe, where he studied at a number of academic institutions in Paris before coming under the influence of modern European painters: Cézanne (whose work he had seen at the Salon d'Automne in 1906 and 1907), Matisse (with whom he had studied), and Picasso (whom he had met on at least one occasion and whose work he saw at the apartment of Gertrude Stein in Paris and in the artist's studio on the Bateau Lavoir).[23]

When Weber returned to New York in 1909, he immediately began to champion the work of European modernists, and his own paintings from this period clearly reveal their influence. Man Ray's introduction to the work of these same artists was likely the result of his discussions with Weber at the Ferrer Center, for it was here that he first painted and exhibited works that broke from the traditions imposed by academic art. His earlier grouping of nudes in a landscape setting, for example (fig. 31)—a theme to which he would frequently return in the next few years—was inspired either directly by reproductions of paintings by Cézanne (which Weber claimed to have been the first to import to America) or by Weber's incorporation of the bather theme in his own figurative works, derived as these themes were from both Cézanne and the idyllic landscapes of Matisse.[24]

By 1910 Weber had already begun to subject his nude figures to the sharp angularization and compression of form associated with Analytic Cubism. By 1913, then, not only could Man Ray consult the few drawings and paintings by Picasso and Braque that he had viewed at 291 or seen reproduced in the pages of *Camera Work,* but he had the example of Weber's paintings at his disposal as well. Whatever his sources, the red wash study of a female nude (fig. 57) may very well have been the earliest work by Man Ray to document his own personal experiments with the faceted and translucent shapes of Analytic Cubism.[25] The naturalistically rendered anatomy of a nude woman is here subjected to an overlay of angular, translucent washes of color, accentuated by groupings of darker parallel lines and brushstrokes. Though somewhat awkward in execution, the overall effect is not markedly dissimilar from the impression one might retain from a casual viewing of Picasso's *Nude* of 1910 (fig. 58), a charcoal drawing that was exhibited in 1911 in the first showing of the artist's work at 291 (where it was purchased by Stieglitz) and reproduced the next year in a special issue of *Camera Work* devoted to the art of Matisse and Picasso.[26]

Man Ray's *Portrait of Alfred Stieglitz* (fig. 59) is thought to be the first painting he made after seeing the Armory Show.[27] Indeed, the fragmented forms in this portrait relate to similar passages in three works by Picasso shown in this exhibition, two of which were lent to the show by Stieglitz himself: *La Femme au pot de moutarde* of 1910 (Gemeentemuseum, The Hague), the drawing of a female nude (fig. 58), and a bust of a woman's head (Art Institute of Chicago). Moreover, the large "291" inscribed in the central foreground of Man Ray's portrait may have been inspired by the bold lettering that appears in Braque's painting *The Violin* (Andreas Speiser Collection, Basel). The presence of these letters may have been drawn to Man Ray's attention by the comments of critics, who singled them out as a subject of exceptional ridicule in their reviews of the Armory exhibition.[28]

In his subsequent experiments with this emerging pictorial idiom, Man Ray appears to

57. *Cubist Figure,* 1913. Pencil and watercolor on paper, 13 x 10 in. Collection of Dr. and Mrs. David J. Rose.

have quickly adopted a new and unique interpretation of Cubist form and space. In his *Portrait* (of an unidentified individual) dating from 1913 (fig. 60), the overlay of sharp lines and angles—which he had used earlier to define the features of Alfred Stieglitz—is replaced by a network of interlocking circular shapes, each of which is harmoniously integrated within the overall framework of the composition by a system of uniform tonal modulations. Even though this painting is only known through an inferior black-and-white photograph, certain details reveal that Man Ray's interpretation of Cubist space depends largely upon his ability to integrate the illusory devices of translucency and overlap. Note that the line running through the woman's hairbun continues to define the figure's upper neck and shoulder and also forms the right edge of a vertically oriented rectangular plane in the immediate background.

Man Ray's use of these illusory conventions is perhaps best revealed in a Cubist still life from 1913 (fig. 61). Here, the general impression of Cubist space is generated almost exclusively through the use of repetition, translucency, and overlap. All three of the major elements in this composition—the teapot on the right (depicted in an earlier drawing: fig. 51), a covered cup in the foreground, and a large watering vessel behind it—are each systematically repeated, so as to allow portions of the duplicated image in the background to remain visible through the foreground

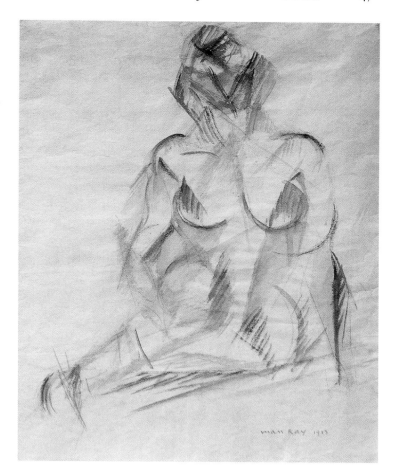

58. Pablo Picasso, *Standing Female Nude,* 1910. Charcoal on paper, 19 1/16 x 12 5/16 in. The Metropolitan Museum of Art, Alfred Stieglitz Collection, 1949, 49.70.34. Copyright © 2002 Estate of Pablo Picasso/Artists Rights Society (ARS), New York.

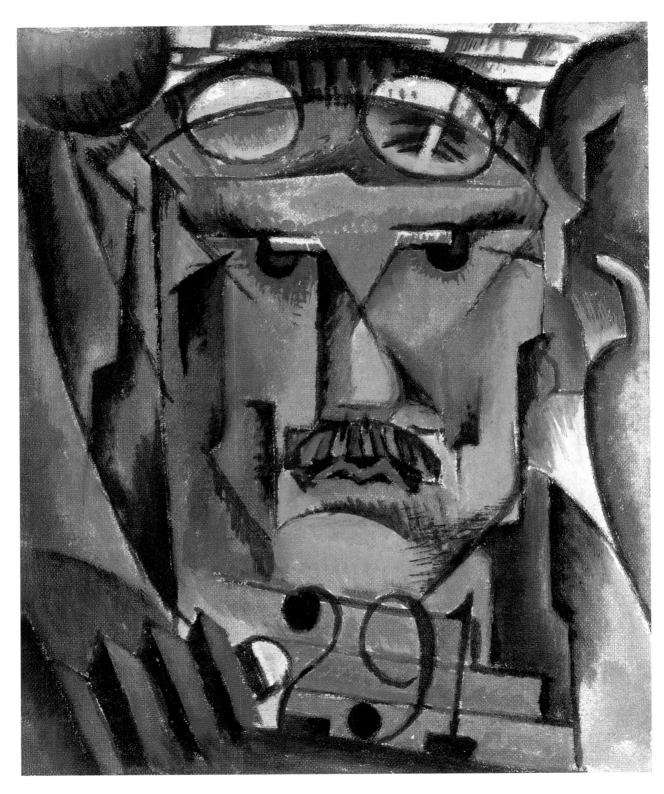

59. *Portrait of Alfred Stieglitz*, 1913. Oil on canvas, 10 1/2 x 8 1/2 in. Yale Collection of American Literature, Beinecke Rare Book and Manuscript Library, Yale University, New Haven, Conn.

shape. The resultant effect curiously matches the impression of a printing accident or a double-exposed photograph, where the same image is mistakenly repeated, but slightly off-register. Although Man Ray painted few of what could be classified as doctrinaire Cubist pictures, he would return to the vocabulary of this new pictorial idiom intermittently throughout this period.

What concerned Man Ray most at this time was not his creative work but rather persistent, ongoing problems in his personal life. Although the Ridgefield community was conducive to work, it was so detached from activities in New York that Man Ray began to suffer from extreme loneliness. What he desired more than anything else was female companionship, a situation that continued to elude him. As the winter months approached, he dreamed about a meaningful relationship, fantasizing that he had fallen in love with a woman who served as his model. After she left, he wrote:

> All I have left of you is an outline in blue
> around cold white flesh. But my hands are
> still warm with the touch of your live
> body. . . . If I had let my hands draw, they
> would have drawn a beautiful warm
> body. . . . Maybe your warm body will
> return to me. . . . My warm hand so not like
> the cold canvas. . . . I cannot talk nor live,
> but I am very warm and someone seems to
> be caring for me. I do not see you, but I feel
> you all about me.[29]

The quality of this stream-of-consciousness prose is hardly an indication of the important role Man Ray would soon play in the modern poetry movement, but the ideal woman would soon walk right straight into the middle of his life, and it would not be long before she occupied an equally centralized position in his poetry and art.

60. *Portrait,* 1913. Oil on canvas, 20 x 16 in. Lost or destroyed (photo: Artist's Card File; see document C).

61. *Still Life,* 1913. Gouache on paper laid down on board, 10 x 13 1/2 in. Private Collection.

# FOUR

---

## NEW WORDS FOR NEW IMAGES: Adon Lacroix and the Modern Poetry Movement (1913: Part 2)

It was not long after his move to Ridgefield that Man Ray discovered he could demonstrate his commitment to modern art not only through painting but also through poetry. His first published poem, "Travail," appeared in the fall 1913 issue of *The Modern School,* the magazine published by the Ferrer Center.[1] Here, we find the artist/author attempting to convey a sense of life's inevitable fatigue, generated, as he sees it, by nature's endless and tiring cycle of day followed by night:

Travail

The days are dead for me
And the nights live
Thru the day I dream
At night I wake
And when I wake I die.

I do not count the hours
Nor watch the sun

But thru a monotone of time I drift
My senses numbed

From afar
Dim music rocks my restless soul to sleep—
Death's lullaby
I sleep—I wake—I die.

Give me a draught of life ere I depart,
Red sparkling life—not over-sweet
Then let me sleep
Fatigued

While the subject of this poem is essentially romantic, its lack of conventional rhythm and rhyme displays at least a rudimentary awareness of the more advanced developments in modern poetry. Indeed, it was through Man Ray's association with a number of young and restless poets (or *vers librists,* as they later became known)—writers who either resided in Ridgefield or visited the colony on weekends—that Man Ray was introduced to the

possibility of publishing his writings, an avenue of literary expression he continued to explore through the course of his life. In an article about the artists and writers living in Ridgefield, a journalist reported upon their shared literary and artistic interests. "Whatever protest and ridicule may be directed against the *vers librists,*" she wrote, "they have aroused almost as much discussion as the Cubist and Post-Impressionist artists. With a colony of their own and a printing press running merrily to the tune of the new rhythms, no doubt the reading public will soon have ample opportunity to taste their wares in larger and larger quantities."[2]

During the summer of 1913, Man Ray, Kreymborg, and Adolf Wolff—who often visited the artists' colony—decided that their somewhat removed residency in Grantwood would be the ideal location from which to launch a new magazine devoted to their combined literary and artistic interests. Perhaps more than the others, Kreymborg was keenly aware of the fact that the more established journals had consistently refused to publish the poetry and prose of the younger, more experimental writers. After some deliberation the artists agreed to call their new magazine *The Glebe,* a title meant to evoke the more poetic usage of the term: as a synonym for the land or the soil.[3] Man Ray envisioned himself as art director, while Wolff volunteered to handle technical details concerning the actual printing of the magazine.

According to Man Ray's recollections, the sculptor arranged to have a friend's printing press shipped out to Grantwood, with the intention of installing it in the shack that Kreymborg, Man Ray, and Halpert shared. A few weeks later, however, when the cumbersome apparatus arrived, they discovered that it had been severely damaged in transport. As a result, they were forced to enlist the services of a local printer, and by September the inaugural issue—devoted entirely to a presen-

tation of Wolff's poetry and bearing on its cover Man Ray's circular design for the name of the review (fig. 62)—finally appeared. Through Kreymborg's efforts, all subsequent issues of this short-lived periodical would be published by the firm of Albert and Charles Boni, well-known promoters of vanguard literature and proprietors of the Washington Square Bookshop in Manhattan.[4]

Beyond supplying a design for its cover, Man Ray would not make any further contributions to *The Glebe.* Instead, he continued to experiment with the notion of releasing his own work independently, by means of a self-styled limited edition series of publications, which he individually designed, hand-lettered, and printed manually at his own expense. According to Kreymborg, it was

62. *The Glebe,* September 1913. Cover. Francis M. Naumann Fine Art, New York.

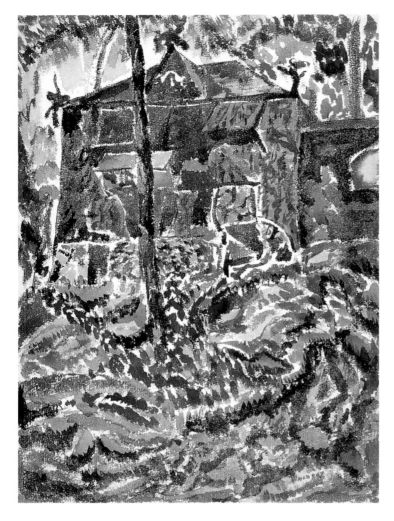

63. *Landscape,* 1913. Watercolor on paper, 23 3/8 x 18 in. The William H. Lane Collection. Courtesy Museum of Fine Arts, Boston.

at the time when they first engaged in discussions about the formation of a new magazine that Man Ray began to issue these limited edition publications. "In the absence of [a printing press for *The Glebe*]," Kreymborg recalled, Man Ray "had started to print by hand, stray, curious documents with a delicacy of line and a feeling for spatial values akin to the papyrus of an ancient era." His first publication of this type, probably entitled "The Bum," was so ephemeral in nature that it quickly disappeared without a trace.[5]

In the very period when Man Ray engaged in these publishing activities, he entered into the most productive phase of his career as a painter, executing an impressive series of landscapes depicting the town of Ridgefield and its environs in ever new and adventurous ways (figs. 63–72).

## RIDGEFIELD LANDSCAPES OF 1913

It was probably soon after the winter snows thawed that Man Ray began a series of ten vibrant watercolor studies based on the densely foliated areas near the cottage he shared with Halpert (figs. 63, 64). In these works, he allowed the white of the paper to show through and interact freely with the surrounding areas of color, recalling, again, the watercolor technique of Cézanne. Not only has he emulated a restrained method of paint application, but the close range and viewing angle selected for these images also seem to have been inspired by the precedent of this famous French painter. Unlike Cézanne, however, Man Ray applies his colors rapidly, in a staccato-like pattern, more with the intention of creating a bright and impressive image than of remaining faithful to the natural coloration and structure of the motif.

In one of these watercolors (fig. 64), Man Ray has selected the scene of a dense forest interior, a

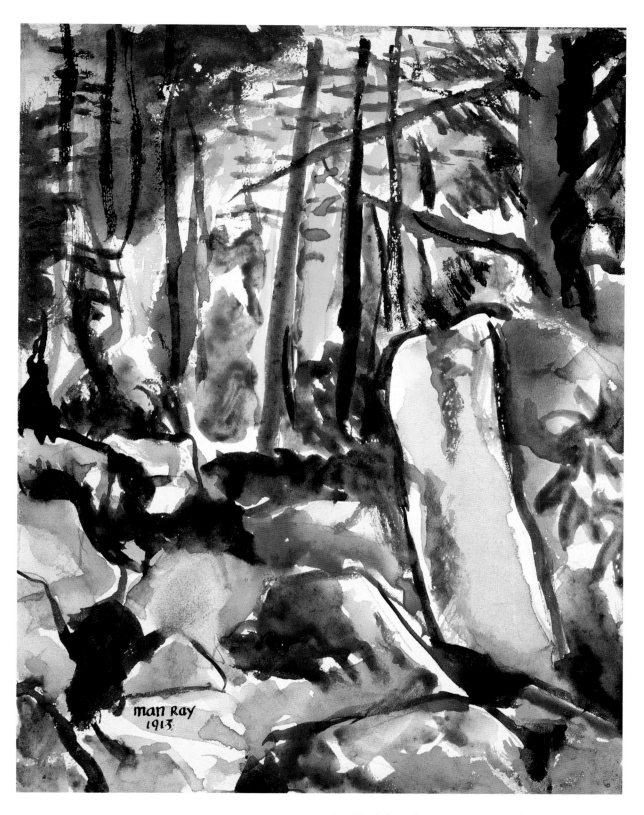

64. *Wooded Landscape*, 1913. Watercolor on paper, 7 1/8 x 5 17/32 in. Collection of Gale and Ira Drukier. Photo by Peter S. Jacobs Fine Arts Imaging.

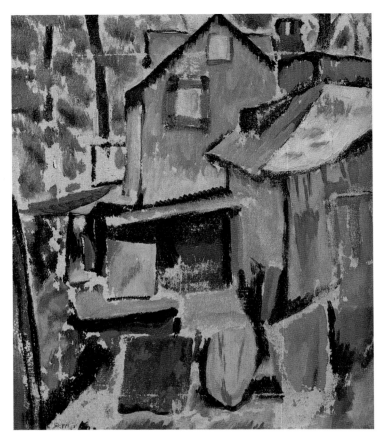

65, left. *Landscape [Ridgefield Cottage]*, 1913. Oil on canvas, 12 x 10 in. Private Collection.

66, below. *Landscape*, 1913. Oil on canvas, 10 x 14 in. Collection of Timothy Baum, New York.

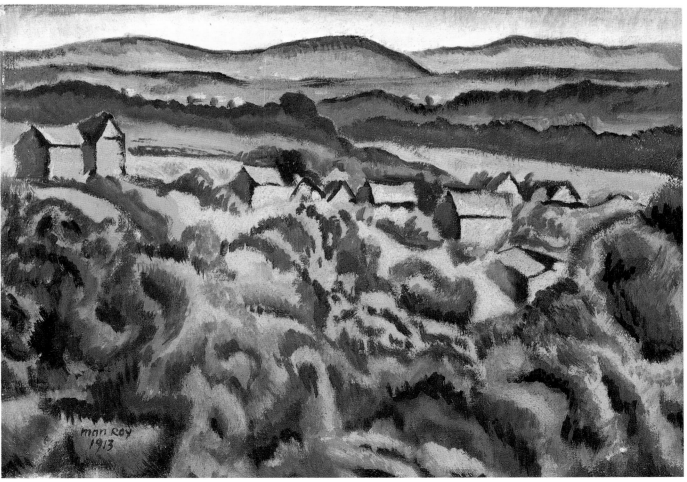

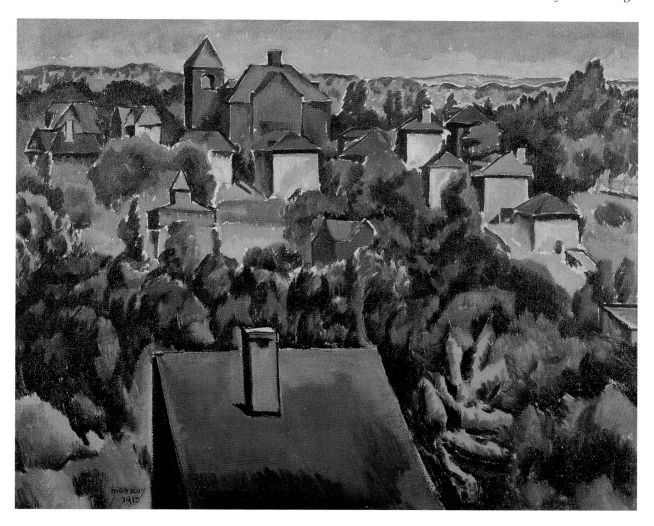

67. *Rooftops Ridgefield,* 1913. Oil on canvas, 18 1/2 x 22 in. Private Collection (on long-term loan to The Patrick and Beatrice Haggerty Museum of Art, Marquette University, Milwaukee, Wisc.).

jumble of rocks in the lower portion of the composition set against a thicket of crisscrossing tree limbs in the upper background. The watercolor pigment was naturally absorbed into the fabric of the paper and accurately captured the quality of light filtering through the branches of trees overhead. Even when Man Ray took out his oil paints —if the canvas he was working on was comparatively small in scale—qualities inherent to the watercolor technique continued to be present, so

much so that in reproduction (figs. 65, 66) some of these landscapes appear to have been painted in the more translucent and luminous medium.

In a rendition of the cottage Man Ray shared with Halpert (fig. 65), portions of raw canvas are contrasted against a colorful display of bed sheets and blankets hanging on the line to dry. A number of views of the distant countryside virtually radiate with energy, the foreground foliage in one so electric in execution that the canvas almost appears to

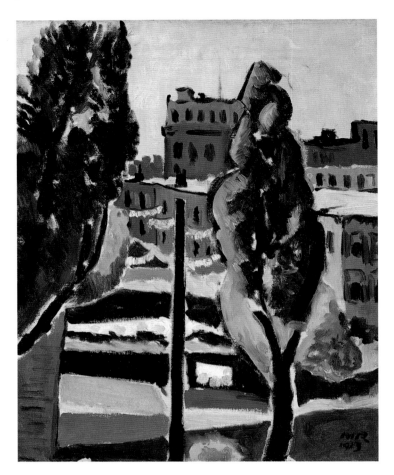

68. *Ridgefield Landscape* [*A Tree Grows in Brooklyn*], 1913. Oil on linen, 20 x 16 in. Courtesy Hollis Taggart Galleries, New York. Photo courtesy Hollis Taggart Galleries.

vibrate (fig. 66). When Man Ray painted these landscapes, he was often joined by Halpert, who continued to make excursions out to Ridgefield on weekends to paint. He recalls, for example, rising early one Sunday in June and working with Halpert until noon, an experience that caused him to realize that he was indeed now living in a true artists' colony.[6]

The influence of Halpert can still be detected in a number of landscapes from this period, particularly those that emphasize a reduction and simplification of form and, to an even greater extent, those in which the contours of form are deliberately reinforced by means of heavy dark lines (figs. 67–72). Although the precise order in which these landscapes were painted was not recorded, knowing the direction in which Man Ray's work would soon develop, it is logical to place them in a sequence that reflects their increasingly modernist vision.

The first image shows the town of Ridgefield from a distance (fig. 67), its block-like, geometric houses emerging from dense foliage along the expanse of a steep hill facing the viewer, its horizontal summit capped by a large brick building with a bell tower clearly visible in a photograph of the town taken in this period (fig. 44). A more closely focused view of another brick building in Ridgefield is flanked by tall, slender trees and punctuated by a thick black vertical pole running through the center of the composition (fig. 68). This unusual element may have been meant to represent either a wireless telegraph pole or the mast of an otherwise unseen sailing ship moored in the harbor and located somewhere below the framing edge of the image.[7]

The first painting in this sequence was called

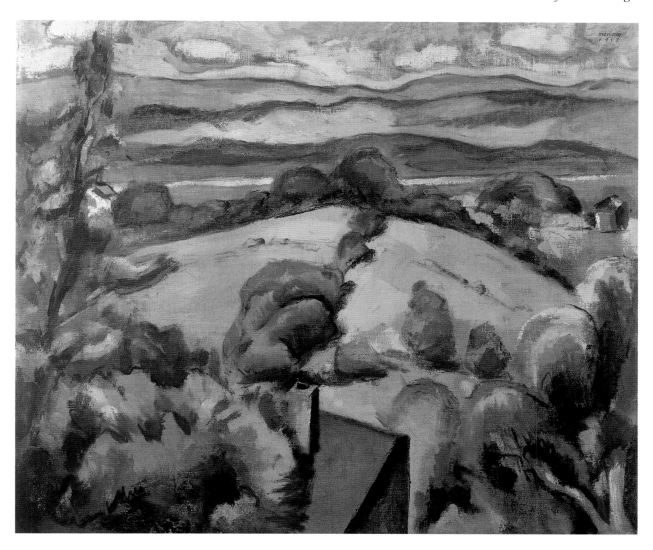

69. *Jersey Landscape,* 1913. Oil on canvas, 24 x 28 in. Collection of David Goldwater.

*Rooftops Ridgefield* because of a prominent building seen from above in the lower central foreground of the composition. This same rooftop with chimney—but viewed from a different angle—reappears as an anchoring element at the base of *Jersey Landscape* (fig. 69), where the town and its buildings are replaced by an uninhabited rural environment, a field on a hill divided by a row of trees set against distant hills receding from view in the far background. Another view of the same terrain features two farmhouses (fig. 70), behind which unfolds the view of a fertile river valley. A freight train travels parallel to a thin blue streak that runs horizontally through the center of the

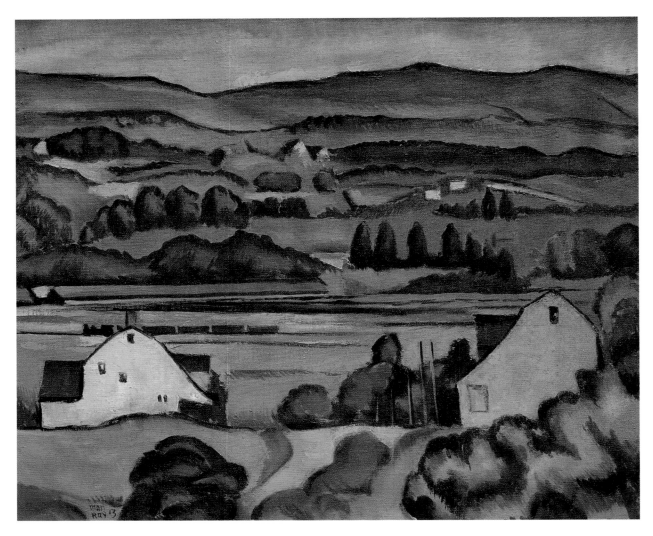

70, above. *Ridgefield Landscape,* 1913. Oil on canvas, 20 x 24 in. Montclair Art Museum; Gift of Naomi and David Savage, 1998.13. Photo by Peter Jacobs Fine Arts Photography.

71, facing page, top. *Ridgefield,* 1913. Oil on canvas, 25 x 30 in. Addison Gallery of American Art, Phillips Academy, Andover, Mass., 1947.20.

72, facing page, bottom. *Landscape,* 1913. Oil on canvasboard, 10 x 19 7/8 in. Collection of Timothy Baum, New York.

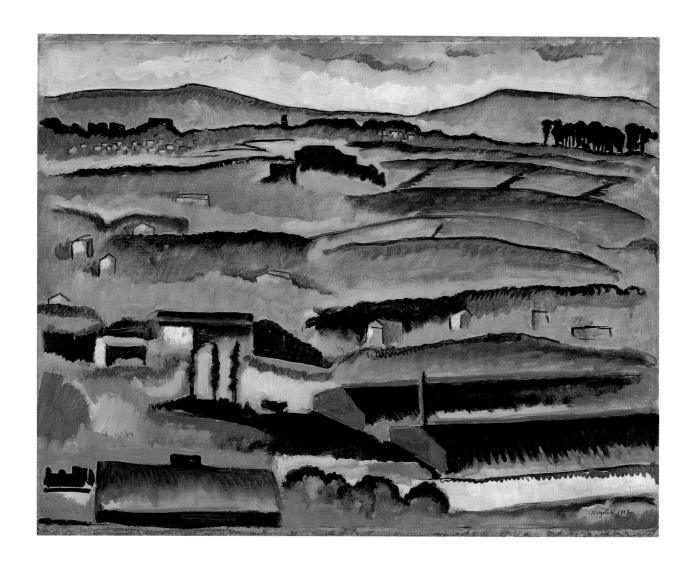

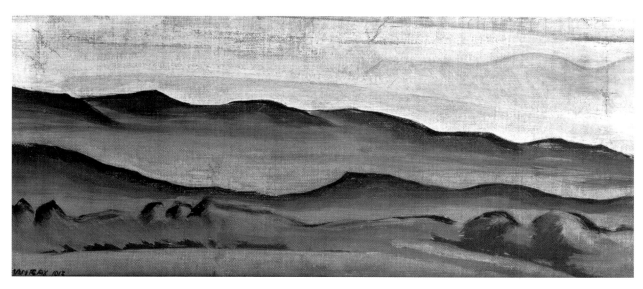

composition, probably meant to represent the Hackensack River, which the journalist had said flows through the valley "like a silver thread in a blue haze."[8]

The bright colors of this landscape suggest a certain familiarity with paintings by the Fauves, not only artists like Matisse (whose work, as we have already discussed, clearly influenced Man Ray) but also a number of the lesser-known painters—Maurice de Vlaminck, Georges Braque, André Derain, and Raoul Dufy, all of whom were represented in the Armory Show.[9] There are, however, no earlier painters—neither Fauve nor Cubist—who reduced the components of their landscapes so severely as Man Ray. In one painting of this period, the hills of Ridgefield are rendered as little more than a series of dark, undulating horizontal lines (fig. 71). A rectangular rooftop seen in elevation from the side is visible in the immediate foreground, while the engine of a train emerges from behind it on the far left. A slice of the river is visible on the bottom right; behind it appears a series of factories and warehouses whose broad expanse is repeated in the delineation of gently rolling hills. This same horizontal pattern repeats itself to the top of the image, concluding with mountains in the far distance, their profile echoing the shape of a cloud overhead.

It is these mountains—and these mountains alone—that serve as the sole subject of a long horizontal landscape from 1913 that is so unusual in format as to suggest that it may have been cut from the top of a larger painting (fig. 72). Whenever Man Ray decided that a particular detail of a finished work was not painted to his satisfaction, or that part of an image was superfluous to the composition as a whole, he simply excised and discarded it, preserving only the portion he considered worthwhile. The result in this case is to have salvaged the fragmented view of a mountainous

terrain that is so thoroughly devoid of life that (like the later paintings of Georgia O'Keeffe) its plastic or formal components are thrown dramatically into focus, precisely the direction in which Man Ray's art would soon evolve.

It was in the summer of 1913—around the time when the landscapes reproduced here were painted—that Man Ray met a person who would change the course of his life, a young poet from Belgium by the name of Adon Lacroix.

## ADON LACROIX

The isolation and detachment of the Ridgefield community was interrupted by occasional visits by friends from the city. On one eventful summer afternoon—to be precise, on August 27, 1913—several friends from the Ferrer Center stopped by, among them the sculptor Adolf Wolff and his companion, Adon Lacroix.[10] Wolff and Lacroix had recently moved to New York from Belgium. Although they were living together and had a child, they were not married; in the true anarchist tradition, they were free spirits, open to whatever amorous opportunities presented themselves. The encounter could not have come at a better time for Man Ray. He found Lacroix beautiful, and her French accent was more than he could resist. Upon learning that her living situation in New York was strained—as his had been when he shared a studio with Wolff a year earlier—Man Ray invited her to live with him in Ridgefield. To his surprise and delight she accepted, stayed that night, and, a few days later, moved in with her seven-year-old daughter, Esther.

Like Man Ray, Adon Lacroix was both a painter and poet. Her father was a wealthy Belgian manufacturer, but he had fourteen children, of whom Adon was the youngest. It was in her teen-

73. *Portrait of Adon Lacroix,* ca. 1914. Photograph. Collection of Constance and Albert Wang.

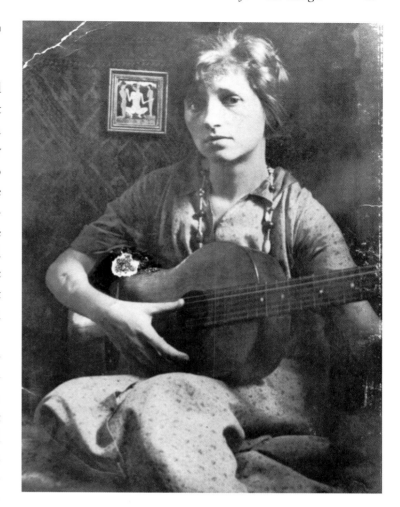

age years that she decided to become an artist, and it was while taking classes in Brussels that she met Wolff, who was a few years her senior and by then already committed to a career in sculpture. Shortly after the birth of their daughter, they moved to America, and both their finances and romance began to deteriorate. For Lacroix, Man Ray's invitation solved many problems. Not only would she be provided with welcome relief from her strained relationship with Wolff, but the remote and idyllic community of Ridgefield would be the perfect place to paint and write, the very activities in which Man Ray was already intensely engaged.

As Man Ray's relationship with Lacroix intensified, the small shack he shared with Halpert created an increasingly awkward living situation, so the couple began to look for another house to rent on the property nearby. They soon found a small but charming cottage, with three or four rooms and a gabled roof that added to the fairy-tale existence Man Ray had earlier dreamed about. Moreover, there was a small but well-lit attic room that would serve perfectly as Man Ray's studio. They moved in immediately, and it was in these new surroundings that the young lovers engaged in an artistic collaboration that was probably more rewarding than either one of them could have imagined.

Adon Lacroix painted landscapes and wrote poetry, while Man Ray directed his attention to her for inspiration. Almost immediately, she became the sole focus of his artistic vision. With his box camera, he took many photographs of her, and, over the next two years, she served as his model for numerous drawings and paintings (figs. 75–78). In one snapshot, she plays the guitar and poses in a flowered dress before one of his paint-

74. Adon Lacroix and Man Ray, Ridgefield, dated May 30, 1915. Photograph. Papers of Helen Ray Faden, Pasadena, Fla.

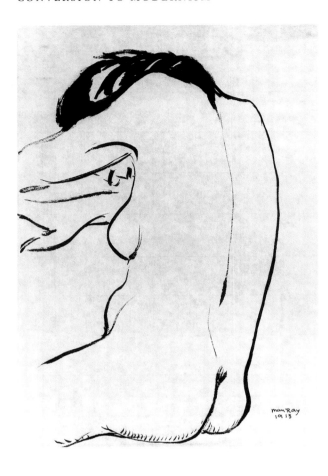

75. *Untitled* [*Seated Nude from Back*], 1913. Brush and india ink on paper, 15 7/8 x 10 13/16 in. Collection of Timothy Baum, New York.

ings (fig. 73); in another, they sit together in a doorway—she wearing a black dress and long beaded necklace, he in a white shirt and smoking a corncob pipe—both looking off into the distance, as if oblivious to the purview of a camera (fig. 74). Man Ray liked the one of Lacroix playing the guitar so much that he took the negative to a local photo shop and arranged for it to be enlarged (he had not yet set up a darkroom of his own). Finally, his adolescent fantasies came true when she willingly disrobed and served as his nude model for a series of sketches and paintings (figs. 75, 76).

For the most part, these drawings and paintings are similar in approach and style to works that Man Ray made while attending classes at the Ferrer Center (see figs. 23–27). But at least two paintings of Adon Lacroix from 1913 are more

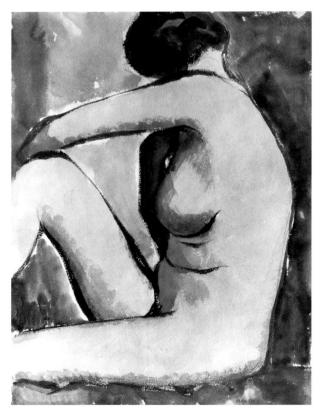

76. *Seated Nude in Profile,* 1913. Watercolor on paper, 15 x 11 in. Collection of Silvia Schwarz, Milan.

77, facing page. *Portrait of Donna* [*Portrait of Adon Lacroix*], 1913. Oil on canvas, 24 x 14 in. Private Collection of Mrs. Isaac Stern. Photo by Peter Jacobs Fine Arts Photography.

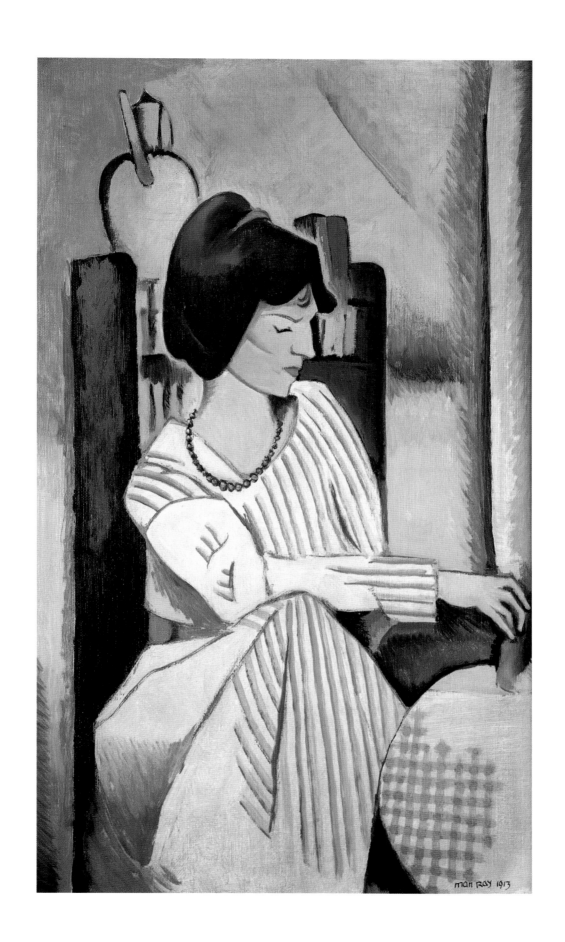

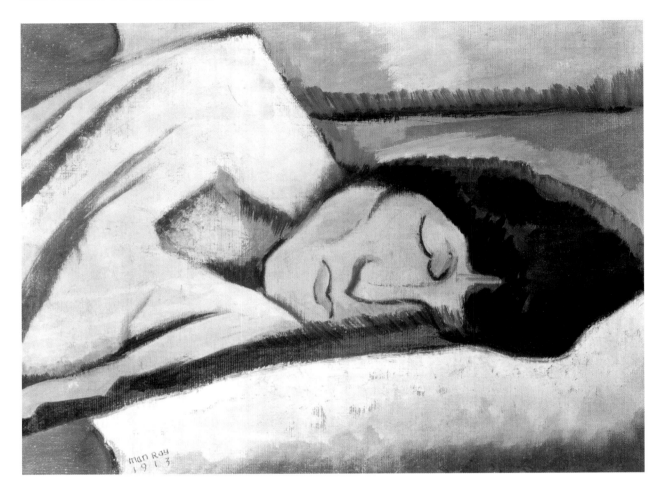

78. *Woman Asleep*, 1913. Oil on canvas, 12 x 16 in. Whitney
Museum of American Art, New York. Purchase 33.30.

consciously stylized (figs. 77, 78); that is to say, her
likeness is not recorded with the sole intention of
displaying technical virtuosity, but the subject's
naturally sharp and angular features have been
artificially enhanced, so as to serve as integral com-
ponents of the painting's overall formal structure.

In the first of these portraits (fig. 77), the pre-
dominantly vertical format of the painting is
clearly reflected in various background elements, a
formal reading that is supported by the bold over-
head view given to the table on the lower right. A
cloth covering decorated with intersecting hori-
zontal and vertical lines that form a rose-colored
pattern provides no indication of perspectival
recession (a characteristic also reflected in the blue
stripes of her dress). But the detail in this painting

that reveals Man Ray's allegiance to the vocabulary of modern art comes in the form of a single diagonal line in the upper right quadrant of the painting. Rather than leave this area blank (which it likely was in the original scene), Man Ray has articulated the space by means of a sharp planar division—painted yellow on one side to pick up the coloration of the background, gray on the other, to reflect the surrounding space—a line that would have no rationale for its existence outside of the realm of Cubist painting.

Man Ray also captured Adon—or Donna, as he later called her in his autobiography—asleep (fig. 78). He recorded her entirely in sharp lemon-yellow tones, the product, he later explained, of an accident. Apparently, the picture had been painted while Lacroix was sleeping, with only faint illumination provided by an oil lamp. Under these conditions, Man Ray had mistaken his tube of yellow for white, accounting for the overall yellow tonality of the picture.[11] He was so pleased with the results, however, that he took the painting to Stieglitz, who said he was not making purchases at the time but recommended Man Ray take the picture to Mitchell Kennerley, a wealthy publisher who was known to have collected modern paintings. Without hesitation, Kennerley wrote out a check for one hundred and fifty dollars, resulting in Man Ray's first major sale.[12]

"My mind was in a turmoil," Man Ray wrote of his thoughts in this period, "the turmoil of a seed that has been planted in fertile ground, ready to break through."[13] The break came in the form of an epiphany that he experienced in September 1913 on the final afternoon of a three-day camping trip to Harriman State Park on the New York–New Jersey border. The poet Alanson Hartpence and his wife, as well as another couple, accompanied Man Ray and Adon Lacroix on the trip. (A snapshot of Lacroix seated on a rock [fig. 79], cane in hand and wearing a sun hat, may very well have

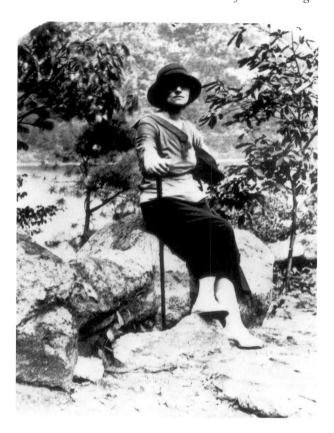

79. Adon Lacroix, 1913 (?). Photograph, 3 3/4 x 2 13/16 in. Collection of Constance and Albert Wang.

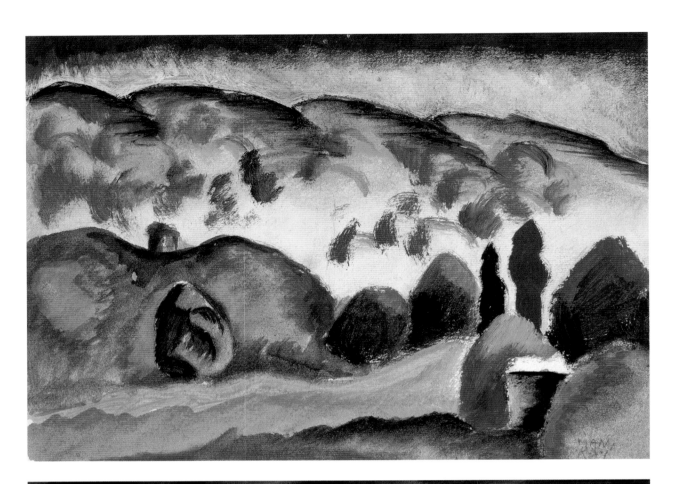

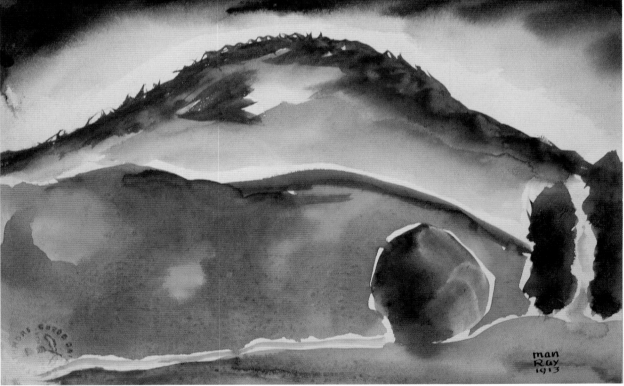

80, facing page, top. *Ramapo Hills,* 1913. Watercolor and gouache on paper, 8 5/8 x 10 1/2 in. Private Collection. Photo courtesy of Hollis Taggart Galleries, New York.

been taken during it.) While discussing future art projects with Hartpence, Man Ray declared that he would no longer seek inspiration directly from nature. "In fact," he declared, "I had decided that sitting in front of the subject might be a hindrance to really creative work." Instead, he announced, upon his return he would paint a series of "imaginary landscapes" based on his recollection of scenes and events that had occurred during the course of the excursion. From that moment onward, he decided, for inspiration he would "turn more and more to man-made sources."[14]

True to his word, upon his return to Ridgefield, Man Ray took out his box of watercolors and executed several "imaginary landscapes" based on memories of his camping trip. One records a tree-covered terrain where the artist and his friends had hiked one afternoon (fig. 80), the colors applied with a freedom and spontaneity that confirm his decision to abandon a direct observation of nature. In the isolation of his studio, the artist was free to invent, so trees and houses within the landscape are changed at will. As a result, colors are often exaggerated, shapes distorted, whatever was necessary to make the image more dynamic and visually appealing (fig. 81).

This was precisely the direction in which Man Ray's paintings rapidly evolved, a stylistic transformation especially evident in two Cubist landscapes of the period that portray houses along the side of a hill in Ridgefield (figs. 82, 83). In his autobiography, Man Ray describes the view from his cottage in a way that sounds like a description of

81, facing page, bottom. *Landscape with Mountain/Ramapo Hills,* 1913. Watercolor on board, 5 3/4 x 7 1/4 in. Timothy Baum Family Collection, New York.

these two paintings. "The whole valley lay before us," he recalls, "with distant blue hills—a continual source of inspiration for landscape work. The hill opposite was dotted with detached simple houses in different tints. I made several studies of the village of Ridgefield."[15]

In the first of these studies (fig. 82), the houses on the hillside are reduced to a series of simple block-like shapes, with little tonal gradation or diminution of scale, virtually eliminating all cues for depth perception and perspective. Despite these spatial distortions, we can see that Man Ray has retained the same brick building at the top of the hill that he had faithfully recorded in an earlier view of Ridgefield (fig. 67), while casting both landscapes in a predominatly Cubist style. When Man Ray showed these paintings to Hartpence, the poet thought that his friend was simply experiencing a "brainstorm" provoked by what he had seen earlier at the Armory Show. To an extent, Hartpence was right, for these paintings closely match the style of landscapes by Roger de la Fresnaye that were included in the Armory Show, as well as several paintings by Francis Picabia.[16]

Even though specific comparisons such as these can be made, Man Ray's Cubist compositions differ in one telling respect from the French paintings he had seen at the Armory Show, and that is in their vibrant use of color. "The winter of 1913–14 passed uneventfully," Man Ray later recalled of his activities in this period. "I started a series of larger canvases, composition of slightly Cubistic figures, yet very colorful, in contrast to the almost monochromatic Cubistic paintings I had seen at the international show in the Armory."[17] Indeed, it is the use of bright colors in these landscapes that most clearly separates them from sources in French Cubism.

Two semi-abstract watercolors from this same period (figs. 84, 85)—images that seem to have been inspired by some sort of organic motif—can

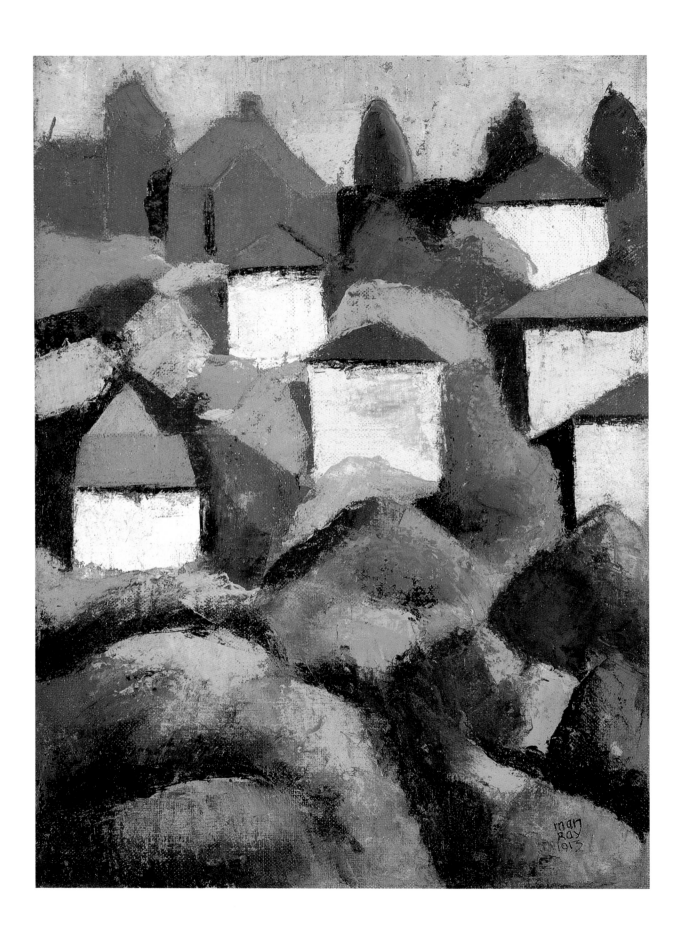

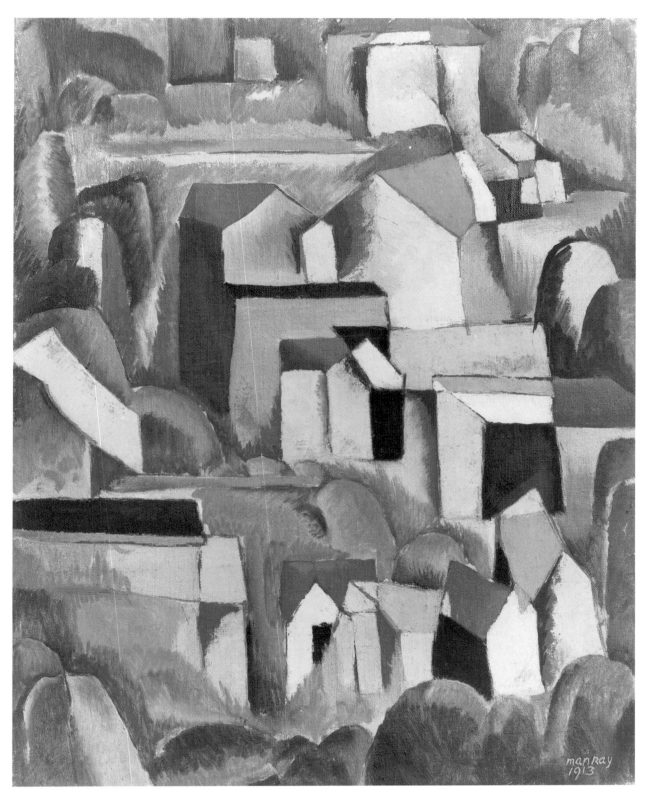

82, facing page. *Landscape,* 1913. Oil on canvas, 14 x 9 1/2 in. (36 x 25 cm.). Collection of Alain Lesieutre, Paris. Photo courtesy of Alain Lesieutre.

83, above. *The Village,* 1913. Oil on canvas, 20 1/8 x 16 1/8 in. Collection of Vera and Arturo Schwarz, Milan.

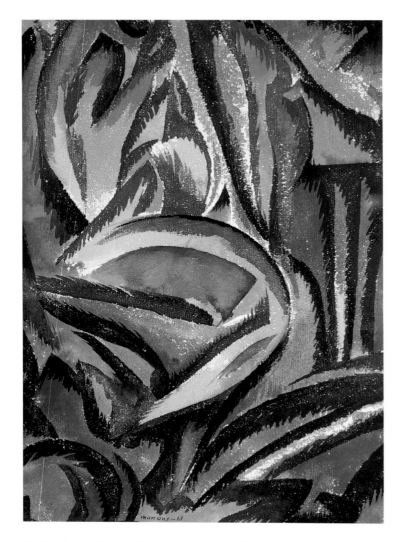

84. *Landscape (Paysage Fauve)*, 1913. Watercolor on paper, 13 7/8 x 9 11/16 in. Smithsonian American Art Museum, Washington, D.C.; Gift of the Man Ray Trust.

be distinguished from the work of Man Ray's European and American colleagues by their exceptionally bright coloration.

The artist must have had works like these in mind when he explained that "by the end of the year I had completed my series of romantic expressionistic paintings of figures in the woods."[18] Although no specific figures can be detected in these images, they certainly fit the description of being both "romantic" and "expressionistic." The first of these two watercolors resembles the general format of Picasso's *The Reservoir at Horta de Ebro* (Museum of Modern Art, New York), a 1909 painting that was not shown in the Armory Show but was reproduced in a special issue of *Camera Work* devoted to Picasso and his work.[19] The

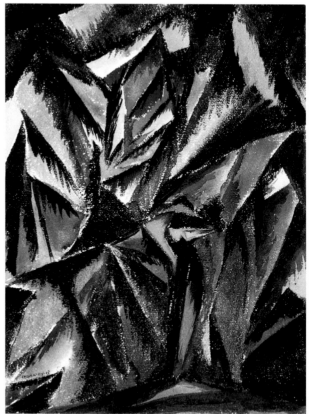

85. *Untitled*, 1913. Watercolor on paper, 13 13/16 x 9 3/4 in. Private Collection, New York. Photo courtesy of Timothy Baum, New York.

Picasso appeared in black and white, so perhaps Man Ray felt perfectly free to add whatever colors he wanted, just as he had when coloring the drawing of a battleship he made as a child.

Man Ray's affections for Adon Lacroix are apparent in virtually everything he did. Even after he decided not to work directly from nature, he continued to use her as a source of inspiration. Although it was no longer necessary for her to serve as his model, he continued to make paintings and drawings of her, his ever-present artistic muse. To demonstrate how radically his artistic vision had changed, however, we need only compare the naturalism of his earlier ink drawing of Lacroix (fig. 75) with a more highly stylized rendition of her seated on a chair (fig. 86). Clearly the latter image did not require a long posing session but was a product of the artist's fertile imagination.

An even more dramatic example of his feelings for Adon Lacroix can be found in a watercolor of himself and her entitled *Double Portrait* (fig. 87), where the artist has depicted their respective facial features—eyes, nose, mouth—in a way that serves

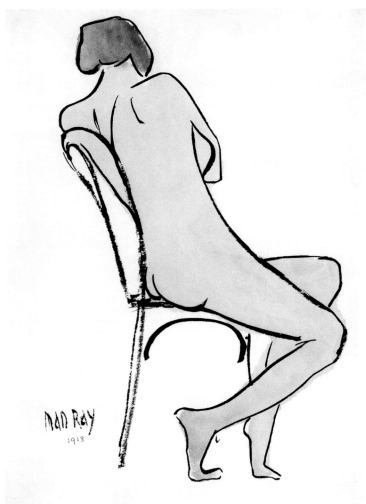

86. *Seated Nude,* 1913. Ink and watercolor on paper, 15 3/4 x 11 1/4 in. Studio Marconi, Milan.

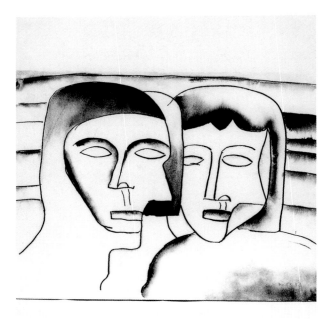

87. *Double Portrait,* 1913. Watercolor on paper, 8 1/2 x 11 in. Private Collection.

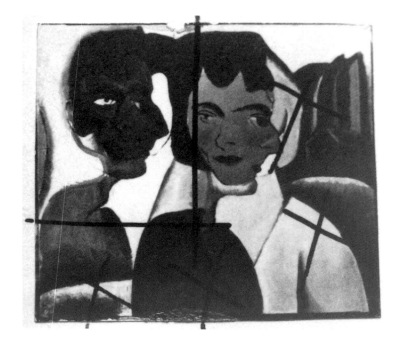

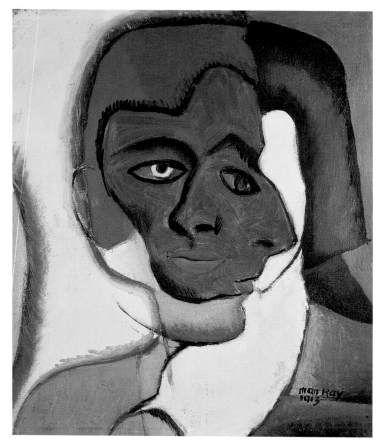

88. *Composition*, 1913. Oil on canvas, dimensions unknown. Partially destroyed (photo: Artist's Card File; see document C).

to emphasize their physical similarities. When he attempted to capture this same effect on canvas, however, he failed (fig. 88), possibly because the features of Lacroix were rendered too simply, almost cartoon-like in comparison with his own. It may have been this reasoning that caused him to excise this detail from the larger canvas and call the salvaged portion *Dual Portrait* (fig. 89). In technique, the remaining portion of this image is surprisingly close to the later paintings of Picasso, where frontal and profile features are often combined and overlap. It may have been a painting like *Dual Portrait* that Kreymborg had in mind when, in the mid-1920s, he noted that Man Ray's work was derivative of Picasso's: "Man was already a remarkably inventive and assimilative individual," he recalled. "In his quiet, smiling fashion, he not only applied the theories of Picasso to the problems of his own fastidious ego, but had begun to play with other media of expression."[20]

Of course, the similarity between this picture and Picasso's later work is almost certainly coincidental, for this particular painting by Man Ray would remain unknown until some years after his death. (Ironically, the picture was stolen from the artist's estate in 1982 and has never been recovered).[21] Rather, *Dual Portrait* represents Man Ray's efforts to graphically illustrate the emotional and intellectual rapport he experienced with Adon Lacroix, his most intimate companion and collaborator in these years and a woman who would inspire his creative production for some time to come.

89. *Dual Portrait*, 1913. Oil on canvas, 11 13/16 x 9 13/16 in. Present whereabouts unknown (stolen and never recovered).

# FIVE

## APPROACHING THE ART OF PAINTING IN TWO DIMENSIONS: The Paintings, Drawings, and Watercolors of 1914

The year 1914 could well be considered the period of greatest experimentation and transition in Man Ray's early work. Curiously, Arturo Schwarz, author of the first major monograph on the artist, characterized the paintings from this year as exhibiting "less variety and style" than works from the previous year.[1] In point of fact, however, there is no single period in Man Ray's artistic development that reveals a greater diversity in approach, nor a more rigorous, though still somewhat unresolved, investigation of the various modernist styles to which he had been exposed. Throughout the course of this year, Man Ray felt perfectly at liberty to employ whatever style best suited the subject he selected, without allowing the dictates of any one approach to impose themselves upon the future development of his work. He was capable of incorporating the characteristics of a certain style in one image, for example, only to adopt a completely new vision with the very next picture he produced.

By the winter of 1913–1914, Man Ray and Adon Lacroix had settled into a comfortable and welcome routine of domestic tranquility. He made the excursion into Manhattan three days a week to work, while she remained at home in Ridgefield caring for her daughter, painting, and writing poetry. Although Man Ray later recalled their first winter together as having been especially severe, as soon as the snows thawed, he ventured outside and discovered interesting subjects to paint. It was a scene he came upon one afternoon in the front of their cottage that provided the subject for a small watercolor (fig. 90) executed with the same degree of naturalism as his earlier landscapes. "Came spring," he wrote, recalling the scene that inspired this work, "it was pleasant to walk through the damp greening woods to the cottage. . . . One warm late afternoon I came upon Donna washing her hair over a basin outdoors; it was a charming picture and I immediately made a watercolor."[2] It may have been a similar scene that he witnessed one day near the cottage that inspired the water-

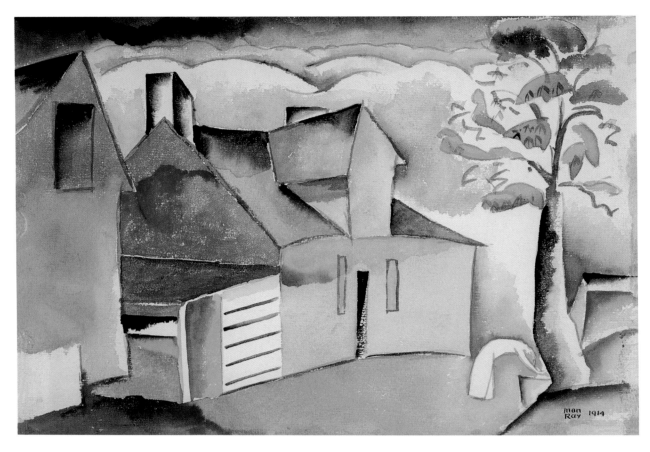

90. *The Cottage,* 1914. Watercolor on paper, 11 x 14 1/2 in. Private Collection.

color sketch of a young woman (possibly Lacroix or eight-year-old daughter, Esther), scantily clad, wearing only a brilliant cobalt-blue sweater, and standing in the out-of-doors (fig. 91).

While a number of drawings from this period were derived from subjects the artist observed in his immediate environment, others appear to have been more imaginatively devised. Having come to the decision that he would no longer rely upon a direct observation of nature as the only inspiration for his work, he used the "imaginary landscapes" he had made upon his return from the Ramapo Hills camping trip (figs. 80, 81) as the basis for two larger and more highly finished oils, paintings that were made on the same size canvas and both given the same title: *Ramapo Hills* (figs. 92, 93).

In the first of these paintings—derived from

91. *Untitled [Girl in Blue Sweater]*, 1914. Watercolor on paper, 7 x 5 in. Present whereabouts unknown (formerly Estate of the Artist, Paris).

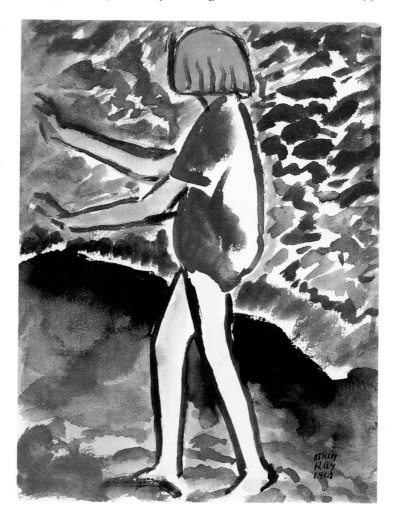

the left side of original landscape study (fig. 80) and executed in greater detail in a subsequent watercolor (fig. 81)—the simplified form and deep blue coloration given to a large tree in the center of the composition make it visually difficult to comprehend. (It looks more like a misshapen, oversized boulder than a tree.) The surrounding landscape appears to have been just as arbitrarily colored; the hill in the background is painted in a vibrant orange hue, while the palette employed in the immediate foreground varies from pale green to bright mauve. An equally intense infusion of color is given to the painting (fig. 93) derived from the right side of the earlier study (fig. 80), a landscape that almost appears to glow from some inner source of radiance. While Man Ray may have been trying to simply capture the bright colors of a beautiful and brilliant autumnal landscape, in the isolation of his Ridgefield studio he felt perfectly at liberty to depart from a strict reliance upon the motif, a tendency toward the acceptance of a more abstract imagery that, as we shall see, he would continue to pursue in his future work.

Meanwhile, memories of the Ramapo Hills camping trip served to inspire other works made in this period, including an unusually large canvas entitled *Departure of Summer* (fig. 94), where three nude female figures are seen bathing in a stream. One morning, Man Ray, Hartpence, and another unidentified individual who had accompanied them on the camping trip arose to quietly observe their female companions bathing in a small stream. "We watched the nude figures moving about through the branches," he recalled. "I thought of Cézanne's paintings, and made a mental note of the treatment of figures in a natural set-

92. *Ramapo Hills,* 1914. Oil on canvas, 20 x 19 in. Private Collection.

ting, for future works."[3] By the time he got around to translating this mental note into a concrete image, the results bore little if any resemblance to the paintings of Cézanne, except, of course, in their selection of subject. One woman reclines in the center of the composition, her right foot immersed in the water, while the other two appear

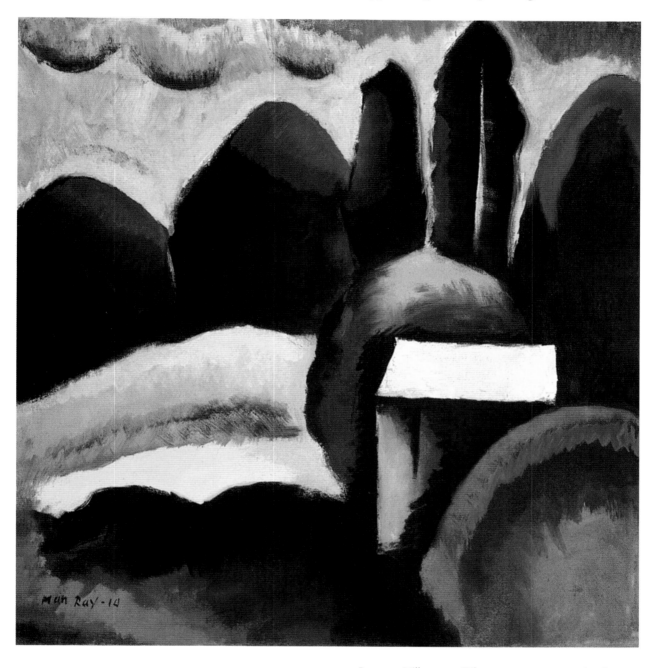

93. *Ramapo Hills,* 1914. Oil on canvas, 20 x 19 in. Present whereabouts unknown (sold Christie's New York, May 30, 1986).

to be helping her stand erect. All three figures are painted with little volumetric suggestion, an impression of flatness that is reinforced as a result of the obvious detachment between the foreground figures and the background landscape. Not only is there a lack of integration between these two elements, but the artist appears to have intentionally

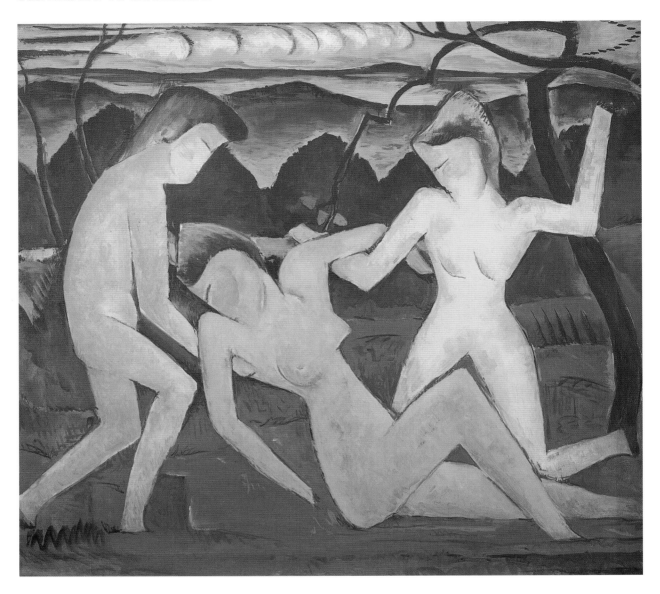

94. *Departure of Summer,* 1914. Oil on canvas, 32 x 36 in. The Art Institute of Chicago, through prior gift of the Mary and Leigh Block Collection.

sought their separation. For the background of this painting, he simply "inserted" the basic forms of an earlier landscape (fig. 95), after having made only minor adjustments to incidental details.

The simplified and sharply reduced elements of this earlier landscape—entitled simply *Hills*—suggest that it, too, might have been composed from the artist's recollection of a given scene, rather than inspired directly from the motif itself.

Behind the silhouetted, twisted branches of two barren trees positioned on flanking ends of a horizontally oriented composition, a magnificent vista unfolds. Deep in the central foreground is the far end of a rectangular field, portions of which are rendered as cultivated ground; a series of black parallel lines was intended to depict freshly plowed furrows. Behind the field there appears a cluster of brown, semicircular shapes, possibly meant to represent a stringcourse of trees, the leaves browned by the encroaching frosts of autumn. Directly behind these shapes can be seen the most distin-

95. *Hills,* 1914. Oil on canvas, 10 1/8 x 12 in. Munson Williams Proctor Arts Institute, Museum of Art, Utica, N.Y., Museum Purchase, 86.1.2.

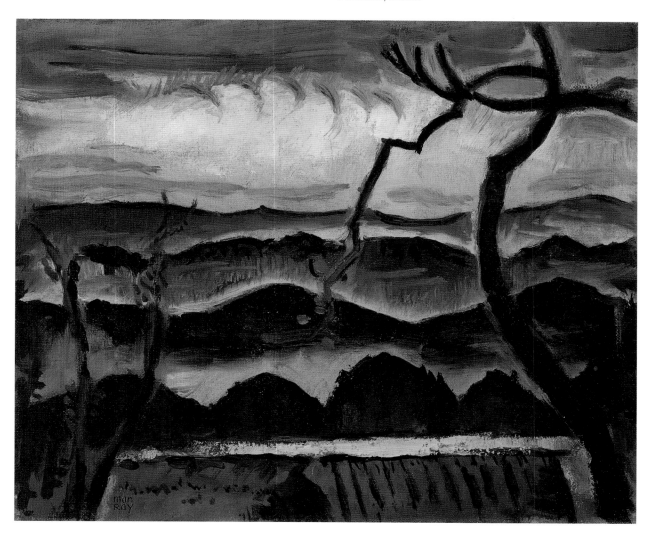

96. Certificate and Record of Marriage for Man Ray and Adon Lacroix, May 3, 1914. New Jersey Department of Health, Trenton, N.J.

guishing feature of the landscape: a series of gently rolling hills, from which the painting derives its title. These majestic hills, separated from one another by a low-lying atmospheric mist, range in hue from a deep gray in the immediate foreground to a brilliant purple color in the central range to a milky gray at the distant horizon. Finally, in the upper reaches of the composition, prominent cloud formations appear to consciously echo the repetitive linear and circular patterns of the landscape below.[4] Such a contrived manipulation of form serves to enhance and reinforce the inherently decorative characteristics of the painting, demonstrating a reliance upon certain formal conventions that would, in the years to come, gain increasingly in importance for the artist.

On May 3, 1914, Man Ray and Adon Lacroix married in a civil ceremony in Ridgefield. Normally, those committed to the basic tenets of anarchism would not have required nor wanted their emotional bond to be sanctioned by a legal authority, but since Lacroix had a daughter, Man Ray thought it would cause their friends to more readily accept their living situation. He got married, he later explained, "in order to set at rest all speculations of our friends and eliminate the disapproval of others."[5] On their marriage certificate (fig. 96), Man Ray gave his age as twenty-four, and listed his occupation as "artist." Adon Lacroix gave her age as twenty-seven; typically for the time, no space was provided for her occupation. Each indicated that it was a first marriage, and they listed the names of their witnesses as Alanson Hartpence and Helen Slade.

After the ceremony—which took place on an exceptionally warm Sunday morning—the newlyweds and their witnesses retired to the lawn in front of the Ridgefield cottage, where they celebrated the event by spreading out a picnic blanket and having breakfast (fig. 97). Man Ray decided to

97. "Wedding Day—Ridgefield, N.J., May 1914." Vintage silver print. Man Ray, Adon Lacroix, Alanson Hartpence, Helen Slade: the four signatories on Man Ray's marriage license. Collection of Michael Senft, East Hanpton, New York. Photo courtesy of Michael Senft.

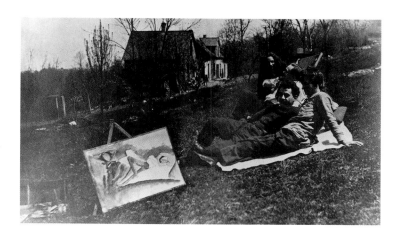

mark the occasion with a painting—entitled *After Breakfast* and dated May 1914 (fig. 98)—where all four figures are quickly sketched in gouache on a large sheet of paper. A comparison of the unfinished painting, visible in the photograph, with the completed picture reveals certain procedural details typical of the artist's technique in this period. In the photograph, we can see that Man Ray has applied the pigment in thin, uneven washes of color, providing a visual description of the basic divisions of form. Only later, in the finished picture, is it clear that he has carefully reinforced the shape of each figure with a dark black line, providing a more precise and graphic definition of these figures. Despite Man Ray's professed admiration for the unfinished quality of Cézanne's watercolors, it does not appear as though he considered his own paintings completed until these finishing details were applied.

Man Ray's inclination toward a more pronounced graphic expression may have been the result of his experience in the field of commercial publication. In the spring of 1914 he was still employed as a draftsman for a publishing firm in Manhattan, where one of his principal responsibilities was to add embellishing details to the designs of ornamental borders around maps and atlases. With few exceptions, line diagrams or boldly rendered ink drawings serve as similar decorative enhancements on nearly every page of the numerous

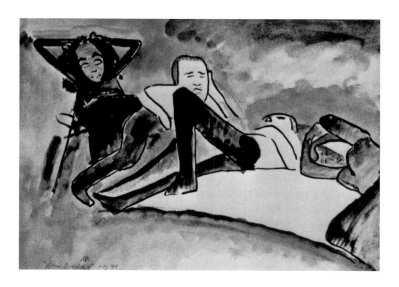

98. *After Breakfast*, 1914. Oil on canvas, 19 x 25 in. Private Collection, Europe (photo from Janus, *Tutti gli scritti* [Milan: Feltrinelli, 1981], p. 212).

# ADONISM

## SOME POEMS BY MAN RAY

RIDGEFIELD   NEW JERSEY

1 9 1 4

*Designed and published by Man Ray at Ridgefield New Jersey.*

*Publisher of "The Bum" and other original papers.*

## SPRING

In these dull tentative days when every little plant timidly pokes her head out of the ground and quickly withdraws again if one observes her — impatiently my desire reaches toward the full-blown summer, the love-steeped, confident summer when nothing is denied and nothing withheld.

## HIEROGLYPHICS

The snow has fallen —
A great white page lies open —
Naked black trees rise out of the white —
Words written in black on white —
A dead language.
Clothed men and women are walking about —
Words forming themselves in black on white —
A living language.
People are killing each other —
Words are being written in red on white —
A dying language.
The sun appears — words are written in fire on blue —
Life and death relax —
O silent melting language of eternity!

99, facing page. *Adonism,* 1914. Booklet of poems, 10 1/4 x 5 7/8 in. Yale Collection of American Literature, Beinecke Rare Book and Manuscript Library, Yale University, New Haven, Conn.

pamphlets and other limited edition publications that the artist designed and hand-printed in these years. A number of small figurines, for example, appear as marginal illustrations in *Adonism* (fig. 99), a collection of poems that, as the title indicates, were written as a tribute to his new bride. As we shall see, several of these drawings would be used as preparatory models for paintings completed later in the year.

In "Hieroglyphics," perhaps the best poem to appear in *Adonism,* images drawn from nature are subjected to a direct correspondence with the written word, somewhat in the manner of Egyptian hieroglyphic writing. But unlike this ancient pictographic language, the alternating lines of this poem rely upon a forced verbal/visual interchange, a concern that will occupy Man Ray for the rest of his artistic career. In another poem—entitled, appropriately, "Intrusion"—Man Ray establishes an interesting metaphor between a person intruding upon a landscape and an ink blot falling on the very page on which the poem appears. An even more literal verbal/visual interplay can be found on the back cover of this ephemeral publication, where, in a small, oval-shaped woodcut, Man Ray presents the simple form of a landscape. A series of sharp architectonic shapes represents cliffs, while a more distant view of hills and mountains can be seen in the background. A second look, however, reveals that these landscape elements vaguely mime the artist's initials: *MR.*

This very same approach is employed in *Man Ray 1914* (fig. 100), a painting that at first glance appears to be little more than a rather simplistically rendered Cubist landscape, composed of a series of roughly parallel, slanting cliffs and a

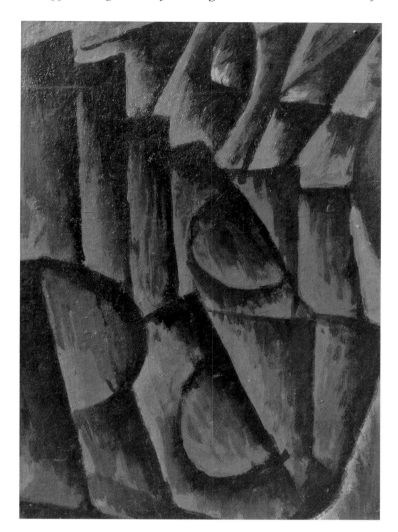

100. *Man Ray 1914,* 1914. Oil on canvas, 7 1/8 x 5 1/8 in. A & R Penrose Collection, England. On loan to the National Galleries of Scotland, Edinburgh.

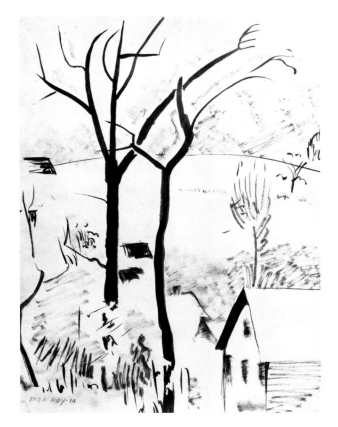

101. *Ridgefield,* 1914. Pen and ink on paper, 11 1/4 x 8 1/2 in. Private Collection (on long-term loan to The Patrick and Beatrice Haggerty Museum of Art, Marquette University, Milwaukee, Wisc.).

grouping of sharp, angular clouds in the far background. A closer inspection, however, reveals that these separate elements are constructed—literally—from the individual letters in the artist's name and the separate numbers of the painting's date: MAN RAY 1914. Although several authors have identified this painting as Man Ray's first Dada picture, it is better understood within the context of his verbal/visual preoccupations of this period.[6]

Whenever Man Ray was not working on a painting, he continued to seek inspiration from the surrounding landscape, completing a series of works on paper in a variety of media that recorded the wooded area around his cottage (figs. 101, 102), as well as more distant views of the countryside near the town of Ridgefield (figs. 103, 104). When he translated his impressions of the landscape to canvas, however, the naturalism that had informed his drawing style became markedly relaxed. While working in his studio, he may have felt sufficiently detached from the source of inspiration to reinvent, or at least artificially enhance, the elements of nature as he remembered them. *Elderflowers* (fig. 105), for example, is an exceptionally large and imposing image that was probably based on reproductions the artist had seen of Monet's celebrated series of water lilies. In spite of the fact that this painting is composed entirely from naturalistic details, it is designed in such a way that its overall, evenly repetitive pattern and square format create a predominantly decorative image, one that not only points in the direction of the artist's

102. *Trees,* 1914. Watercolor on paper, 7 x 5 in. Collection of Dr. Steven Taswell, Bethesda, Md.

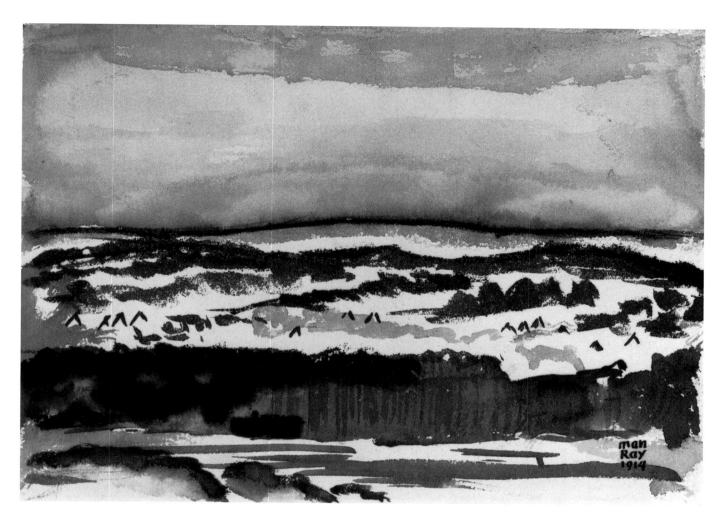

103. *Ridgefield Landscape,* 1914. Ink and ink wash on paper, 5 x 7 in. Collection of Timothy Baum, New York.

104. *Palisades,* ca. 1914. Ink on paper, 8 x 10 inches. Collection of Alexei Lucca Naumann, Yorktown Heights, N.Y.

105. *Elderflowers,* 1914. Oil on canvas, 30 x 30 in. Private Collection (on long-term loan to The Patrick and Beatrice Haggerty Museum of Art, Marquette University, Milwaukee, Wisc.). Photo courtesy of Francis M. Naumann Fine Art, New York.

future work but curiously foreshadows the movement of Lyrical Abstraction by more than six decades.

The basic monochromatic palette of this painting stands in sharp contrast to other landscapes of this period. *Wood Interior* (fig. 106), for

example, is painted with such a pulsating staccato of color that the branches of a tree in the center of the composition almost appear to vibrate. The inner darkness of the forest is illuminated entirely by the light of a radiant full moon, which, set against a pale yellow orb, emits a golden aura that permeates the ambience of the entire scene. The painting may have been based on an actual event Man Ray witnessed during a lightning storm. "With each illumination the landscape stood out

106. *Wood Interior*, 1914. Oil on canvas, 16 x 20 in. Present whereabouts unknown (formerly Estate of the Artist, Paris; sold Sotheby's London, March 22, 1995).

as in daylight," he recalled, "but with a quality of intense moonlight."[7]

An equally vibrant palette is employed in *The Reaper* (fig. 107), a landscape that features the figure of a man harvesting wheat in an open field. Here we view the Ridgefield landscape from an elevated position, screened on the left by a dark rock formation and on the right by the edge of a multicolored hill, painted in a spectral array of color. The field in which the figure works is bordered on the near side by a bright red farmhouse and in the distance by a pearl-white river, beyond which rises a series of majestic rolling hills, softly colored in gradual modulations of deep cobalt blue.

In light of Man Ray's political convictions in this period (discussed in chapter 2), one could be easily tempted to interpret the laborer in this landscape as a symbol of the proletariat. With few exceptions, however, Man Ray carefully avoided making such bold political statements with his paintings. (He did make them occasionally when drawing, as in the two illustrations that he did in this same year for covers of *Mother Earth,* figs. 38, 39). Instead, the figures in his landscapes of this period should be understood as relatively incidental details, no more important than other elements in the composition that are meant to facilitate our reading of the subject.

107. *The Reaper,* 1914. Oil on canvas, 28 x 36 in. Francis M. Naumann Fine Art, New York.

108. *Figures in a Landscape*, 1914. Oil on canvas, 35 x 36 in. Collection of M. Schecter. Photo courtesy of M. Schechter.

In at least one painting from this year (fig. 108), these figures are so dramatically enlarged that they barely fit within the confines of the canvas. Similar in style to the anonymous figures that populate the pages of *Adonism*, these larger painted effigies are decidedly more monumental, rendered as if to represent monoliths carved in stone. The reduction and simplification of form that characterizes the figures in this landscape represents an

109. *Still Life,* ca. 1914. Pen and ink on paper laid down on foil, 8 1/2 x 11 in. Private Collection.

intermediate step in the development of a more abstract vision, a direction in which Man Ray's art would soon evolve.

That this progression had already begun in Man Ray's paintings of this period can be demonstrated by placing into an approximate chronological sequence a group of five still lifes painted in 1914 (figs. 109–113). In following this order, we could very well be paralleling the very steps Man Ray himself followed in his gradual attainment of a more abstract style.[8]

The first of these still lifes is essentially a line drawing with highlights of watercolor representing an assortment of bowls and dishes arranged into a corner space (fig. 109). The severe isometric configuration establishes a perspectival recession, an illusion of depth that diminishes sharply as we view the remaining still lifes in this sequence. In the larger oil that follows, for example (fig. 110), various household items—coffeepot, sugar bowl, serving dish, cup and saucer—are placed on the seat of a homemade chair, its back cut into a triangular shape and set against the surface of a colorful Native American rug hanging on the wall in the background. Since the rug, chair back, and dish are presented in full frontal elevation (facing the viewer), our sense of space is compressed, lending the overall composition a flatness Man Ray seems to have consciously desired.

In the two smaller painted still lifes that follow (figs. 111 and 112), a similar effect is achieved through a simplification of form. In the first, a long, tapering candlestick featured prominently in the center of the composition is overlapped by an

110. *Still Life* [*Indian Carpet*], 1914. Oil on canvas, 24 3/8 x 18 7/8 in. Private Collection.

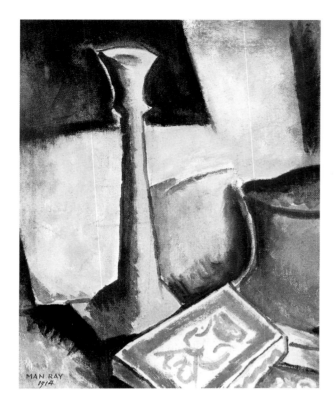

111. *Still Life No. 3,* 1914. Oil on canvas, 10 1/8 x 8 1/8 in. Columbus Museum of Art; Gift of Ferdinand Howald.

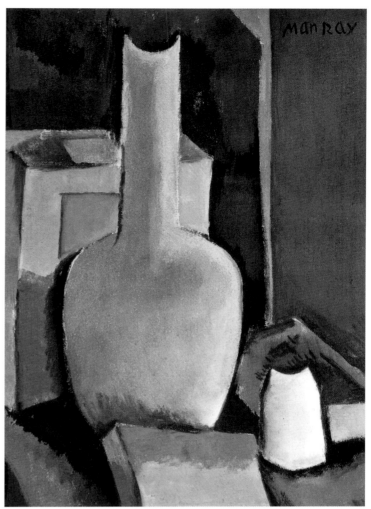

112. *Still Life No. 2,* ca. 1914. Oil on canvas, 13 1/2 x 9 1/2 in. Columbus Museum of Art; Gift of Ferdinand Howald.

ornamented rectangular object (perhaps a book), which, in turn, extends beyond the visual field at the lower edge of the canvas. These objects, placed in the company of others that are even less distinctly rendered, appear locked into a somewhat ambiguous spatial setting, while an almost incidental distribution of harsh shadow throughout the painting does little to enhance or clarify our understanding of the space. Finally, the objects in this image appear unnecessarily crowded, a problem that is compounded by the inclination of an unidentified flat, rectangular object in the painting's background.

In the second of these two small still lifes, Man Ray has eliminated nearly all textural details and has dramatically simplified the shape of each element within the composition. Although orthogonals still fail to align properly, spatial positioning is

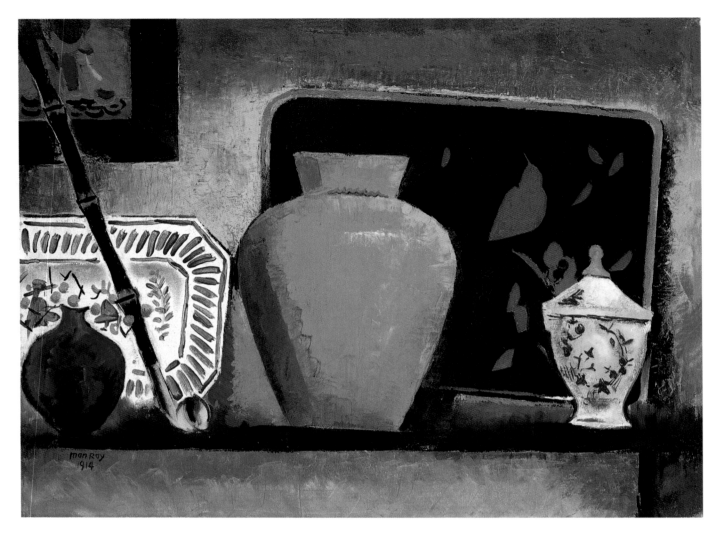

113. *Black Tray*, 1914. Oil on canvas, 18 x 24 1/4 in. Acquired 1927, The Phillips Collection, Washington, D.C.

made somewhat clearer due to a more consistent application of shadow. As in the earlier examples, the objects within this image are depicted as if seen from an elevated vantage point, a natural position, one might argue, from which to view objects placed on a tabletop.

But in the last example from this sequence, *Black Tray* (fig. 113), the viewer's position is centralized, raised to a position directly opposite the objects represented. Here Man Ray has so consciously sought to compress the depicted space that he has forced his objects to be aligned along a narrow horizontal shelf. In this shallow confinement, he has placed three vases, a long bamboo-

114. *Still Life* [*Basket of Pears*], 1914. Gouache on paper laid down on board, 10 1/2 x 12 in. Private Collection.

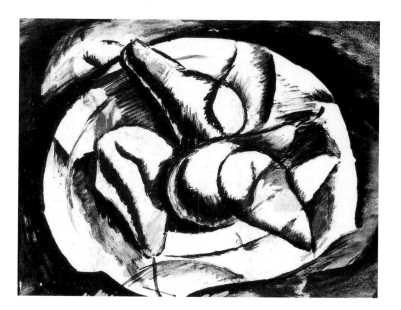

stemmed clay pipe, two oblong serving trays, and, hanging on the wall in the upper left corner, the partial view of a framed print or drawing. It is the sheer simplicity of its design, combined with the overpowering frontality suggested by the planar elements in the background, that allows us to consider *Black Tray* as one of the most critical steps in Man Ray's attainment of a more abstract style.

The majority of Man Ray's paintings during the latter half of 1914 continue to exhibit a dependency upon the precedence of Cubism, first in its Analytic phase—already explored in paintings made in 1913 (figs. 59, 60)—and then, before the year was out, in its more advanced, so-called Synthetic phase. But in looking at two small Cubist paintings from 1914—a still life of pears in a basket (fig. 114) and a landscape of houses along a hillside in Ridgefield (fig. 115)—we will quickly discover that Man Ray's work in this style lacks the elegance and sophistication common to most of the French paintings from which it is derived. This is not due to a lack of talent on the artist's part but to an inevitable loss that results from attempting to translate the visual vocabulary that comprised the original movement in France, a country from which all American artists (with the exception of Max Weber, who studied there) were physically removed.

In Analytic Cubism, the internal forms of a composition are subjected to multiple angular breakup, translucency, and planar fragmentation. To demonstrate that these techniques are operational in Man Ray's work of this period, we need only examine two landscapes from 1914, *The*

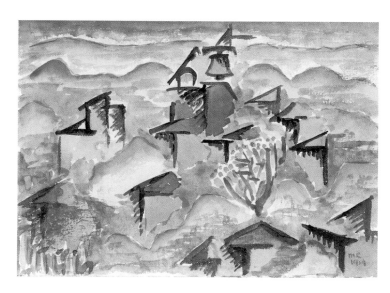

115. *Landscape*, 1914. Watercolor on paper, 5 1/16 x 7 in. Hirshhorn Museum and Sculpture Garden, Smithsonian Institution. Gift of Joseph H. Hirshhorn, 1966.

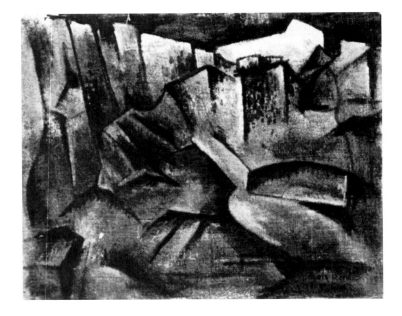

116. *The Village*, 1914. Oil on canvas, 8 x 10 in. Lost or destroyed (photo: Artist's Card File; see document C).

*Village* (fig. 116) and *The River* (fig. 117). Although these paintings have been lost and are known only through inferior black-and-white photographs, it is still possible to detect the extent to which Man Ray was proficient in applying the vocabulary of the new Cubist style. In both paintings, prominent geometric forms were meant to suggest architectural components within the landscape. In *The River*, these elements appear to radiate inward, as if controlled by a mysterious, centrifugal force that draws everything into the center of the composition. In *The Village*, these components are arranged in a more chaotic pattern, and lines appear to have been added in the form of an afterthought, just to provide the landscape with an overall Cubist appearance.

It was the box-like, geometric qualities of Cubism in the earliest phases of its development—the "cubified" look that gave the movement its name—that most strongly appealed to Man Ray. Providing one of the few citations of a specific time period in his entire autobiography, Man Ray pinpointed the development of this style to the winter of 1913–1914: "I started a series of larger canvases," he wrote, "compositions of slightly Cubistic figures, yet very colorful."[9]

It is likely that this geometric style was developed through a series of relatively small figure studies, similar to those that appeared as marginal illustrations in *Adonism* (fig. 99). Indeed, certain of these images were simply enlarged and form the basis of more elaborate, painted studies. The embracing nude couple that accompanies the

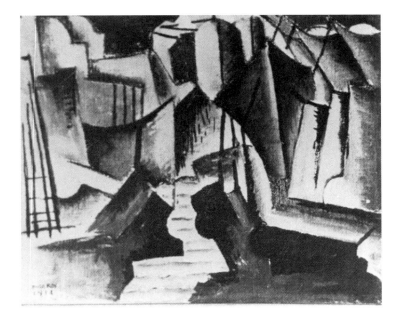

117. *The River*, 1914. Oil on canvas, 8 x 10 in. Lost or destroyed (photo: Artist's Card File; see document C).

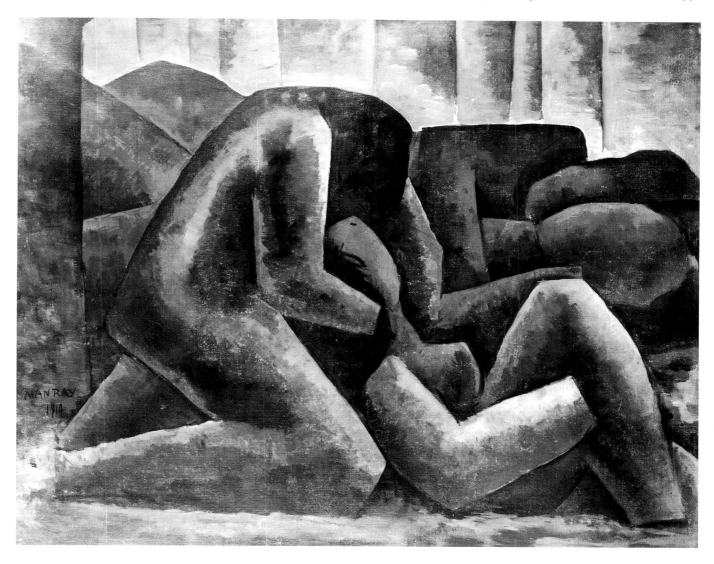

118. *The Lovers,* 1914. Oil on canvas, 32 x 39 1/2 in. Sezon Museum of Modern Art, Tokyo, Japan.

poem "Spring," for example, was clearly used as a preliminary study for *The Lovers* (fig. 118), one of Man Ray's most powerful paintings in this new geometric style. While the blunt and simplified form given to these figures closely resembles the early Cubist paintings of Picasso, Braque, and Picabia, as well as works by a number of other French painters Man Ray would have seen at the Armory Show, it was the example of Adolf Wolff's Cubist sculpture that provided the most direct and accessible source of influence; compare, for exam-

ple, the severe geometry and angularization of Wolff's *The Suppliant* (fig. 36) with similar features in Man Ray's *The Lovers*.[10]

It is likely Man Ray had himself and his wife in mind when he called this painting *The Lovers,* for another image made in this same period depicts an entangled couple (fig. 119), one of whom has a guitar in hand. We know that Adon Lacroix played the guitar (see fig. 73), but Man Ray may have included this instrument to signify more than his affection for his wife. He may also have wanted to allude to the union of painting and music, a theme, we will recall, that he had explored a few years earlier with his fellow students at the Ferrer Center. The shape of the reclining figure in the foreground is articulated in such a way as to echo the profile of the distant mountain range, a repetition of form that might have contributed to the painting's title, *The Rug,* for the overall effect is not dissimilar from the decorative pattern found in Native American blankets or Persian rugs.

The remarkable degree to which Man Ray was influenced by French Cubist painting can be demonstrated by comparing his *Five Figures* (fig. 120) with Picasso's *Les Demoiselles d'Avignon* (fig. 121). Today the *Demoiselles* is one of the most important pictures in the collection of the Museum of Modern Art in New York, but in 1914 it was still in Picasso's studio in Paris and, outside a close circle of friends, virtually no one knew it existed. Ironically, years before the French would learn of this work, a handful of Americans knew about the painting. In May of 1910 it was reproduced as a black-and-white illustration in an article on modern art written by the poet and artist Gelette Burgess for *The Architectural Record*.[11] It was from publications such as this that Man Ray learned a great deal about advanced European art. "Although he has never been abroad," noted a jour-

nalist who interviewed him in 1919, "and consequently has not followed the development of Picasso and Picabia, to name but two, he has of course seen stray works by them and reproductions that have come to America."[12]

Burgess's article featured interviews with Matisse, Picasso, Braque, Derain, and others and included not only a reproduction of Picasso's *Demoiselles* but also his monumental *Three Women* (Hermitage State Museum, St. Petersburg). In *Five Figures,* Man Ray may very well have derived different features from each of these two great paintings by Picasso. The subject, compressed space, and angular forms given to the figures are similar to these same features in Picasso's *Three Women,* and the two figures wearing African masks on the right in the *Demoiselles* correspond approximately to the masked figure on the right in Man Ray's painting. Primitive art became of increasing interest for the artist in this period. In the fall of 1914, he saw an exhibition of African sculpture at 291, a show organized for Stieglitz by the Mexican caricature artist Marius de Zayas (who had borrowed most of the sculpture from the Parisian dealer Paul Guillaume). The show represented one of the first serious attempts to display African art for its artistic merits and not purely for the ethnographic or cultural value it may also have possessed.[13]

When *Five Figures* was acquired by the Whitney Museum in the late 1950s, Man Ray was asked to fill out a questionnaire explaining, among other things, his motives for having painted the picture. It was in this context that he identified the painting as "one of a series of compositions inspired by forms in primitive sculpture."[14] Indeed, there can be little doubt that the masked figure was derived from sources in African art; the pointed chin and generally ovoid cast of the head resemble similar details found in Baule masks, while the repetition of short parallel lines on the side of the face may

119. *The Rug,* 1914. Oil on canvas, 18 1/2 x 20 1/2 in. Collection of Fiona and Michael Scharf. Photo by Peter Jacobs Fine Arts Imaging.

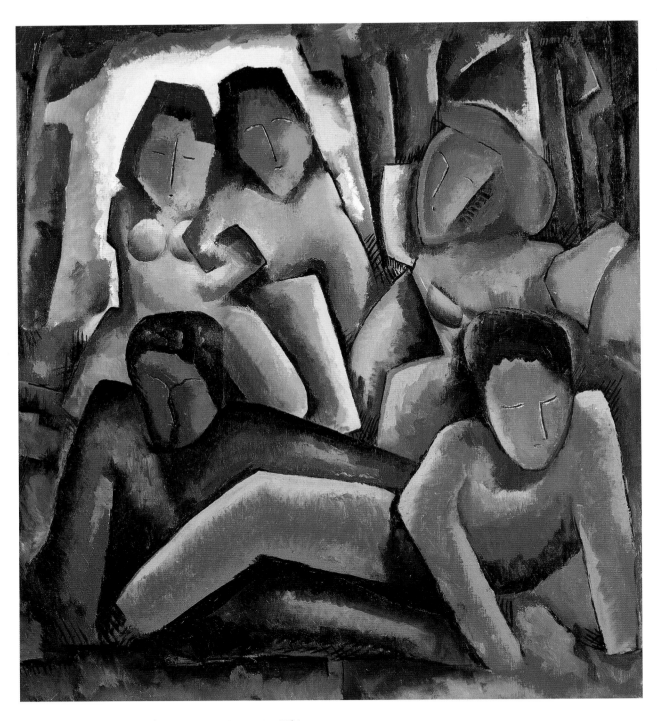

120. *Five Figures,* 1914. Oil on canvas, 36 x 32 in. Whitney
Museum of American Art, New York; Gift of Katherine Kuh,
1956.36. Photo by Geoffrey Clements.

121. Pablo Picasso, *Les Demoiselles d'Avignon,* 1907. Oil on canvas, 96 x 92 in. The Museum of Modern Art, New York. Copyright © 2002 Estate of Pablo Picasso/Artists Rights Society (ARS), New York.

have come from the striated patterns common to many Kota reliquaries.

Like Picasso's *Demoiselles,* Man Ray's *Five Figures* was preceded by a number of preliminary studies: one for the two seated or crouching figures on the upper left (fig. 122) and another for the two reclining figures in the lower foreground (fig. 123).[15] Both of these studies were executed in watercolor, a medium conducive to the use of a bright and tonally atmospheric palette, qualities that, to a degree, are retained in the final composition. The reclining figures are exceptionally bright and colorful, clearly in contrast to the predominantly monochromatic palette of most Analytic Cubist painting. The figures themselves are placed in opposing positions, in the fashion of river gods in Renaissance and Baroque art. The comparison may not be entirely coincidental, for, just as with the painting *Departure of Summer* (fig. 94), the subject of *Five Figures* may have been inspired by his recollection of having seen nude women bathing by the side of a river during his camping trip to the Ramapo Hills.

Given the way in which light reflects off the surface of bodies in *Five Figures*—note especially the red figure with orange highlights in the immediate foreground, as well as the glowing light behind the two figures in the background—it may be that Man Ray envisioned the whole scene as being illuminated solely by the light of the moon. With this in mind, it is possible that a small landscape from this period entitled simply *Moonlight Landscape* (fig. 124) may also have served as a preparatory study for *Five Figures.* The smaller painting, however, contains no figures and is purely a

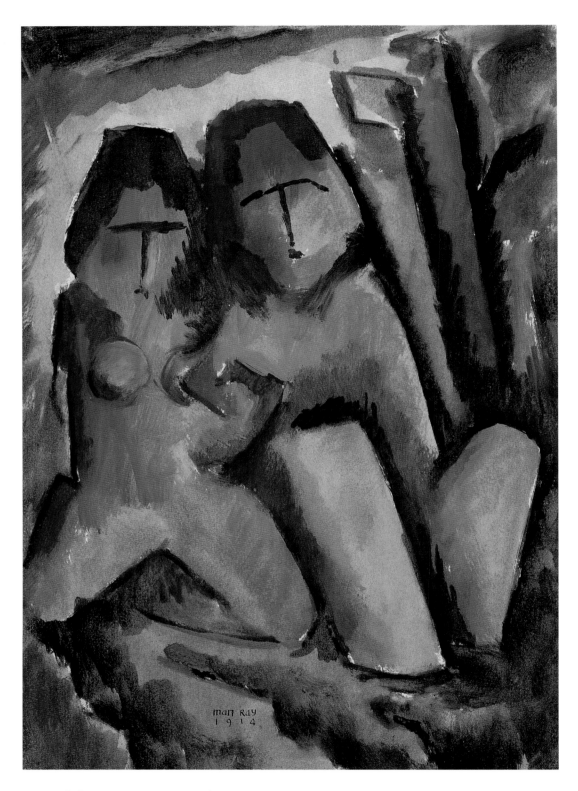

122. *Study for Painting*, 1914. Watercolor on paper, 13 1/2 x 9 1/2 in. Private Collection.

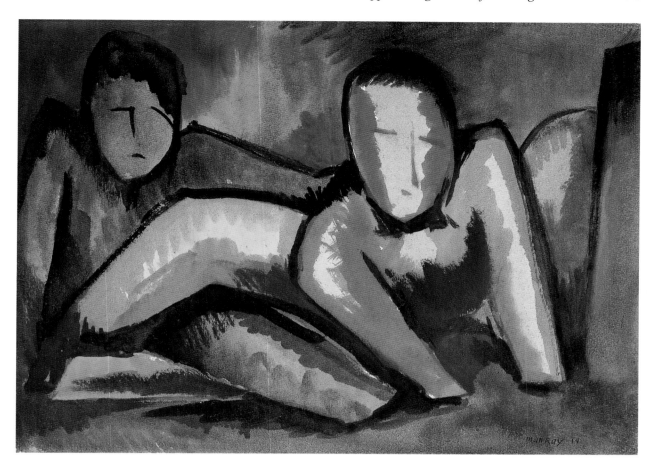

123. *Two Figures*, 1914. Watercolor, 14 x 10 in. Private Collection.

night scene; a tree on the left and a cluster of houses in the distance are silhouetted by the light of a bright and full summer moon.

Although Man Ray would soon resolve "never to allow any primitive motive to influence [his] work,"[16] in 1914 primitive art was still a very important source of inspiration. This is nowhere more apparent than in his painting *Totem* (fig. 125). Gail Levin, a scholar of American art who wrote about this painting in the context of primitive art, described it as "a pastiche of such American Indian wood carvings as Zuni War Gods and Northwest Coast Indian totems, such as could be seen at the Brooklyn Museum and the Museum of Natural History."[17] Totemic imagery does indeed

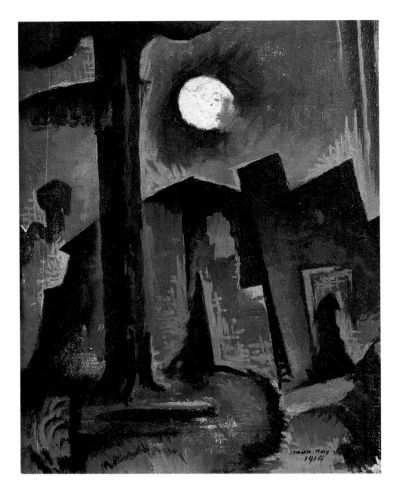

124. *Moonlight Landscape*, 1914. Oil on canvas, 13 x 10 in. Private Collection.

figure prominently in the makeup of this picture: surrounding the large, towering head in the center of the composition is a dark rectangular frieze, which observant viewers will notice is populated by an alignment of crouching, distorted figures, not unlike the carved and painted totems traditionally placed before the tepees and houses of Native Americans. Another reference to the American West can be discerned in the form of the quiet, rambling landscape that appears superimposed on the chest of the dominant central figure. Whereas these are perfectly viable and accessible sources for Man Ray, until now it has not been noticed that the large, truncated figure in *Totem* more closely resembles the monumental volcanic stone carvings from Easter Island, huge heads (some thirty-six feet high and weighing up to fifty tons) that were propped up in the soil and positioned with a view of the sea. Man Ray would have known about these artifacts from a variety of popular publications, for they had been a subject of fascination ever since they were discovered in the eighteenth century.

Man Ray's heightened political awareness in this period coincided with a thoughtful reexamination of painting's more formalistic qualities—from both a historical and a modern perspective—resulting in a radical departure from his earlier work. To this end, he was led to investigate the various solutions offered to this problem by the art of the past, looking for inspiration to Byzantine and Early Renaissance sources. These historical precedents, combined with his pacifist reaction toward the outbreak of war in Europe, were among the most significant factors to influence the selection of technique and subject in Man Ray's most important politically inspired pictures of this

125. *Totem*, 1914. Oil on canvas, 36 x 24 in. Collection of the Tokyo Fuji Art Museum, Tokyo, Japan.

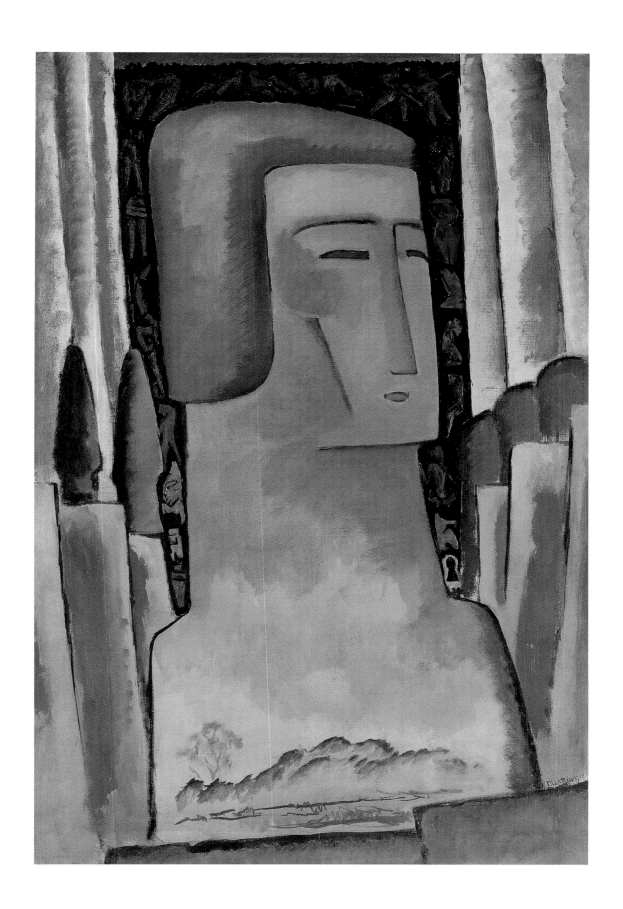

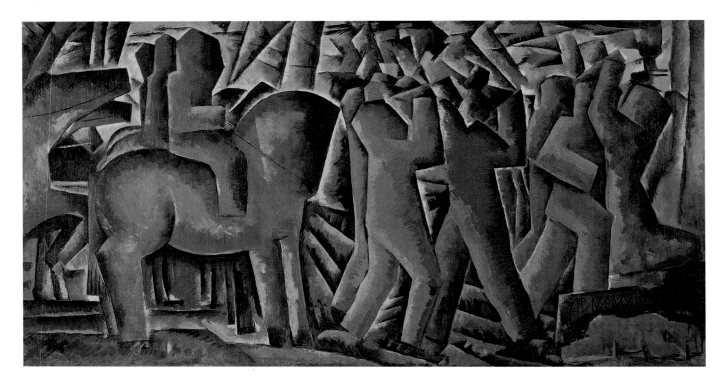

126. *War (A.D.MCMXIV)*, 1914. Oil on canvas, 37 x 69 1/2 in. Philadelphia Museum of Art, A. E. Gallatin Collection. Photo by Graydon Wood, 1998.

period: *War (A.D.MCMXIV)* (fig. 126) and *Madonna* (fig. 127).

Measuring just under six feet in width, *War (A.D.MCMXIV)* remains Man Ray's most monumental Cubist composition. Modeled almost entirely with a palette knife, the figures are rendered as overbearing, cylindrical forms—their severe geometry and lack of articulation recalling, again, the sculpture of Adolf Wolff (fig. 36), while their positions and frozen postures seem to imply the frustration and inevitability of their struggle. Locked into never-ending combat with their oppressors, these soldiers are rendered as mere automatons, mindlessly engaged in their struggle, obeying without question the futile orders of their commanders. According to Man Ray, the title of this painting was suggested by his wife, who was dramatically affected by the war in Europe, for her parents were still living in the country of her birth—Belgium, which, despite its position of

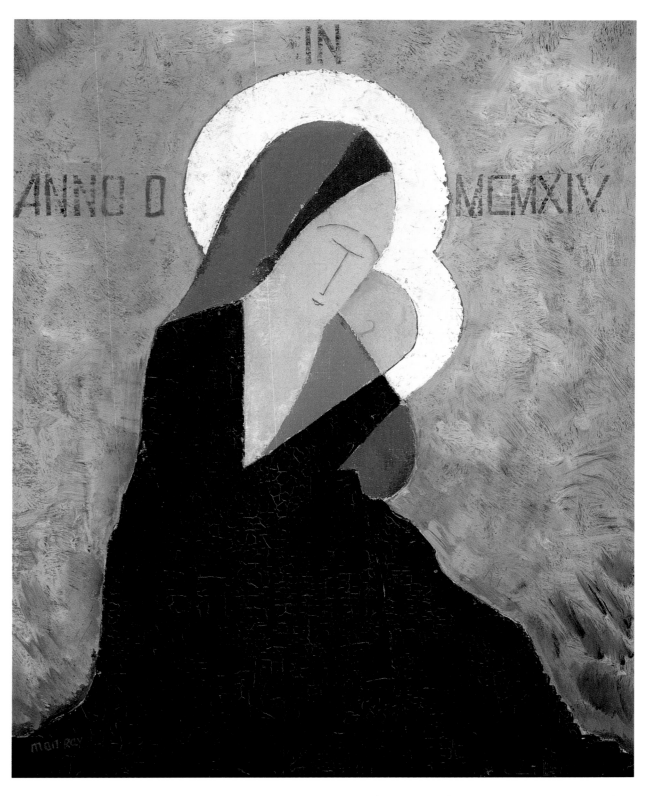

127. *Madonna,* 1914. Oil on canvas, 20 1/8 x 16 1/8 in. Columbus Museum of Art, Ohio; Gift of Ferdinand Howald.

neutrality, was ruthlessly invaded by German troops in August of 1914. In the lower right corner of this painting, Man Ray dated the picture by adding the Roman numerals A.D.MCMXIV, employing stencil-styled letters that were later overpainted and replaced by a more calligraphic inscription. While Lacroix may have suggested the title, the prominent dating of this picture may have been inspired by Frank Stephens's "A.D. 1914," a poignant antiwar poem that was published in the October 1914 issue of *Mother Earth*.[18]

The near-six-foot horizontal expanse of this painting was determined by a space Man Ray had to fill in his living room, and its inordinate scale and positioning reminded him of the kind of problems that must have confronted the wall painters of the Renaissance. In emulation of these earlier masters, he prepared the canvas with a base of fish glue and plaster dissolved in water, to provide a matte and chalky surface reminiscent of the intonaco used in fresco.[19] Even the subject, he later explained, was inspired by reproductions he had seen of Paolo Uccello's famous battle scenes. But rather than accept and apply the recessional effects created by a strict application of the rules governing Renaissance perspective systems—of which Uccello was a well known practitioner—Man Ray rendered the figures and background shapes in his painting as if they were mere reflections of one another. The blunt, angular, and unarticulated forms given to the horses and soldiers are echoed in their surrounding environment, creating a uniform surface tension that serves to reassert the painting's inherent physicality.

Such a formalist reading of this picture is precisely what Man Ray would have wanted. Some fifty years after painting it, the artist tried to explain the reasons behind its production in his autobiography. "I myself had been fascinated by the problems of perspective," he wrote. "In my paintings, however [as opposed to his architectural studies], I never forgot that I was working on a two-dimensional surface which for the sake of a new reality I would not violate, or as little as possible." He then even claims to have consciously renounced his own geometric style, due to its unavoidable volumetric suggestion: "I decided, after finishing this series, to work in a more two-dimensional manner, respecting the flat surface of the canvas."[20]

Obviously the formalist vocabulary that informs these statements was derived from the critical writings of the 1940s and 1950s, the majority of which were developed to explain the theoretical basis for Abstract Expressionism. This rhetoric would have been familiar to Man Ray at the time when he wrote his autobiography in the early 1960s. Nevertheless, no matter how derivative his wording may have been, the immediate evolution of Man Ray's paintings in the 1914–1915 period indicates that he was indeed in the process of initiating a change in style, one that would eventually find theoretical support in a fully developed and remarkably early formalist program. In *Madonna* (fig. 127), a subject derived from Italian painting and an image based on the appearance of Byzantine religious icons, Man Ray has not only retained the frontality and flatness for which these historical precedents are well known but, for "the sake of a new reality," has intentionally amplified them. The madonna, child, and background of this picture are painted entirely with a subdued, opaque pigment, intentionally left unvarnished so as to resemble the chalky plaster surface of fresco. The painting's inherent two-dimensional qualities are reinforced in the form of a bold Roman-numeral inscription arranged in a cruciform format around the madonna's head, indicating the year in which the picture was made.

Shortly after it was completed, Man Ray sub-

128. *Study for Madonna*, 1914 (mounted on catalogue for the Daniel Gallery, 1916). Ink on paper, dimensions unknown. Photo courtesy Lucien Treillard, Paris.

titled this painting *In Mourning*, but the relationship of this image to the war in Europe can only be understood when we examine two preparatory studies (figs. 128, 129), ink drawings that were both later used for catalogue covers.[21] In the first of these sketches, we can see that the tapering black shape used to describe the madonna's arm in the finished painting was actually derived from the neck of a large black cannon, while the halos given to the figures are taken from the billowing, cloud-like formations issuing from the cannon's smoldering mouth. "Perhaps the idea was to express my desire for peace as against war," the artist later remarked. "There were no religious intentions."[22]

The tendency to increasingly flatten the internal forms of his compositions—which one author likened to "a slowly deflating tire"—was further intensified through the artist's use of collage and collage-related techniques.[23] Man Ray was first exposed to the possibilities of this new medium in his viewing of the Picasso/Braque exhibition at 291, held from December 9, 1914, through January 11, 1915. Included in this exhibition were the most recent works by these celebrated Cubist painters, thereby presenting the American public with the most current developments in modern French art: Braque's pioneering *papier collés* and Picasso's daring and expressive use of collage.[24]

Not surprisingly, American critics found the works in this exhibition utterly incomprehensible. But the technique of collage produced an effect that coincided perfectly with Man Ray's formalist

129. *Study for Madonna*, 1914 (mounted on catalogue for the Daniel Gallery, 1916). Ink on paper, 12 3/16 x 7 in. Francis M. Naumann Fine Art, New York.

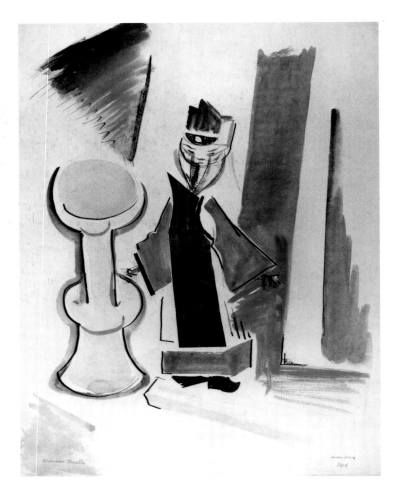

130. *Chinese Theatre*, 1914. Watercolor on paper with collage, 17 x 13 1/2 in. Kunsthaus, Zurich.

concerns: the flat, rectangular pieces of paper and pasted cloth reasserted the pictures' surface tension, forcing a reading of all elements within the pictorial field in relation to the inherent two-dimensional quality of the paintings or drawings. Man Ray was especially impressed by the lack of detail: "The stark-black charcoal lines of Picasso with here and there a piece of newspaper pasted on seemed very daring—rather incomprehensible though."[25] Whether or not he fully understood the implications of this new medium, the artist quickly proceeded to make use of it.

Man Ray's first documented use of collage probably occurred in December 1914, in the form of a response to the Picasso/Braque exhibition. To the surface of a small watercolor entitled *Chinese Theatre* (fig. 130), he glued a scrap of thin gold metallic paper, boldly accentuating the torso of a small Asian figure. The subject of this collage was probably related to a commission the artist received in these years to remodel a theater in New York, a project that was never realized because his design for a large folding screen was considered too expensive to construct.[26] For the element of collage in this watercolor, it is significant to note that the piece of paper Man Ray employed was irregularly cut and fails to align with the contours of the figure to which it is attached. Consequently, it appears as if the artist salvaged an incidental scrap of paper, the refuse of an earlier cutting project that would normally have been discarded, unlike the carefully cut and shaped geometric pieces of paper and oilcloth used by Picasso and Braque. The artist's incorporation of this scrap curiously resembles his childhood experience of making quilts and blankets from the scraps of his father's tailoring business. As we shall see, however, this technique would soon find an even more significant application in the artist's future work.

For Picasso and Braque, the use of collage and

collage-related techniques coincided with the earliest developments of what is today called Synthetic Cubism, the second and more formally abstract phase of the movement. The earlier practice of subjecting a particular motif to analysis gave way to a system whereby the motif itself was created, or "synthesized," from a combination of artificial materials. Newspaper fragments, stamps, calling cards, oilcloth, wallpaper, and other inherently flat materials all contributed to the formation of this new style. In his paintings, Picasso usually affixed these materials directly to the surface of the canvas, while Braque and a number of other so-called decorative Cubists (such as Juan Gris) preferred to depict them illusionistically. From the time of his viewing of the Picasso/Braque exhibition at 291, Man Ray frequently experimented with the basic principles of both techniques.

An untitled and lost still life of 1914 (fig. 131) records the extent to which the artist had already absorbed the lessons of Synthetic Cubism. An opened, shallow box with flat octagonal inserts has been depicted illusionistically, so as to make it appear as if the materials themselves were physically flattened and affixed to the surface of the pictorial field. Just as Picasso and Braque frequently employed illusory devices derived from the tradition of *trompe l'oeil,* Man Ray has so skillfully painted a number of details in this picture—such as the label (from a Chinese restaurant or laundry service) and crumpled corners of the box—that the depicted elements are interpreted as visually analogous to the objects they represent.[27] Despite the pronounced degree of illusionism, the artist has provided certain details that openly proclaim the painting's inherent abstraction. Two circular objects, for example, interact with the flat elements of the composition so as to defy a logical explanation of their physical properties. The ring

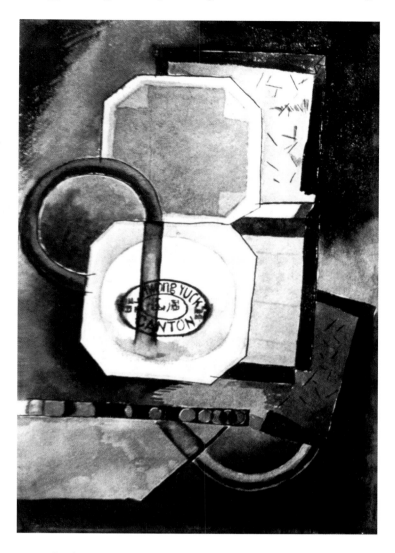

131. *Still Life,* 1914. Watercolor on paper, 14 x 10 in. Lost or destroyed (photo: Artist's Card File; see document C).

on the left appears to be overlapped by the octago-
nal shape in the center of the composition, indi-
cating opacity. This ring, however, continues to
form the shape of a cane, which, in turn, overlaps
the octagonal box, indicating translucency (a read-
ing reinforced by the fact that one can see the let-
ters on the label through the cane). Additional
visual anomalies contribute to the painting's ab-
stract qualities, but it is predominantly the large

octagonal and square shapes in the center of the
composition that serve to reinforce the picture's
inherent flatness and sense of physicality.

As we shall see, in the years that follow, Man
Ray would continue to experiment with a variety
of media and techniques to develop a methodical
and systematic means by which to express what
he increasingly came to call "an art of two di-
mensions."

# SIX

---

## THE ART OF PAINTING IN TWO DIMENSIONS, PART 1: The Paintings, Drawings, and Watercolors of 1915

In January of 1915, Man Ray and Adon Lacroix released *A Book of Divers Writings* (fig. 132), a lavish folio-sized publication that was designed and illustrated by Man Ray and featured examples of Lacroix's prose writing and poetry.[1] The edition was limited to only twenty copies, each bound in dark paper with covers decorated with an original drawing surmounted by a collaged strip of paper on which Man Ray's signature appeared. Shortly after the book appeared, they sent a copy to Alfred Kreymborg, in hope that he might help to publicize their efforts. In an accompanying letter, the collaborators explained that this publication represented "the epitome of our work since our partnership [began]." They further described the book as being composed of "elements from the animal, vegetable and mineral kingdom—leather, paper and paint." Finally, they concluded their description with an almost mythical interpretation of their creative efforts: "Its spiritual elements are equivalents for fire, earth and water," they wrote. "They are in terms of love, life and art."[2]

*A Book of Divers Writings* contained a play and six poems by Adon Lacroix. Years later Man Ray described his wife's writings as "calm and lyrical," although he confessed that her poetry could be "rather awkward at times," a quality he regarded as "sincere and fresh like the paintings of naïve artists."[3] Following the title page, the first image in the publication was an ink-drawn portrait of Lacroix, where the poet's dark black eyes and furrowed lower lip give her an expression of deep concern and worry. This may have been precisely the emotional state Man Ray wanted to convey, for his wife was terrified by the fact that the war had broken out in Europe and she had not heard from her family in Belgium for six months. The most poignant poem in the publication is "War," which, like Man Ray's painting of the previous year (fig. 126), describes soldiers as mindless combatants

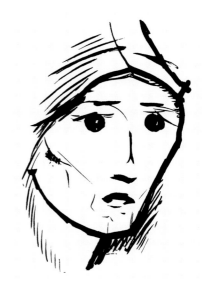

132. *A Book of Divers Writings*, 1915. Arensberg Archives, The Marian Angell Boyer Library, Philadelphia Museum of Art. Photo by Eric Mitchell, 1982 (cover photograph courtesy Virginia Zabriskie Gallery, New York).

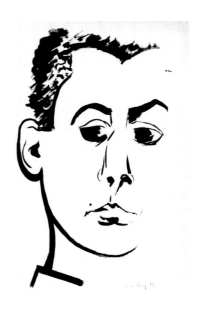

who blindly follow orders and, without thought, mindlessly destroy their fellow man. The poem was accompanied by a line engraving of *War,* which, in an inscription below the image, was acknowledged as having been copied "from a painting."

The illustrations Man Ray made for this publication were all intended to serve as visual enhancements to his wife's writings. Thus the play "Pantomine" was accompanied by a fine-line pen-and-ink drawing representing actors performing on a stage, and a prose piece describing the sound of a robin in the wood, which Lacroix compares to a love call, is appropriately illustrated by a decorative border in brush-and-ink containing, at the top, the image of a bird in a thicket and, at the bottom, a pair of reclining entangled lovers. But perhaps the most succinct merger of verbal and visual interests in this publication is the drawing that Man Ray made to accompany Lacroix's poem devoted exclusively to the subject of trees: "Wild black gracefully shaped trees," as she describes their majestic presence, "standing upright and rising toward the sky." The drawing is comprised of nothing more than a grouping of dark vertical masses, a configuration clearly meant to allude to the shapes of the trees themselves, while at the same time—utilizing an approach similar to that employed in the landscape painting that was made in the same year (fig. 100)—Man Ray has ingeniously spelled out the separate letters of the poem's title: TREES.

The last drawing to appear in the publication was a self-portrait (fig. 133), an ink-and-brush drawing made in the same style as the portrait of Lacroix and clearly meant to reflect the dual and equal credit assigned to each collaborator. In contrast to the drawing made of his wife, however, Man Ray has rendered his own facial expression to suggest a more pensive mood. He may very well have been possessed of a more optimistic disposi-

tion than his wife, for he had many reasons to be encouraged about his prospects for the future, in respect not only to his private life but to his career as well.

It was probably in the early months of 1915 that Alanson Hartpence introduced him to Charles Daniel, a saloon owner who had taken an interest in modern art. Daniel operated a hotel and café with his brother on the corner of Ninth Avenue and Forty-second Street in Manhattan. Several artists and poets who frequented his establishment, including Hartpence, encouraged him to begin purchasing examples of the art that had interested him. In the years that followed, Daniel's collection grew quickly, and he soon had to open a small office on West Forty-seventh Street as a place to store his paintings and a convenient location where he could arrange to meet those American modern artists whose work interested him.[4]

But it was at his café—over beers and a sandwich—that Man Ray first met the future art dealer, the artist recalls. Hartpence, who had been advising Daniel on his purchases, had convinced the café owner to open a gallery and offered his services in the position of its director. With this future enterprise in mind, Hartpence sought out the work of modern painters who were not already represented by other galleries, and it was for this reason that he arranged a meeting with Daniel and Man Ray. Hartpence asked the artist to bring along a small example of his work, probably to test Daniel's reaction. The saloon owner reacted favorably and purchased a painting for twenty dollars, thus beginning the provision of necessary financial support that would continue throughout Man Ray's years in New York.

For the time being, Hartpence could only promise Man Ray that once Daniel opened the gallery, he would try to arrange for a showing of his work—that is, if by that time he had produced

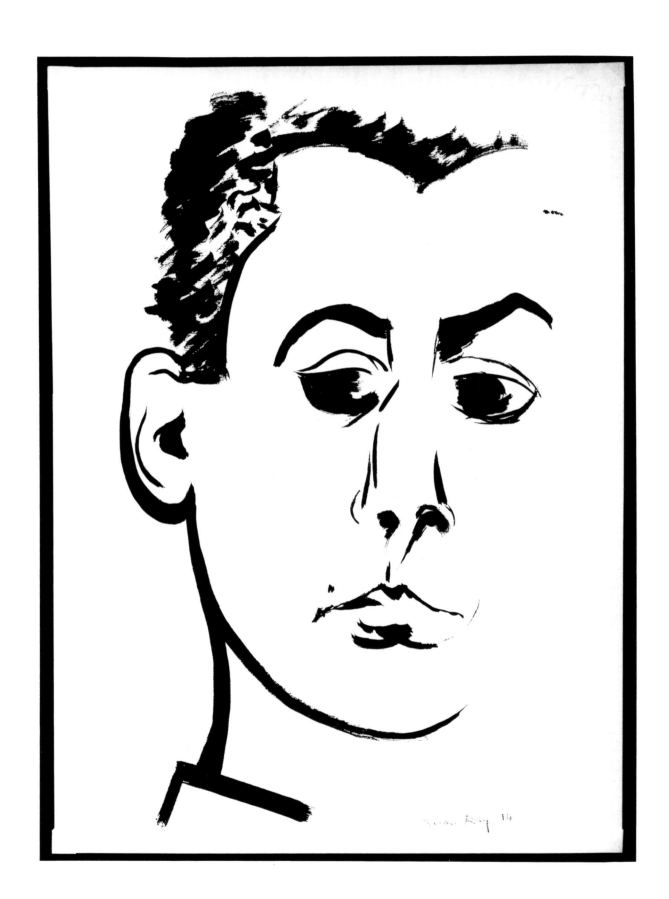

133, facing page. *Self Portrait*, 1914. Ink on paper, 25 x 19 in. Private Collection. Courtesy Robert Miller Gallery, New York. Photo courtesy Studio Marconi, Milan.

enough paintings for an exhibition. The prospect alone must have sent the artist back to Ridgefield with renewed enthusiasm. The new paintings, he might have imagined, should not only reflect his commitment to modern art but, collectively, should form a coherent body of work that would, at the same time, proclaim his independence and individuality.

In the spring of 1915, Man Ray made several trips into Manhattan to sell copies of his and Lacroix's *Book of Divers Writings*. One copy sold to Charles Daniel, and three were purchased by Alfred Stieglitz. Eventually, over the course of the next few months, a host of important individuals within the world of art in New York—dealers, artists, art critics, collectors—would acquire copies: Hamilton Easter Field, N. E. Montross, John Weichsel, Joseph Stella, Paul Haviland, Alvin Langdon Coburn, John Quinn, Walter Arensberg, Arthur Jerome Eddy, and others.[5] Kreymborg, we will recall, was sent a copy shortly after the publication appeared. It was a promotional effort that paid off, for the poet had been recently hired by the *Morning Telegraph* to write a series of human interest articles, and he decided to devote one of his alternate-weekly full-page columns to the couple and their impoverished living situation in Ridgefield (fig. 134).[6] Kreymborg focused his article, subtitled "They Live on Twenty-five Dollars a Month and Enjoy It," on how the couple managed to live happily on so little money. The lead illustration was a reproduction of Man Ray's *Portrait of Adon Lacroix* as it appeared in *A Book of Divers Writings,* as well as photographs of Man Ray working in his studio (a detail of fig. 45), Lacroix glancing through a book in her library (a detail of fig.

135), and a rare view of the cottage these artists shared.

Kreymborg reported that they paid a rent of eight dollars monthly on their four-room cottage and spent no more than ten dollars a week for everything else, although, as he pointed out, they could easily live on half that amount. He seized the opportunity to say that Man Ray's best poem was "Hieroglyphics," which had appeared in "a little volume" that was "a tribute to his wife" entitled *Adovism* (*sic,* by which, of course, he meant *Adonism*: fig. 99). From *A Book of Divers Writings,* he singled out Lacroix's "War" as a work of special significance, for, as he explained, its author was Belgian and very much concerned over the well-being of her parents in Europe. He provided readers with a complete reprint of the poem in his column. "It is, however, as a painter," Kreymborg concluded his article, "that Ray makes his principal appeal." A year earlier, he reported, the artist turned the garret of their cottage into an art gallery. "That garret exhibition was a notable little pilgrimage for those who braved the adventure," he explained. "But one does not have to travel to Ridgefield to see Ray's work these days. There are always several examples on display at the Daniel Gallery at 2 West Forty-seventh street, just off the avenue."

"Ray's paintings, like the life he leads out in these Jersey hills," Kreymborg continued, "express a joy in the mere existence from day to day. . . . There is in addition a lyrical element, a love of rhythm, of quiet, song-like rhythm that is placid and self-sufficient. And his compositions are inventions, often with an allegorical meaning, if you will—not an arbitrary meaning necessarily, but one that the beholder may create for himself." After commenting on Man Ray's somber use of color, which he compared to the artist's relaxed manner of speech and working method, Kreymborg made a few comments that reveal he had dis-

(Copyright, 1915, by The Lewis Publishing Co.)

# MAN RAY AND ADON LA CROIX, ECONOMISTS

## They Live on Twenty-Five Dollars a Month and Enjoy It

### By ALFRED KREYMBORG

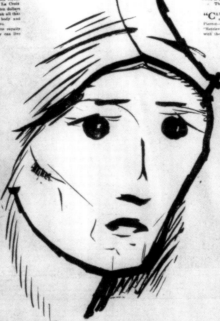

*A head by Man Ray.*

"MONEY," writes that glorious institution the Funk & Wagnalls New Standard Dictionary, "is any material that by agreement serves as a common medium of exchange and measure of value in trade." In the days of the primitives, cattle, pieces of cloth, trampum, beads, everything was money. If your neighbor owned a three-legged mule you fancied, and you owned a green-eyed daughter that he fancied, the pair of you exchanged commodities. The mule and your daughter—also a mule, because of her stubbornness in agreeing to the pretty transaction—were "money."

To-day, of course, money means gold, silver, copper, nickel, greenbacks—or, more definitely, the salary your employer pays you for the service of your body and brain. The two-step five-dollar bills you receive on Saturday night are money to you; your body and brain and cheerful smile are money to him. You must live. You need food to keep your body going a while longer. He must live. He needs food to keep himself going. Hence the mutual bargain. Also you need shelter for the warmth of your body against the rather unpleasant breezes of Winter. So you pay of your Greenbacks so many per month for two rooms and bath in a certain kind of domesticity called the landlord. He, too, requires a little shelter, as well as food; so you strike a bargain with him. If you have no money, you have no food and shelter. You live on air—for a few days, at least. And living on air is rather a precarious undertaking. As poor old ——— ———, the moonlight, who committed suicide, used to say: "Rockefeller and Morgan will own the air some day. They will sell it to you, throw breathes for a nickel. And then you'll pay, they'll turn off the air."

In other words, there are folk in this cheery world who own things, and there are those who don't. Those who don't have to pay those who do in service. And it those who do pay those who don't with munificent packages of favor, as it is called.

THERE is, however, a class of mortal we call dreamers. They refuse to pay for their food and service in the ordinary way. They refuse to let their bodies. They let their dreams, it is true, but that is a more honorable profession, as the saying is. At least their bodies and the will that reins their bodies are free to roam the hills. They don't have to report at a hardwood desk at such and such an hour. Dreams are not to be tangled in that way. Not that dreamers do not have to strike bargains! Far from that—everybody alive has to strike some sort of a bargain. But they possess this advantage over the rest of us mortals: they have a name for their profession, a pretty what for their part of a bargain with you, art. You can their picture, or their poem or their symphony; you call the thing you buy art; they call the thing they buy appreciation, a higher economics has been put into execution. And both sides are proud. Which is well. Pride is the great rules of destinies: Hence a transaction in pride is the highest of transactions. It ranks with the trade (as the move and can indulge in. It is godly. And that is why those who have the honor and glory of their acquaintance revere those two youthful economic-dreamers, Man Ray and Adon La Croix.

THEY have been married for over a year. They live in a frame home just across the Hudson River and not far from that amusement resort, Palisade Park. To be explicit, on the heights of the picturesque town of Ridgefield, N. J. Their frame houses houses four rooms, but they are four of the happiest rooms in creation. Three of the rooms are on the ground floor, the fourth, a garret, invites you up to a glorious view of Nature by means of an old-fashioned stairway. The view extends for miles and miles to the north, west and south, beyond the Hackensack River and the Orange Mountains to Paterson. One cannot look beyond a horizon, and it is only the horizon that prevents the adventurer from ...

*The home of the Rays.*

... coming farther. The home is fairly isolated from the surrounding community. Even if one goes into a detailed account of the way to the Man Rays, you would doubtless lose your way. And yet they are less than an hour's trip from New York. And in the heart of Nature, with all its solitude, its healthfulness, its inspiration, and the unlimited opportunity for work undisturbed. For the privilege of that home, that view, those opportunities, the Man Rays pay the humble sum of $8 per month!

AND nowhere could you ask for more intimate comfort and cheer than that afforded by the dwellings and decorations. The walls, to be sure, are tastefully decorated with some of Ray's own paintings. These are among the most imaginative being done by the younger Americans of to-day. What furniture, ready-made, the sitting room lacks not display, was made by Ray from the rude material that the Mother supplies to any one of a willing mind and a pair of average arms and shoulders. And so with the bedroom. The kitchen, with its gracious old stove, represents the other side of the department of necessaries.

... the dollars a week"! At any rate, we are certain that Man Ray could refuse the argument. He and Adon La Croix live on considerably less than ten dollars a week! And they eat and drink all that humans require to keep the body and spirit going another day or two. A couple of humans can live royally on a dollar a day. But one can live adequately on half that. As a matter of fact, an inquiry into the expenditures of the Rays—if one were of an inquisitive turn and did not take advance for granted—would discover the phenomenon that they live comfortably on an average of twenty-five dollars a month, or three hundred dollars a year. Of course, they are unable to indulge in luxuries or waste, but do you have to have luxuries? A pound of candy occasionally, and an ice cream soda, I suppose, but beyond these necessary items, what need is there? Most of us make a necessity of luxury instead of making a luxury of necessity.

RECENTLY, Adon La Croix expressed her problem of housekeeping by stating: "Thirty dollars a month assured would make us millionaires." Think of it, ye specialities! And that means meat once a day—as your humble empire can reach through his own dollars a week, and they never look starved. As a matter of fact, they are as healthy and cheerful looking a couple as you could meet anywhere along Madison avenue, New York City. Ray has a sufficient income through the honest labor of his hands to meet the grocer and candlestick maker, and the rent of the time he can devote to his dreams. And Adon La Croix to boot.

Once in a long while you meet a man or woman who seems to be successfully coping with her dreams. Approach the average man and what is his tale of woe. "Well, if I could only get away from that after work of mine I might take up my hobby of collecting butterflies. Or if I could only get away for an hour or two a day. But I would lose my position if I tried. And then there is my wife, Rachel. Rachel needs her support. And our expenses are so high. Our flat off Riverside Drive costs us sixty dollars a month. And what with our servant to pay and the high rate of food expenses and laundry and electric light bill, and fares and weekly amusement excursions and all the rest of our trying circumstances, my seventy-five a week scarcely see the end of the month. It is simply impossible to ...

WITH two books came an explanatory note: "We have just concocted an epitome of our work since our partnership. It is a book—a folio made up of cloaspan from the animal, vegetable, and mineral kingdom—leather, paper, and paint. Its spiritual elements are equivalents for fun, earth and water. They are in terms of love, life and art."

The poem on "War" is as follows. It is of special significance that Adon is Belgian—and that she has not heard from her parents in over six months:

　　Flag-speckled with the folded of solders.
　　You are an intended symbol of courage.
While cowardice lies sprawled across your space,
　　While we must forward to our doom,
　　　　　Rag-flag,
While we simple soldiers must forward to our
　　brothers—
　　　　　To our doom.

　　Hell—hell—fires of hell—we cannot rest,
　　Mothers and sisters we cannot spare,
　　Our own fathers and brothers—all—all
　　　　　March on!
　　　　　Passing in review.
　Before our superiors high and haughty,
　　March with head low—
　　Hall! Poor arms! Feet!
　Hell—hell—fires of hell—we kill them all—
　Not one is left, but those commanding
　Our own kin lie stretched right and left,
　　On—on—we must not stop.
　　　What does it matter now—
　We can march and march and nevermore stop,
　Our brains are on fire—our hearts are rent,
　We have no names—there is no end in sight.

### THE WARNING

*By Philip L. Wahlberg*

Sings the fool, "The world's all pleasure,
I'll drink to-day and gain full measure."
Oh, fool! The world has more of sorrow,
Heed the Book—you die to-morrow.

Mrs. Tinkins was taking her son to school for the first time, and after impressing the schoolmaster with the necessity of his having a thorough education, finished up by saying:

"And he must be learns Latin!"

"But, my dear madam," said the schoolmaster, "Latin is a dead language."

"All right," said Mrs. Tinkins; "he'll want it. He's going to be an undertaker."

*Adon La Croix.*

We most ear-ves-tite brains are on fire. There is nothing left but the doomed flag. That rag-flag by our side."

"CAPRICE" is an exquisitely imagined and beautiful tribute to Pierrot—a little too long for quotation. "Retrieval" is a fine hymn permeated with the philosophy of Ridgefield:

"Dominions full of glitter and noise of women and men moving about in unsoothing contrast. A voice in the air faintly choking is heard singing a heartrending air in the grime of the room, while women in dazzling attire and amazing contrast moves about like satished stars in the heaven. It sings—the voice of possible joy, and O' much of the sorrow of those who are there and those who are not—and all the universe is included in it, so large is the meaning of that faintly choking voice singing a heartrending air. And it seems to all that this voice we have heard many times full of clamor—often subdued—it is true—but purposing and contrasting. To the voice of the few inspiring, the many—a voice in the air clamoring out the truth."

Other books that Man Ray has printed as an appreciation of and tribute to his wife are a series of prose pieces, the most notable of which is a direct sketch called "The Book." Ray has likewise published some of his own work as well as occasional pieces by others of the younger American element. The best of his own work is included in a little volume called "Adonism," a set of prose and free rhythm numbers "Spring" represents the stirred longing of youth for achievement.

"In these dull tentative days when every little plant timidly pokes her head out of the ground and quickly withdraws again if one observes her—tumultuously our desire reaches toward the full-blown Summer, the love-steeped, confident Summer when nothing is denied and nothing withheld."

INTRUSION is an aristocratic as opposed to a democratic point of view. It would not find favor with Whitman or Ponchel—but it is interesting as a landscape:

"I was moving over a Winter landscape—
The snow-drifts were of mountain ranges.
And the frozen pools great white deserts.
With fury and there where the water still rippled, no ocean.
And the black trees huge sky pillars.
Their branches tapering away as if in temperature—
And nowhere a sign of life or of movement outside of myself.
Then as I hung over the whole like a god who had just created it—
Suddenly a human figure entered on the scene—
As if an ink blot had fallen on this page—
　　　And marred it."

The best of Ray's poems is "Hieroglyphics." It is at once a landscape and an interpretation:

　The snow has fallen—
　A great white page lies open—
　Naked black trees rise out of the white landscape.
　Words written in black on white—
　　A dead language,
　Clothed men and women are walking about—
　Words forming themselves in black on white—
　　A living language.
　People are killing each other—
　Words are being written in red on white—
　　A dying language.
　The sun appears—words are written in fire on blue—
　　Life and death relax—
　O silent smiling language of eternity!"

*Man Ray.*

IT is, however, as a painter that Ray makes his principal appeal. A year ago he turned the garret of his home into an art gallery! What don't they do out at Ridgefield? Even music, kind friends! Both Man and Adon, if you please, play the guitar, and the latter sings as well. That garret exhibition was a notable fitting in pilgrimage for those who braved the adventure, But one does not have to travel to Ridgefield to see Ray's work these days. There are always several examples on display at the Daniel Gallery at 2 West Forty-seventh street, just off the avenue. Everything finds its way to the great clearing house in time.

Ray's painting, like the life he leads out in those Jersey hills, expresses a joy in the mere existence from day to day. Life is good enough just as it is. It is up to oneself whether one subtracts from life or adds something to it. Ray is content with the adding to. There is so much playground for the imagination in a world that must full that a dreary routine of commercial activities, as it were, that no doubtless is too busy with the somber and serious. Ray is not a humorist. He is slow-going, slow of speech, slow of method. There is plenty of time to do things. Nature is in no hurry. And the days are longer especially when one is young. And there is so much freedom to be enjoyed.

BUT there must be form to one's madness. Even the weirdest individuality must find restraint, must be caged within some walls, when it comes to putting him on paper or canvas. Hence, each of Ray's expressions are inclosed inside some definite plastic mode. Looking at some of these, one is tempted to ask the old phrase: "Is form freedom or freedom form?" The question is an old and unanswerable as the one concerning the hen and the egg.

To be sure, Ray's work betrays certain definite influences. He owes much to Cezanne, the Byzantine and Egyptian, but most particularly to Picasso and some of the Futurists. All artists, as such, have influences, especially during the earlier years. When the influences are of such far-reaching significance and value and so indispensable, so to speak, as the great moderns, the sum total of attempted criticism would have to admit that such influence is for the best. Whether or not Ray has as yet contributed anything new to art at large is perhaps too early to say—for me at least. Or whether one might even venture to predict that he will contribute something. It would take a more keenly sensitive intellect than mine, one more thoroughly grounded in abstract artistic and with more of the artist eye to make such proclamation. However, I can say this much: his canvases are among the most significant, the most pleasure-

able and the most inviting to joyous concreteness that are being painted in America. Even without the added greatness of contribution, the above is in itself something—to me.

EVERYBODY is constantly in need of instruction. Unfortunately, most of us are through learning at an early age. It is a self-evident axiom that one is never too old to learn, and also that you cannot teach an old dog new tricks. If you are not obsessed with old fogies, or for that matter any other ism, you have something to learn from Man Ray and Adon La Croix, dreamers. Even if all your dreams have come true, you have need of further dreams and their working out to make the remainder of your existence bright. And dreamers are valuable only in proportion as there are other dreamers to enhance them.

We have a world to live in on the one hand and ourselves to live in on the other. The problem is how to live ourselves without in the least compromising too far with the world. One earns one's bread, one's right is to day and to morrow, from the world. One can only earn one's self from one's self and all that one can have from the world to one's self. The body must live in order to survive. But if the self is to be liberated to keep the body alive, for better that the body hand itself as soon as possible.

So, if you have a strong predilection for reducing butterflies—if that is the true and substance of your deepest self—give up your job as a bell clerk and get down to real work, and especially so if you have a wife to support and to support you. The Man Rays do in on twenty-five dollars a month. They have a home, food, and all the luxury of realizing their dreams and of dreaming new ones with the coming of each new day. Perhaps you can break their record. I, for one, am sure that you and your better half can do all these things on twenty-five dollars a month! All you need is a little of that rare entity: courage. Here's luck to you!

134, facing page. "Man Ray and Adon La Croix, Economists," *Morning Telegraph,* New York, March 14, 1915 (microform copy). The New York Public Library, Astor, Lenox and Tilden Foundations.

cussed with Man Ray the formal program behind the paintings, although he confessed that, as a poet, he was not in a position to fully grasp its more complex theoretical significance. "Each of Man Ray's expressions are enclosed inside some definite plastic mode," he said. But he immediately expressed a word of caution, explaining that too strict an adherence to any specific mode of operation might result only in restricting an artist's creativity. "Looking at some of these [paintings]," the poet noted, "one is tempted to ask the old paradox: 'Is form freedom or freedom form?' The question is as old and unanswerable as the one concerning the hen and the egg."

Kreymborg's reservations were doubtlessly based on his experience with the modern poetry movement, where the traditional elements that had determined the formal structure of verse were being systematically rejected. Indeed, knowledge of Man Ray's "definite plastic mode," as he called it, led Kreymborg to question whether or not Man Ray had made an important contribution to the new art. "It would take a more keenly sensitive instinct than mine," he explained, "one more of the artist['s] eye to make such proclamation." After having declared his ignorance in this regard, he boldly concluded: "I can say this much: his canvases are the most inviting to joyous resposefulness [*sic*] that are being painted in America."

Exactly what paintings Kreymborg saw in Man Ray's garret is difficult to say, for his description is vague. With the exception of *War* (which he

notes was reproduced in *A Book of Divers Writings*), he mentions no specific painting by title. In the course of his evaluation of Man Ray's paintings, Kreymborg identified the artist's influences as "Cézanne, the Byzantine and Egyptian, but most particularly . . . Picasso's and some of the Futurists." A reference to Byzantine art leads us to suspect that he probably saw Man Ray's *Madonna* (fig. 127), but the references to Cézanne and Picasso are too imprecise to permit a secure identification of other paintings. It is hard to imagine, however, that he would not have shown Kreymborg some of the canvases he was working on at the time, and we do have an approximate idea of what kind of paintings those were.

In the first few months of 1915, Man Ray consciously broke from what he called the "romantic expressionistic" style of his earlier work. He explained the moment of this transition in his autobiography:

I changed my style completely, reducing human figures to flat-patterned disarticulated forms. I painted some still-lifes also in flat subdued colors, carefully choosing subjects that in themselves had no aesthetic interest. All idea of composition as I had been concerned with it previously, through

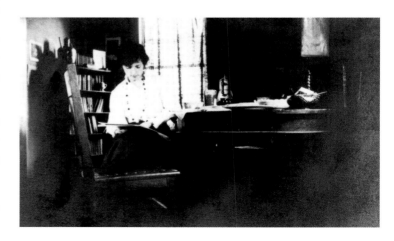

135. Adon Lacroix working in her study, ca. 1914. Photograph, 2 3/4 x 4 3/8 in. Collection of Constance and Albert Wang.

136. *Still Life*, 1915. Oil on canvas, 13 1/2 x 9 3/4 in. The Addison Gallery of American Art, Phillips Academy, Andover, Mass.; Gift of Matilda S. Bing.

my earlier training, was abandoned, and replaced with an idea of cohesion, unity and a dynamic quality as in a growing plant. This I felt more than actually analyzed.[7]

Despite the intuitive approach he claimed, Man Ray's new paintings were actually tightly organized compositions, images with unified and cohesive design elements that, among other things, indicate a careful and well-thought-out analysis of internal form. As in the case of his paintings of the previous year, this change in style may have been worked out through a series of still life paintings. Apparently, the ability to freely arrange a group of inanimate objects into any desired order or position was a procedure that—in and of itself— duplicated the artificial process of arranging a picture space and thereby represented a preliminary step in the realization of an abstract composition. Moreover, in the painting of still lifes (as opposed to portraits and landscapes), the artist must have felt at greater liberty to distort the appearance or physical properties of the objects he represented, for, unlike subjects inspired directly from sources in nature, man-made objects could, he may have reasoned, have been fabricated in a variety of differing shapes and materials. Taking the liberty of arranging five of these still lifes into an order that reflects their increasing tendency toward abstraction (figs. 136–140), we may very well be following the same steps Man Ray himself took when painting these pictures.

The first painting (fig. 136) continues to exhibit an approach reminiscent of the artist's earlier "romantic expressionistic" style. A yellow candlestick and a tall brass-colored vase are positioned against a dish and placed on a chair, mimicking the arrangement of still life elements in his earlier *Indian Carpet* (fig. 110). Here, however, the view is more tightly focused, and various details are

brushed onto the surface of the canvas with greater freedom, lending the whole composition a more graphic quality. The compression of space is accentuated by a sharp black vertical line that runs along the right side of the brass vase but continues artificially downward and over the surface of this vessel, providing a predominantly decorative effect.

The next still life in this sequence is sharply more minimal in appearance (fig. 137), even though some of the same still life elements reappear, positioned, again, against the same triangular chair back that had appeared in several earlier paintings (figs. 110, 136). But here the level of abstraction is intentionally heightened, for the tall tapering vase (this time with animal figures painted on its surface) is rendered in proper perspective, its lip and circular mouth seen from above (although a roughly spherical object is placed into it). By contrast, the octagonal plate next to it is presented frontally, seemingly propped up and held into position by an open book in the immediate foreground. Not only does this plate parallel the picture plane, but it is given a translucent quality, so that the base of a stylized candlestick that appears directly behind it is completely visible. This candlestick is, in turn, rendered without dimensions, and it seems to artificially hover in space, for the ground plane upon which it rests is nothing more than a horizontal line that defines the lower portion of a dark rectangle in the center of the chair back. The result is an image where a suggestion of depth is sharply diminished, for we are forced to comprehend the plate, candlestick, and background as enmeshed within the same planar dimension, a conjunction of foreground and background space that reflects the inherently two-dimensional qualities of the canvas surface.

In the next painting in this sequence (fig. 138), a relatively straightforward, naturalistic rendering

137. *Still Life,* 1915. Oil on cardboard, 18 1/2 x 12 1/4 in. Philadelphia Museum of Art; A. E. Gallatin Collection.

138. *Untitled/Still Life,* 1915. Oil on paperboard, 18 1/2 x 12 1/4 in. Smithsonian American Art Museum, Washington, D.C.; Gift of Flora E. H. Shawan from the Ferdinand Howald Collection.

of still life elements on the left side of a composition (although they, too, barely suggest a spatial reading) is bluntly juxtaposed with an even more flatly rendered frontal elevation of objects on the right. Two vases and a fan-like shape appear positioned on a tabletop; one of these vases floats above the other objects in the composition and is shown in vertical bisection, while the dark-colored circular jar to the left casts a pronounced shadow on the far wall, upon which hangs a painting that depicts a figure with upraised arm. If the picture ended here, there would be nothing exceptional about its design. But visually grafted to the right side of the painting—on the same canvas surface—there appears a wide vertical strip containing an ambiguous casting of still life elements. With the information provided, it is not clear whether Man Ray conceived of these objects in plan or elevation, but either way, their sharp juxtaposition with the more naturalistic details on the left is a purely abstract conception—abstract in the sense that the painting was not meant to be read as an accurate illusory representation of something else. Rather, as the artist must have reasoned by now, the painting must be understood first and foremost for what it is: a flat canvas surface, which may also contain a variety of shapes and colors, echoing (but not precisely duplicating) the design and configuration of elements found in our natural environment.

This or a similar line of reasoning must have contributed to the sharply reduced imagery and abstract design in the next still life (fig. 139), where a bowl, covered jar, and candlestick are so thoroughly fused to the frontal plane of the painting that viewers are compelled to read all forms within the image as an integral part of the canvas surface. All shading and modeling have been eliminated, and, by means of translucent, overlapping forms, even the recessional edges of the tabletop are

incorporated within a reading of the painting's two-dimensional framework. The white rectangle at the far wall serves to unite the various elements of the composition; its vertical edges diametrically bisect all three of the still life components, interpenetrating their flat-patterned shapes at the same planar dimension, fusing their separate identities into a coincident reading of the whole. It is the painting's pronounced degree of abstraction—combined with the fact that it probably represented Man Ray's first significant departure from his earlier work—that caused him to give this painting the title *Arrangement of Forms No. 1.*

The last still life in this sequence—which, unfortunately, has been lost and is known in only a black-and-white photograph (fig. 140—is also called *Arrangement of Forms.* Within the thicket of lines and shapes that comprise its internal components, we are barely capable of distinguishing the still life elements. The result is to have genuinely approached the limits of pure abstraction. Only the curved lines in the picture can be recognized as having been derived from the outer contours of jars and vases of varying shapes and sizes. A number of these objects appear in only fragmentary form, their outer profile graphically rendered against the flat canvas surface. The dark tapering shape just to the right of the center is bisected vertically and appears to be attached to (or to emanate from) a rectangular shape to its left.

Not all elements within this composition, however, were derived from such clearly recognizable sources. In order to determine the accurate circumference of the circular shape at the very base of the picture, for example, the artist first established its approximate geometric center, a precise point that he marked with a white dot encircled in black. Not only was this mark retained in the final composition, but it was emphasized by the addition of white radial lines. This tendency—to pre-

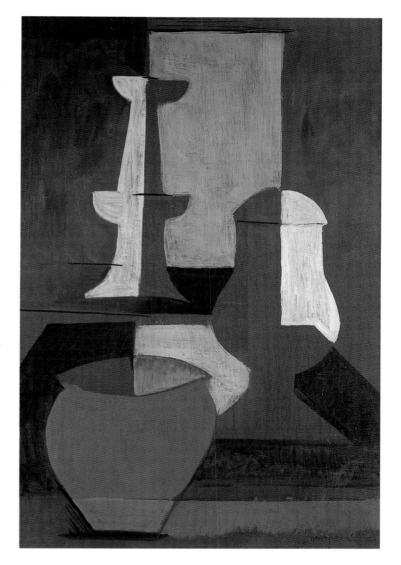

139. *Arrangement of Forms No. 1,* 1915. Oil on canvas, 18 1/8 x 12 3/16 in. Present whereabouts unknown (formerly Estate of the Artist, Paris; sold Sotheby's London, March 22, 1995).

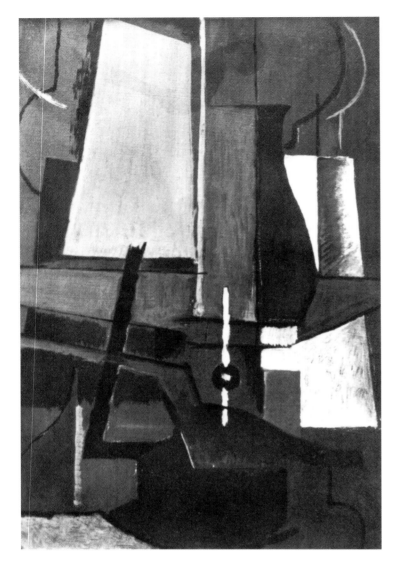

140. *Arrangement of Forms,* 1915. Oil on canvas, 18 x 12 in. Lost or destroyed (photo: Artist's Card File; see document C).

serve the lines of construction in his drawings and paintings—is a working method the artist may have retained from his experience as a mechanical draftsman. But no matter what its origins, this procedure represents an important early step in the artist's eventual acceptance and development of a more mechanical and, fundamentally, more abstract imagery.

In the very period when Man Ray began to systematically explore the development of this new "flat-patterned" style, he submitted two paintings—an unidentified still life and his *Madonna* (fig. 127)—to a group exhibition held at the Memorial Art Gallery in Rochester, New York, the first public showing of his work within the context of vanguard American painting.[8] Most of the artists represented in this show had already established their reputations in New York galleries, including Arthur B. Davies, Charles Demuth, James Daugherty, William Glackens, Walt Kuhn, Maurice Prendergast, Morton Schamberg, and Charles Sheeler. By and large, reviewers of the show were intrigued by the new modern paintings, as were the well over five thousand visitors to the exhibition. But it appears that only one critic made mention of the works by this little-known painter from Ridgefield: "Man Ray's small 'Madonna,'" wrote an anonymous reviewer in the *Post Express,* "is softly colored, but in stiffness the face and figure out-Byzantine the most Byzantine mosaic ever created."[9]

A few days after this show closed, another exhibition, which included many of the same artists, opened at the Montross Gallery in New York.[10] Although in the business of selling art since 1885, the gallery only began to show the work of progressive artists after the Armory Show. Its owner and proprietor, Newman Emerson Montross, explained that he wanted to show the new artists while their work was still available. "I con-

sider it wiser to open the door from inside," he explained to a reporter in 1914, "rather than to have it thrust in your face from outside. . . . The only safe rule is to give the men who have something fresh to say a chance to say it whether it disturbs us or not."[11] Fortunately, such a frank disregard for adverse critical reaction was a position maintained by a number of the more adventurous galleries, and this courageous attitude made it possible for artists like Man Ray—who were relatively unknown but committed to the new art—to exhibit their work before the comparatively large gallery-going public of New York. Upon invitation, Man Ray sent three paintings to the Montross Exhibition: *War (A.D.MCMXIV)* (fig. 126), *The Rug* (fig. 119), and an unidentified landscape, as well as a number of drawings. "The show produced a little flurry in art circles," the artist later recalled, mainly, he said, because critics reacted unfavorably to American artists whose work openly displayed the influence of progressive European art.[12]

While the Montross show was still on display, Man Ray prepared an ink sketch for *The Ridgefield Gazook* (fig. 141), a single hand-printed sheet (folded to form four pages) that is dated March 31, 1915.[13] The contents of this proposed publication are so radical and bombastic in spirit, they reveal that Man Ray had not abandoned his anarchist beliefs, even though he was becoming increasingly dedicated to his activities as a painter. Reproduced on the cover is a drawing by Man Ray of two insects engaged in the act of mating, captioned "The Cosmic Urge—with ape-ologies to PIcASSo." The remaining contents are devoted primarily to parodies of his friends Adolf Wolff ("Adolf Lupo"), Adon Lacroix ("Adon La+"), Hippolyte Havel ("Hipp O'Havel"), Manuel Komroff ("Kumoff"), and Alfred Kreymborg ("A. Kreambug"). Other than a casual reference to the Czech anarchist

Joseph Kucera ("Mac Kucera"), however, the only portion of this publication referring specifically to anarchist activities is a poem entitled "Three Bombs," illustrated by Man Ray and allegedly written by Wolff. The poem consists of nothing more than a series of blank lines, two exclamation marks, and a sequence of seemingly arbitrarily distributed letters, all of which are enveloped by the smoke of three sizzling explosives placed in a dish, flanked by accompanying knife and fork, located below the poem. While the literary contribution of this poem is best left unarticulated, the three bombs are undoubtedly a reference to the three young anarchists from the Ferrer Center who were killed in July of 1914 when a bomb they were preparing blew up accidentally.[14] Wolff knew the three young men and immediately after their deaths dedicated a poem to their memory, but he was best known in anarchist circles for his design of a bronze urn that was used to contain their ashes.

Since *The Ridgefield Gazook* was produced in the very period when Man Ray was most actively involved in the development of his "flat-patterned" style, it is difficult not to speculate that he might have considered his formalist concerns such a radical departure from conventional painting as to constitute a visual expression of his anarchist philosophy. Whatever his motives, we can be fairly certain that Man Ray must have looked forward to prospects of becoming a recognized and accomplished painter in the new modern style. As the year progressed, he would venture closer and closer to pure abstraction, without ever actually crossing the threshold. At first glance, for example, three similarly patterned charcoal drawings from 1915 (figs. 142, 143, 144) appear to contain no semblance of a recognizable subject. It was only when one of these drawings was acquired by the Museum of Modern Art in 1954 that the artist identified the origin of these mysterious waves and undulating

141. *The Ridgefield Gazook,* 1915. Ink on paper. Destroyed (formerly Arnold Crane Collection, Chicago, Ill.).

Clockwise from top right:

142. *Untitled/Ridgefield Landscape,* 1915. Charcoal on paper, 24 1/4 x 18 3/4 in. The Museum of Modern Art, New York; The Riklis Collection of McCory Corporation. 924.83.

143. *Untitled,* 1915. Charcoal on paper, 24 3/8 x 18 3/4 in. The Museum of Modern Art, New York; Mr. and Mrs. Donald B. Straus Fund. 288.58.

144. *Untitled,* 1915. Charcoal on paper, 24 1/4 x 18 3/4 in. (?). Lost or destroyed (photo: Artist's Card File; see document C).

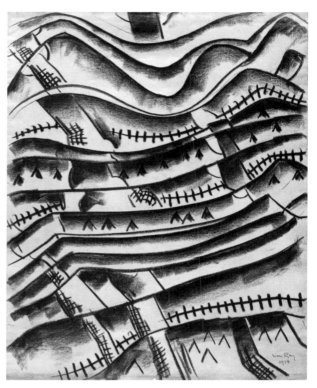

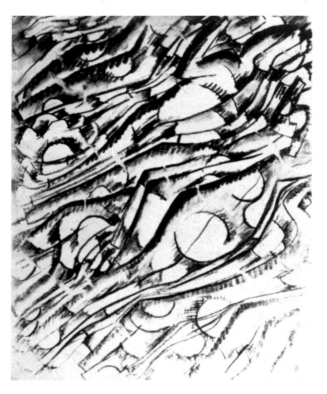

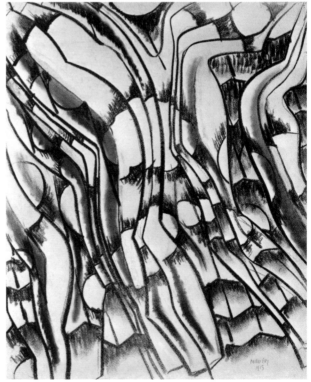

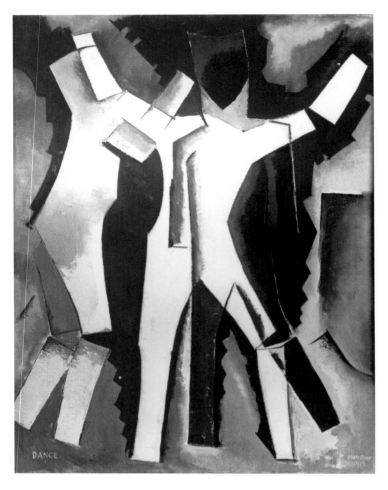

145. *Dance*, 1915. Oil on canvas, 36 x 28 in. Present whereabouts unknown (sold Sotheby's New York, November 13, 1997).

lines. The drawings were "based on human forms after studies in life classes (1912–13)," he wrote, "intended for a large painting, but never carried out."[15]

No matter how removed the imagery in his paintings and drawings was from the objects that inspired them, Man Ray was not willing—at least for the moment—to completely relinquish his subject, even if the subject were disguised to the point of being completely undetectable. Of course, in the years when abstract art was in the earliest stages of its development, it was not uncommon for artists to think in these terms. Initially, even the pioneer abstractionists warned their fellow painters of the dangers inherent in the total elimination of subject. "Today the artist cannot confine himself to completely abstract forms," wrote Kandinsky in 1912; "they are still too indefinite for him. To confine oneself exclusively to the indefinite means depriving oneself of possibilities, of excluding the purely human element. This weakens one's means of expression."[16] On this very point, the Cubists were even more adamant. "Let us admit," wrote Gleizes and Metzinger in 1913, "that the reminiscence of natural forms cannot be absolutely banished; not yet, at all events. An art cannot be raised to the level of a pure effusion at the first step."[17]

Although Man Ray certainly would have been familiar with these warnings, it is unlikely that they would have been among the issues that concerned him most in this period. Rather, as we shall see, his interests were increasingly directed to a search for the most appropriate means by which to visually represent all the arts: not only painting, sculpture, and architecture but also music, literature, and dance. It was probably with these thoughts in mind that he began the painting *Dance* (fig. 145), the portrayal of what at first appears to be three dancing figures in animation. Closer inspection reveals that

the two figures in the immediate foreground—one painted white with upraised arms, the other maroon-colored with arms by its side—were actually meant to be read as multiple visions of the same dancer. This intention is confirmed by the fact that these figures share the same crest-shaped head, and their bodies are rendered as if fabricated from a translucent material, making it possible for their separate identities to be read through one another. As several critics would later note, the unusually flat shape given to the figures makes them resemble the paper cutout patterns used by seamstresses and tailors, an intuitive though insightful observation in light of the fact that Man Ray's father had earned a living as a tailor.

It was probably at some point during the summer of 1915 that Man Ray was informed that his first one-man show at the Daniel Gallery was scheduled for the fall. It may have been in anticipation of this exhibition that he prepared his largest canvas of that year, *Black Widow* (fig. 146), a painting that in vertical orientation approximates the dimensions of *War (A.D.MCMXIV)* (fig. 126). Years later, Man Ray recalled that it was the large and impressive modern paintings by European artists that he had seen at the Armory Show that prompted him to begin work on a larger scale. "It gave me," he recalled some fifty years after seeing this influential exhibition, "the courage to tackle larger canvases."[18] The inordinate size of this particular painting, however, may have been more directly inspired by his growing concern with acknowledging and reinforcing the inherent flatness of the canvas surface. For him, as for the Abstract Expressionists who would come to this same conclusion some forty years later, oversized canvases not only defied association with the conventions of the easel tradition, but their sheer physical expanse also suggested an obvious rapport with the flat planar surface of their support.

Whereas fresco painters were naturally aware of these problems, not since the Renaissance had a contemporary artist become so thoroughly preoccupied with such formalist concerns.

It may have been for these very reasons that Man Ray first called this painting "Invention-Nativity," as if to imply, perhaps, that the painting represented the birth of a new approach or technique.[19] Indeed, in certain passages, the work represents the artist's first incorporation of details derived from mechanical forms. Although the dominant image in this picture consists of a large black headless figure—painted in the "flat-patterned," unarticulated style of his earlier work—a long, maroon-colored translucent form, which appears to have been traced from the outer contours of a lathe-turned mechanical object, prominently overlaps this figure in the fashion of a casually discarded template. A slight variation of this shape reappears on a smaller scale in the background, where it is superimposed on a series of abstract, rectangular elements, which, because of their varying colors and patterns, resemble a selection of cloth samples or incidental swatches of fabric, items that the artist would have been familiar with from his father's work. Additional references to the profession of tailoring abound in this picture; the dark, blue-gray form (or piece of simulated fabric) on the upper left is defined by a serrated edge, as if cut by a pair of seamstress's pinking shears, a detail that is echoed in the prominent diamond pattern located along the right edge of the picture. Moreover, the unusually wide cast given to the legs of the large black figure suggests that its shape may not have been intended to represent an actual figure at all but, rather, that its vaguely anthropomorphic shape was only meant to represent a portion of material to be used in the making of a suit or a pair of pants. This reading is reinforced by the thin white lines that serve to

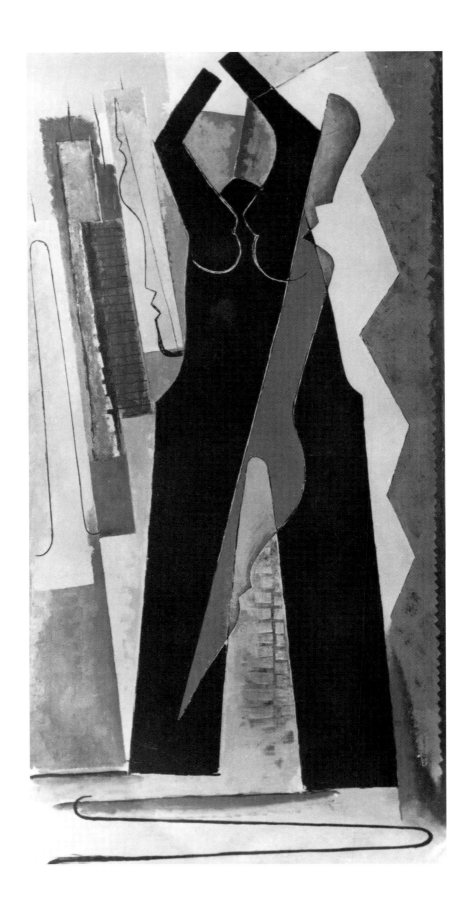

146, facing page. *Black Widow* or *Nativity*, 1915. Oil on canvas, 72 x 34 in. Private Collection, Europe. Photo courtesy Lucien Treillard, Paris.

separate the upraised arms of this shape from the trunk of its body, for their imprecise rendering (they have been painted with a dry brush) closely resembles the soap or chalk marks applied temporarily to fabric by tailors, in order to indicate the specific points or areas of material that still must be either cut or sewn in the making of a given garment.

A small drawing that has been identified as a preliminary sketch for this painting (fig. 147) was probably in actual fact made sometime after the painting was completed. Entitled *Couple with Cat*, the ink-and-pencil sketch shows two opaque headless figures standing next to a black cat; in the place where the two figures overlap, Man Ray has created a void, an empty space that describes the periphery of a blank, faceless figure. This figure reappears as the central motif in a small gouache study on paper from 1915 entitled *Promenade* (fig. 148), the study for a painting that would not be completed until the following year (fig. 153). The subject of *Promenade* may have been inspired by an earlier watercolor of the same title painted in 1912 that represents a fanciful portrayal of amorphically distorted nudes strolling to and fro in a nebulous environment, in the position of sleepwalkers, dazed somnambulists in a dream state.[20] The more abstract conception of the 1915 gouache prevented such specific figurative associations. The only indication of a subject is provided by the manner in which the artist has positioned the legs of the central figure. In spite of their pronounced degree of stylization, these limbs are given the

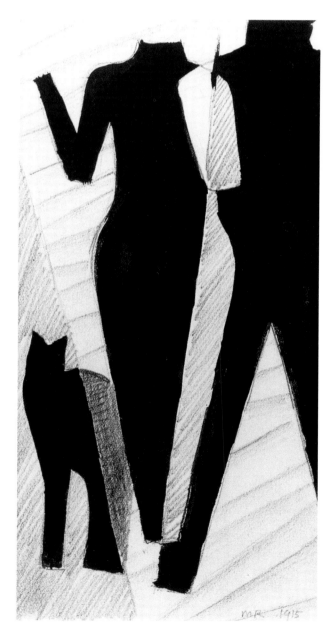

147. *Couple with Cat*, 1915. Ink on paper, 18 x 9 in. Collection of Lucien Treillard, Paris.

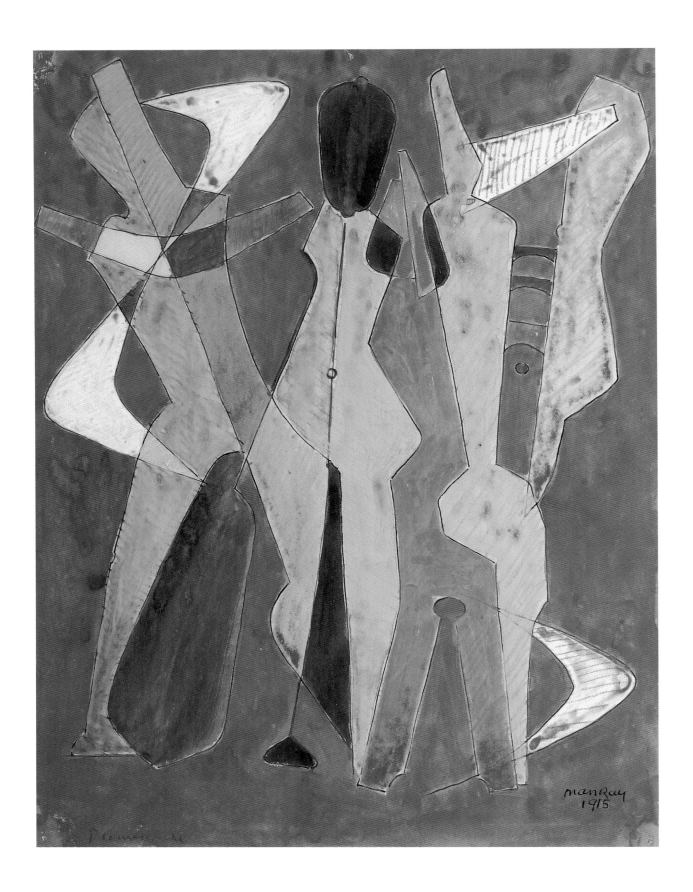

148, facing page. *Promenade,* 1915. Gouache on paper, 10 1/2 x 8 1/4 in. Present whereabouts unknown; formerly Estate of the Artist, Paris (sold Sotheby's London, March 22, 1995).

appearance of extension and retraction, as if to provide the suggestion of a relaxed forward advance—in the fashion of a walk, or promenade. But in the case of this gouache, it is obvious that the subject was of secondary consideration to the purely pictorial concerns that motivated its creation.

The central figure, for example, which appears to have been fashioned after the design of a dressmaker's mannequin, shares such a strong formal rapport with the flanking figures and surrounding environment that its precise spatial position becomes virtually impossible to identify. For example, the line that defines the right torso of the figure on the left overlaps the central figure at the waist and continues down to establish the position of its inner thigh. The final extension of this line, then, serves to simultaneously describe the lower leg position of both figures, an intentional alignment and interpenetration of form that eradicates the recessional effect created by normal perspectival overlap. Even though the figures are distinguishable from the red ground that surrounds them, they are joined to its planar dimension by virtue of this overlapping technique, which is applied consistently throughout the image and causes us to read the shapes as if we can see through them; they seem like thin filters of translucent plastic or glass, with few or no volumetric associations.

The relationship between figure and ground is one that was of special interest to Man Ray in this period. If the ultimate goal was flatness, he may have asked himself, and if one dealt with figuration of any kind, no matter how abstracted, then how could one avoid the sensation of depth that would naturally be suggested by any awareness of foreground and background space? One solution

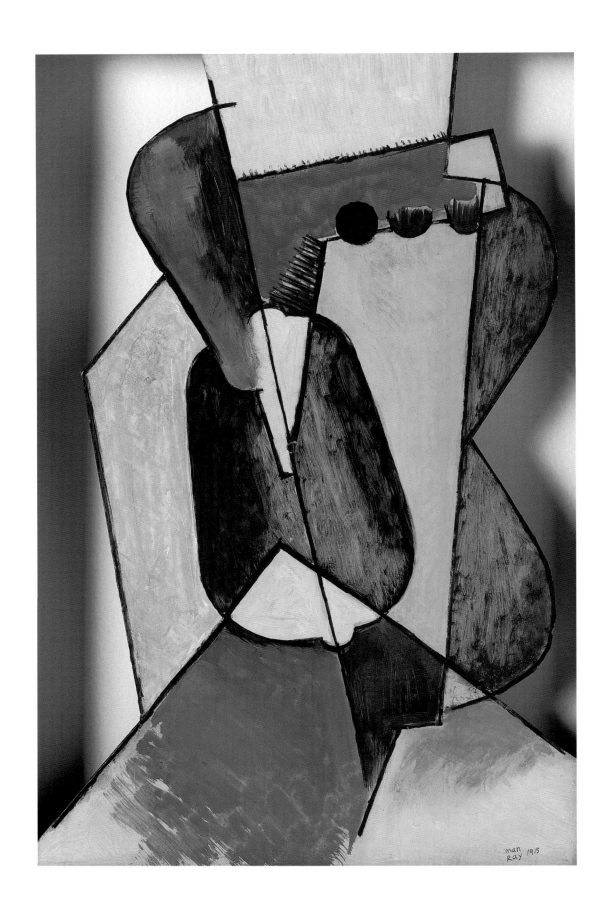

149, facing page. *Cut Out*, 1915. Oil on cut cardboard, 17 11/16 x 11 5/8 in. Collection of Paula and Joel Friedland. Photo courtesy of Joel Friedland.

would be to literally cut it out. That is exactly what Man Ray did in the small painting he appropriately entitled *Cut Out* (fig. 149). Abstract, overlapping shapes—at least one of which was borrowed from the head of the central figure in *Promenade*—are painted in oil on the surface of a thin, rectangular board, which in turn has been trimmed of its flanking background and suspended within the confines of a shallow, open-backed frame. Thus, the figurative elements of the painting hang freely, silhouetted against whatever wall surface the painting happens to be hung from.

In 1915 Man Ray composed a poem entitled "Three Dimensions," which, considering its title, is best understood within the context of his ongoing formalist concerns. The poem appeared in *Others,* a magazine founded by Kreymborg and the wealthy poet and art collector Walter Arensberg, who also provided the initial financial backing for the review.[21] In his autobiography and in later interviews, Man Ray mistakenly said that the title of this magazine was meant to imply his personal detachment from its activities—that is to say, only *others* would be allowed to contribute.[22] The first six issues of this self-proclaimed "magazine of the new verse," as it was subtitled, were published in Grantwood, New Jersey. The last of these numbers contained contributions by Marianne Moore, Carl Sandburg, William Zorach, and others, as well as a single poem each by Adon Lacroix and Man Ray.[23] Lacroix's "Intimacy" is a work in two parts, wherein an allusion of encroaching darkness is juxtaposed with an impression of impending death. By contrast, Man Ray's "Three Dimensions" avoids such emotionally charged

subject matter and, instead, presents a carefully constructed, rhythmic verse, describing a view of houses seen in the dead of night:

THREE DIMENSIONS

Several small houses
Discreetly separated by foliage
And the night —
Maintaining their several identities
By light

Which fills the inside of each —
Not as masses they stand
But as walls
Enclosing and excluding
Like shawls

About little old women —
What mystery hides within
What curiosity lurks without
One the other
Knows nothing about.

In the first stanza of this poem, Man Ray provides his readers with the visual impression of a cluster of houses viewed in complete darkness, distinguishable from one another only by the radiance of their interior light. The second stanza tells us that these houses are seen not as three-dimensional bodies—possibly an allusion to the title—but rather as a series of impenetrable walls, separating their mysterious interior spaces from that of an unknowing but curious outside world, a separation he compares to the effect of shawls worn by old women. This element of apparel, he suggests, serves to symbolically shelter these women from the perils of their immediate environment, of which, he concludes, "One the other / Knows nothing about."

At the very moment when Man Ray was in the

process of formulating the theoretical basis for his paintings, he met the famous French artist Marcel Duchamp, then best known for the scandalous reception accorded his *Nude Descending a Staircase* when it was shown at the Armory Show in 1913. Duchamp came to America in June of 1915 and was a guest for a brief period at the home of Walter and Louise Arensberg. In the fall, Arensberg brought Duchamp out to the Ridgefield colony to meet some of the artists there. At first, Man Ray recalled, communication was difficult, for he spoke little French and Duchamp no English. Although Lacroix occasionally served as translator, the language barrier offered little resistance to their growing friendship, one that would continue for well over fifty years, throughout the remaining years of their lives. After their meeting, we can be fairly certain, Man Ray would have followed the activities of his French friend with some interest. With his anarchist leanings, it is likely that he would have been attracted to Duchamp's iconoclastic pronouncements, which appeared with some regularity in the art magazines.

Even before the two artists met, Man Ray may have seen two examples of Duchamp's work in an exhibition of modern French art that was held in March 1915 at the Carroll Galleries in New York.[24] Both versions of his *Chocolate Grinder* (Arensberg Collection, Philadelphia Museum of Art) were shown there and severely criticized for their mechanical execution. On this basis, one reviewer even questioned their artistic merit: "It is not easy to take seriously as 'Art' two such mechanical evocations," wrote William B. McCormick in the *New York Press,* and he went on to describe these paintings as "two engines for grinding chocolate impeccably drawn and colored as if for a machinery catalogue."[25] But it was the precise, mechanical quality of these works that would have appealed most to Man Ray, who was then employed as a part-time draftsman in a commercial firm.

During the late summer of 1915, Man Ray spent most of his time preparing for his forthcoming show, placing finishing touches on canvases and assembling a portfolio of reproductions that could be used for the catalogue and circulated for publicity purposes. Not being satisfied with the results of professional photographers, the artist decided to prepare these reproductions himself. "Translating color into black and white," he explained, "required not only technical skill but an understanding as well of the works to be copied. No one, I figured, was better qualified for this work than the painter himself."[26] So he acquired a camera and the necessary filters and proceeded to prepare several photo albums of his work, which he distributed to dealers and a number of interested friends. "I studied [the taking of pictures] very thoroughly," he later recalled, "and after a few months I became the most expert photographer for reproducing things!"[27]

At some point during the summer months, Man Ray's work managed to attract the writing talents of Willard Huntington Wright, brother of the Synchromist painter Stanton Macdonald-Wright. At that time, Wright was art critic of *Forum,* a highly respected literary journal (which, coincidentally, was then published by Mitchell Kennerly, the very collector who first purchased a painting by the artist). It was in his general review of modernist exhibitions in New York that this important and influential critic first mentioned Man Ray's paintings, for which, apparently, he had not yet developed a very high regard. He described two works by the artist that he had seen in a group exhibition at the Daniel Gallery:

> Man Ray shows two works, one of which is quite large. A standing portrait, painted flatly and effectively, exhibits both the good and bad qualities of Gauguin and Manguin, and, in addition, is reminiscent of Munter.

Ray's color is grayish and agreeable—not a mean attribute when one considers the senseless assault on the optic nerves by some of our chaotic modern painters. Of the two works he exposes there is little preference aesthetically, although I prefer the still-life.[28]

It was probably the anticipation of his forthcoming one-person show at the Daniel Gallery that caused Man Ray to cooperate with the critic John Weichsel, who wanted to write an article about the artist and his work. Weichsel, founder of the People's Art Guild, an organization devoted to making the new art accessible to all classes of society, was a regular contributor to *East and West,* a monthly magazine of Jewish art and culture. The article Weischel wrote was exceptionally long and detailed and, when published, was accompanied by ten black-and-white reproductions of works by the artist, beginning with his *Ridgefield Landscape* (fig. 70) and including other paintings and drawings produced over the course of Man Ray's two years in Ridgefield (the majority of which are reproduced in the present volume: figs. 78, 83, 92, 125, 127, 139, 144). At the beginning of his article, Weichsel indicates that he knew something about Man Ray's formalist concerns. "Without denying the artistry, technical and aesthetic, of previously accomplished masterpieces," he writes, "the New artist nevertheless refuses to recognize in them the limit of plastic expression."[29]

Weichsel derived much of his information about Man Ray's theories from an elaborate statement the artist prepared specifically for publication in this article (see document A), a statement that he would revise the following year and publish in the form of a small booklet entitled *A Primer of the New Art of Two Dimensions* (fig. 155). After presenting the entire text of this statement, Weichsel tells his readers that Man Ray omits a very important point from consideration: an ex-

planation of why a formalist approach is so effective. "This form of plastic rendering is effective," he explains, "because man's visual nature is constituted to receive the structure of things in just this natural manner."

Weichsel informs his readers that the illustrations accompanying his article were selected by the artist himself and chosen specifically because they "represent practically every phase of his work." Man Ray had certainly made use of the photographic skills he recently acquired. With these prints in hand, Weichsel proceeds to analyze specific paintings. He describes *Ridgefield Landscape* (fig. 70)—which was here given the title "Landscape Arrangement"—as exhibiting "a love of the lyrics of nature, expressed in charming color and tender modeling and generosity of incidentals." He identifies Man Ray's *Madonna* (fig. 127) as "another example of the incursion of democracy in art" and claims that "its very execution is of the people's primitive heritage." Perceptively, he describes the artist's "Still Life in Two Dimensions"—today called *Arrangement of Forms No. 1* (fig. 139)—as "an effort to embody the logical aesthetics formulated in Man Ray's essay." But he surprisingly describes *Totem* (fig. 125)—in the article called "Interpretation-Life"—as being "obviously an instance of phallic symbolism," a tenuous Freudian analysis that it is hard to imagine Man Ray would have readily accepted.

When this article appeared, Man Ray wrote a letter to Weichsel enclosing a copy of it with marginal comments. Although this marked copy no longer survives, his letter makes it clear that he had mixed feelings about what Weichsel had written. "As a whole the article is stimulating," he writes, "and really helpful in sensing my place in art-movements. It satisfies one's curiosity and gives a chance for mental exercise." In this same letter, he declines an invitation from Weichsel to participate in an exhibition the critic has proposed of progres-

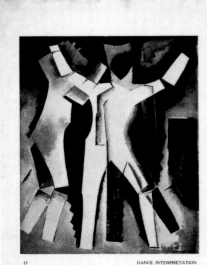

150. *Exhibition of Drawings and Paintings by Man Ray,* 1915. Catalogue,
Daniel Gallery, New York. Collection of Teruo Ishihara.

sive American art to be placed on display in a number of different neighborhoods throughout New York, at settlement houses and other public spaces. "I have decided to keep out," he explains. "I have enough work and attention demanded of me under present conditions. Then again my own studio is not more obscure than the exhibition places you mentioned, and I really prefer to have my things with me."[30] The excuse Man Ray presents is rather curious, for when this letter was written, he was about to have his first show at the Daniel Gallery.

Called "Exhibition of Drawings and Paintings by Man Ray," it opened during the second week of November 1915. The catalogue, which was designed by the artist (fig. 150), listed the titles of thirty paintings, six of which were given the simple title "Study in Two Dimensions," making it clear that the artist wanted to emphasize his formalist concerns. In fact, it was precisely this point that most confounded reviewers of the exhibition, who tended to classify the two-dimensional stud-

ies with the design experiments of an art student. The paintings ranged in date from the time when Man Ray moved out to Ridgefield in 1913 up to examples of his new "flat-patterned" style.

When Man Ray showed up with these works at the Daniel Gallery, they were all still unframed, and Daniel—with limited resources—was naturally hesitant to assume the enormous expense of having so many paintings and drawings professionally prepared for display in the exhibition. The dealer, who years later best remembered the artist for his "marvelous analytical mind," must have been delighted with the ingenious solution proposed by Man Ray.[31] In keeping with his concern for retaining an awareness of an inherent flatness of painting, Man Ray devised a method whereby the canvases were recessed into a temporary wall surface constructed of cheesecloth, making it look as if the works had been painted directly on the surface of the wall.

Man Ray recalled that most reviews of this exhibition were "deprecatory or outrightly hostile."[32] Conservative critics preferred the earlier, more representational portraits and landscapes, which they cited as proof that the artist could paint with skill if he really wanted to. As an example of the opposing extreme, they repeatedly singled out his painting *Dance* (fig. 145)—or "Dance-Interpretation," as it was titled for this show—probably because this work was conveniently reproduced in the catalogue (fig. 150). One critic described the painting as "some tailor's patterns . . . having a gay time," while another not only accused the artist of imitating Picasso and Duchamp but also said the paintings "resemble the work of a drunken patternmaker."[33] An anonymous reviewer in the *New York Sun* can be credited with what were probably the most insightful observations. "Mr. Ray appears to have cut certain shapes of dancing figures from a paper

roughly," he wrote in describing *Dance*. "Then he cut the figures again into careless segments and pasted the whole together in fine disregard of the original shapes."[34] Whether Man Ray constructed this particular work in the fashion described by this reviewer is uncertain, but the analysis is keenly prophetic, for it describes precisely the technique the artist was to use the very next year in the production of his most important painting of this period (fig. 159).

This same reviewer in the *Sun* also thought Man Ray's landscapes noteworthy for their "undeniable charm" but rightly observed that the real purpose of the exhibition was "evidently to test the larger, two-dimensional canvases with the public." In this light, there follows an analysis of *Dance:*

> Our artist, instead of using the four dimensions of Mr. Picasso, uses but two, but art in two dimensions is even more intricate than in four. . . . Picasso is always concerned with form and that thing more than form that gives the fourth dimension, but these dancers of Mr. Ray are of tissue paper thinness. They have width and height only.

This reviewer then notes that this flattening effect can be of some value and proceeds to establish a connection with the art of the past:

> From the mural point of view the two dimensions are theoretically more correct than the four that are used by Picasso. The great success of Puvis lay in his ability to keep his great wall spaces flat. What is fair for classic art is fair for the moderns.

Clearly the most important and informed critical response to this exhibition came from the pen of Willard Huntington Wright, who by this time had

become well established as the most brilliant and articulate defender of modernism in America.[35] Wright had earned this pinnacle of recognition through years of producing articles that are now considered to be the most intelligent and provocative writings on modern art published in this period. By the end of 1915, his writings on art had become known to an even larger audience, for this year marked the appearance of his book *Modern Painting: Its Tendency and Meaning,* a volume that has been rightly described as "the first important American contribution to the discussion of contemporary art."[36] Even though similar acknowledgments were expressed in contemporary reviews of this pioneering study, it has since been criticized for its personal bias toward Synchromism, the American art movement of "painting in pure color," founded in 1912 in Paris by Morgan Russell and Wright's brother, Stanton Macdonald-Wright.[37]

It was doubtlessly Wright's interest in abstract art that initially attracted him to Man Ray's work. We will recall that, on the basis of seeing only two isolated paintings, Wright described the artist's color as "agreeable." Now, after seeing the many works in his one-man show, the celebrated critic found his use of color "most pleasing." In what was ostensibly a review of current exhibitions in New York, Wright's renewed enthusiasm for Man Ray's painting caused him to single out his work more for its potential than for its inherent aesthetic value. Without stating so specifically, he implied through the title of the article—"Art, Promise, and Failure"—that Man Ray's work contained the greatest degree of hope for the future, or "promise," as he put it, in what was then a rapidly growing arena of artists who consciously sought to emulate the most recent advancements in the visual arts.[38]

After commenting favorably on Man Ray's use of color, Wright went on to state that, because the artist's influences could be so easily detected and identified, in his opinion the work lacked a certain degree of resolve. "He is an artist in process," wrote Wright. "There is nothing final about any one of his pictures. He is searching for an ultimate personal expression." Although Wright felt this search would eventually yield positive results, he took the opportunity to say that, for the moment, Man Ray was not yet adequately versed in the formalist tenets that comprise all great art: "I believe Man Ray will take this personal route to good work," he said, "even though at present he is handicapped by an ignorance of the fundamental principles of all great aesthetic expression."

This having been said, the critic then allowed himself a lengthy regression on the subject of those texts that purport to have an understanding of these principles. "What we sorely need," he said, "is a school of instruction in composition, or a book, replete with diagrams, explaining to artists the foundation on which all true art is built, and why." He then condemned every text that already existed on this subject as being "superficial, objective and injurious"; although he named no specific titles—except Clive Bell's *Art,* which he caustically proclaimed "halts on the hither side of the simplest profundity"—he must have had in mind books such as Henry Rankin Poore's *Pictorial Composition* (1903), Denman Ross's *Theory of Pure Design* (1907), or Arthur Wesley Dow's *Composition* (1899, 1913).[39] According to Wright, the authors of these books "mistake pattern for form, delimited spaces for volumes, outlines for lines, balance for composition, surface harmony for organization, and two-dimensional linear sequence for rhythm." Whether right or wrong in his claims, here the erudite critic was prematurely beating his own drum, for at the time of this writing he had already planned the publication of a book on this very subject, to be entitled "Principles of Aesthetic

Form and Organisation." Even though the study never materialized, a good number of the formalist issues he considered essential to the production of all great art were addressed in his book of 1916 entitled *The Creative Will,* a collection of over two hundred and fifty individual "studies in the philosophy and the syntax of aesthetics."[40]

Redirecting his attention to the work of Man Ray, Wright went on to identify what he believed were the artist's immediate influences. He accurately connected some of the smaller canvases to the pre-Cubist production of Picasso, calling the paintings "competent admirations of that great leader"—adding, however, that "they do not possess the stupendous *commodité de la main* that the Spaniard possesses." In other paintings he detected the influence of Picabia, asserting—surprisingly—that Man Ray "has passed beyond him," even claiming that "[Man Ray's] work is more artistic." Wright probably admonished the work of Picabia for the same reasons that earlier had led him to place Kandinsky in a category with "the lesser moderns."[41] From what Wright could ascertain, Picabia must have given the impression that he composed his latest abstractions without any reference to forms in the natural world—in opposition to what Wright's brother and Morgan Russell had consistently followed in the creation of their numerous Synchromies. For Wright, a reliance upon forms in nature was an a priori consideration for all great art, no matter how abstract in appearance. Just as the earlier theorists had warned against the pitfalls of total abstraction, Wright observed that "even in the most abstract of the great painters the form is concrete," asserting further that "colour for colour's sake would result only in paltry decoration."[42] In Man Ray's paintings, however, a dependency upon forms in nature was still clearly in evidence. "He is still treating his form from an objective standpoint," Wright noted. "He

deals with nature, distorted, simplified, arranged and flattened."

After some general remarks aimed at explicating what he believed were the underlying motives of Man Ray's technique, Wright directed his criticism to specific paintings he had seen in the Daniel Gallery exhibition. Curiously, he thought very little of *Dance* (fig. 145), which he described as simply "childish." According to Wright, the painting "harkened to the injunctions of Futurism," the Italian art movement the outspoken critic had already gone on record to condemn for its chaotic effect and for what he felt were its unjustified aims. In summation, Wright readdressed Man Ray's handling of certain formal problems, finding his use of color "meaningless, save as rich pattern." On the other hand, he apparently found the artist's treatment of form satisfactory: "His forms are," noted Wright, "as he himself admits, two-dimensional." Doubtlessly inspired by the emphasis placed on chromatic organization in Synchromism, Wright then warned Man Ray to pay closer attention to his selection and balance of color. He ended his evaluation of the artist with a somewhat reserved though optimistic opinion of Man Ray's prospects for the future: "If his great promise can be headed toward organization," concluded Wright, "we may expect significant things from him later on."

In spite of the vast quantity of publicity generated by his first major showing in New York, not a single painting or drawing sold during the course of the exhibition. A few days after the works were taken down, however, the Chicago lawyer, author, and art collector Arthur Jerome Eddy stopped into the gallery and offered two thousand dollars for six paintings.[43] Daniel was pleased with the sale, even though it represented a bit less than the five to six hundred dollars that was asked for each canvas during the time of the exhibition. Not only did he know that Eddy was an important collector, long

recognized for his patronage of modern art (particularly for his daring purchases at the Armory Show), but as a businessman Daniel naturally wanted to nurture a professional relationship with such a wealthy and important prospective client. In fact, in order to secure the sale, Daniel volunteered to waive his commission and very generously turned over the entire two thousand dollars to the artist. In the end, Eddy walked out of the gallery with six paintings: *The Reaper* (fig. 107), *Figures in a Landscape* (fig. 108), *The Lovers* (fig. 118), *Five Figures* (fig. 120), and two others that have not yet been identified.[44]

The sudden and unexpected revenue made it possible for Man Ray and Adon Lacroix to move out of their little shack in the country. Neither of them wanted to face another winter in such a remote location. "Hadn't we had enough of this back-to-earth life?" he asked his wife. "No more woodchopping or melting snow for water, for me."[45] This said, they immediately packed their bags and began a search for more convenient and comfortable quarters in town. Within a comparatively short time, probably by the first of December, the couple had moved into an artist's studio on Lexington Avenue and Forty-second street, in an area that was then the center of Manhattan's art gallery district. Most of the modern galleries were located in the immediate vicinity, among the elegant shops, office buildings, and palatial private residences that then lined Fifth Avenue. Daniel was at Forty-seventh and Fifth; the Carroll Galleries at Forty-fourth; Montross at Forty-fifth; Bourgeois at Fifty-third; and 291, the farthest away, was located between Thirtieth and Thirty-first streets, just a ten- to fifteen-minute walk downtown from their new studio.

The closest gallery was de Zayas's recently opened Modern Gallery at 500 Fifth Avenue, just one block away, on the northwest corner of Forty-second Street. At first envisioned as a commercial offshoot of 291, the Modern Gallery opened in October 1915, and its inaugural exhibition lasted through mid-November, the very month when Man Ray's show was hanging at Daniel's. "The opening exhibition," de Zayas recalled, "consisted of paintings and drawing by Braque, Burty, de Zayas, Dove, Marin, Picabia, Picasso, Walkowitz; sculpture by Adolf Wolff; photographs by Alfred Stieglitz; and Negro Art."[46] Since many of the American artists were his friends, it is likely that Man Ray attended this inaugural exhibition. But the show at the Modern Gallery that would have made an even greater impression on the young painter was de Zayas's important exhibition of recent work by Picasso (and of African sculpture), held at the Modern Gallery during the last two weeks of December 1915.

It may have been the example of Picasso's highly inventive use of collage and collage-related techniques that inspired Man Ray to investigate the potential of this revolutionary new medium in his own work. As we have already discussed, Man Ray experimented with collage for the first time in a work of 1914 entitled *Chinese Theatre* (fig. 130), where, primarily for the purposes of adding a decorative enhancement, a small scrap of metallic paper was affixed to the torso of a figure in the composition. The artist's next effort in this medium, *Interior* (fig. 151), would have greater consequence for his future work, particularly in regard to his formalist concerns. In this collage, the artist has boldly affixed a thin, rectangular sheet of silvered paper (mounted at a slight angle) to the center of the composition. Several details in this collage were appropriated from the painting *War* (fig. 126): the large, white, heavily outlined form in the background is derived from the horse and rider that appear in the left portion of the painting, and it has been noted that the three figures on the silvered paper are suggested by other details from this same image.[47] Thus, in strictly formal

terms, as Picasso did with his use of newspaper fragments, Man Ray incorporated into his composition details that assert an inherent two-dimensional quality. Rather than literally include elements from his environment, however, he freely adapted figurative details that had already undergone the flattening process in his own earlier work.

Convincing explanations of the meaning of other details in this painting have not yet been provided. The enigmatic and contradictory nature of these details caused Carl Belz—author of an article that was perhaps the first probing analysis of Man Ray's paintings from this period—to attribute the inclusion of these seemingly illogical details to a "playing [of] Dada games."[48] Belz interprets the number boldly inscribed on the left—"1000"—as an indication of a precise hour: "10 o'clock." If this number refers instead to the year 1000, then this inscription may not be so illogical and intended, as Belz suggests, to misdirect and confuse the viewer. It may refer to A.D. 1000, a date feared by Europeans in the Middle Ages, for it was predicted that in this year the world would come to an end. Man Ray may have known this historical fact and, by incorporating a reference to war in the same image, may have been suggesting that the war in Europe would be the modern cause of universal devastation. The chains, weight, and pendulum, then, may not only have provided the inspiration for the work's title—for, as Belz points out, they all belong to the "interior" mechanism of a clock—but could also have been intended to indicate that because of the inevitable escalation of the European conflict, the coming of the end of the world would just be a matter of time.

Whatever the precise meaning of these mechanical devices, their very inclusion may have been a reflection of the sudden interest among artists in acknowledging the importance and revolutionary implications of an increasingly emergent

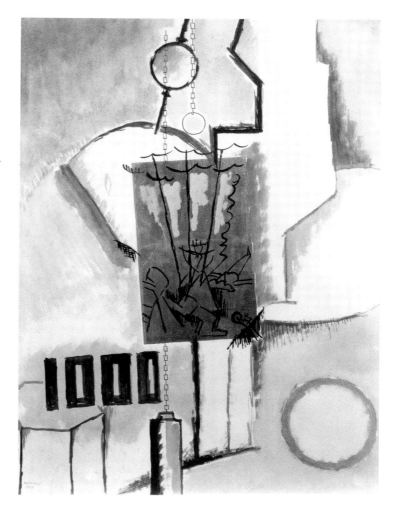

151. *Interior,* 1915. Watercolor, gouache, and silvered paper, 24 3/4 x 17 1/4 in. Philadelphia Museum of Art; A. E. Gallatin Collection.

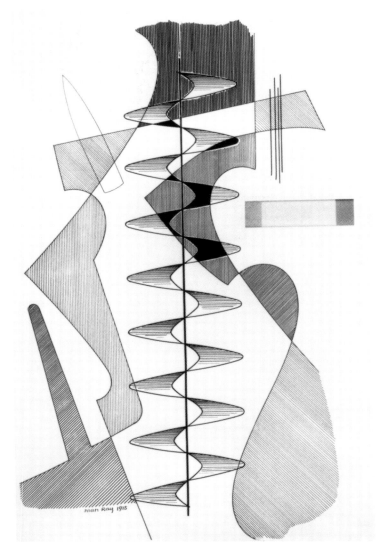

152. *Untitled,* 1915. Ink on paper, 19 7/8 x 13 in. Collection of Herbert Neumann, New York.

mechanical age. As we have mentioned, by the time Man Ray met Duchamp in the late summer of 1915, he may already have been familiar with selected examples of this artist's straightforward adaptation of mechanical imagery. But it was Picabia's vociferous exaltation of the machine and the example of his newly developed mechano-morphic style that provided the most outspoken and visible proclamation of this new aesthetic. "The machine has become more than a mere adjunct of life," he told a reporter. "It is really a part of human life—perhaps its very soul."[49] Although Picabia went on to explain that he was then just beginning to work out the possibilities of this new style, during the summer of 1915 he had already completed a series of symbolic portraits: mechanical caricatures of his friends in New York. It is likely that Man Ray would have seen these works when they were published as the complete July-August issue of *291,* a short-lived though pioneering broadsheet published by Stieglitz and designed to bring new life into the faltering spirits of his gallery.[50]

Coincidentally, Man Ray's earliest exposure to this new machine aesthetic coincided with his move to midtown Manhattan, where he was literally surrounded by the most recent advancements of the mechanical age. "They were building the Lexington Avenue subway," he recalled, "and the racket of concrete mixers and steam drills was constant." But the incessant noise, he claimed, did not bother him. "It was music to me and even a source of inspiration," he said, "I who had been thinking of turning away from nature to man-made productions." With these new and exciting surroundings, he later explained, "it was inevitable that I change my influences and technique."[51]

An untitled ink drawing of a spiral with an overlay of abstract geometric forms that is signed and dated 1915 (fig. 152) indicates that Man Ray

had at least experimented with the possibilities of this new technique before the end of the year. In discussing the themes of his work in this period, the artist provided a virtual description of the non-functional mechanical imagery in this piece: "The new subjects were of pseudo-mechanistic forms," he recalled, "more or less invented, but suggesting geometric contraptions that were neither logical nor scientific."[52] Indeed, neither logic nor science figures into the design of the seemingly unrelated, intertwining shapes that make up this drawing. A thin vertical corkscrew bisects the center of the composition and appears to be surrounded by a number of sharply delineated forms, connected to one another at singular points of coincident align-ment. It is only when this design is later reworked for inclusion in a series of ten collages (fig. 162) that it becomes clear that these seemingly unre-lated shapes were actually produced by a logical system of overlapping, irregularly cut transparent sheets.

During the course of the forthcoming year, Man Ray would achieve a successful combination of the two prevailing concerns that relentlessly dominated his thoughts about his work in this period: first, to develop the most appropriate means by which to express the inherent flatness of painting, and, second, to develop a style that would reflect simultaneously the industrial and technological advances of the mechanical age.

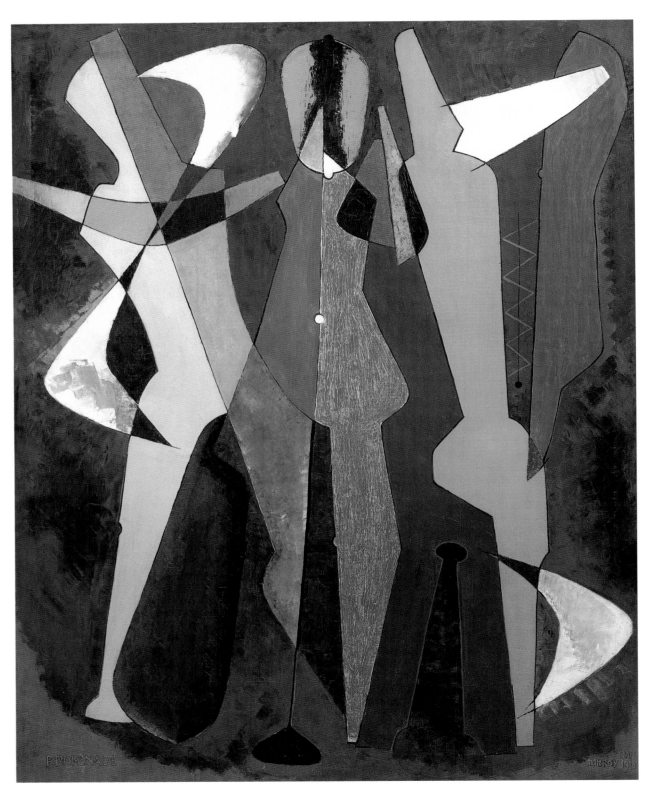

153. *Promenade,* 1916. Oil on canvas, 42 x 34 in. Private Collec-
tion. Photo courtesy of Alan Tarica, Paris.

# SEVEN

## THE ART OF PAINTING IN TWO DIMENSIONS, PART 2: The Paintings, Drawings, Watercolors, and Collages of 1916

For Man Ray, the new year could not have begun on a more positive note. In January, Wright's long review of his show at the Daniel Gallery appeared, singling out the burgeoning young artist from among his fellow painters as one of the more promising new talents to emerge during the current gallery season.[1] We will probably never know exactly what Man Ray thought of Wright's criticism, though years later he would describe the author as "a very intellectual critic."[2] We do know, however, that shortly after Wright's review appeared, Man Ray "headed toward organization," just as the critic had advised in the closing remarks of his review. During the course of 1916, the artist further developed and refined the theory of formalist organization he had composed for John Weichsel, which the critic reprinted in his article (see document A). Man Ray would expand this text into a complex theoretical tract, which, as we shall see, touched upon some of the same concerns propounded by Wright in his various writings on aesthetics. Meanwhile, Wright's comment that the artist's work appeared to be in a continuous state of process—that there was "nothing final about any one of his pictures"—would prove to be a remarkably astute observation.

In January, Man Ray painted *Promenade* (fig. 153), a large painting based on the small gouache study he had completed just a few months earlier (fig. 148). The finished canvas is little more than a straightforward mechanical enlargement of the original image, with only minor alterations made to color and form. When executing the finished painting, Man Ray did not exercise the option of completely rearranging or reworking the composition, as painters often did. Once he had determined the final configuration of his subject, the painting was—theoretically—finished. The acceptance and employment of such an overtly mechanical procedure—one, perhaps, garnered through his familiarity with the technical aspects of photography—would provide the basis for the

artist's occasional duplication of a given image in a variety of media and, in later years, enable him to issue editions and freely produce replicas of various paintings and sculptures whenever demand necessitated.

When Wright wrote that Man Ray's paintings were still evolving, he probably meant that, based on the works he had seen in the Daniel exhibition, Man Ray's ideas about painting appeared in a state of flux, moving toward what he had hoped would represent a solution to various aesthetic problems he had perceived. As we shall see, however, before the year was out, this formal evolution would take Man Ray in a direction the critic would find thoroughly disappointing. For the time being, Wright considered Man Ray's paintings of sufficient merit to feature them with the work of sixteen other artists in the celebrated Forum Exhibition of Modern American Painters, held at the Anderson Galleries in New York during the month of March 1916.[3]

The Forum Exhibition was to include only the work of important American modernists, with the intent, as the organizers stated in the accompanying catalogue, of turning attention away from European art in order to "concentrate on the excellent work being done in America." Most of the artists selected were then working in an essentially abstract, or at least a semi-abstract, mode, and each was given an opportunity to explain his or her work in a catalogue statement, which was to be accompanied by a reproduction of one painting. (In spite of Wright's lack of regard for the picture, Man Ray's *Dance* [fig. 145] was reproduced.) As might be expected, the main theme of each statement centered around the argument of abstraction versus representation, with most of the artists agreeing that the significance of plastic elements of composition—color, form, line, etc.—was equal to or even greater than that of the subject. Man

Ray echoed this position in his statement (quoted in full below), but, unlike the others, he placed an added emphasis on the flat planar surface, which, along with color, texture, and organization of form, he considered an absolute quality shared by the great paintings of all time:

> Throughout time painting has alternately been put to the service of the church, the state, arms, individual patronage, nature appreciation, scientific phenomena, anecdote and decoration.
>
> But all the marvelous works that have been painted, whatever the sources of inspiration, still live for us because of absolute qualities they possess in common.
>
> The creative force and the expressiveness of painting reside materially in the color and texture of pigment, in the possibilities of form invention and organization, and in the flat plane on which these elements are brought to play.
>
> The artist is concerned solely with linking these absolute qualities directly to his wit, imagination and experience, without the go-between of a "subject." Working on a single plane as the instantaneously visualizing factor, he realizes his mind motives and physical sensations in a permanent and universal language of color, texture and form organization. He uncovers the pure plane of expression that has so long been hidden by the glazings of nature imitation, anecdote and the other popular subjects.
>
> Accordingly the artist's work is to be measured by the vitality, the invention and the definiteness and conviction of purpose within its own medium.

Man Ray was represented in the exhibition by ten

paintings and three drawings. Among the paintings included were *The Village* (probably fig. 83), *Dance* (fig. 145, here still called "Invention-Dance"), *Black Widow* (fig. 146, which still went by the title "Invention-Nativity"), and the large version of *Promenade* (fig. 153). Artists were asked to price their work, for everything in the exhibition was supposed to be available for sale. Man Ray gave most of his paintings fairly modest prices, ranging from one hundred dollars for still lifes to four hundred for *Dance* and six hundred for *Promenade*. *Black Widow,* however, was listed at one thousand dollars, an enormous price in those days, but one probably meant to reflect the inordinate size of the painting.[4]

Despite the fact that each artist was given approximately the same amount of wall space, Man Ray was upset when he discovered that his work was hung off to one side and hidden in a corner. Nevertheless, Stieglitz, who had attended the opening of the exhibition, not only noticed his work but praised it highly, which, Man Ray later recalled, gave him a great deal of comfort. Standing in front of *Black Widow,* he told Man Ray that he had understood "the hermaphroditic significance of the work."[5] In fact, Man Ray later acknowledged that the dominant figure in the painting could be that of a man or a woman. Whatever its sexual implications, to the general public this large anthropomorphic being in the center of the composition would appear as if "steamrolled" into position, squashed, along with the various elements in its immediate surroundings, onto the flat surface plane of the painting. These "depth-defying" characteristics—equaled in intensity only by other examples of Man Ray's work included in this exhibition—were precisely the qualities that continued to attract Wright's enthusiastic regard for the work of this young painter.

Even though Man Ray said his work was displayed in a corner of the gallery, in a cartoon that appeared in *The World Magazine* (fig. 154), visitors to the Forum Exhibition are depicted viewing his painting *Dance* as if it hung "on-line," that is, along the same line of sight as other paintings in the exhibition. Although no artist was singled out in the accompanying review, the critic did note that "each painter was a law unto himself, and not a single picture in the lot was an illustration of any person, place or thing." This anonymous critic ended his review with a remarkably insightful observation about the future course of modern art: "Above all," he wrote, "it [the Forum Exhibition] stimulated the interest of artists, critics and the public alike by demonstrating the essentially decorative quality of modern painting, in its scientific use of pure color to achieve deeper and more subtle emotional expression, in place of a conventionalized, superficial appearance of reality."[6]

In April, Willard Huntington Wright published a long review of the Forum Exhibition, wherein he provided a critical appraisal of each of the seventeen artists who were included in the show.[7] Having already expressed some regret in an earlier essay for his adverse criticism of Man Ray, in this review he found the work more fully resolved and matured. "From out [of] the work of student days," Wright noted, "[Man Ray] has come to guide his own star." He again compared the artist's work to that of Picasso, feeling that, although the famous Spaniard had left his impression on the young American, the result in Man Ray's work was "of a totally different mental attitude." This difference, he maintained, was due to the fact that Picasso had always been "a slave of objectivity . . . while Ray's desire to create was inspired less by nature than by thought." Then, perhaps with information gleaned from Man Ray's catalogue statement or from conversations with the artist, Wright proceeded to discuss the work in

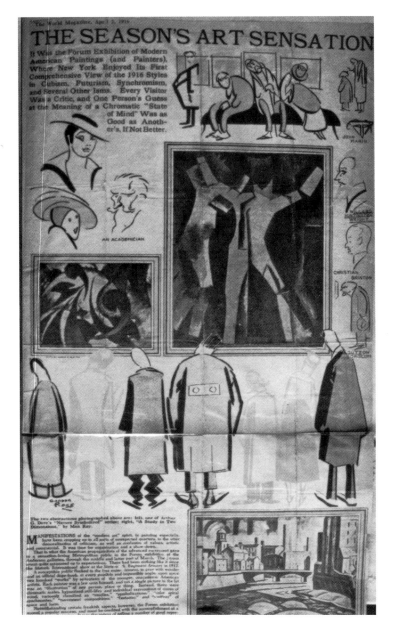

154. "The Season's New Art Sensation," *The World Magazine*, April 2, 1916 (microfilm copy). New York Public Library, Astor, Lenox and Tilden Foundations.

terms of Man Ray's preoccupation with flatness in painting:

> Ray believes that painting, being done on a two-dimensional surface, should satisfy itself with this flat restraint; and he has set himself to beautify his canvas even more diligently than if he were a sculptor. That he has penetrated far into the fundamental problems of formal order in two dimensions is undeniable. That he has achieved much on the way is quite as evident.

The critic then concluded his review by reversing his former opinion concerning the unfinished or unresolved appearance of the artist's earlier work. "[Man Ray's] expression thus far is not in advance of his technical ability," he wrote, "and his very approximation toward a complete finish gives his work an appearance of finality."

In the months following this important exhibition, Man Ray continued in earnest to pursue the ultimate expression in the art of two dimensions. In early April, he wrote to the painter and collector Hamilton Easter Field, inquiring about an "Amberwax" preparation that reportedly produced a nonglossy finish, an effect he had been trying to achieve in his own work for a number of years; in order to accentuate the flat surface of his canvases, he wanted to duplicate the generally matte and textural appearance of fresco.[8] These technical considerations were important to the formalist program Man Ray was in the process of implementing, a theoretical program that not only influenced his exploration of various techniques but would even determine his choice of subject. Man Ray outlined the basic principles of this theory in a small but important hand-printed booklet, privately published in 1916 under the title *A Primer of the New Art of Two Dimensions* (fig. 155).[9]

In part, the text for Man Ray's treatise was

# A PRIMER

### of the

# NEW ART

### of

## TWO DIMENSIONS

### by

# M A N   R A Y

### 1916

### N E W   Y O R K

INVENTION
*(black and white version)*

The individual desiring to experience all the sensations of life, is forced by his physical and temporal limits to receive them in a concentrated form. This concentration of life is offered by the expressive arts.

If the individual is an artist, that is, conscious, his appreciation demands proportional creative powers. An active mastery of all the arts as a means to simultaneous expression is beyond him as much as is an actual participation in all the phases of life itself. The greater the extent of the perceptions the more concentrated must be the expression. Just as the lens sacrifices actual space to focus all of that space upon the plate, so the artist must condense the time and space element to create life's equivalent.

This leads his medium to a static condition implying the unity of time and space, that is, a concrete form of two dimensions, which is comprehensible from one point of view in an instant of time. Any re-extension of this medium into time or space becomes merely a fragment of life. Now we shall see how this two-dimensional medium maintains its identity as well as its microcosmic quality. Although conceivable in an instant of time, its static quality makes it as eternal as life itself.

Beginning with all the expressive arts as concentrated phases of life, the conscious individual seeks to contain their characteristics in the plastic medium of two dimensions. This is possible because each of the arts, the dynamic as well as the static, has a characterizing factor that is static and containable in the flat plane. We shall consider music, literature, dancing (the actually dynamic arts), architecture, painting and sculpture (the static arts).

Music originates in the contact of points, lines and planes in instruments. In musical notation these contacts are plastically expressed by points on lines in two dimensions. To the musician these are symbols of sound. But in themselves, points and lines are static. An arrangement of these on a flat plane at once conveys *musical quality* to one who hears music with his mind, as does a composer.

In literature, idea and matter are plastically expressed by written words which possess distinct individual forms. Likewise any plastic form of two dimensions with distinct character has a literary quality for one with a literary sense. An individual plastic form is the result of thought as is an arrangement of words.

In dancing, rhythm is the essence. While thought connects words, rhythm connects gestures, determines their relations and combines them into a unit. Static forms of two dimensions are like gestures in their expressiveness, and can also be related by rhythm — a rhythm physically static but having the dynamic origin. So dancing finds its parallel in the static plane.

All architecture is based on the principle of proportion, a purely plastic element adaptable to form in two dimensions and fully expressive of the architectural element in life.

Painting, as an illusion of matter, or whatever the inspiring subject, is identified among the forms of expression by the color and texture of the material, that is, pigment or other material that

may practically be reduced to the flat plane. This quality, detached from its representative function and cultivated in itself, replaces the illusion of matter by a parallel realization in the material itself, thereby satisfying the desire for realism. So the essence of painting is preserved in the two-dimensional medium.

The final expression in sculpture is attained by the creation of values through light and shadow. On a flat plane the contrast of absolute plastic values produces the same sensations as the effect of light on opposed planes in a space of three dimensions. Thus the quality of sculpture also is retained in two dimensions.

. . . . . . . . . .

In the respective factors of the first three arts mentioned (music, literature, dancing) namely: points and lines, form, and rhythm; the process of their organization on the flat plane gives the dynamic quality of the arts; while the other three: proportion, color and texture of material, and values (representing architecture, painting and sculpture, respectively), in terms of content supply the static element. Just as the dynamic and static balance in life, so they do here.

The organization of all these art elements into the flat plane unit frees them from the incompleteness they separately suffer as mere symbols of idea and emotion. By mutual dependence and common relationship they produce an activity in the two-dimensional limits which is entirely self-expressive and obedient to the laws of these limits.

The new two-dimensional medium is not merely painting any more than it is merely drawing or color. It is a most universal and concentrated form of expression. With it the artist can really begin to create, which is the highest and most joyous form of expression.

. . . . . . . . . . . . .

155. *A Primer of the New Art of Two Dimensions*, 1916. Pamphlet. Arensberg Archives, The Marian Angell Boyer Library, Philadelphia Museum of Art.

based on the statement he had prepared the previous year for Weichsel's article on his work (see document A). But here—with the help of a diagram that appears on the last page of the booklet—he more clearly establishes a common basis for all the arts by demonstrating that their various modes of expression all possess the potential for reduction on a flat surface. He identifies painting, sculpture, and architecture as the "static arts," for they can be understood in a single viewing and in an instant of time, while music, literature, and dance are classified as "dynamic arts," for they require the passage of time for full comprehension. Each of these arts is then analyzed individually, with the intent of establishing their equivalent form in two dimensions. The artist attempts to convince his audience that these parallel states actually exist, subjecting his reader to some rather tenuous interpolations, especially in the case of the dynamic arts. Music, for example, is said to originate from contact points on instruments, which are recorded as musical notation on flat sheets of paper. Literature is similarly interpreted, as the form of words in a given arrangement.

The parallel for dance in the static plane is established with greater difficulty. According to the artist, rhythm is the common element, for it lends unity to the temporal components of dance, just as it establishes a relationship between static forms on a two-dimensional surface. The static arts are then individually analyzed with the same intent. Architecture becomes adaptable to the two-dimensional plane through proportion (presumably he means through plan and elevation drawings), while sculpture finds its planar equivalent in its ability to create light and shadow, which are plastic values that can be expressed in two dimensions.

Finally, with painting—Man Ray's primary medium of expression—we are presented with the basic tenets of a remarkably prescient formalist theory, one that contains the seeds of a critical approach that would not be fully explored in American art for some forty years, not until the so-called second generation of formalist critics applied their analysis to the paintings of the Abstract Expressionists in the 1940s and 1950s. The three basic tenets of formalism espoused by these critics can be summarized as follows: (1) primary interest in the structural order of a work of art; (2) purity of the medium; and (3) integrity of the picture plane. All three of these concerns are either directly stated or implied in Man Ray's writings. His interest in structural order, however, was more clearly expressed in the statement he prepared for the Forum Exhibition (quoted earlier), in which he explicitly stated that the creative force in an artist's work relies on, besides color and texture, the invention and organization of form on the picture surface, or, as he referred to it, "the flat plane." In the *Primer*, he notes again that it is the organization of points, lines, form, and rhythm on the flat plane that gives the arts their dynamic quality. As for the purity of the medium and the integrity of the picture, Man Ray stresses the importance of color and texture in making the viewer conscious of a painting's material quality, which he notes can be "detached from its representative function and cultivated in itself." This is an important point, for he goes on to say that the desire for realism in painting can be satisfied by "a parallel realization in the material itself."

For precedents to the *Primer*, we can search in vain through the publications of contemporary critics and aestheticians who were noted for their emphasis on form in the interpretation of a work of art—particularly the Englishmen Clive Bell and Roger Fry—to find theories of formalism that are as precise and conclusive as Man Ray's. Although his reading of these sources undoubtedly influ-

enced his thinking, we must turn to the technical manuals of design and composition in order to find an immediate precedent. Most important were the writings of Denman Ross and Arthur Wesley Dow, especially the latter's *Composition* (1913), a book that influenced a host of American painters, particularly Max Weber and Georgia O'Keeffe.[10] Both of these writers isolated the plastic components of design—line, texture, color—and demonstrated how they could be incorporated into a composition through the use of harmony, balance, and rhythm. In an article that appeared in 1915, Dow noted that great pictures and artifacts of all cultures and in all periods of history shared the common feature of good design; in another, published in 1917, he stated that the primary concern of the modern artist was, among other things, to find "a common basis for all the visual arts."[11] Other than occasionally evoking the musical metaphor, however, neither Ross nor Dow attempted to establish a parallel between music and painting.

But earlier books published in America did. George Lansing Raymond's *The Genesis of Art-Form* (1893) is now largely forgotten, but its lengthy subtitle would certainly have been of interest to Man Ray: *An Essay in Comparative Aesthetics, Showing the Identity of the Sources, Methods, and Effects of Composition in Music, Poetry, Painting, Sculpture, and Architecture.*[12] Except for dance, all the art forms Man Ray considered are fully analyzed in this volume, and Raymond demonstrates that they share common principles of formal organization. No matter how close the similarities of approach, however, no theorist before Man Ray (as far as this author can determine) so emphatically established the flat plane as a common factor in the unity of the arts.

What Man Ray's friends and fellow painters thought of his theories is unknown. (In his autobiography, the artist himself either forgot about the

*Primer* or intentionally left it out of an otherwise detailed account of his activities in these years.) We can be relatively certain, though, that at least one prominent critic would not have approved. In *The Creative Will,* which appeared late in 1916, Willard Huntington Wright included a note that was, without doubt, intended to dismiss the ideas outlined in treatises such as Man Ray's. "The numerous attempts which have been made to synthesize the arts have been the outgrowth of a vague realization that the aesthetic fundamentals of all the arts are identical," he wrote. "Their failure has not been due to any inherent impossibility of unifying different stimuli so as to produce an intensity of reaction, but to the fact that the arts as yet are not understood with sufficient precision by any one man. Not until a definite *rationale* has been established, embodying every phase, complexity and variation of the different arts, will such a synthesis succeed."[13]

Of course, if we are willing to accept the basic premise put forth in Man Ray's treatise—that the static and dynamic arts could attain unity through a common vehicle of expression, namely, "the flat plane"—then it could be argued that Man Ray had indeed discovered the definite rationale Wright claimed was lacking and that, consequently, he *had* succeeded in attaining the desired synthesis. Whether we agree or disagree with Man Ray's theories, the artist proceeded to put them into practice by selecting the subjects for his paintings and drawings from the three separate subdivisions he had established for the dynamic arts: dance (as in his 1915 painting by that title: fig. 145), literature (as in his many illustrations for poems and plays: figs. 99, 132), and music, a theme which he had already addressed on a number of earlier occasions (figs. 42, 43, 119), and that would increasingly occupy his interests as his work became more and more abstract.

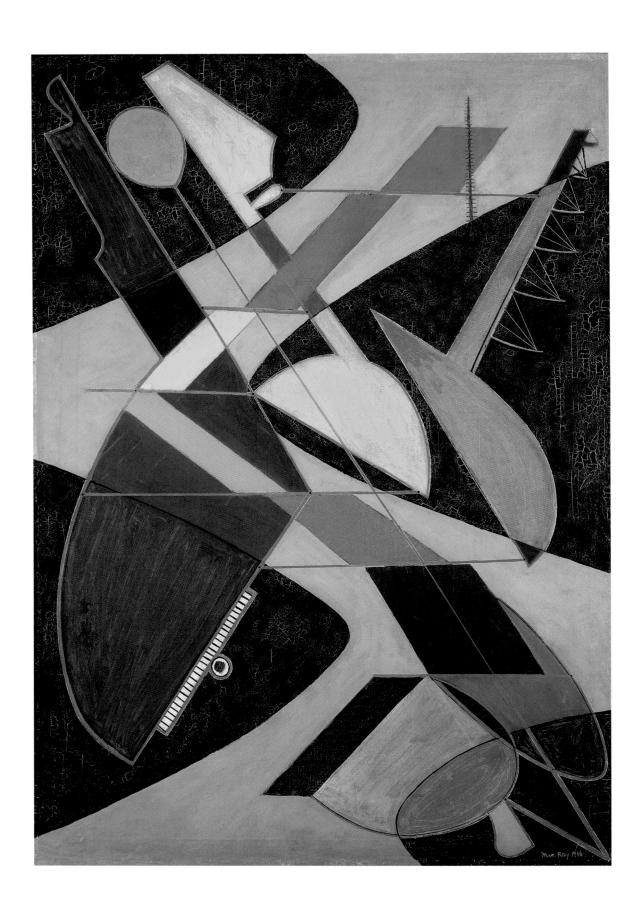

156, facing page. *Symphony Orchestra*, 1916. Oil on canvas, 52 x 36 in. Albright-Knox Art Gallery, Buffalo, N.Y.; George B. and Jenny R. Mathews Fund, 1970.

Analogies to music had long been cited in defense of abstraction, reasoning that if music could be appreciated for its balance, harmony, and tonal qualities, why not painting? In 1917 Arthur Wesley Dow isolated the musical analogy as one of the most desired ambitions of the modernists. "Ceasing to make representation a standard but comparing the visual arts with music," Dow said, was one of the most important esthetic issues of the time.[14] Certainly aware of this analogy, Man Ray appears to have arranged the internal elements of his drawn and painted compositions of this period in a balanced and harmonious fashion, as if to draw conscious attention to a parallel with these same qualities in music. In *Symphony Orchestra* (fig. 156), a large painting from 1916 that is often overlooked in historical evaluations of the artist, there is a very conscious fusion of subject and form, one clearly intended to evoke a metaphor between painting and music.

In *Symphony Orchestra,* intersecting ovoid forms in the extreme lower right of the painting balance musical notes that seemingly break from their registers and, across the diagonal expanse of the composition, metamorphose into the necks of stringed instruments on the upper left. An overhead view of a piano, fully equipped with keyboard and stool, is represented by the large blue form in the lower left quadrant of the painting, while the entire image is unified by a twisting white shape in the background, undulating in and out of the composition like the theme and variations in a Bach concerto. "Bach moved me because of my own precise training in mechanical subjects," Man Ray recalled years later. "He was a kindred spirit who inspired me to greater efforts in

my line."[15] Indeed, the prominent linear elements in this painting are executed with such detail and precision that they almost appear to have been mechanically generated. While the artist's ability to apply the pigment in such an exacting fashion may have been facilitated through his experience with mechanical drawing instruments, which he had learned to use during his employment as a draftsman, the motivation to encapsulate form in this particular fashion may have been inspired by quite another source: his continuing fascination with the art and ideas of Marcel Duchamp.

Although Man Ray had been introduced to Duchamp about a year earlier, it was not until 1916 that the influence of this famous French artist could be seen to have directly affected the development of his work. In *Symphony Orchestra,* for example, many of the major foreground shapes are outlined by thin copper-colored bands, as if Man Ray had intentionally emulated the lead-and-wire construction used by Duchamp in defining the position of various elements in the lower section of *The Large Glass* (fig. 157), the masterwork he had begun shortly after his arrival in New York. Even if for some reason Man Ray did not see this work, he surely would have learned about such an unusual method of picture-making by the early months of 1916, either through visits to Duchamp's studio or by attending (or simply reading about) the controversial and highly publicized exhibition of pictures by Duchamp, Jean Crotti, Albert Gleizes, and Jean Metzinger held at the Montross Gallery in April.[16]

This exhibition—dubbed by the press "The Four Musketeers Show"—was one of the first exhibitions in America (or anywhere, for that matter) to emphatically demonstrate that there existed an even more radical approach in the making of art than that offered by the Futurists and Cubists, who were then considered to represent the most extreme forefront of the artistic vanguard. In an

157. Marcel Duchamp, *La Mariée mise à nu par ses célibataires, même* [*The Bride Stripped Bare by Her Bachelors, Even*], known as *The Large Glass*, 1915–1923. Oil, varnish, lead foil, lead wire, and dust on two glass panels, 109 1/4 x 69 1/4 in. The Philadelphia Museum of Art; Bequest of Katherine S. Dreier. Copyright © 2002, Estate of Marcel Duchamp/Artists Rights Society (ARS), New York/ADAGP, Paris.

interview that was conducted in 1915, Duchamp categorically renounced the foundations of Western art and even criticized the modernists who considered themselves followers of the Cubists: "Now we have a lot of little cubists," he remarked, "monkeys following the motion of the leader without comprehension of their significance."[17] It was during the Montross exhibition that the differences between Duchamp's iconoclastic views and the comparatively conservative position maintained by the Cubists were first brought to the attention of the public, although the press repeatedly stated that only the paintings by Gleizes and Metzinger should be considered serious work. Nevertheless, more astute observers would have been able to see that the work by Duchamp and Crotti represented the most radical and advanced work being done in America at the time, a defiant and nonconformist approach to picture-making that a young artist with anarchist leanings would hardly have overlooked.

At this time Duchamp shared a studio in the Lincoln Arcade Building on Broadway at Sixty-sixth Street with his colleague and compatriot Jean Crotti. When Man Ray first visited their studio—probably in the spring of 1916—he saw not only Duchamp's unfinished glass panels but "on a small easel," he recalled, "a glass and metal construction by a friend, Jean Crotti."[18] This work can be identified as Crotti's *Les Forces mécaniques de l'amour en mouvement* (fig. 158), a construction that was not shown in the Montross exhibition; Crotti had specially set it up for viewing in his studio during the time of his show, in order to display the quality of its transparency to an interviewer.[19]

Like Duchamp's glass panels—which Man Ray described as "covered with intricate patterns laid out in fine lead wires"—Crotti's work consisted of a series of mechanically inspired forms affixed to a glass surface by a system of rigid wire

encasements. But unlike Duchamp's work, the prominent circular shapes in Crotti's construction are brightly colored, as are the various foreground elements in Man Ray's *Symphony Orchestra* (fig. 156). Moreover, Crotti's glass panel was mounted against the face of a shallow rectangular box, which contained a grouping of metal rods that could be seen through certain unpainted passages in the glass. The flat, non-textural shapes in Man Ray's painting produce a similar effect, for they appear as if held in suspension on the surface of a transparent plane, behind which can be seen the simplified, curving shapes in the background, suggesting, as one critic recently remarked, "the relationship between a large, visually diverse orchestra and its single, unifying musical expression."[20]

No matter how it is interpreted, the background in *Symphony Orchestra* was clearly intended to function in response to the musical analogy. But the background of a painting could not always be so easily rationalized within the context of a totally flat, two-dimensional schema, as we saw earlier with the painting *Cut Out* (fig. 149), where the background was literally excised from the composition. Man Ray probably learned of an alternative solution to the treatment of background space through his association with Duchamp, for the issue had concerned the Frenchman for a number of years—but for very different reasons. In part, Duchamp wished to eliminate the immediate visual field surrounding the various elements portrayed on the *Large Glass* for the purpose of alluding to the existence of a fourth dimension. Years later he explained his rationale to an interviewer in terms that might not have been very different from the way he would have explained it to Man Ray in 1916:

> Anything that has three-dimensional form
> is the projection in our world from a four-

158. Jean Crotti, *Les Forces mécaniques de l'amour en mouvement* [*The Mechanical Forces of Love in Movement*], 1916. Oil, metal tubing, and wire affixed to glass, 23 5/8 x 29 1/8 in. Private Collection, Paris. Copyright © 2002 Artists Rights Society (ARS), New York/ADAGP, Paris.

dimensional world, and my Bride, for example, would be a three-dimensional projection of a four-dimensional bride. All right. Then, since it's on the glass it's flat, and so my Bride is a two-dimensional representation of a three-dimensional Bride, who also would be a four-dimensional projection on a three-dimensional world of the Bride.[21]

Duchamp might also have added some information as to how this projection could more easily be explained through the metaphor of shadows, an idea that he picked up a few years earlier from a book on the fourth dimension: "The shadow cast by a 4-dimensional figure on our space is a 3-dimensional shadow."[22]

Even if Man Ray did not completely understand all this talk of the fourth dimension and shadows, he must have realized that he and his French companion were working independently on ideas of mutual interest, however differently they might have put them to use. By 1916 the idea of shadows figured prominently in Man Ray's obsession with the art of two dimensions. In what is rightly regarded as his most important painting of these years, *The Rope Dancer Accompanies Herself with Her Shadows* (fig. 159), the two-dimensional images cast by the rope dancer are essentially the subject of this picture. Moreover, all the figurative details in this image (including the shadows) are set against the surface of gray-white background, creating an illusion not unlike the transparent effect of glass, especially when the painting is hung on a solid white wall.

In his autobiography, Man Ray revealed the technique employed in the design of this picture, which he began shortly after moving into his studio on Lexington Avenue late in 1915.[23] Here the artist provides a step-by-step account of the proce-dure that was followed in the construction of this important painting:

> The subject was a rope dancer I had seen in a vaudeville show. I began by making sketches of various positions of the acrobatic forms, each on a different sheet of spectrum-colored paper, with the idea of suggesting movement not only in the drawing but by a transition from one color to another. I cut these out and arranged the forms into sequences before I began the final painting. After several changes in my composition I was less and less satisfied. It looked too decorative and might have served as a curtain for the theater. Then my eyes turned to the pieces of colored paper that had fallen to the floor. They made an abstract pattern that might have been the shadows of the dancer or an architectural subject, according to the trend of one's imagination if he were looking for a representative motive. I played with these, then saw the painting as it should be carried out. Scrapping the original forms of the dancer, I set to work on the canvas, lay-ing in large areas of pure color in the form of the spaces that had been left outside the original drawings of the dancer. No attempt was made to establish a color harmony; it was red against blue, purple against yellow, green versus orange, with an effect of maxi-mum contrast. The color was laid on with precision, yet lavishly—in fact, the stock of colors was entirely depleted. When finished, I wrote the legend along the bottom of the canvas: *The Rope Dancer Accompanies Herself with Her Shadows.*[24]

Doubtlessly with the intent of enlivening the nar-rative, the artist emphasized the sense of discovery

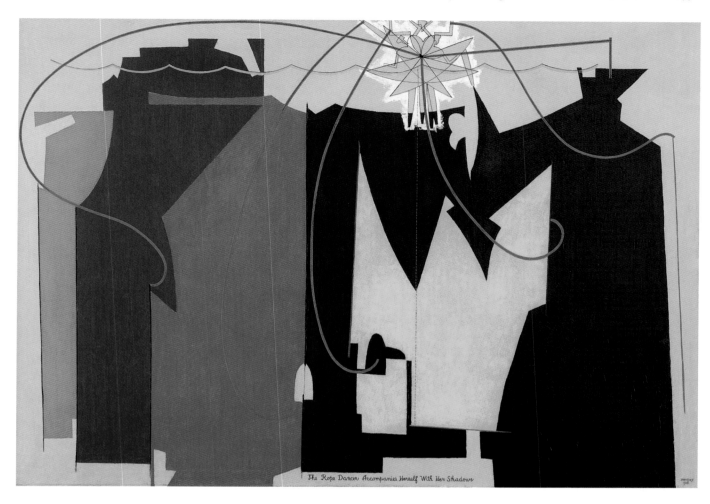

159. *The Rope Dancer Accompanies Herself with Her Shadows*, 1916. Oil on canvas, 52 in. x 6 ft. 1 3/8 in. The Museum of Modern Art, New York. Gift of G. David Thompson, 1954.

that led to the creation of this picture, implying that his decision to use the cutout, formerly discarded scraps of paper as the very basis for the composition came to him literally in the form of an afterthought. We know from examples of his prior work that the negative shapes surrounding figurative groupings (such as in *Promenade* [fig. 153]) and in the background of his paintings (*Symphony Orchestra* [fig. 156], *Cut Out* [fig. 149]) were formalist concerns of increasing importance in his continuing efforts to reconcile the inherent dichotomy between a painting's flat surface and the illusionism its painted forms naturally generate. In

fact, when the Museum of Modern Art acquired *The Rope Dancer* in 1954, the artist was asked to complete a questionnaire, providing information concerning this picture and its production. Here, in terms similar to those expressed in his autobiography, Man Ray again described the making of this picture, but with several noteworthy differences: the elements of chance and accidental discovery are absent, and, even more revealing of his motives, the artist concluded his description by establishing a formal connection between this painting and his earlier work:

> First I made drawings for three positions of a ballet dancer. Then enlarged them on different colored papers. The forms were cut out of these—and destroyed. The remaining pieces of colored paper were used as the final forms to create an abstract effect, and a vibration of large masses of color. The whole was painted with specially shaped palette knives. The theme of the ballet dancer was added afterwards to recall the original idea (at top), with serpentine lines connecting the various surfaces. I had already made several paintings in which I emphasized the surrounding spaces, making them as important as the original forms—the whole producing a more abstract—or invented—composition.[25]

While the subject of a tightrope walker, or rope dancer, had well-established historical precedents in both art and literature—where the precariously balanced figure usually symbolized man's struggle for existence—Man Ray acknowledged that the inspiration for this subject came from a vaudeville performance he had attended.[26] Although the artist probably did destroy the specific drawing that was used in determining the final configuration of the rope dancer and her shadows, as he claimed in his autobiographical account, at least one preliminary sketch for this subject survives (fig. 160), as well as an ink drawing entitled *Ballet-Silhouette* (fig. 161), where the forms of the dancer and her surrounding shadows are recalled with mechanical precision.

The brush-and-ink sketch records the position of two or three dancers, the basic shapes of their bodies and skirts rendered quickly and expressionistically. By contrast, a more accurate and precise conception of the dancers and their accompanying shadows is provided in *Ballet-Silhouette,* a drawing showing three figures in animated positions, as if in response to the presence of a musical stimulus, symbolized by the decorative volute emerging from the neck of a stringed instrument on the lower right register of the drawing. With the combined theme of music and dance, Man Ray brought together at least two of the three subdivisions he had established for the dynamic arts. Although the subject of music is not very prominently displayed in the finished painting, this drawing provides an indication that the theme must have been a part of its original conception.

Until recently, *Ballet-Silhouette* was presumed to be a preliminary study for the painting; we now know that it was made *after* the *Rope Dancer* was completed.[27] Nevertheless, a similar drawing, or at least one containing many of the same details—a work the artist said he "scrapped" or "destroyed" —must have been employed in the construction of the finished picture. In *Ballet-Silhouette,* the three dark ovoid shapes behind the dancers are clearly meant to represent their shadows (as produced by the beam of a circular spotlight). If we can take the liberty of visually excising these figures from their immediate environment, then the remaining negative material would literally represent the shadows of the dancers. If these shapes were then transferred to the surface of the paint-

160. *Study for the Rope Dancer Accompanies Herself with Her Shadows*, 1916. Ink on paper, 8 7/8 x 11 in. Studio Marconi, Milan.

ing, they would naturally retain certain details that reflect the outer contours of the original dancers. Indeed, such details can be detected in the six brightly colored shapes that represent the areas of shadow in the finished painting (fig. 159): a number of rectangular indentations reflect the projections of the dancers' arms and legs; the truncated, cylindrical form enclosed within the foremost yellow shape represents the silhouette of a dancer's head, while its sharp, irregular periphery appears to have been determined by the starched and fan-shaped contours of several dancers' tutus.

According to the account Man Ray provided for the Museum of Modern Art, it was only after he had painted the dancer's "shadows" that he decided to include the form of the dancer herself. Thus, at the top of the composition he painted a sharp, almost crystalline form comprised of three separate dancers, joined in a single point at the waist, making it clear that these three translucent, superimposed forms were meant to represent multiple readings of the same figure. From this single point emanate three lines that connect the dancer to her "shadows" below. (The ends of three more lines, or ropes, as they might have been envisioned, are held in the dancers' hands.) With these connecting cords established, the dancer literally accompanies her shadows—in the fashion of an individual accompanying his or her dog on a leash, a visual image that may have provided the artist with a suggestion for the lengthy, narrative title

161. *Ballet-Silhouette*, 1916. India ink, charcoal, and gouache(?) on wood pulp board, 20 15/16 x 25 1/4 in. The Solomon R. Guggenheim Foundation, New York. Peggy Guggenheim Collection, Venice, 1976. 76.2553.68.

that he boldly inscribed across the base of the painting: "I gave the picture an almost literal," he said, "if not literary title!"[28]

Much has been made of the similarities between this painting and the *Large Glass* (fig. 157), particularly the lower portion of Duchamp's work, where the Nine Malic Moulds, or "Bachelors," are portrayed. There are indeed formal similarities in the positioning of various elements; the ropes descending from the dancer do mimic the so-called capillary tubes that radiate from the Bachelors in the *Large Glass*. And the placement of the female element in the uppermost extreme of Man Ray's painting does resemble the general layout of Duchamp's masterpiece, where the Bride and related apparatus are confined to the upper panel. Authors have even recognized the similarities between the titles of the two works, noting that Man Ray inscribed his directly on the surface of the painting, just as Duchamp had done on several occasions, particularly his famous *Nude Descending a Staircase,* as well as both versions of the *Chocolate Grinder.*

More than the similarities between these two works, however, their differences reveal the formal meaning and importance of Man Ray's painting. Unlike Duchamp, Man Ray was not concerned with recording his subject in an accurate, perspectivally correct fashion. Even the rope dancer is rendered as a transparent being, portrayed in flat, multiple images against the surface of the painting, with only a white aura to help distinguish her from the planar background whose coloration she shares. Moreover, Man Ray might have reasoned that if Duchamp were right and four-dimensional figures did cast three-dimensional shadows, then by extension, when it came to painting on an opaque surface (rather than on the surface of glass), a three-dimensional object (the actual rope dancer) would naturally cast a two-dimensional shadow. And that is exactly what he portrayed.

Since the shadows of the rope dancer were derived from abstract, irregularly cut shapes of scrap paper, Man Ray's painting can be considered to represent an illusion of flatness—a pseudo-collage, or what at least one author described as a *trompe l'oeil* rendition of collage.[29] In other words, rather than follow the customary procedure of Synthetic Cubism—whereby the artist creates an image that, once finished, resembles the general appearance of a collage or assemblage—Man Ray followed the procedure in essentially the reverse order, using an actual collage to determine the final configuration of his painted image. By directly translating the collage medium in paint, he produced—perhaps unwittingly—one of the most extreme expressions that can be imaged in the art of two dimensions. As in the works of Jasper Johns, who, some fifty years later, would select subjects to paint that were by their very nature inherently flat, the prominent shapes in Man Ray's painting were derived from the design of an object that was by its very nature virtually without volume or mass: a flat, pasted paper collage.

Man Ray's experimentation with the spectrum-colored papers that were used in the making of *The Rope Dancer* provided not only the inspiration but also the modus operandi for an entire series of collages from this period (fig. 162), each of which was supposed to serve as a preparatory study for a larger work in oil (although only one actually did: fig. 166). The series consisted of ten separate collages, the individual panels of which were prepared from carefully cut pieces of colored construction paper pasted onto the surface of white cardboard. For their first installation, at the Daniel Gallery in 1919, each collage was separately framed and hinged onto a revolving support, so that the entire ensemble could be spun around like a revolving door—hence the title Man Ray gave to the entire series: *The Revolving Doors.*

Each panel was assigned a somewhat unusual

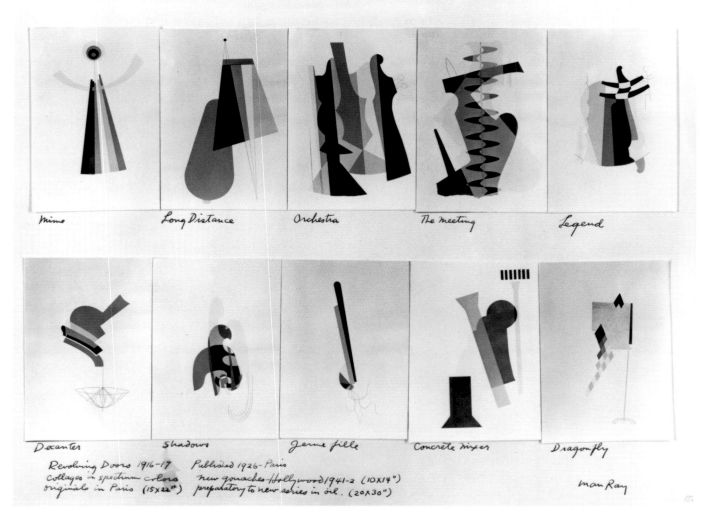

162. *The Revolving Doors*, 1916–1917. Photographs attached to board, assembled ca. 1945. Private Collection. Photo courtesy of Andrew Strauss, Paris.

though generally descriptive title. In addition, he composed a series of what he himself described as "long" and "rambling" texts to accompany each collage. On occasion insightful, most of these written statements are actually rather abstruse analyses of the individual images (see document B). Both the titles and the texts were most likely inspired by their finished forms (and not the other way around), a method the artist frequently employed. Thus, the title for the first in the series, *Mime,* was probably suggested by its general anthropomorphic shape, which, with the vertical

III

163. *Orchestra,* 1916–1917. Collage on paper, 21 X 13 1/2 in. Collection of Mr. and Mrs. Meredith J. Long.

spectral-colored striations and outstretched arm-like forms, resembles a mute clown, or mime. A number of authors have been quick to suggest that all ten of the panels in this series were based on recognizable imagery, stretching their analysis beyond credibility in an attempt to relate the essentially abstract shapes of each collage with the image suggested by its title. This has caused certain writers to find a dirigible in *Long Distance;* an iconic bird confronting a stick figure in *Legend;* male and female sexual organs in *Jeune Fille;* a parrot or hawk in *Shadows* (fig. 164); a man, rake, and troughs in *Concrete Mixer* (fig. 165); and a harlequin in *The Dragonfly.*[30] While a number of these observations may be perfectly legitimate—such as finding stringed instruments in the shapes of *Orchestra* (fig. 163)—other panels were clearly conceived on a more abstract basis. Even the authors cited above, for example, were forced to describe the fourth collage in this series, *The Meeting,* in exclusively abstract terms: "*The Meeting,*" they wrote, "cleverly uses transparency to draw the observer into a game of seeing which form is behind another in an illusionary depth."[31]

*The Meeting* was based on the drawing he had made a year earlier (fig. 152). In the final collage, three abstract shapes, or "beings," as the artist called them in his accompanying text, are rendered as if they were separate pieces of colored acetate, placed in overlapping positions on an evenly illuminated surface. In places where two or three primary colors overlap, secondary and tertiary colors result, creating the effect of viewing translucent color gels on the surface of a light table (something the artist would have seen or perhaps even worked with himself in his employment as a draftsman). "I traced the forms on the spectrum-colored papers," he later explained, "observing a certain logic in the overlapping of primary colors into secondary ones."[32] Whereas only four of the

ten collages accurately produce an illusion of over-lapping color planes, the general effect of translucency is suggested by each panel in the series. This effect, considered along with his elaborate system of installation, makes it clear that Man Ray must have intended the white cardboard background of each collage to represent—at least metaphorically—glass.

*Shadows* (fig. 164), the eighth panel in this series, differs markedly from the other collages. Four separate shapes overlap: one blue, another red, and two yellow. At first, this collage appears to have been constructed in the same way as the other nine panels, but further analysis reveals that the four shapes are determined by a method of projection, and not just of simple overlap as in the other collages. The method is similar to that simulated in his high school drawing of triangles hovering in space and casting their shadows onto curved and geometric surfaces (fig. 13). Here, however, Man Ray has recorded the shadows cast by a French curve (a draftsman's template) held at varying angles above the picture surface. As with the *Rope Dancer* (fig. 159), he has succeeded in capturing the two-dimensional reflection of a three-dimensional entity. Unlike in the painting, in this collage the object responsible for the shadow is not represented within the pictorial field. Instead, we are presented with the effect of something we cannot see—only a shadow, which by its very nature is without mass. In a theoretical sense, then, this panel is even "flatter" than the other images in the series, for the other collages assimilate the appearance of separate pieces of acetate, which, however thin, still imply a degree of depth through the accumulation or buildup of successive, overlapping layers. Later, Man Ray emphasized the dematerialized effect produced by these images when he described the entire collage series as follows: "The inevitable result is a projection into space," he

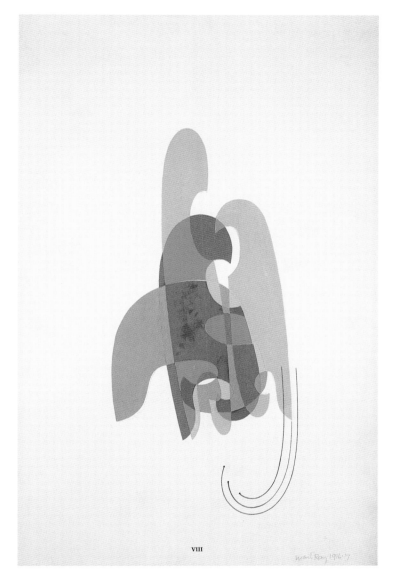

164. *Shadows,* 1916–1917. Collage on paper, 21 X 13 in. Collection of Mr. and Mrs. Meredith J. Long.

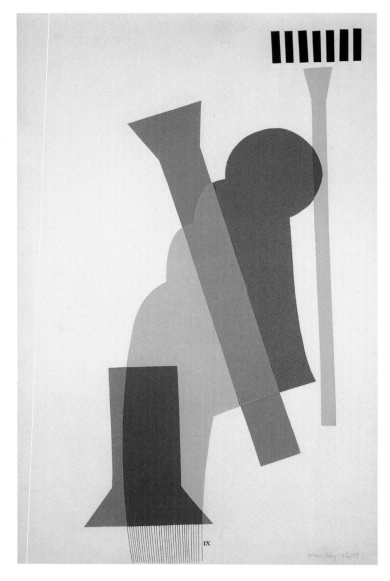

165. *Concrete Mixer,* 1916–1917. Collage on paper, 21 X 13 1/2 in. Collection of Mr. and Mrs. Meredith J. Long.

166, facing page. *Legend,* 1916. Oil on canvas, 52 x 36 in. Collection of Mr. and Mrs. George L. Lindemann. Photo courtesy of Mr. and Mrs. George L. Lindemann.

said, "an equivalent of light."[33] This may appear to be a minor detail, but it is one of which Man Ray was aware. Although he expressed it in rather awkward terms, this point was made clear in the first sentence of an introduction he prepared for *The Revolving Doors:* "The concern of a period of time often leads to the disappearance of material space" (see document B).

Man Ray began his series of collages in the fall of 1916, shortly after he and Adon Lacroix moved from their Lexington Avenue studio to a smaller but more comfortable apartment on Twenty-sixth Street off Broadway. As he prepared for his second one-person show at the Daniel Gallery, which was scheduled to open in January of 1917, his efforts to create an imagery that best reflected the inherent flatness of a painting's two-dimensional surface appear to have gradually given way to an alternative method: an essentially sculptural technique wherein the viewer's attention would be increasingly directed to a painting's purely physical properties. This effect was achieved through a variety of methods: by the physical buildup of paint, through the application of texture, by creating the illusion of shallow relief, and, in certain instances, by attaching actual two- and three-dimensional objects to the surface of the canvas.

A large untitled ink drawing of this period (fig. 167) appears to represent an intermediary step in this transition. A series of overlapping abstract shapes is rendered with the properties of both opacity and translucency. In the lower center of the composition, a compressed ovoid appears to hover above these irregular shapes at the very position of their confluence. In turn, these shapes then gradually darken as they approach their own extremities, toward the periphery of the drawing's outer format, suggesting that they have attained approximately the same spatial position as the overlapping small opaque ovoid. Thus, as with

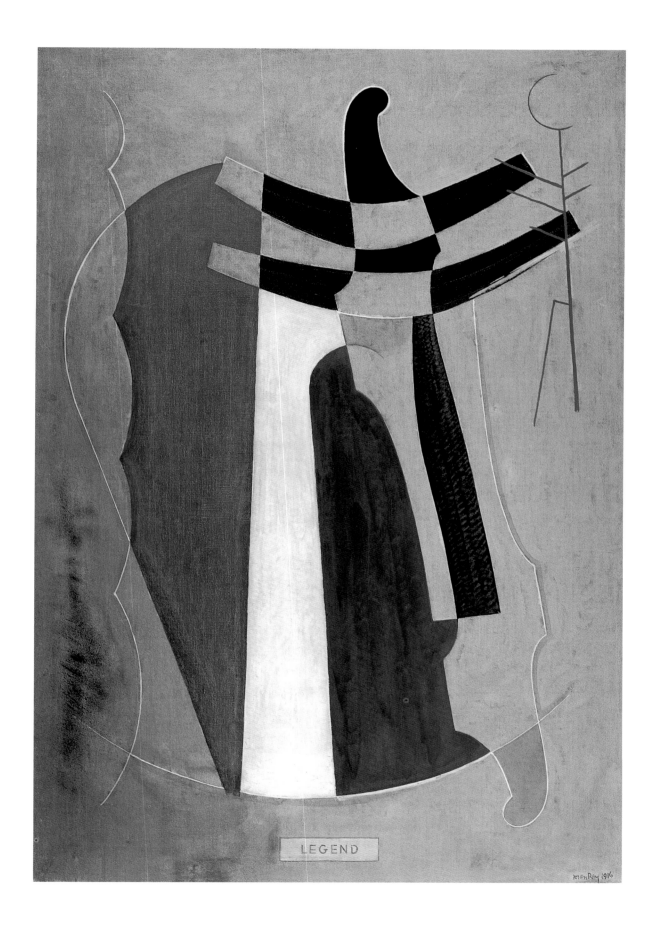

LEGEND

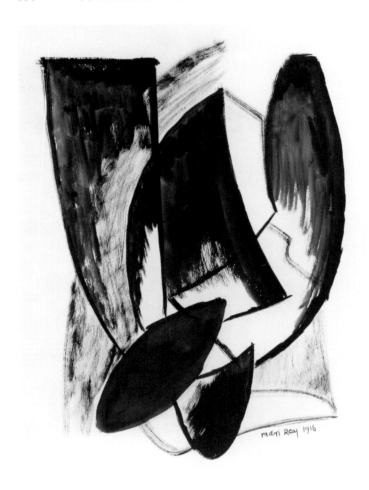

167. *Untitled,* 1916. Brush and ink on paper mounted on board, 21 3/4 x 16 1/2 in. Present whereabouts unknown.

selected panels from the *Revolving Doors* series (particularly *Shadows,* fig. 164), the resultant effect produces the illusion of an abstract image that seems to occupy a relatively compressed though somewhat ambiguous spatial position on both sides of the picture plane: seeming to hover above it and, at other times, appearing to recede into the shallow depths beyond it.

Angular, tapering shapes, similar to those that had formed the basic motif of this drawing, reappear as background elements in an essentially abstract composition that has been known under a number of variant titles: *Invention,* as it was first called; *Painting,* as it was renamed in the early 1920s; and *The Mime,* as it is now known (fig. 168). Only the latter title provides an indication of the possible origin of these angular shapes; they may have been loosely extrapolated from the figure with outstretched arms in *Mime,* the first panel in the *Revolving Doors* series (fig. 162). In the painting, however, these shapes exhibit no such overtly figurative associations. Rather than replicate the unarticulated forms and mechanical precision of the collage, the angular shapes in the painting are accentuated by means of diverse textural patterns. Once the location of these various shapes was determined, and before the pigment was allowed to completely dry, the artist added these textural patterns by cutting into or scoring the paint surface with a pointed instrument, as if to suggest that these shapes were fabricated from a variety of materials. In the painting, these impressions appear to have been made with a number of relatively common utensils: a comb, pulled across the paint surface to create a series of parallel and cross-hatched markings; a fork, bounced over the surface of the prominent shape in the central foreground, producing a somewhat irregular pattern of puncture marks; and a palette knife, which was used to apply the paint and, in certain details, to provide emphasis or further definition to the shapes them-

selves. The darker pigments are applied in such a way as to create the illusion of shadow, an impression that is especially effective when the painting is viewed from a distance. The assertive quality of the textural patterns, then, juxtaposed with the suggestion of a shallow recessional space, produces the general effect of a collage or assemblage, wherein these separate, angular shapes appear to have been affixed to the surface of the rectangular support in the fashion of a relief.

When the painting is examined at a closer range, however, the impression of relief quickly dissipates. The *trompe l'oeil* effect that was employed in works begun earlier in the year—as in *The Rope Dancer* (fig. 159)—is here replaced by a more prominent and assertive surface tactility. Indeed, in a number of his paintings of this period, it appears as though Man Ray has intentionally juxtaposed a contradictory or opposing reading of the picture surface. In spite of the illusory details contained in *The Mime* (fig. 168), for example, it is a painting that would be virtually impossible to physically reconstruct, for it would not be possible to determine the precise spatial positioning of one abstract shape in relation to another. The diagonal line cutting through the upper right quarter of the composition, for example, appears connected to the inner corner of the curved, tapering shape on the right, a form that is clearly rendered as if receding into the background of the painting. At the lowest point where this diagonal line begins (or ends), it forms a near-right-angle alignment with the upper border of the tapering shape, creating the impression that this diagonal was meant to define the edge of an overlapping, frontally positioned translucent plane. This reading is reinforced by the positioning of this diagonal with respect to the prominent central shape, the uppermost reaches of which appear masked or overlapped by the translucent plane. Thus, the illusory qualities of this plane can be seen to function in a

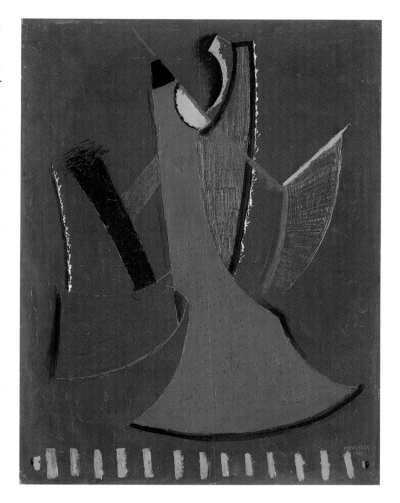

168. *The Mime*, 1916. Oil on masonite, 24 1/4 x 18 1/8 in. The Metropolitan Museum of Art, New York; Gift of Everett B. Birch, 1982 (1982.333).

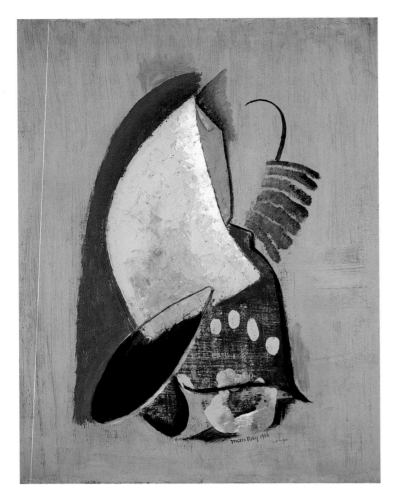

169. *Painting with Hand Imprint,* 1916. Oil on composition board, 24 1/2 x 18 1/2 in. The Art Institute of Chicago; Gift of Muriel Kallis Newman in memory of her mother, Ida Kallis, 1980.282.

physically contradictory manner, simultaneously exhibiting the properties of opacity and translucency. The overall planar frontality of the composition is further reinforced by a pattern of short, light-colored vertical brushstrokes, aligned in uniform succession along the lower border of the composition.

Paradoxical readings of a similar nature contribute to the spatial complexities of another work of this period, *Painting with Hand Imprint* (fig. 169), which, as the title indicates, includes the impression of a hand dipped into fresh paint and applied to the surface of the canvas. Like the pattern of short, vertical brushstrokes in *The Mime,* this handprint serves to reinforce the physical tactility and planar surface tension of the painting as a whole. But in this case the hand might also have been intended to represent the artist's signature, just as primitive man placed the mark of his hand on the surface of cave walls in prehistoric times or as American artists of the nineteenth century occasionally signed their paintings by leaving the impression of their fingerprints in the paint surface. For Man Ray, this method of assigning authorship would have seemed especially appropriate, for, even with his limited knowledge of foreign languages, his Belgian-born wife would have made him aware of the fact that in French his first name was phonetically equivalent to the word for hand: *main* = man.[34] The painting's physical properties are further enhanced by the large light-colored shape in the center of the composition, defined by an exceptionally thick impasto, loosely modulated with a palette knife so as to produce a visibly textured surface. The resultant tactility is formally challenged by the dark-colored, semi-opaque ovoid in the lower left corner—a form whose approximate shape and position were already determined in the untitled ink drawing discussed earlier (fig. 167). But here, as in selected details of *The Mime,* this shape both covers and

reveals those positioned beyond it, exhibiting the properties of both translucency and opacity.

While most of the remaining details in this painting seem to have been generated from purely abstract sources (other than the hand, of course), the coiled, spring-like shape on the upper right appears to have been derived from a similar detail in Picabia's *I See in Memory My Dear Udine* (Museum of Modern Art, New York), a monumental picture Man Ray would have been familiar with from the time of its first showing in Picabia's second major one-person exhibition at 291 in January of 1915.[35] Even if he missed this painting while on exhibition, the same spring-like shape appears in Picabia's *Fille née sans mère* [*Girl Born without a Mother*], a drawing that was published in the June 1915 issue of *291,* a magazine with which Man Ray was certainly familiar. In spite of the remarkable precedence of this shape in works by Picabia, it is doubtful that Man Ray would have consciously appropriated such a specific detail from the work of a fellow painter. It is more likely that, in following the example of Picabia's machinist style, he associated shapes of this type (those produced by means of an even, repetitive pattern) with a general notion of mechanical imagery. Rather than allow these details to carry a symbolic significance within the complex structure of the painting as a whole—as did both Picabia and Duchamp—Man Ray has presented this mechanical form in a literal and straightforward fashion, just as unaltered and as bluntly stated as the impression of his hand.

It was probably Man Ray's increasing familiarity with the ideas and work of Duchamp, combined with an unsettled desire to emphasize the innate physicality of a painting's natural two-dimensional surface, that led him to present such a literal display of this machine aesthetic in a painting he originally called *Entities,* now known by the title *Love Fingers* (fig. 170). This work is domi-

nated by five sharply defined vertical "entities," stylized mechanical forms derived from the design of tin chimney ventilators that the artist saw on neighboring rooftops from one of the windows in his Twenty-sixth Street studio. In 1915 Duchamp had selected such an item to serve as a readymade, which he inscribed *Pulled at Four Pins* and gave to one of his friends. If Man Ray was familiar with this work, then, as Arturo Schwarz has noted, this painting may very well have been envisioned as "an indirect homage to Duchamp."[36]

*Entities* was shown in the company of eight other relatively recent works in Man Ray's second major exhibition at the Daniel Gallery, which opened during the first week of January 1917.[37] The show was accompanied by a small catalogue (fig. 171) that contained a reproduction of the drawing *Ballet-Silhouette* (fig. 161) and provided a list of the titles assigned to the ten works shown. Included as an insert to this catalogue was a long statement by Adon Lacroix, wherein the poet suggested that the idea for a painting could not be disassociated from its physical makeup and that words devoted to explaining a given work of art lacked the expressive qualities exhibited in the work itself. In its consciously repetitive style, this statement appears to have been composed in emulation of the writing techniques of Gertrude Stein. It begins with a quotation in French from Alex Borg:

. . . tout était aussi naïf que l'est chez l'enfant la conception simplifiée des richesses de la nature, de son inepuisable diversité de formes et de couleurs lesquelles son perceptibles seulement a l'oeil arrivé a un haut degré de developpement.

—ALEX BORG

Words with meaning or words without meaning, words will be words always. But whether a painting includes a picture or vice

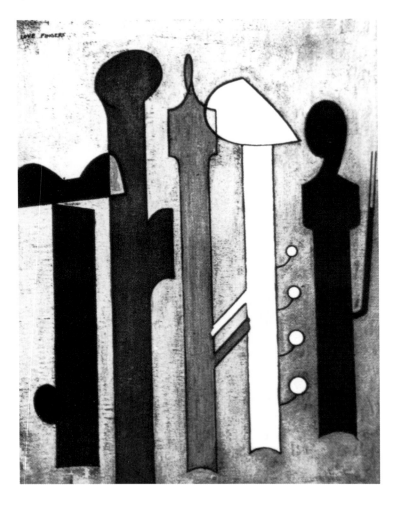

170. *Love Fingers* or *Entities,* 1916. Oil on canvas, 23 5/8 x 18 1/8 in. Estate of E.L.T. Mesens, Brussels, Belgium.

EXHIBITION OF PAINTINGS
& DRAWINGS BY MAN RAY
UNTIL JANUARY SIXTEENTH

NEW YORK PUBLIC LIBRARY-ART DIV.

THE DANIEL GALLERY
2 WEST 47TH STREET

versa . . . a picture includes a painting and a painting includes a picture and one is both and both are one. The pervading subject in everything is the idea. In everything an idea is in existence but like degrees of quality ideas differ in quality. Out of an idea comes everything in existence, no matter what the idea may be. The idea includes the picture painted, the idea comprises the substance itself; color; and from the color—the subject. The idea is, in a word, the backbone of everything existing. It may be one clear, crystallized idea or a chaos of ideas; ideas and matter are one in painting—the one cannot accomplish anything without the other. But words written on paper with ink or pencil, or thrown into space—words will be words always, and their value depends entirely upon the idea. Let someone blunder out incoherent sounds or rather gesticulate instead of having recourse to words; it will be far more expressive, for words have that mild adopted form that will never make them as expressive as the gesture. The hardship in combining successfully both ideas and paint into words is the same as the expression of ideas by words: while by one gesture the artist can say so much, besides leaving so much more to the imagination. Words will be mild in comparison, always.

—ADON LACROIX

171. *Exhibition of Paintings and Drawings by Man Ray.* Catalogue, Daniel Gallery, New York, January 1917. New York Public Library, Astor, Lenox and Tilden Foundations (original destroyed).

Along with *Entities,* most of the works that were shown in this exhibition can be positively identified from the list of titles that was published in the catalogue: *Promenade* (fig. 153), *Mime* (fig. 168), *Ballet-Silhouette* (fig. 161), and *Black Widow* (fig. 146), here still called "Nativity." But these paintings and drawings drew relatively little notice from visitors to the gallery, particularly in comparison to works that the artist more vaguely identified with the titles "Invention I" and "Invention II," as well as "Portrait I" and "Portrait II." One of the works probably categorized as an invention consisted of nothing more than a rectangular panel that was intentionally hung at an angle in a corner of the exhibition space. When viewers tried to adjust the painting's alignment, because of a second nail affixed to the wall behind the painting, the work insistently swung back like a pendulum to its original position.

Another work—originally categorized as a portrait—was also designed to confound the sensitivities of well-intentioned spectators. Known today as *Self Portrait* (fig. 172), this mixed-media assemblage was, as the artist later reported, "the butt of much joking." The work consisted of a vertical panel painted with black and aluminum paint, resembling the general shape of a doorway and its opening. Upon the panel were affixed two actual doorbells and a pushbutton, as if to suggest that pushing the button would cause the bells to ring. But such was not the case, for these devices were never connected, causing considerable disappointment among visitors to the exhibition. "They were furious," Man Ray told Arturo Schwarz. "They thought I was a bad electrician."[38] But it was not the artist's intention to set up a simplistic stimulus-and-response demonstration such as one might encounter in a psychological experiment. He only wanted the visitors to his exhibition to assume a more participatory role in their viewing of his artistic productions. As he himself put it: "I simply wished the spectator to take an active part in the creation."[39]

A desire to involve the viewer in the creative process may owe a good deal to Man Ray's conversations with Duchamp, who later carefully outlined a theory wherein he established that an art object could not be considered complete without taking into consideration the role of the spectator.[40] No matter what the motivation may have been, Man Ray's inventions were immediately labeled "humoristic" and flatly dismissed by critics of the exhibition who saw them as evidence that the artist failed to take his own work seriously. Willard Huntington Wright, who earlier in the year had written favorably about the artist, found the humor in these works objectionable: "Ray formerly showed unmistakable signs of talent," he wrote, "but his new work possesses none of his earlier good qualities. Such artificial devices as electric bells, push buttons, gilt paper, daring silk and finger prints, which are plastered about his canvases, do not create any divergency of surface material. In their obviousness they serve only as somewhat humorous distractions."[41] Only the insightful art critic of the *New York Sun,* Henry McBride, seems to have made a serious attempt to analyze the implications of a spectator's participatory role, even though he felt that the work itself should not actually be touched:

> Mr. Ray submits a few "inventions" and portraits in a most arbitrary of modern/manners, so that the would-be lover of his art is compelled to advance at least seven-eighths of the way along the path to meet the artist's intention. In former days it used to be considered enough, nay gracious, to go half way. But times certainly change.
>
> One of the portraits has some sort of a

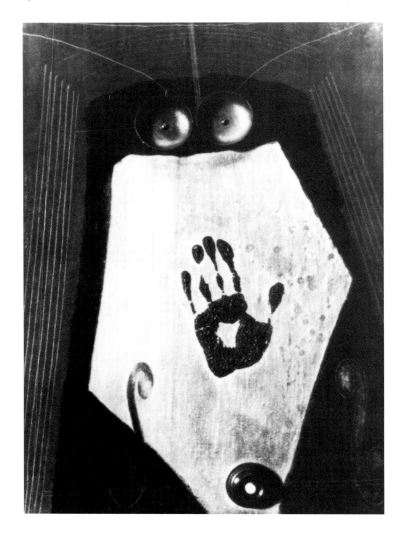

172. *Self Portrait,* 1916. Oil on canvas with attached bells and pushbutton, 24 x 18 in. Lost or destroyed (photo by Man Ray, gelatin silver print, 3 3/4 x 2 3/4 in. The J. Paul Getty Museum, Los Angeles, Calif.

bell, a real bell, attached to the panel, and below it is fastened a real bell button. All the people who were in the gallery at the time of my visit betrayed, each in his turn, a strong desire to touch the bell button. I felt it myself, but knowing the respect due to serious art, successfully resisted the temptation.

Mr. Ray thus shows that as an artist he has a genuine command over what Bernhard Berenson calls the "tactile values." The art experts of the future may hold that Mr. Ray's "Portrait II" marks as strong an advance in tactile values over the art of Masaccio as Masaccio's art did over Giotto's.[42]

It would seem that the controversy generated over this picture alone would have been enough to have drawn the artist's attention to the seemingly insurmountable gulf that existed between the idea for a picture and any attempt to express this idea in the picture itself, a problem that had already been anticipated in the prophetic catalogue statement prepared by his wife for this exhibition. Yet, in the face of these unavoidable difficulties, the artist continued to emphasize the precedence of a given idea over any technical considerations that might be involved in its actual execution. Such an approach, however, offered certain obstacles. "I didn't realize at that time," the artist later recalled, "that the public, the people, even those who are intelligent, above all things, hate ideas."[43]

Of course, such a conceptually oriented approach marks a break from the formalist concerns that had so thoroughly dominated the artist's earlier work. This sensibility, as we have already indicated, owes a considerable debt to Duchamp,

who maintained that ideally the production of a work of art should avoid appealing to purely optical properties, or to the "retinal," as he put it, and that it should instead be a "cerebral" act. These ideas certainly had their effect on the young painter. In an interview conducted later in life, Man Ray explained how his efforts to avoid repetition led to his realization that in the art-making process the mental should take precedence over the visual:

> When I first began to paint independently from the schools, I never drank or took dope or anything, but the smell of paint, of turpentine, would intoxicate me the way alcohol would intoxicate others. I loved that smell and it was a voluptuous thing to be able to paint. As a reaction, to avoid complacency and repetition, we began to use our brains, to use the painting medium to express ideas and not just to demonstrate our virtuosity. The Americans couldn't grasp that.[44]

Indeed, the Americans truly could not understand. As might well have been expected, Man Ray's second showing at the Daniel Gallery resulted in no sales whatsoever. His dealer was as bewildered in his efforts to comprehend the new work as were the majority of visitors to the gallery. Moreover, Daniel had problems of overhead to consider, so he naturally attempted to discourage the artist's experimentation. On a regular monthly basis, he even offered to purchase the artist's earlier more figurative, and thus eminently more saleable, work. "But I couldn't go back," Man Ray later explained. "I was finding myself, I was filled with enthusiasm at every new turn my fancy took, and my contrary spirit aiding, I planned new excursions into the unknown."[45] In the years to follow, these excursions would lead Man Ray through artistically uncharted territories to even more adventurous and experimental avenues of artistic expression.

visual words
sounds seen
thoughts felt
feelings thought

ADON LACROIX 1915

WITH THE BOX OF THE CHOCOLATE EDGE

not so
DA DI ME
OMA DO RE TÉ
ZI MATA DURA
DI O. Q DURA
TI MA TOITURA
DI ZRATATITOILA

la la lar-r-rita

lar-r-rita   lar-r-rita
I love you.

mi o do ré mi mi o
"marmelade"

PN
ZAZZ
O MA QU
RRO RRO
RU K
ASHM ZT
PLGE
ZR KRN NMTO TO

NM E SHCHU
KM NE SCU

# EIGHT

## THE ART OF PAINTING IN MORE THAN TWO DIMENSIONS: The Paintings, Drawings, Watercolors, *Cliché Verre*, and Airbrush Compositions of 1917–1919

In January 1917—the same month when his exhibition at the Daniel Gallery was held—Man Ray hand-lettered and -printed another small pamphlet of poetry, on the cover of which were inscribed the words "visual words / sounds seen / thoughts felt / feelings thought," a somewhat accurate summary of the intent and contents of this ephemeral publication (fig. 173). The text consists largely of nonsense syllables, twists and variations on a musical scale that, when read aloud, evoke the incantation of an amusing love poem: "*mi o do ré mi o 'marmelade'.*" Exactly what motivated Man Ray to issue this pamphlet at this time

173, facing page. *Visual Words, Sounds Seen, Thoughts Felt, Feelings Thought,* January 1917. Pamphlet. Arensberg Archives, The Marian Angell Boyer Library, Philadelphia Museum of Art.

is unknown, unless he intended it as a private, amorous message for his wife, written, perhaps, in gratitude for her having contributed the introduction to his show.

Whatever prompted the creation of this modest literary achievement, after his show closed at the Daniel Gallery, it is clear that Man Ray began to question the direction he had been pursuing as a painter. Soon he would consciously abandon his adherence to the formalist program that had so thoroughly affected the development of his work. Indeed, as he later explained in his autobiography, the adverse reaction he had received during the course of this exhibition only served to fuel what he himself described as a "contrary spirit," rekindling his determination to not turn back. Rather, in the future he would explore alternative

approaches and techniques, pursuing with even greater enthusiasm what he called "new excursions into the unknown."[1] With his most recent experiments so thoroughly misunderstood by the public and press alike—not to mention his dealer, as well as some of his closest friends—from this point onward Man Ray's work would become increasingly identified with the younger generation of American modernists who sought inspiration from the example of their more renowned European colleagues.

No doubt in realization of his newly established position, three works by Man Ray were included in an exhibition of modern art—said to have been organized by a group of European and American artists—held at the Bourgeois Galleries in February of 1917. Here, for the first time in a prominent New York gallery, Man Ray's work was shown in the company of progressive American *and* European art—from European modernists who had already established their reputations (Georges Braque, André Derain, Albert Gleizes, Francis Picabia) to younger American painters and sculptors whose work was just then becoming associated with the most recent developments of the modern school (John Covert, Jean Crotti, Morton Schamberg, Charles Sheeler, Joseph Stella, and Adolf Wolff). Although it was not emphatically stated in the accompanying catalogue, one of the primary purposes of the exhibition was to point out that modern art did not stop with the Armory Show—that a new generation of modernists was just beginning to emerge. "The men who have not reached the point where their artistic character is determined," read the catalogue statement, "feel a great freedom before the means from which they are to choose, and search for the ones that will carry them farthest."[2] Indeed, during the course of 1917, this search would lead Man Ray to choose both the inspiration and means by which to carry his work even further than that of his most advanced American colleagues.

The next major exhibition in which Man Ray was to participate was the first showing of the newly established Society of Independent Artists, to whose board of directors he had only recently been appointed.[3] According to the rules of the society, anyone who paid the required initiation fee of one dollar and an annual dues of five dollars was allowed to submit two works to the first exhibition. In preliminary statements, it was announced that each work would be displayed in full daylight, with the additional guarantee that at least one by each artist would be hung "on the line," or at eye level. With only one exception, the hanging committee kept its promise for over one thousand exhibitors, in spite of the fact that they received over two thousand works for exhibition. So as to further guarantee equality among the exhibiting members, the board of directors endorsed Duchamp's suggestion that the works be hung in alphabetical order, in accordance with the first letter of the artist's last name. It was also Duchamp's idea that the first entry to be hung be determined by the drawing of letters from a hat.[4] As chance would have it, the letter *R* was selected, so Man Ray's submission—*The Rope Dancer* (fig. 159), then still entitled "Theatre of the Soul"—was placed in the most desired position available, at the northeast corner of the main gallery, greeting visitors upon their entry to the exhibition.

Years later Man Ray recalled that a number of his fellow exhibitors were displeased with the hanging. In fact, some even went so far as to claim that the arrangement of the pictures may have been the results of a publicity stunt. But it was not the prominent position of Man Ray's painting they complained about. It was his vibrant use of colors, which apparently drew too much attention away from the surrounding works. "My painting

made theirs look dull and insignificant," he recalled. Indeed, Stieglitz, who again confronted the artist before his work (as he had in the Forum Exhibition a year earlier), thought the painting was "very significant," that "it vibrated." "In fact," the prominent dealer and photographer noted, "it was almost blinding."[5]

It was not Man Ray's entry, however, that drew the most attention from the press. Reviewers of the exhibition repeatedly singled out works for their unusual subjects and materials, while predominantly conservative critics and would-be critics had a virtual field day with the paintings and sculptures that displayed even the most remote of modernist tendencies. Historically speaking, however, the work that was to make the most significant impression was an object that was not even shown in the exhibition: Duchamp's infamous white porcelain urinal, submitted under the pseudonym R. Mutt and assigned the simple but provocative title *Fountain*. In spite of the society's "no jury" policy, an emergency meeting of its directors was called to decide whether such an "indecent" object could be placed on public display. The directors solved the problem by officially declaring that the work was not a work of art and thus could not be included in an art exhibition. Of course, this was exactly what Duchamp expected, for his entry not only tested the liberal rules of the society he helped to establish but also forced the public to consider the question of exactly what constituted a work of art, a subject Duchamp had been thinking about for a number of years in connection with his concept of the readymade.

It was in this crucial period of Man Ray's artistic development—while gaining ever-increasing exposure to the nihilistic attitudes of Duchamp and his friends—that the young painter must have come to seriously question the importance and validity of his former working methods. Certainly,

it was the freedom expressed by the Independents that caused him to question the ability of others to judge the quality or importance of a given work of art. Some forty years later he would proudly declare that he had "never submitted a work to a jury or in competition for a prize."[6] Moreover, as he had doubtlessly already discovered, a strict adherence to an art comprised of exclusively two dimensions imposed natural formal limitations that the artist was no longer willing to accept. Furthermore, this new, more adventurous attitude toward the art-making process coincided with a number of important events in the artist's life—both public and private—each of which contributed in varying degrees to the radical change in style and approach that marked the transition of his work in this period.

First, President Wilson's declaration of war with Germany on April 6, 1917, must have had a profound effect on the artist's attitude toward his government, as it did, in one way or another, on all American citizens. Since this important historical announcement coincided with the opening of the Independents, reviewers of the exhibition were quick to draw comparisons between the democratic principles of the society and America's defense of world democracy. Man Ray's pacifist leanings and friendship with a number of anarchists, however, would have protected him from developing any blind patriotic attitudes about war, and they certainly would have prevented him from supporting an active participation in the war effort. Nevertheless, the artist could hardly have failed to compare his own artistic liberation with the theme of political liberation that had dominated the headlines. The general impression promoted by the American government was that we were entering the war not only in defense of our European allies but as a necessary step in securing total world freedom. It is hard to imagine that

174, facing page. Photographs of Adon Lacroix, ca. 1917–1919. Collection of Constance and Albert Wang.

artists predisposed toward the most current tendencies in modern art would not have readily transposed this concept of liberation to their own personal struggle to break from the restrictions and entrenchments of a more established and accepted form of academic art. Indeed, Frederick James Gregg, who wrote about both art and politics for *Vanity Fair,* said that the Independents exhibition "stands for the spirit of the greater freedom that all real Americans confidently believe will mark the end of the War," concluding, "Art, like a man, can live truly only when it is free."[7]

Second, on a far more personal level, it was approximately in this same period—while pondering the future course of his artistic production—that, Man Ray later recalled, he first began to experience certain marital difficulties. In the spring of 1917, after the close of his second exhibition at the Daniel Gallery, Adon Lacroix apparently became concerned with the fact that no works managed to sell. Without sales to depend upon in order to supplement their meager income, she complained that their rent was too high and feared that they might no longer be able to meet their normal living expenses. On at least one occasion she resorted to outright thievery; against her husband's better judgement, she stole a winter coat from a big department store in New York—a criminal act, Man Ray conceded, probably committed more to create excitement than for reasons of necessity. In a group of photographs that he took of his wife in these years (fig. 174), she can be seen sporting a leopard-skin wrap, possibly the very item of apparel that she pilfered. If the expression on her face in these photographs is any indication, it seems that Lacroix, too, was beginning to question the happiness of their marriage. The

couple occasionally engaged in a game of chess, which, according to Man Ray, inevitably ended in a quarrel, because she hated to lose.

As Man Ray became increasingly involved in his work, he started leaving his wife alone for long periods of time (a situation that later contributed to her having an affair with another man and the couple's eventual separation). Whether these personal difficulties contributed to the dramatic change in style that Man Ray experienced at this time would be difficult if not impossible to establish with certainty. It is likely, however, that these important events in his life would have forced the artist at least to momentarily step back and assess the status of his current situation—on both a personal and professional level—while contemplating the direction of his future.

At some point in early 1917, the couple moved to less expensive quarters in Greenwich Village: a small apartment on Eighth Street off Fifth Avenue, just around the corner from the famed Brevoort Hotel, in an area that had already established itself at the heart of Manhattan's growing bohemian district. As comfortable as these new, more domestic surroundings might have been, in smaller and more restrained quarters Man Ray found himself unable to carry out his work. Just after settling in, however, his landlady offered him the rental of an empty attic room. In this garret-like space, Man Ray decided to abandon the standard tools of painting, in order to discover an entirely new method of pictorial expression. "I'd already done away with brushes and was painting almost exclusively with knives," he told Arturo Schwarz, "but I was still not satisfied."[8]

Man Ray had employed the palette knife in a number of earlier works—as in *Dance* (fig. 145) and a few small paintings from the previous year (figs. 168, 169)—and he seems to have favored the control of paint application offered by this tool

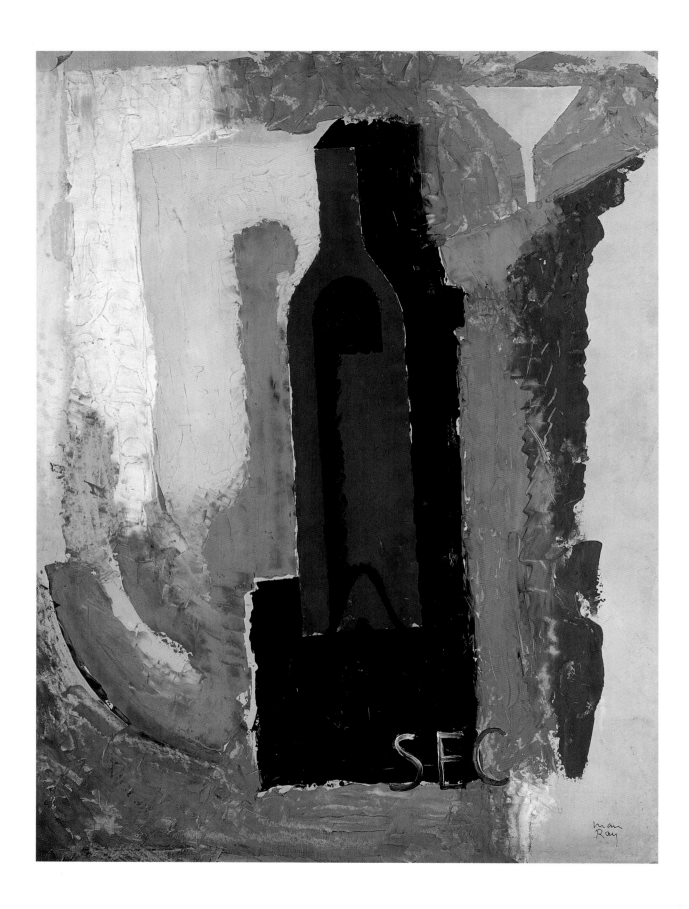

175, facing page. *Sec, 1917*. Oil on plasterboard, 24 x 18 in. Private Collection.

throughout his career as a painter. The heavily textured layers of pigment in two still lifes from 1917, *Sec* (fig. 175) and *Filter* (fig. 176), appear to have been applied entirely with the blade of this sharp, planar instrument. While the specific images of these paintings may have been inspired by his domestic surroundings, the subjects reveal certain interests that had already made their appearance in his earlier work. In *Sec*, for example, Man Ray's Francophile penchant is revealed in the word *sec* (French for dry) inscribed at the base of the dark bottle in the center of the composition that contains either wine or liquor (depending on how you interpret the Martini glass in the upper right corner of the picture).

In *Filter*, the artist's interest in machines and machinist imagery, which he had explored in works dating from as early as 1915, is more overtly acknowledged. In this case, however, the machine part he has depicted does not come from a car or some other example of modern technology, but—like Duchamp's readymades—is an ordinary utilitarian item. Indeed, Man Ray's choice of a coffee filter may have been inspired by Duchamp's earlier painting *Coffee Mill* (Tate Gallery, London). Man Ray would not have been familiar with the painting itself, for at the time it still hung on the wall of Duchamp's brother's kitchen in France, but he might have known it through its reproduction in Gleizes and Metzinger's book *Cubism*.[9] In subject, the stark isolation of such a commonplace manufactured item bears an even greater resemblance to Duchamp's two versions of the *Chocolate Grinder*,

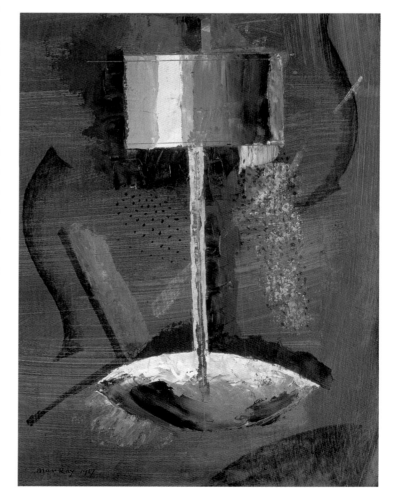

176. *Percolator* or *Filter*, 1917. Oil on board, 16 x 12 in. The Art Institute of Chicago; Partial gift of the Albert Kunstadter Family Foundation.

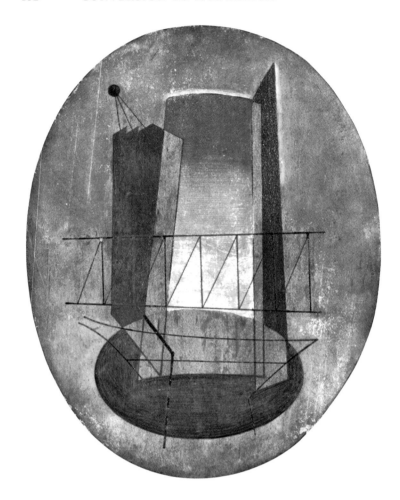

177. *Narcissus* or *The Ship "Narcissus,"* 1917. Oil and varnish on wood, 14 x 10 1/2 in. Private Collection, Amsterdam. Photo courtesy Rijksdienst Beeldende Kunst, Amsterdam.

which by this date Man Ray certainly would have known through exhibitions in New York or through visits to the Arensberg apartment, where both of these paintings hung on the wall of the main sitting room.[10]

While the use of a palette knife may have liberated Man Ray from the traditional tools of a painter, the resultant textural effect was in direct contrast to the precisely defined forms of an industrially manufactured object. Moreover, the palette knife was not an instrument that lent itself easily to filling in detailed areas of background color, and perhaps for this reason, in a number of his paintings from this period—such as *Filter* (fig. 176), *The Ship "Narcissus"* (fig. 177), and *Arrangement of Forms* (fig. 178)—Man Ray allowed the paintings' natural support to serve as the primary background coloration of the image.

In *The Ship "Narcissus,"* onto the surface of a thick, oval-shaped breadboard, Man Ray has depicted the hull, smokestack, and details from the upper deck of a large seafaring vessel. These geometric shapes are set against the natural brown tonality of the wood, as if to suggest that the exposed background material was meant to be equated with the open expanse of the surrounding sea. The pronounced degree of abstraction in this picture has caused at least two authors to incorrectly identify its subject, seeing in the image the forms of a narcissus plant growing in a pot.[11] Knowing the correct title, however, allows us to identify a specific image the artist may have consulted in painting this picture: an ink sketch he made many years earlier of men painting a smokestack on a large steamship (fig. 34). Although everything in the painting is more schematically

178. *Arrangement of Forms,* 1917. Oil on cement board covered with paper, 36 x 32 in. Musée national d'art moderne, Centre Georges Pompidou, Paris.

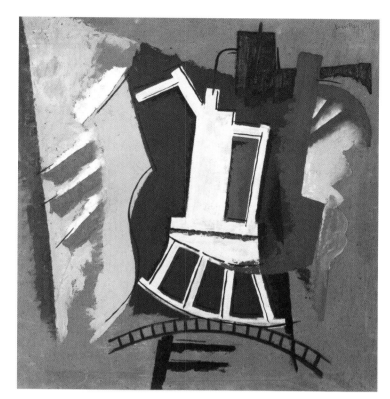

rendered, certain details were carried over: the smokestack in the center of the image, a railing in the foreground, and even a semblance of the hanging scaffolding, retained in the form of lines emanating from a black circle in the upper left corner of the painting.

As was noted, this image was painted onto the surface of an ordinary breadboard, an unusual support for painting, but one the artist selected in order to affect the way in which viewers would comprehend the image. He was no longer interested in capturing the essence of a three-dimensional object in two dimensions, as artists had since the Renaissance, but rather in presenting the two-dimensional object for what it was: a physical entity that occupies space and inhabits the very environment occupied by the viewer. It may have been a similar line of reasoning that caused Man Ray to paint his next picture, *Arrangement of Forms* (fig. 178), onto the surface of heavy construction board, a building material made from a thin slab of concrete covered by paper that was used for the construction of interior walls (similar to today's plasterboard). This material would certainly have lent the painting a more enhanced physical presence, for painting on its surface was the equivalent of painting directly on a wall, just as the fresco painters of the Renaissance, for whom he had earlier professed such strong admiration, had done.

*Arrangement of Forms* is aptly named, for the theme that may have inspired this picture is so thoroughly interfused with its abstract shapes and colors that the subject is no longer discernible. Fragments of what appears to be mechanical imagery are set against less defined and only par-

tially contained areas of pure, unmodulated color, all of which in turn is given the appearance of hovering in suspension against the brown tonalities of the exposed paper support. But the harsh juxtaposition of an impasto surface (created by the continued use of a palette knife) against a wholly unarticulated background plane serves only to enhance the expressive and painterly qualities of the image, precisely the impression Man Ray said he wanted to avoid. "My efforts [during] the last couple of years," he later said of his artistic goals in this period, "had been in the direction of freeing myself totally from painting and its aesthetic implications."[12]

"I wanted to find something new," he later proclaimed in an interview, "something where I would no longer need an easel, paint, and all the other paraphernalia of the traditional painter."[13] The solution presented itself in the form of a mechanical device he had learned to use in his commercial work: the airbrush, essentially an instrument used by illustrators to produce a light, even spray of ink or paint. The airbrush was usually employed to cover large areas with color or to create the convincing impression of reflective surfaces and shadows. In order to control the precise direction of spray, it was necessary to fabricate templates of varying shapes and sizes. But it was not the potential of the airbrush to create illusionistic techniques that excited Man Ray about the use of this instrument in his work. His obsession with remaining exclusively within the confines of a purely two-dimensional art was over. Instead, he sought to explore any alternative that would take him beyond the confines of traditional painting. "When I discovered the airbrush," he said, "it was a revelation—it was wonderful to be able to paint a picture without touching the canvas; this was a pure cerebral activity. It was also like painting in 3-D; to obtain the desired effects you had to move the airbrush nearer or farther from the canvas."[14]

Although Man Ray may not have been aware of it at the time, there is a certain similarity of procedure between the airbrush technique and the process of printing in photography, the skill he had taught himself a few years earlier in order to take pictures of his painting. Just as the light must be partially obstructed or filtered through a translucent plane in photography (the negative), before making its impression on photosensitive paper, the ink or pigment forced through the nozzle of an airbrush must first be placed in temporary suspension with the atmosphere, whereupon, through the use of varying obstructing devices (templates), it is allowed to rest in selected areas on the surface of the paper or canvas. Indeed, since he tended to employ only a monochromatic range of colors in his airbrush pictures, it has frequently been noted that Man Ray's aerographs (the generic term used to describe these pictures) often take on the appearance of photographic prints—a curious resemblance, for later in life the artist would also be accused of trying to make his photographs look like paintings.[15]

One of Man Ray's first aerographs—and the only one to survive from the year when he began his experiments with this technique—is known today by the title *Suicide* (fig. 179). Originally the work was entitled "The Theatre of the Soul," the name given to a play by Nikolai Evreinof, the Russian director and playwright known for his theatrical parodies, satires, and monodramas (plays written for a single performer in which spectators were invited to participate).[16]

In the magazine *TNT* (fig. 197), Man Ray later published the complete text of this play in an English translation.[17] It is unlikely that the work was ever intended for actual production, although performances were later staged in England and America. "The action," Evreinof directed, "passes in the soul in the period of half a second." The principal character is identified only as a professor, who,

179. *Suicide*, 1917. Oil and tempera airbrushed on cardboard, 22 7/16 x 18 1/8 in. Menil Collection, Houston, Tex.

before the curtain rises, appears before the audience to explain the characters and the action that will follow. "'The Theatre of the Soul,'" the professor explains, "is a genuinely scientific work, in every respect abreast with the latest developments in psychophysiology." Acknowledging that his analyses are dependent upon the researches of Wundt, Freud, and Theophile Ribot, he goes on to divide the human soul into three divisions: the Rational, Emotional, and Subliminal Entities of the Soul, which, when combined, represent what he calls "the great integral self" or "the entire personality." On a blackboard, the professor then proceeds to illustrate the dramatic situation that will follow in the play itself. Evreinof has the professor describe this diagram as follows:

> This plan, ladies and gentlemen, represents, as no doubt you can see, a large heart, with the beginning of its main red artery. It makes from 55 to 125 pulsations a minute, and lies between the two lungs which fill and empty themselves from fourteen to eighteen times a minute. Here you see a little system of nerves, threads of nerves, pale in color, and constantly agitated by vibration which we will compare with a telephone.

According to Man Ray, *Suicide* was meant to represent "the dramatic situation on the professor's blackboard."[18] Although the various abstract elements in the aerograph do not exactly conform to a literal visualization of the professor's words, Man Ray may have intended to let the two seemingly suspended ovoid forms in the foreground of the composition represent the lungs mentioned in the professor's description, while the triangular config-

uration of lines in the upper center was probably meant to illustrate the system of nerves. On the other hand, it is also possible that Man Ray may have intended the oval shapes to represent the main characters in the actual play itself: the Rational and Emotional Entities of the Soul, who, throughout the performance, argue with one another over the respective virtues and vices of a wife and cabaret singer, each of whom is envisioned in alternating conceptions by the opposing states of the soul. Eventually, the cabaret singer triumphs over the wife, and, after being rejected by the singer, the Emotional Entity of the Soul despairs and begs to be shot with a revolver, which is accomplished in the closing moments of the play. Since the Emotional and Rational Entities are actually one and the same, representing opposing states of the self, this act could be interpreted as a suicide.

It is likely this interpretation of Evreinof's play that provided Man Ray with the rationale for later retitling this work, inscribing the single word *suicide* at the base of the picture, and allowing a photo of the aerograph to be published in 1924 as his sole response to a question directed to the Surrealists by André Breton: "Is Suicide a Solution?"[19] It was probably in this period—and not contemporary with the making of the picture, as several authors have believed—that, inspired by its title, the artist contemplated the possibility of using this work to play a part in his own suicide.[20] Apparently in a moment of severe depression, he considered rigging up a gun behind the picture so that, with a string attached to the trigger, he could look directly into the image and kill himself. But for a number of reasons, he decided against the idea. There was the thought that his suicide might give pleasure to some people, not one of the results he wanted to achieve.[21] Also, "I'd be accused of committing suicide with a mechanical instrument," as

he later explained, adding, "When I began painting with the airbrush I had already been accused of debasing art by painting with a mechanical instrument."[22]

Even though nothing as drastic as suicide was on Man Ray's mind in 1917, he must have been concerned with the fact that his work was probably only understood by a handful of close friends and his shows resulted in few sales. It was not that he wanted to be accepted by the general public. "I can only deal with one or two people at a time," he later told an interviewer. "I never think of the public, of pleasing them, or arousing their interests." In fact, by the end of his life, Man Ray developed a genuine resentment and animosity toward the public: "I despise them," he said, "just as much as they have despised me through the years—for the things I've done."[23] Nevertheless, it must have been frustrating for the young artist to realize that his most recent experiments failed to attract the interest of at least one or two discerning collectors of modern art.

It must have been with this predicament in mind that in July of 1917 he wrote to the well-known lawyer and collector John Quinn, asking him to consider the possibility of purchasing one of his works. In his letter, Man Ray pointed out the general prosperity of the art market, indicating that he was part of a small group of young artists excluded from this success because of his "individual ideas." He invited Quinn to visit his studio, where he could submit various works to the collector for purchase consideration. In a characteristically nasty response, and one that could only halfheartedly be considered apologetic, Quinn explained that under no circumstances would he allow an artist's personal needs to enter into his decision pertaining to the acquisition of works for his collection. "I have done my share," he wrote, "and I think more than my share of 'encouraging

your artists' or of buying the work of men with 'individual ideas.'"[24]

Man Ray's training as a mechanical draftsman, and his continued access to the tools and technical equipment of the trade during his employment for a map and atlas publisher, served the artist well in these years, as he increasingly sought to remove himself from the "romantic expressionistic" style of his earlier work, and produce a style that reflected the precise, linear, and more mechanically generated forms of an emergent machine aesthetic. It may have been for these reasons that in this period the artist experimented with a technique known as the *cliché verre,* a process whereby a drawing is incised onto the surface of a coated plate of glass, which in turn is used in the fashion of a photographic negative; the plate is exposed against a sheet of sensitized paper, resulting in a contact print of the image that could be reproduced in an unlimited edition.[25]

In 1917 Man Ray produced no fewer than five *cliché verre* prints, images that vary as greatly as the style of his work in this period. They could range from a straightforward portrayal of a standing female figure seen from behind (fig. 180, perhaps Adon Lacroix) to what appears to be an entirely abstract image (fig. 181).[26] The subject of at least one print was derived from the artist's earlier interest in musical themes: *Orchestra* (fig. 182) includes the neck of a bass viol, a chair, and a number of music stands placed in precarious balance for a conspicuously absent orchestral ensemble. The only indication of the missing musicians is found in the form of four claw-like mechanical hands, one of which appears to be grasping the neck of the viol. Indeed, from this point onward in Man Ray's artistic production, the human presence was to be increasingly diminished, either severely abstracted, represented only metaphorically, or, as in most cases, eliminated altogether.

180. *Untitled* [*Figure in Harem Pants Seen from Behind*], 1917. *Cliché verre,* gelatin silver print, 6 13/16 x 4 13/16 in. The J. Paul Getty Museum, Los Angeles, Calif.

181. *Untitled* [*Abstract Lines and Shading*], 1917. *Cliché verre*, gelatin silver print, 4 11/16 x 6 1/16 in. The J. Paul Getty Museum, Los Angeles, Calif.

In a *cliché verre* entitled *Automaton* (fig. 183), three robotic mannequins are assigned the duties of human musicians, the sound they generate as mute and as empty as their bodies. And in another *cliché verre,* entitled *Fire Escape and Umbrellas* (fig. 184), the people who might have been seated in a streetside café at the base of the image are hidden from sight by a cluster of parasols. The subject of this scene may have been inspired by a view from the window of Man Ray's attic studio; the design of the three-story fire escape and crisscrossing electrical wires lend themselves readily to the linear quality of the *cliché verre* technique. Finally, a rooftop ventilator on the far right of this image is the very object Man Ray had used (albeit in a more highly stylized fashion) in a painting made a year earlier, *Love Fingers* (fig. 170).

For Man Ray, the year 1918 was a period of limited activity and sharply curtailed artistic production. His relationship with Adon Lacroix was not improving, and socially the war years in New York were not as nonchalant and free-spirited, nor as openly optimistic, as times gone by. In March, Man Ray showed a landscape in the Exhibition of Contemporary Art at the Penguin Club, and in April he was represented by the painting *The Ship "Narcissus"* (fig. 177) at the Second Annual Exhibition of the Society of Independent Artists—the only two public showings of work by the artist recorded in this entire year.[27] In June, Duchamp left for Buenos Aires, to remain absent from New York for over a year and a half. Meanwhile, in this

182. *Orchestra*, 1917. *Cliché verre*, gelatin silver print, 15 1/2 x 11 1/2 in. Private Collection.

183. *Automaton*, 1917. *Cliché verre*, gelatin silver print, 9 1/4 x 7 1/2 in. Private Collection.

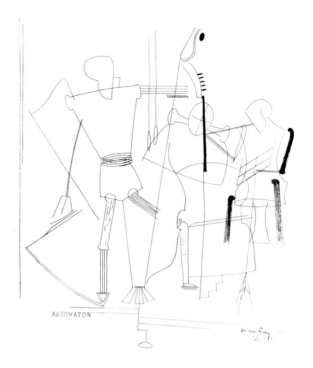

period Man Ray seems to have worked intermittently in a variety of media. On at least one occasion he continued his experiments with the palette knife, producing an abstract painting of irregular shapes defined entirely by layers of thickly modulated pigment (fig. 185). This is a most unusual painting by the artist, for it is known to exist in two separate versions (fig. 186), one image so perfectly replicating the other that until recently they were believed to be the same painting. Moreover, although both of these paintings are today signed and dated by the artist "Man Ray / 1924," from a record kept by the artist of works from this period, we know that the original painting was made in 1918 and that the pattern of white dots to the right of center in both paintings is conspicuously absent from the original composition (fig. 187).[28]

What accounts for multiple versions of the same painting is difficult to say, but there can be little doubt that these paintings represent Man Ray's most abstract work of these years. In both works, angular color planes are carefully defined by means of a palette knife, their surfaces so emphatically textural that the image is more readily comprehended for its material presence than for any illusionistic properties one might associate with the art of painting. Indeed, as if to underscore this very point, in certain passages the artist applied unmodulated areas of black pigment, which at first glance can be interpreted as areas of shadow. But these same dark passages hover conspicuously in a cruciform format in the lower left

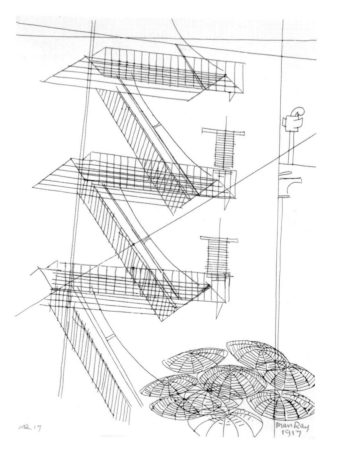

184. *Fire Escape and Umbrellas*, 1917. *Cliché verre*, gelatin silver print, 6 7/8 x 4 13/16 in. The J. Paul Getty Museum, Los Angeles, Calif.

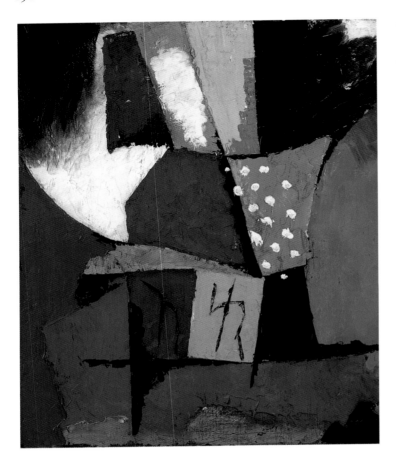

185. *Abstraction*, 1924. Oil on canvas, 17 1/4 x 14 1/16 in. The Baltimore Museum of Art; Gift of Cory and Stanford Rothschild, Baltimore, 1998.265.

portion of the composition, defying our spatial comprehension of the image by visually fusing foreground and background planes. Finally, with the edge of his palette knife, Man Ray applied thin lines of black paint to the surface of three angular shapes in the lower center of the painting. These lines resemble primitive calligraphic markings, the centermost of which takes on the shape of the artist's own monogram. Combined with the textural buildup of pigment and the work's self-referential title—both versions are simply called *Painting*—the lines applied to the surface reinforce our reading of the painting as an object, an effect the artist certainly strove to attain.

The years 1918 and 1919 saw the production of Man Ray's most accomplished and successful airbrush paintings. The subjects for these pictures were either derived from his immediate environment or inspired by an event he had recently witnessed. "I'd start with a definite subject," he explained, "something I had seen—nudes, an interior, a ballet with Spanish dancers, or even some odd miscellaneous objects lying about which I used as stencils, but the result was always a more abstract pattern."[29] The most interesting aerograph of 1918 (fig. 188), however, may have been more abstract than the subject of its inspiration, but the figurative content is certainly more easily recognized than it was in the artist's painted rendition of this same subject two years earlier (fig. 159).

In the aerograph—which was given the same title as the earlier painting, *The Rope Dancer Accompanies Herself with Her Shadows*—the form of a precariously balanced rope dancer and her surrounding shadows are immediately apparent. In this work, however, the various positions and amorphic distortions given to the shadows appear

186. *Painting*, 1918/24. Oil on canvas, 17 1/4 x 14 1/8 in. Courtesy of Forum Gallery, New York.

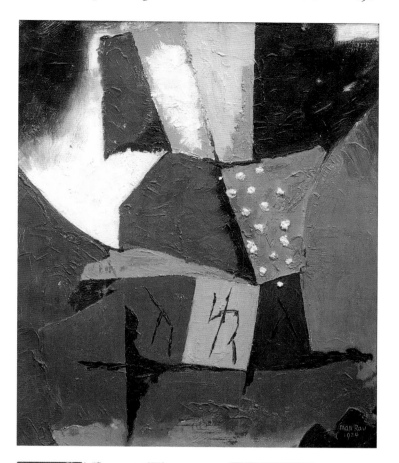

to have been determined literally, that is, by the actual deflection of four separate beams of white light cast against the surface of a rather abstractly conceived and sharply delineated shape meant to represent the rope dancer. In following such a procedure, the precise contours and positions of the shadows could have been recorded by first tracing their silhouettes lightly in pencil, then fashioning various irregularly shaped stencils to help guide the flow and direction of sprayed pigment. In an aerograph of this type, then, the suspended paint functions in the same capacity as light, which is only allowed to leave its physical impression on a given surface in areas where it is allowed to penetrate without obstruction. Conversely, in the airbrush paintings, shadows are generated in areas where the flow of pigment is intentionally obstructed. Thus, perhaps unwittingly, Man Ray has treated the surface of this particular aerograph in very much the same fashion as a light-sensitive plate, allowing the surface of his picture to preserve not only the accurate record of an image but also the physical impression of its cast shadows (a procedure that closely parallels the technique used in the making of rayographs, a unique photographic process Man Ray would not develop until after his move to Paris in 1921).

This second rendition of *The Rope Dancer* was followed by a sketch simply entitled *Memo for Aerographs* (fig. 189). This drawing was appropriately named, for along with three rope dancers—taken with little variation from the sketch of 1916 (fig. 161)—Man Ray has here combined a number of themes derived from his earlier work with those

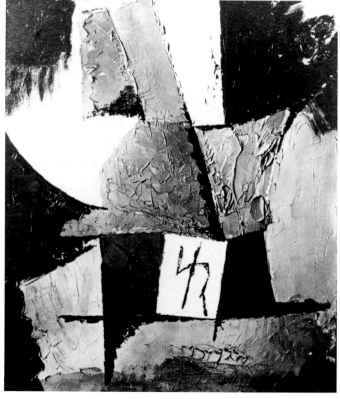

187. *Painting* or *Abstraction*, 1918. Oil on canvas, 24 x 18 in. Painted over? (photo: Artist's Card File; see document C).

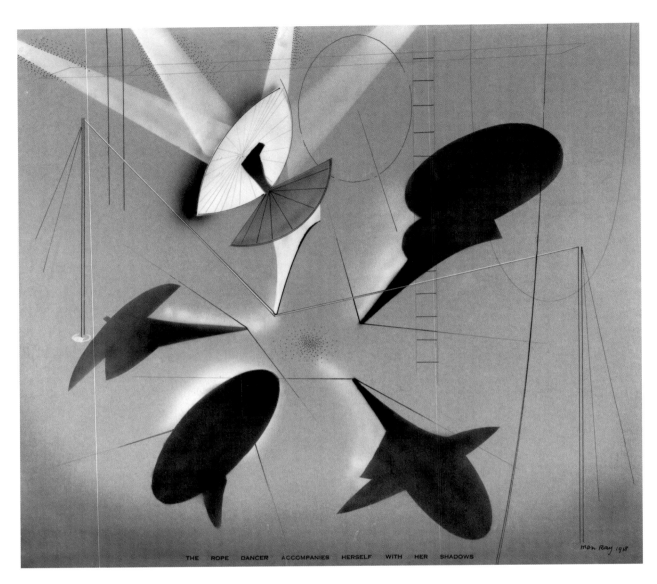

THE     ROPE     DANCER     ACCOMPANIES     HERSELF     WITH     HER     SHADOWS

188. *The Rope Dancer Accompanies Herself with Her Shadows,*
1918. Airbrush and tempera on paper, 15 5/8 x 17 1/2 in. Col-
lection of Herbert Neumann, New York.

of subjects that he would explore in several subsequent paintings. In the lower left corner of this sketch, for example, automatons and their musical instruments are recalled from a *cliché verre* made the previous year (fig. 183), while, as in the finished aerograph (fig. 188), beams of light can be seen shining down on the rope dancer in the upper center of the composition. Surrounding the indistinctly rendered forms of the rope dancer in this sketch, however, are details derived from a group of Spanish dancers, a subject that would be more precisely defined in an oil painting of 1918 (fig. 190), as well as in an aerograph made the following year entitled *Seguidilla* (Hirshhorn Museum and Sculpture Garden, Washington, D.C.).[30]

The subject of these pictures was inspired by Man Ray's attendance at a performance given by a group of Spanish dancers. He made a special study of the female dancer (fig. 191), the hem of her lace skirt spun into a circular pattern at the base of the drawing, as the dancer herself is shown spinning to the pulsating beat of clicking castanets held tightly in the palms of her hand. In the final composition (fig. 190), Man Ray elected to depict the male dancer, his black pants and lower torso visible in the background, dancing on a tabletop, while five white fans were meant to represent the surrounding female dancers. Cones of black Spanish lace reinforce the ethnic identity of the subject; the three umbrella-like shapes barely visible in the upper right corner were probably inspired by the whirling skirts of the Spanish dancers.

It was in the 1918–1919 period, coincident with his development and refinement of the aerographic technique, that Man Ray's marital problems took a critical turn for the worse. With the artist devoting more and more time to his work, Adon Lacroix justifiably complained that she no longer received the degree of amorous attention she desired. Before long, she sought the affections of another man, a young Cuban farmer by the

189. *Memo for Aerographs*, 1918. Pencil on paper, 9 3/4 x 7 3/4 in. Robert Miller Gallery, New York.

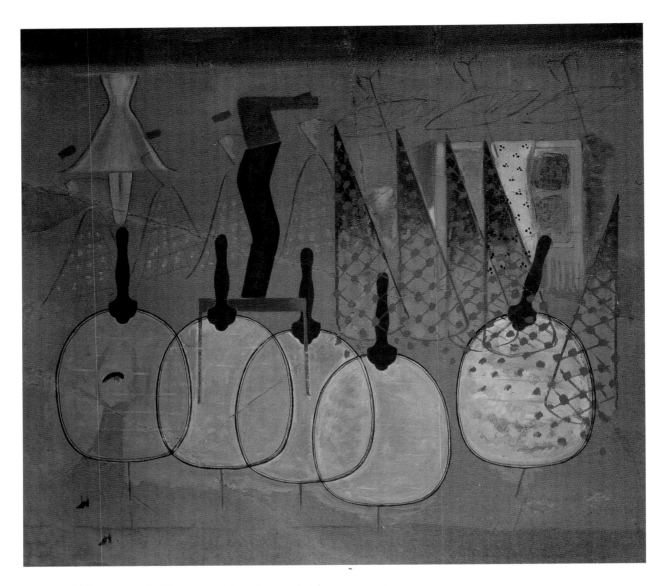

190. *Spanish Dancers,* 1918. Oil on cement board covered with paper, 32 3/4 x 36 in. Collection of the Tokyo Fuji Art Museum, Tokyo, Japan.

191. *Spanish Dancer,* ca. 1918. Pencil on cardboard, 42 5/16 x 30 5/16 in. Present whereabouts unknown (formerly Estate of the Artist, Paris).

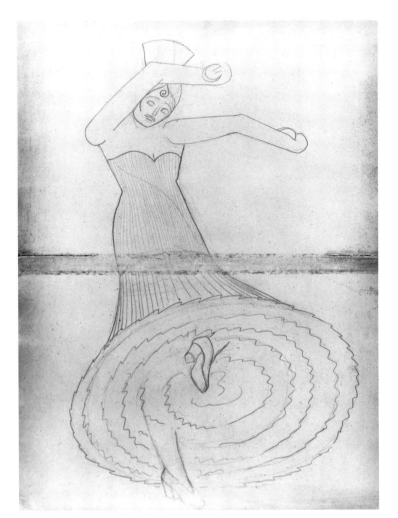

name of Luis Delmonte, who had recently moved to America and was working in New York as an office clerk. The two began to see more and more of one another, and eventually Man Ray grew to find his domestic situation intolerable. He decided that the only solution was to present as little opposition as possible to her intentions and move out.

Even if Man Ray had not been having marital difficulties, he still needed a larger space in which to work, so he asked his landlady if she had any other apartments for rent. Without any vacancies at the time, she offered the artist a large space in the brownstone next door, a basement room she had been using primarily for storage. As soon as the room was cleared out, the artist moved in, asking his landlady if she would leave a few miscellaneous items behind that he might find some use for in the future: a table, some chairs, a bed, and some old dress forms, which the artist said he wanted because "they seemed to furnish the place with a substitute for human company."[31] He also asked his landlady to leave an old sign hanging on the wall that read NOT RESPONSIBLE FOR GOODS LEFT OVER 30 DAYS (fig. 192). Initially, he had planned to rearrange the words to read LEFT OVER GOODS NOT RESPONSIBLE FOR 30 DAYS, a word-order change that would have closely paralleled Duchamp's earlier alteration of the letters in a metal advertising sign in a rectified readymade entitled *Apolinère Enameled* of 1916–1917 (Philadelphia Museum of Art; Arensberg Collection). But Man Ray never got around to realizing his intentions, claiming that the thought alone was sufficient. "I never made the change," he later explained, "being satisfied with simply imagining the transformation."[32]

The new basement studio was surprisingly

192. *Man Ray's Eighth Street Studio*, ca. 1918–1920. Gelatin silver print, 3 13/16 x 4 5/8 in. The J. Paul Getty Museum, Los Angeles, Calif.

spacious and comfortable, with exceptionally high ceilings and a large fireplace. In order to make the space feel more lived in, the artist displayed a number of paintings and drawings around the room, including (on the far right wall) his aerograph of the *Rope Dancer* (fig. 188). He unrolled his large *Tapestry Painting* of 1913 (fig. 43) and used it as a tablecloth (a typewriter and books rested upon it), and he hung a large unstretched canvas composed of mechanical diagrams and chess figures on the main expanse of wall between two large rectangular pilasters with carved Corinthian capitals, decorative enhancements to the Victorian architecture that gave the room a classical yet warm and inviting appearance. Man Ray would occupy this studio/apartment for his remaining years in New York, and it was in these inauspicious surroundings that his work would rapidly develop into a more self-consciously conceptual and uniquely individualistic style.

At first it was the surroundings themselves that provided the subject matter for his new work. In a period when most Americans were preoccupied with the war effort in Europe, Man Ray increasingly turned to themes inspired by the imagery in his immediate environment. Psychologically, such a decidedly introspective orientation may have been a product of the overwhelming personal problems that he had experienced at home, or it may simply have been that, in his efforts to freely explore the potential of the airbrush medium, any random assortment of objects would have provided equally suitable subjects for experimentation.

Whatever the motivation may have been, it was the environment of his studio that supplied the basic subject matter for a large painting on board entitled simply *Interior* (fig. 193). Here, as in

193. *Interior* or *Still Life + Room,* 1918. Collage, paint, and airbrush on cement board covered with paper, 31 3/4 x 36 in. Collection of the Tokyo Fuji Art Museum, Tokyo, Japan.

194. *La Volière*, 1919. Airbrush on paper, 27 3/4 x 21 7/8 in. The Roland Penrose Foundation, London.

the aerographs, the natural coloration of the two-dimensional surface is integrated within our visual comprehension of the depicted space, allowing the painting's support to represent the overall background upon which the various objects in the interior scene are positioned. The objects themselves consist of several pieces of furniture—a table, chair, screen, rug, and overhead lamp—and, in the center of the composition, just to the side of the paneled door on the right wall, can be seen a depiction of the artist's 1914 painting *Madonna* (fig. 127). The only suggestion of a human presence in this room is provided by the dressmaker's form on the far right. Knowing the details of Man Ray's difficult separation from Adon Lacroix at this time, it would be tempting to interpret this hollow, headless female form as a surrogate for his wife, symbolizing her sudden and unexpected disappearance from his life.

No matter how we interpret this lifeless mechanical form, the unclothed dressmaker's dummy served as the principal subject of an important aerograph of this period entitled *La Volière* (fig. 194), the French word for an aviary or large birdcage. It may be that Man Ray selected this title as an allusion to the alleged captivity of his wife, who during the time of her affair had repeatedly pleaded for more independence. Unlike in *Interior*, however, the various other elements in this composition are rendered in a far more abstract fashion, a particular mode of rendering to which the aerographic technique naturally lent itself but to which it had rarely been applied in the past.

Exploring various methods of applying paint with the airbrush, Man Ray discovered a technique that would generate an inevitable comparison with photography. In allowing the spray of ink or pigment to trace the periphery of forms, he was applying color in almost the same way that light passes through a negative before coming to rest on

195. *Untitled* or *Aerograph,* 1919. Airbrush and tempera on cardboard, 26 3/8 x 19 5/8 in. Graphische Sammleingder Staatsgalerie, Stuttgart.

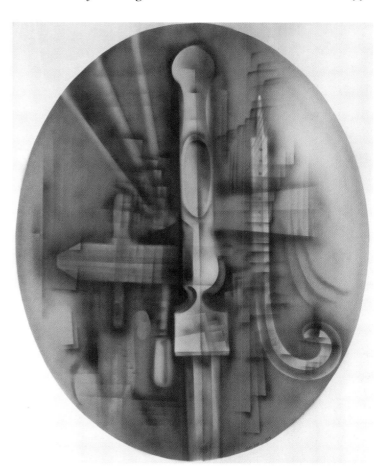

photosensitive paper. When the colors he used were basically monochromatic, a comparison with the black-and-white images of photography would be that much more apparent. Like photographic prints, which were often cut into tondo formats (especially portraits), and like a number of Analytic Cubist paintings that are predominantly monochromatic, an untitled aerograph of 1918 is oval-shaped and painted in the same overall sepia tone (fig. 195). Abstract though this image appears, close inspection reveals that the central form running vertically through the center of the composition was established by allowing a light spray of pigment to outline the form of a found-object sculpture from 1918 entitled *By Itself II* (visible hanging on the wall on the left in the photograph of his studio: fig. 192). By manipulating the angle and direction of spray, Man Ray has created an essentially abstract image that takes on the appearance of a soft-focused Cubist painting. In conversation with Arturo Schwarz, the artist explained his procedure in words that almost appear to describe this image:

> I put all kinds of things in it [in his aerographic compositions], a press for holding wood together, parts of a camera, pieces of cut out cardboard, some of my draughtsman's instruments, etc. I moved everything around and sprayed, and moved again and sprayed, changing their position all the time. I was doing a Cubist painting with a new technique and with curves instead of straight lines.[33]

The subtle tonal graduations that were possible

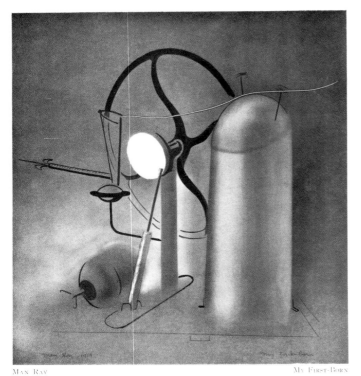

MAN RAY    MY FIRST-BORN

THE THEATRE OF THE SOUL.
A MONODRAMA IN ONE ACT
By Nikolai Evréinof

196. *My First Born*, 1919. Airbrush on paper, dimensions unknown. Lost or destroyed (reproduced in *TNT*, 1919).

with the airbrush made it an especially useful tool for commercial illustrators, who were frequently required to produce a convincing rendition of reflected light on smooth, industrially produced metallic surfaces. Man Ray used the airbrush for precisely this purpose when he turned the subject of this machine upon itself and produced a work appropriately entitled *My First Born* (fig. 196). In this aerograph, the artist has portrayed selected details of the compressor and motor assembly that powered the spray of this large and cumbersome mechanical device. In using the title *My First Born*, Man Ray was not identifying this work as his first aerograph but rather suggesting that this object gave birth to many works created by means of this new and exciting method. In this respect, he may have been inspired by Picabia's characterization of the machine as a "girl born without a mother."[34]

*My First Born* was reproduced in Man Ray's *TNT,* the single-issue review that appeared only once, in March of 1919 (fig. 197). Of all the aerographs he had completed up to that point, the artist selected a reproduction of this particular work to illustrate his publication of Evreinof's "The Theatre of the Soul," the play that inspired the making of his first aerographic picture, *Suicide* (fig. 179). Although it is not clear from the context alone, the connection Man Ray may have had in mind is that it was this particular Russian play that provided the subject—or, in metaphorical terms, gave birth to—his first artistic application of the airbrush.

Years later, Man Ray described *TNT* as "a political paper with a very radical slant," and he also claimed that it was "a tirade against industrialists, the exploiters of workers."[35] But other than the

# TNT

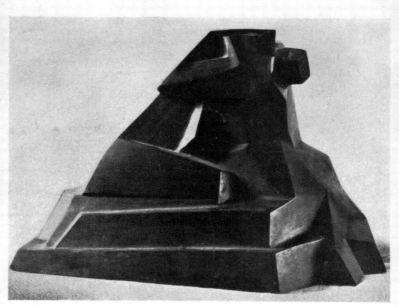

BRONZE — ADOLF WOLFF

New York                    March, 1919                    Fifty Cents

197. *TNT*, 1919. Printed pamphlet. Arensberg Archives, The
Marian Angell Boyer Library, Philadelphia Museum of Art.

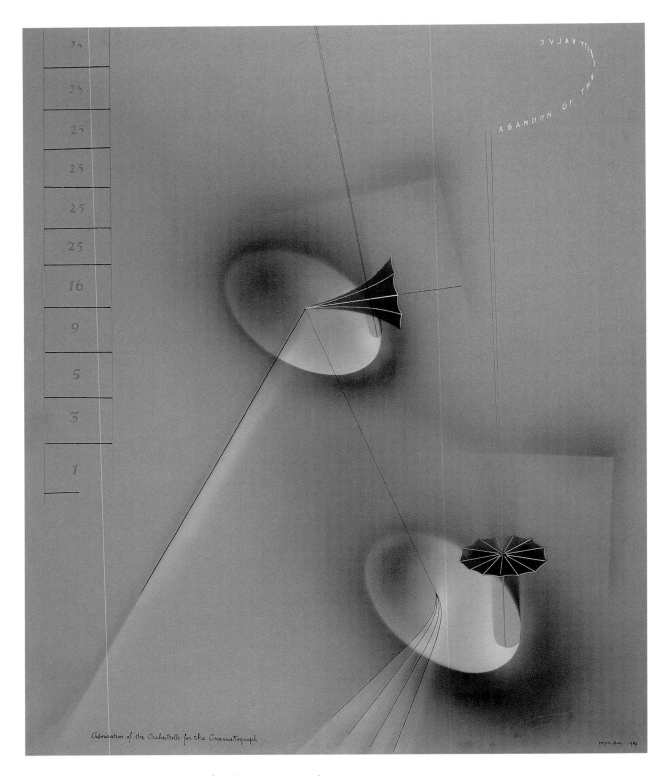

*Admiration of the Orchestrelle for the Cinematograph*

198. *Admiration of the Orchestrelle for the Cinematograph,*
1919. Airbrushed ink and gouache, brush, pen and ink and
pencil on gray paper, 25 7/8 x 21 1/2 in. The Museum of Mod-
ern Art, New York; Gift of A. Conger Goodyear, 231.37.

magazine's explosive title—which ran across the cover in large black letters above the reproduction of an abstract bronze sculpture by Adolf Wolff—there was little in the publication that could be even remotely construed as a reference to anything politically subversive. Henry McBride, who reviewed the new magazine for his column in the *Sun*, mistakenly identified the subject of *My First Born* as "the study of an electric fan," and he found the entire review "droll" and "not particularly amusing." He especially disliked the quality of printing, which, he said, was "monotonous" and resembled "commercial reports that are usually fired into the waste basket without a glance."[36]

In strictly visual terms, perhaps the most refined and elegant airbrush drawing from this period is *Admiration of the Orchestrelle for the Cinematograph* (fig. 198); its meaning, however, remains the most difficult and cryptic of all the aerographs' to decipher. Against a background of gray construction paper, the artist has portrayed two umbrella-like shapes hovering above the ghostly forms of two floating disks. The "umbrella" in the center of the composition appears closed, while the one below it is spread open, with two thin, converging red lines accentuating the ascent of its vertical axis. At the top of these lines is an amorphic projection of letters—twisting in space like the advertising streamers carried behind small airplanes—which spell out the cryptic message ABANDON THE SAFETY VALVE. Finally, rising vertically in a ladder of rectangular compartments up the left side of the page is an irregular progression of numbers, all painstakingly executed in fine lines of striking red gouache.

Perhaps the most informative description of this work comes from the artist himself, who in 1954 was asked by the Museum of Modern Art in New York to fill out a questionnaire explaining the meaning of this work (although the museum had acquired the work some seventeen years earlier). When asked if there were any exceptional circumstances or incidents that led to the creation of this aerograph or its subsequent history, Man Ray responded, "The technique and motive are so bound together that at first glance the painting is almost invisible." To describe the subject, he supplied the following statement:

> The forms, I think, were suggested by an old-fashioned phonograph-horn, which in turn suggested a morning glory. The ladder to one side bears a series of numbers which is the progressive ratio in the development of a spiral—a form that occurred in man-made works as well as in nature. The title is a poetic addition, and in no way describes the painting. I like a literary title—it doesn't change or affect the work.[37]

In spite of Man Ray's dismissal of the title as a key to understanding this work, in a recent catalogue published by the Museum of Modern Art (written by John Elderfield, then the museum's curator of drawings), the word *admiration* is taken for its literal implications, and the work is interpreted as a sexual machine, to be compared with Duchamp's exploration of this very theme in his most important work of these years, *The Large Glass*. "The female 'Orchestrelle,'" Elderfield writes, "leans over invitingly to the beaming Cinematograph." The progression of numbers is then seen to represent a growing crescendo of amorous activity. "And in a strip up the side of the drawing," he writes, "even, passion begins rising, then reaches a climax and crosses the edge of the sheet."[38]

No matter how we interpret the subject of this aerograph, there can be little doubt that at the time of its creation the new and highly innovative technique the artist employed was of greater

importance for him than the thematic origins of the work. Asked on the same questionnaire to comment on the technique, quality, and significance of this drawing, he prepared the following explanation:

> The use of the airbrush and mechanical drawing instruments in creating a work of art [was] being frowned at; this would serve my purpose in painting a picture that did not cater to the taste for sloppy virtuosity. It was my object to express an idea almost photographically—before I took up photography—and remove all traces of manual dexterity.
>
> It was a relief to carry out an idea like blowing one's breath on a windowpane. While the preparation and care involved in creating an idea by this means were more laborious than painting directly on canvas, the results fully justified the effort which became invisible. The idea remained clear and direct.
>
> This was a period of reaction to sensuous painting, leading into the dada spirit. If there was any shocking to do, I wanted to be the first to feel its effects, since like others I had been for years smearing paint on canvas with brushes.

It is clear, then, that Man Ray developed the aerographic process primarily to explore an artistic technique that departed from that of traditional painting. As he indicated in this statement, by this time his opposing and reactionary spirit was fueled by an ever-increasing desire to affiliate himself with the Dada movement. Whatever his intentions, when these works were shown for the first time in Man Ray's third and last one-person exhibition at the Daniel Gallery in November of 1919

(fig. 199), they were not particularly well received, neither by the general public nor by the conservative press. As Man Ray recalled, the critics responded to the exhibition with "a hue-and-cry," accusing him of having "vulgarized and debased art," because of his brash and blatant use of mechanical and commercial instruments.[39]

In this exhibition, Man Ray showed a selection of eighteen works that had been produced during the course of the previous six years, from paintings that had been made during the time of his stay in Ridgefield—more traditional works, which his dealer preferred—to the most recent examples of the new airbrush technique. The series of ten collages known as *The Revolving Doors* was also shown (figs. 162–165), and it was in this exhibition that they were first displayed as a group, each panel framed and hinged to one another in a circular format, resembling the general appearance of a revolving door.[40] When Daniel asked Man Ray to provide him with some sort of an explanation for these works, so that he might better inform critics and potential clients, the artist flatly refused. Indeed, Alanson Hartpence, Daniel's advisor and assistant in the gallery, told Man Ray not to divulge any technical details. If he had to say something about his work, Hartpence maintained, he should speak only "in general abstract terms," making the works themselves appear as mysterious as possible.[41] Naturally, such an attitude must have frustrated the former owner of a saloon, and the total lack of sales probably perturbed him even more. Man Ray's dedication and complete commitment to his current work, however, prevented the artist from even considering the possibility of turning back to an earlier, more conventional style. With such completely differing concerns, a clash between the artist and his dealer was inevitable. Without Hartpence's intervention, Man Ray recalled, Daniel surely would have elimi-

nated his name from the roster of artists whose work he represented at the gallery.

At least one critic objected to Man Ray's selection of such elaborate titles: Hamilton Easter Field thought they interfered with an appreciation of the essentially abstract message contained within the works themselves, which he felt was more important. But he liked Man Ray's use of commercial instruments. "In his hands," wrote Field, "the despised air brush has created beauty."[42] But it was precisely his use of these instruments that other critics found objectionable. Royal Cortissoz, the notoriously conservative art editor of the *New York Tribune,* failed to make any sense of the show whatsoever and seized the occasion to condemn all forms of modernist experimentation:

> Mr. Ray's diagrammatic works would seem
> to aim at the expression of emotion through
> symbolical terms, strange patterns of line
> and painted surface in which only the
> extreme modernist could detect an equiva-
> lent for ordinary pictorial intent.
>
> We have endeavored with the best will
> in the world to ascertain the abstract mean-
> ing of the artist's purpose. Whatever it may
> be, we cannot detect in it any relation to the
> production of a work of art. Fantasticalities
> of this sort are believed in some quarters to
> acquire all the validity they need from the
> artist's inner conviction that what he is
> doing is worth doing. They will have to jus-
> tify themselves on broader grounds before
> they can be taken seriously.[43]

A considerably more impartial view of the exhibition was provided by C. Lewis Hind, art columnist for the *Christian Science Monitor.*[44] In comparison with the close-minded approach of Cortissoz, Hind made a far more honest and con-

199. *MAN RAY: An Exhibition of Selected Drawings and Paintings Accomplished during the Period 1913–1919.* Catalogue, Daniel Gallery, New York, November, 1919. The New York Public Library, Astor, Lenox and Tilden Foundations (original destroyed).

certed effort to understand the unfamiliar works in this exhibition. After having seen the show three times, he followed up his interest with a visit to the artist's studio. Thus, his review of the exhibition is especially important, as it indirectly relays the artist's ideas about his work in this period. Hind described *The Revolving Doors* as "flat and geometrical, never plastic and representative." Man Ray had "abjured plasticity," he wrote, "had banished the third dimension." *The Revolving Doors,* he observed, "were all in two dimensions." Noting that the series was made entirely of collage—and not painted, as he had originally thought—Hind went on to say that he learned directly from the artist that this method was adopted as "a protest against the importance that has been, and is, accorded to technique." On this point he elaborated further:

> He [Man Ray] strives to escape from technique, to give not a quality of paint, but a quality of idea. He wants to work in a medium that is already controlled, like musical notes, so that he can give all his thought to inventive form and line in two dimensional aspects: he wants his painting to be unworried by tactile values (which Mr. Berenson adores) and to show not handiwork but the idea at the back of it.
>
> Carrying on this notion of negation, of protest against the obtrusive handiwork of technique, he shows in the next room a group of paintings that are produced entirely by the air brush. He invents the design, schemes the colours with mathematical precision, and then squirts the colour on the board, always exactly following his formula. To him the idea and the abstract realization are everything; the concrete carrying out of the idea he maintains

is mechanical, and can be done by anybody with a little training. Mr. Ray looks forward to the time when pupils, with air brushes, will repeat a master's design in colour a dozen, a hundred times, as often as needed by the public.

This highly informed account indicates that by this time Man Ray had made a definitive break from a strict reliance on the formalist theories of painting that had so thoroughly dominated the production of his earlier work. Moreover, the tenets of a more conceptual, or Dada-oriented approach to the art-making process already appear to have been ingrained within his artistic sensibilities. This change, as others have frequently pointed out, owes a considerable debt to Duchamp, who by this time had become Man Ray's closest friend and collaborator. Duchamp believed that a mechanical technique helped to depersonalize the work of art, ridding it of the overbearing effect of an artist's ego. He also maintained that art should avoid the "retinal" approach, as he referred to it, and that it should instead be a "cerebral" act. The notion of the idea taking precedence over form has one inevitable result: painting as an exercise in the exploration of formal properties will stop.

Indeed, other than occasional experiments in later years, after 1919 Man Ray painted only when some other medium was not appropriate for the expression of a specific thought. The extent to which Man Ray had hoped his ideas would take precedence over the objects he created to represent them (a conceptual position that anticipated developments in modern art by some fifty years) can be found in the artist's response to questions posed by a newspaper reporter in February 1921. He was asked to explain the concept of "tactilism," a term that had been promoted in this period to

accentuate the physical, three-dimensional values of a work of art. "I want to eliminate the material," he replied, "show the idea." For Man Ray, it was no longer enough for artists to simply provide their audience with a simulation of objects found in their everyday environment. "We don't want a record of the actual object," he said. "We want a result of it."[45]

# NINE

---

## FROM AN ART IN TWO DIMENSIONS TO THE HIGHER DIMENSION OF IDEAS

### (1920–1921)

In concluding his review of Man Ray's exhibition at the Daniel Gallery, C. Lewis Hind attempted to find a single term that would suitably describe the artist's work over the course of the previous seven-year period. (The show included paintings and drawings from 1913 through 1919.) After rejecting a few tentative possibilities—from "Abstract" and "Intellectual" to "Geometrical Joy Pictures"—Hind concluded that it might be best to simply call Man Ray's work "Ray Paintings," a designation that he deemed appropriate "for," as he observed, "in them are rays of a new vision."[1] The critic doubtlessly offered this suggestion with the intent of leaving his readers with a witty and amusing comment at the close of his review. What Hind probably could not have foreseen at the time is that his casual observation would soon prove to be remarkably accurate.

Man Ray's paintings did indeed contain the seeds of "a new vision," but it was not, as Hind might have assumed, a vision confined exclusively to the realm of painting and drawing. As we saw in works dating from as early as 1916, when the situa-

tion called for it, Man Ray was perfectly willing to break from a strict adherence to the physical limitations of an art defined exclusively by the confines of two dimensions. In *Chinese Theatre* (fig. 130) and *Interior* (fig. 151), for example, he used collage, and in the assemblage *Self-Portrait* (fig. 172) he attached two bells and a pushbutton to the surface of his painting.

It should be noted, however, that, in the collages and assemblages he made, the addition of these objects appears to have been generated by the formal and/or iconographic configuration of the object itself. In other words, it is likely that these details were conceived of and added only after the two-dimensional surface of the object was completed, and then they were probably attached or grafted to the finished product in the form of an embellishment—as a decorative enhancement or physical extension of the object itself. Before long, however (by the end of 1917), Man Ray would—without hesitation—break into the world of three dimensions, creating his first mature and fully realized contributions to a sculptural oeuvre that

would later be considered among the most important and exemplary works of the Dada and Surrealist movements—works Man Ray himself would eventually categorize by the warm and intentionally emotive title "Objects of My Affection."[2]

Once Man Ray discovered the expressive potential of objects—particularly when these objects were combined with amusing or provocative titles in order to provide a newfound literary context—he would no longer consider himself exclusively a painter, at least not a painter in the fashion to which he had earlier aspired (in the tradition of an artisan dedicated to the physical properties of his chosen medium). Man Ray wanted his creative efforts to go well beyond the five-hundred-year tradition established by the representational arts. For him, it no longer made any sense for an artist to carve some material into a predetermined shape or to manipulate pigment on a flat canvas surface in order to represent something other than what it was—even if that something were nothing more than abstract planes of color arranged in a certain order. The airbrush offered one solution in attaining this goal, but objects offered an even more alluring and exciting alternative. Once the idea for a given object took precedence over all other considerations, it was only for Man Ray to select the medium that best expressed his intentions.

In strictly formal terms, the first of these objects, *Boardwalk* (fig. 200), could be considered an intermediary step in Man Ray's evolution to an art of three dimensions. In the lower center of a nearly square piece of thick, discarded plywood—its surface heavily textured by numerous coats of weatherworn paint—Man Ray painted the vertical and horizontal divisions of an irregularly shaped checkerboard. At the base of the composition, the individual tessellations of this pattern stretch to inordinate lengths, while at the same time they

200. *Boardwalk,* 1917. Assemblage: oil on wood board, furniture knobs, chord, 25 1/2 x 28 in. Kultusministerium Baden-Wurtemberg, Staatsgalerie, Stuttgart.

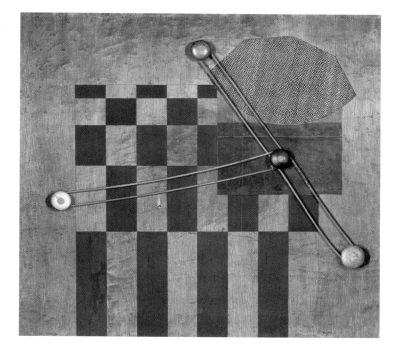

rapidly diminish in size approaching its center, suggesting the incorporation of a geometrically accurate linear perspective system, without, however, providing any additional visual cues to create a convincing spatial recession. This defiance of perspectival diminution—which, for all intents and purposes, takes place on the two-dimensional surface of this object—is further enhanced by the addition of three physical elements grafted directly to its surface, each of which, in differing ways, addresses various aspects of traditional artistic practice, particularly those pertaining to the history of illusionism and our spatial comprehension of a given object.

First, it appears as though Man Ray has attached an irregularly shaped scrap of tweed fabric to the upper right corner of the work; closer inspection, however, reveals that this detail is completely illusionistic. Just as the European Cubists had employed the technique of *trompe l'oeil,* with the deft illusionism of a trained draftsman Man Ray has here simulated the pattern and texture of this fabric sample, employing only the traditional materials of the artist (namely, paint). Then, as if intended as a comparative test to his skills, directly below this detail he has attached a strip of rectangular, wood-grained veneer, to the center of which he has, in turn, affixed a small circular furniture knob, of the type customarily found on kitchen drawers. Three other knobs have been added toward the periphery of the composition, and two separate loops of cord are stretched over them, creating parallel lines that hover slightly above the checkerboard pattern and intersect at the position of the central knob. Finally, the title, like so many other works by the artist from this period, probably came after the construction was completed, and it was probably suggested by a detail in the object itself. In the case of *Boardwalk,* it may have been the fact that the object was constructed on

the surface of a thick slab of plywood—or a board —and that the roped-off area might have suggested the path where one was allowed to walk (whereupon, if we take this reference further, the furniture knobs would represent pedestrians). It is more likely, however, that the stretched-out checkerboard format simply suggested the recession of wood planks on a seaside promenade, or boardwalk.[3]

Another sculpture dating from this same year, *New York* (fig. 201), was not so laboriously constructed, nor was its title so cryptically conceived. Like *Boardwalk,* the work was probably inspired by materials lying about in the artist's studio. Utilizing nothing more than a carpenter's C-clamp and ten wood strips of varying lengths (probably discarded scraps of canvas stripping used to protect the outer edges of his paintings), Man Ray created an image whose sleek verticality and ascending angular profile produced the general impression of a New York skyscraper, reminiscent of the sharp geometrical style given to numerous high-rise constructions for which the city had already become well known. Indeed, most Europeans residing in New York during the war years saw the skyscraper as a symbol of American progress and industrialization. Within months of his arrival in New York, for example, Duchamp denounced this country's artistic dependency on European tradition, citing the skyscraper as a specific example of how America had gone far beyond European precedent. "Look at the skyscrapers," he told a reporter. "Has Europe anything to show more beautiful than these?"[4] To this same interviewer, the artist even confessed that he had tried to find a studio "in one of their lofty turrets," until he had been informed that people were not permitted to live in them. And a few months later, in January of 1916, Duchamp wrote a long note to himself that concluded with the reminder: "Find

an inscription for the Woolworth Building as a ready-made."[5]

There can be no doubt that Duchamp's concept of the readymade had a tremendous impact on Man Ray's willingness to incorporate found objects into his work, but there are vast differences in their approaches. When asked to distinguish between his treatment of objects and Duchamp's, Man Ray always took great care to emphasize the more poetic nature of his approach:

> My attitude toward the object is different from Duchamp's for whom retitling an object sufficed. I need more than one factor, [I need] at least two. Two factors that are not related in any way. The creative act for me rests in the coupling of these two different factors in order to produce something new, which might be called a plastic poem.[6]

Thus, while Man Ray readily acknowledged the importance and revolutionary impact of Duchamp's introduction of the readymade, he did not seek to merely duplicate its operating principles in his own work. Rather than select an object with what Duchamp called "aesthetic indifference," Man Ray preferred to alter, or in some other way manipulate the design of the manufactured object, sometimes combining it with other objects and adding provocative titles to create a sense of what he preferred to classify within the realm of poetical expression. "Whatever elements that may come to hand or that are selected from the profusion of materials," he explained, "are combined with words to create a simple poetic image."[7] Man Ray sought no historical or aesthetic justification for his procedure, which he preferred to regard as simply an activity of "gratuitous invention."[8]

When questioned about the meaning of his

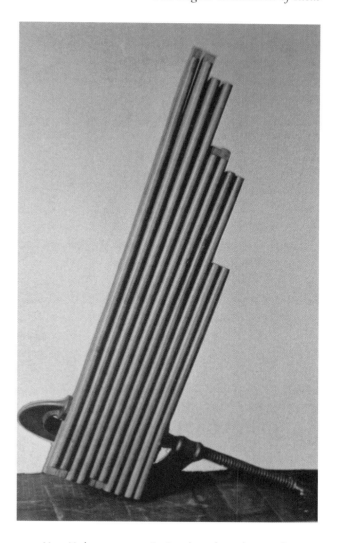

201. *New York 1917*, 1917. Assisted readymade: wood strips and metal carpenter's C-clamp, 21 in. high. Original destroyed (photo: Artist's Card File; see document C).

objects, Man Ray repeatedly emphasized that the objects themselves should not be admired on the basis of their technical construction—as in the evaluation of traditional sculpture—but rather should be appreciated on the basis of their poetic qualities. "Whenever I made objects," he later explained to Arturo Schwarz, "never would I make anything with the idea that it should be pretty, decorative, or attractive or fascinating. I would pick up something absolutely meaningless, add a little something or detract something from it and transform it a little bit, so as to get almost a poetic image rendered in three dimensions. And the title would be as important as the object itself, as a clue to it."[9]

For an eighteen-month period—from January 1920 through June 1921—Duchamp and Man Ray saw quite a bit of one another, solidifying a friendship that would endure for the remaining years of their lives. They frequented a local café known as the Pepper Pot and played chess quite often, eventually both becoming members of the Marshall Chess Club in the West Village. We know they also visited one another's studios. Duchamp had a small ground-floor apartment on the Upper West Side, a short walk from the area he had known well from the time when he lived with the Arensbergs. Man Ray, who had just recently moved out of the apartment he shared with Adon Lacroix and her daughter, still occupied the small basement studio on West Eighth Street (fig. 192). Duchamp reportedly found the mechanical instruments lying about in Man Ray's studio fascinating, and Man Ray was quite impressed by the clutter of his friend's studio, which always looked as if someone were just moving in or out: "There was absolutely nothing in his place," he recalled years later, "that could remind one of a painter's studio."[10]

In this period, Man Ray and Duchamp worked so closely together that some have described their work as the product of a collaboration. In truth,

however, with the exception of a failed attempt to make a film together, because of Man Ray's exceptional skills as a photographer he served more in the capacity of a "documentalist" (albeit an exceptionally creative one) for Duchamp's various projects and experiments. In 1920, with the support and encouragement of Katherine Dreier, a wealthy collector who had served on the board of the Independents exhibition, Man Ray and Duchamp founded the Société Anonyme, Inc., the first museum in America devoted exclusively to the display and promotion of modern art. And in April 1921 they co-edited *New York Dada,* the first and only publication issued in America to fully embrace the tenets of the European Dada movement. But, as Man Ray later recalled, "the paper attracted little attention. There was only one issue. The effort was as futile as trying to grow lilies in a desert."[11]

In an interview conducted just a few years before his death, Man Ray was asked to sum up the spirit of Dada during this period in New York. "There is no such thing," he asserted. "I don't think the Americans could appreciate or enter into the spirit of Dada any more than they could enter into the spirit of learning the French language."[12] In spite of the tone of conviction this denial was intended to convey, in a statement prepared for a Dada exhibition in Germany, the artist not only acknowledged his participation in Dada activities in New York but even claimed to have been its principal exponent: "I might claim to be the author of Dada in New York," he wrote. "In 1919, with the permission and with the approval of other Dadaists I legalized Dada in New York. Just once. That was enough. The times did not deserve more."[13]

Though the times may not have deserved more, Man Ray was convinced that he did. In June of 1921, in a letter written to Tristan Tzara, the ardent proselytizer of Dada in Europe, Man Ray proclaimed: "Dada cannot live in New York."

Neither could he. If he could raise the capital necessary for the trip, he would leave on the next boat.

Since his paintings were not selling well at the Daniel Gallery, Man Ray decided to seek advice from another dealer, Alfred Stieglitz, who, on an earlier occasion, had helped to sell one of his paintings. As luck would have it, a day before their meeting, Stieglitz received a visit from Ferdinand Howald, a wealthy collector from Columbus, Ohio, who had already purchased a number of Man Ray's paintings from the Daniel Gallery and had reportedly spoken highly of the artist's talents as a painter.[14]

Howald was in the process of setting up a residence in New York, and Stieglitz thought that he might be interested in acquiring more examples of Man Ray's work. That night, Man Ray sat down and wrote a letter of appeal, offering Howald a free choice of one or more paintings if he would consider financing his European trip. A few days later the artist and his patron met for lunch. According to Man Ray, "Mr. Howald was a florid gentleman with a white mustache, very distinguished-looking, not very talkative." When the artist repeated his appeal, Howald reportedly responded with candor: "How much do you need?" The only response Man Ray could come up with was "I have no idea," whereupon the quiet and reserved collector wrote out a check in the amount of five hundred dollars. Man Ray told Howald that he could select anything he wanted from his work that was placed on deposit at the Daniel Gallery, or, if he preferred, he could wait and select from whatever new work he would produce in Paris.[15]

.     .     .

Within months of his arrival in Paris, Man Ray discovered a photographic process that virtually solved the formal problems he had been trying to work out during the course of the previous ten years. One evening, while preparing some contact prints from plate glass negatives, he accidentally developed a sheet of light-sensitive paper, which earlier had been inadvertently exposed to the overhead light in his makeshift darkroom. The resultant print produced a startling impression. In a sort of reversed silhouette, an uneven pattern of opaque white shapes described the periphery of objects that had been lying on the surface of the light-sensitive paper at the time when it was exposed. It was not long before Man Ray realized that if he used translucent objects, or if he simply held any object at a slightly removed distance from the surface of the paper while it was being exposed, subtle yet rich and detailed tonal gradations could be achieved.

Although photographers had experimented with similar techniques in the past, Man Ray believed his results were so unique that—eventually—he decided the process should carry his own name: hence, the invention of the rayograph. In 1922, the American magazine *Vanity Fair* ran a full-page article reproducing a portrait of the artist and four of these new photographic images (fig. 202), each of which is captioned by a long descriptive title. The accompanying text provides an explanation of the artist's method and includes an insightful comment by the poet Jean Cocteau, who proclaimed that with this new technique "he [Man Ray] has come to set painting free again."[16]

Initially the artist thought his discovery was so important and meaningful in relation to his earlier work that, before long, he began informing friends that the new technique had replaced his need and desire to paint. In April of 1922, he provided an intentionally vague description of this new procedure in a letter to Howald:

> In my new work I feel I have reached the
> climax of the things I have been searching
> [for] the last ten years,—I have never

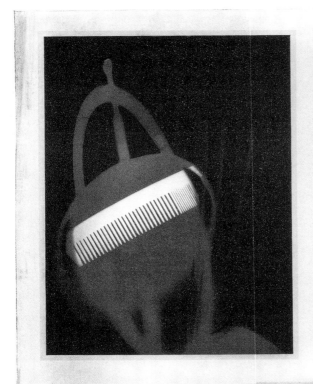

"A Comb Entering the Gyroscope"—
a delicate and finely patterned abstract study in white, gray and black

"Imitation of the Gyroscope by the
Magnifying Glass, Assisted by a Pin."
Note the contrasts of light and shade

*MAN Ray—the well-known American painter now
living in Paris and closely allied with the modern
school of French art—has recently been experimenting
along new lines with the artistic possibilities of photography.  These "rayographs", as he calls them, are
made, without the aid of a camera lens, by interposing
the objects photographed between the light, which is
made to fall upon them in a certain way, and a sheet
of sensitive paper.  Jean Cocteau, the French critic,
has written of these prints that they are "meaningless
masterpieces, in which are realized the most voluptuous
velvets of the aquafortist.  There has never been anyone else who has been able to produce anything like
this scale of blacks sinking into each other, of shadows
and half shadows?  He has come to set painting free
again.  His mysterious groups are infinitely better than
any of the ordinary still-lifes which attempt to conquer
the flat canvas and the elusive mud of the colors."*

A Torn Letter, a Spool of Wire and
a Watch Fob—a full and curiously
satisfying photographic composition

"Composition of Objects Selected with
Both Eyes Closed." This suggests the
modern artistic passion for machinery

# A New Method of Realizing the Artistic Possibilities of Photography

*Experiments in Abstract Form, Made without a Camera Lens, by Man Ray, the American Painter*

worked as I did this winter—you may regret to hear it, but I have finally freed myself from the sticky medium of paint, and am working directly with light itself. I have found a way of recording it. The subjects were never so near to life itself as in my new work, and never so completely translated to the medium.[17]

Although Howald responded to Man Ray's report with a certain degree of curiosity—and he eventually purchased a number of photographs from the artist—we can be reasonably certain that the veteran collector would have preferred to see this young American painter pursue the "sticky medium" he had elected to abandon. Duchamp, on the other hand, who by this time was living back in New York, reacted quite differently. Upon learning of his friend's new work, he wrote, "I am delighted to know that you are having fun, and that above all you have given up painting."[18]

In retrospect, it is possible to understand why the artist came to this dramatic conclusion about his earlier work (even though he would eventually go back to painting, which he always considered his "first passion"). It is true, as he mentioned in his letter to Howald, that a good part of the previous ten years in New York and Ridgefield had been devoted to a search—a formal search, as we have seen, that led from the development of a reasonably sophisticated treatise on the art of two dimensions to a gradual liberation from these very theories, in his attempt to express the essence of a particular idea. From the time of his camping trip in the Ramapo Hills in the fall of 1913—at which

202, facing page. "A New Method of Realizing the Artistic Possibilities of Photography." *Vanity Fair*, November 1922, p. 50. Photograph. Photo courtesy of Condé Nast Archive, New York.

time he decided to free himself from a strict reliance upon forms in nature—Man Ray actively pursued the more purely self-reflective concerns of picture-making, concentrating, as he later explained, upon acknowledging the inherent two-dimensional properties of a painting's surface. With this in mind, he freely experimented with the tactile aspects of the medium. Initially he worked with a variety of transparent and translucent shapes, allowing these entities to overlap one another to create the illusion of a compressed space, or flatness. He then drew attention to the physical characteristics of a painting by manipulating its surface with a palette knife. Alternately, in the airbrush paintings, he allowed the pictorial surface to preserve only the physical residue of a procedure that took place directly before it, thereby emphasizing its materiality and physical presence. Eventually, these formal concerns gave way to the expression of ideas through the use of actual objects, which, when combined with a literary or poetic title, were elevated to the realm of another dimension—to what we have identified as a higher dimension of ideas.

The rayograph, then, can be seen to represent the culmination of these formal concerns, because, as the artist himself acknowledged in his letter to Howald, "the subjects were never so near to life itself . . . and never so completely translated to the medium." Indeed, unlike the case with painting—where, at best, the painted surface represents only a visual reflection of its chosen subject—through the rayographic process, the medium itself represents a literal two-dimensional replication of the very object or objects that were used in its making. Subject and medium were never so inextricably intertwined. And nothing could be more Dada in conception or spirit, for the resultant images virtually made themselves. At long last, Man Ray had arrived. He had accomplished what he strove to

achieve for nearly ten years, and he could not have found a better time, nor a better place in which to realize his creative efforts.

During the course of the next fifty years—whether associated with the Dadaist or Surrealist movements, identified as a painter or a photographer, called a Parisian or an American—Man Ray continued to draw upon the artistic experiences of his early years in New York and Ridgefield. But after he moved to Paris, there would be one very important difference: the selection of medium no longer took precedence over the idea he wished to express. "I paint what cannot be photographed," he repeatedly explained, and "I photograph the things that I don't want to paint."[19] Whatever it took, from this point onward Man Ray never painted a picture, took a photograph, or created an object without allowing his idea to take precedence over the medium. "Perhaps I wasn't as interested in painting itself," he later confessed, "as in the development of ideas."[20]

## ARTISTS AND ART COLONIES OF RIDGEFIELD, NEW JERSEY

Gail Stavitsky

We took the ferry to the Jersey side and a trolley to the top of the Palisades. It was open country without any houses. We walked up a road for about half a mile and came to a clump of woods. We followed a narrow path for another 10 minutes with silence all around us except for the twittering of a bird now and then, and came out on an open hillside with a panoramic view of a valley. In the foreground, scattered here and there stood a few simple and picturesque little houses with fruit trees in between. To the right, among taller trees, could be seen more substantially built rustic stone houses. It certainly looked like my idea of an artists' colony.

—MAN RAY, *Self Portrait*

During the 1890s, the hillside community of Ridgefield, New Jersey, emerged as a noteworthy locale for growing numbers of artists, many of whom sought a quiet, bucolic retreat from the noise and crowds of Manhattan.[1] Located atop the Palisades, across the Hudson River from Morning-side Heights in New York City, Ridgefield was incorporated as a borough in 1892. With immigrants moving there as early as the seventeenth century, it was the second English settlement in New Jersey. Artists and writers of the late nineteenth and early twentieth centuries were primarily attracted to the Heights section near Ridgefield's borders with Cliffside Park and Fairview, commonly designated as Grantwood (figs. 203, 44).[2] As recalled by former longtime resident William Monaghan, this bucolic area was once "fertile with woods and fields and wells and paths of mystery."[3] Along streets named Studio Road, Art Lane, and Sketch Place, creative minds congregated. Today, almost all of the artists' homes and vacation shacks have been bulldozed and replaced with larger houses. Only these street names and a few original homes remain, along with the panoramic vistas, stretching beyond the meadows to the Watchung Mountains.

One of the first artists to settle in this area was the illustrator, portraitist, and genre painter James E. Maxfield (1848–?), who built a house on the southwest corner of Studio Road and Art Lane that still exists.[4] Maxfield's home became the head-

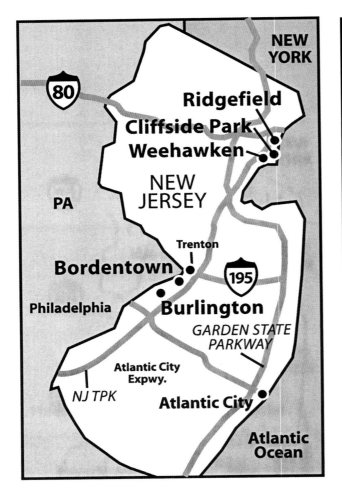

203. (a, left) Map of New Jersey with the location of Ridgefield, New Jersey. Drawn by Richard Sheinaus, Gotham Design, New York. (b, right) Map of Ridgefield, New Jersey, with detail of the section known under various names, including Ridgefield Heights or Grantwood. Drawn by Rich Rainey/Staff Artist. Originally reproduced in Peter J. Sampson, "Redevelopment Slowly Erasing Shadows of Artists' Colony," *The Record,* June 19, 2000, p. L–1. Photo courtesy of *The Record,* North Jersey Media Group, Hackensack, N.J.

quarters for the Country Sketch Club, founded by his friend Van Dearing Perrine (1869–1955), which was officially formed in 1897 and flourished from 1898 to 1912. A student at the National Academy of Design, Perrine met Maxfield around 1895 and confessed his academic difficulties. The elder Maxfield suggested that Perrine retreat to Ridgefield in order to practice sketching directly from nature, a practice that was not sponsored by the Academy. In exchange for use of Maxfield's property, Perrine built a rustic bungalow, which served as a dwelling and studio for the two artists. Perrine's biographer Lolita L. W. Flockhart described his initial enthusiastic encounter with Maxfield's Ridgefield property as follows:

> When Van first saw this property—a lovely woodland on the slope of a hill above the peaceful Hackensack Valley—patches of dogwood bloom shone among the elms and oaks, not yet in full leaf. For several years he had been cut off by pavements from the earth that he loved, enslaved by artificial city ways. . . . Now he came back to the pantheism of his childhood. . . . The loneliness that his soul craved . . . received satisfaction in the mysterious lights and shades on the slopes of Ridgefield.[5]

Returning to the National Academy School in 1896 with some of his Ridgefield sketches, Perrine kindled the enthusiasm of fellow students; soon on the weekends "a sanguine group were invading the hills and dells of Ridgefield, the nucleus of the Country Sketch Club."[6] Among these friends were the artists Maurice Sterne (1878–1957) and Clem B. Davis, Perrine's city flatmates. In his memoirs, Sterne recalled his camaraderie in Ridgefield with urban realist William Glackens (1870–1938) and the charming watercolorist George Overbury

"Pop" Hart (1868–1933), a resident of nearby Coytesville who sang wonderful songs.[7]

Also drawn to the natural beauty of Ridgefield were fellow National Academy students Alfred H. Maurer (1868–1932) and Samuel A. Weiss (1874–?). Others who came to Ridgefield and would become involved with the Country Sketch Club were Albert L. Groll (1866–1952), Edmond Weill (1877–?), Grant Wright (1865–1935), Ernest David Roth (1879–1964), E. Tracey Noe, and George Glenn Newell (1870–1947).[8] One of the club's Ridgefield outings was picturesquely characterized by Perrine's biographer:

> Later in the season—on a beautiful June day in 1897—the group followed Perrine to their choice outdoor sketching field. Cattle browsed in the lush grass, a woods in the background provided grateful shade, and before them stretched a long view over the valley to the misty purple mountains beyond the river.[9]

The club's objectives were defined as the encouragement "of individual work among members and the fostering of an art native to this country."[10] Its membership grew rapidly, and in 1898 its first exhibition was held. The following year's well-received show at the National Academy of Design was organized as a benefit to raise funds for a new clubhouse in Ridgefield. In the foreword for the exhibition catalogue, Edmond Weill articulated the group's desire for a permanent home "where students with limited means and time can paint and study, unrestrained from the drudgery of the classroom." He characterized the current clubhouse as being "situated on the slope of a steep hill, overlooking a most picturesque part of the Hackensack valley, from where the surrounding country stretches out in a broad and beautiful

204. Van Dearing Perrine, *Playing along the Palisades*, n.d. Oil on canvas, 22 x 26 in. Montclair Art Museum; Gift of Dr. and Mrs. Milton Luria, 1974.5.

expanse."[11] A reviewer for *The Art Collector* observed that its members, "working away for a couple of years," had caused the Academy to start "quaking in its very shoes."[12] Contributing nonacademic paintings "as fair and wholesome and sincere as a meadow lit by the sun," the club members offered urban and rural subjects that reflected their dual headquarters in New York City and Ridgefield.[13] Van Dearing Perrine was singled out for the "reckless sincerity [of] his land and sea work" (fig. 204).[14] Perrine eventually became known as the "Thoreau of the Palisades" for his somber, turbulent canvases of massive rock, sky, and water painted between 1902 and 1912.[15]

A turning point in the history of the Country Sketch Club occurred in 1901 with the presentation of a large show of 139 paintings and sketches by twenty-four artists at the Art Institute of Chicago. Among the exhibitors was William Glackens, whose participation has been traced to a visit made by his teacher and colleague Robert Henri (1865–1929) to Ridgefield in 1900. Residing in Fort Lee, New Jersey, Perrine himself did not exhibit and became less involved; his New York City studio was no longer listed as the club's urban headquarters. There was evidently a shift in emphasis from a study group and sketching club closely engaged with Ridgefield's natural scenery to a loose confederation of cosmopolitan, progressive artist-visitors to the area, concerned primarily with exhibitions and social activities. By 1912 the club ceased to exist; many of its members, no longer students, had progressed to positions of influence and travel abroad.[16]

Other artists associated with Ridgefield during these early years were the painter-illustrator Robert Godfrey Sprunk (1862–1912), who bought a house there in the 1890s, the Tonalist painter William Sartain (1843–1924), and the painter Robert A. Carter (1860–?). Van Skyke, illustrator for the old *Life* magazine, and sculptor Sigurd Neandross

(1871–1958) were also residents.[17] The anarchist Emma Goldman (1869–1940) spent time in Ridgefield around 1910, enjoying its beauty and restfulness.[18] Bernard Karfiol (1886–1952), best known for his simplified paintings of classical nudes in interiors or landscape settings, created many of his earlier works in Ridgefield, where he was discovered in 1912 by the art patron Hamilton Easter Field (1873–1922).[19] Residing by the northwest corner of Art Lane and Studio Road until about the mid-twenties, Karfiol later recalled that "Ridgefield in time became quite a lively colony of artists and writers."[20]

.    .    .

A second and forward-thinking chapter of Ridgefield as a bucolic artists' colony occurred during Man Ray's residence there for approximately three years between late 1912 and the end of 1915. During his first visit, in the fall of 1912, Man Ray was accompanied by his painter friend Samuel Halpert (1884–1930), who had invited him to experience "an art colony on the Jersey side."[21] Man Ray had met the older artist and pioneering modernist at the Ferrer Center, a progressive educational institution in New York, and received encouragement from him to break away from academic influences. He and Halpert decided to share a shack that was among a group of houses in an orchard, rented in the summer to painters. They were attracted to Ridgefield's picturesque views and appreciated the walk through the woods and cold clear water from a local well—regarded by Man Ray as "symbols of an escape from the sordidness of the city."[22] Thinking of Thoreau, he hoped to liberate himself from the constraints of civilization. Thereafter, Halpert, who came out only on the weekends, joined the full-time resident Man Ray occasionally on painting excursions in the countryside and briefly exerted a strong modernist/Fauvist influ-

ence upon the younger artist (fig. 46).[23] The remaining room in the house was soon rented by Halpert's friend Alfred Kreymborg (1883–1966), the vanguard poet, journalist, playwright, and mandolin player who later wrote extensively about the Ridgefield colony in his autobiography *Troubadour* (1925). Having "never received the benefits of an extended contact with nature," Kreymborg recalled falling in love with "the view of the Jersey meadows, striped and streaked with the Passaic and Hackensack rivers, lazily rolling away to the horizon."[24]

Man Ray was very pleased with the additional companionship of Kreymborg, believing that the group "might develop into something more than merely an artists' colony; Ridgefield, New Jersey, could become an advanced cultural center embracing all the arts."[25] Man Ray's own aspirations to pursue writing as well as painting were further advanced by the arrival that summer in 1913 of the writer and painter Adon Lacroix (ca. 1888–ca. 1975), the companion of Man Ray's anarchist friend, the poet and sculptor Adolf Wolff (1883–1944).[26] Sharing Man Ray's desire to retreat from the city, Lacroix soon moved in with him, painting and writing prose and free verse in solitude during the day while Man Ray commuted to his work as a commercial artist in New York City. The inaugural issue of a short-lived magazine, *The Glebe,* appeared in September 1913, with poetry by Wolff and Man Ray's circular design for its title (fig. 62).[27] The title chosen was an appropriate synonym for the soil or mother earth, which may have also been intended to reflect their rustic surroundings in Ridgefield.

Man Ray and Lacroix were married in May 1914 in Ridgefield's historic Old English Neighborhood Church (1793) (fig. 96). Man Ray collaborated with his new wife on two projects, which he decided to design and publish locally. *Adonism* (1914) comprised woodcuts and poems that are

replete with landscape imagery, suggesting the artist's immersion in nature as a resident of Ridgefield (fig. 99). Featuring a schematic Ridgefield landscape on its cover, *A Book of Divers Writings by Adon Lacroix* (January 1915) contained a play and six poems, which were designed, calligraphed, and hand-printed by Man Ray (fig. 132).[28] Excerpts from their writings were published in an article by Kreymborg that appeared in the *Morning Telegraph* on March 14, 1915. Residing "on the heights of the picturesque town of Ridgefield," Man Ray and Lacroix enjoyed "a glorious view of nature, [which] extends for miles and miles to the north, west, and south, beyond the Hackensack River and the Orange Mountains to Paterson." Less than an hour from New York, they were at "the heart of Nature, with all its solitude, its healthfulness, its inspiration, and its unlimited opportunities for work undisturbed"—a privilege secured by "these two economist dreamers" for "the humble sum of $8 per month."[29]

Nevertheless, the solitude of Man Ray and Lacroix was pleasantly disrupted by groups of visitors, often on Sundays, including fellow students from the Ferrer Center, such as the artist and musician Manuel Komroff (1890–1974), who rented a nearby property and eventually became better known as a novelist.[30] Also associated with the Ferrer crowd was the visitor Max Eastman (1883–1969), founder and editor of the leftist magazine *The Masses.*[31] After an introduction by Kreymborg in New York, another regular visitor was the poet Alanson Hartpence (active ca. 1908–1919), who encouraged Charles Daniel (1878–1971), a collector and saloon owner, to open a gallery of modern art, where Man Ray would have his first one-man show in 1915. Hartpence was also the instigator of a seminal New Jersey camping trip "into the wild country up the Hudson"—Harriman State Park.[32] During this three-day excursion, Man Ray declared that he would no longer seek inspiration directly from nature. Instead, he announced that, upon his return to Ridgefield, he would paint a series of "imaginary landscapes" based on his recollection of the scenes and events that had taken place during the course of the trip. Thus, this experience was a pivotal moment in Man Ray's conversion to modernism and to a greater degree of abstraction in his work.

Others who came to the town at that time included the poet Orrick Johns (1887–1946) and his wife, Peggy, who settled in Ridgefield in the spring of 1915 to write and paint, discussing poetry with their nearest neighbors, Man Ray and Lacroix. There they found "a country refuge from the fads and wartime hysterias that were taking possession of people in Greenwich Village."[33] Another visitor who established a residence was the poet and writer Robert Carlton Brown (1886–1959). Parties at his lavish stone home, adorned with murals by Komroff, were the colony's chief social attraction, and his home became a gathering place for the original Provincetown Players acting group. His book *Let There Be Beer* (1932) captured the lively, boisterous spirit of these events, especially at the Old White House Tavern.[34]

During the early fall of 1915, Man Ray received two important visitors. One was the infamous French artist Marcel Duchamp (1887–1968), soon to become a leader of the New York Dada movement and an influential, lifelong friend. The other was Walter Arensberg (1878–1954), a prominent collector of modern art, who, along with Kreymborg, had already developed the idea for another collaborative avant-garde magazine venture. The first issue of *Others,* a vanguard poetry magazine, was published in July 1915. Kreymborg, the manuscript handler, editor, and general manager, rented a shack at Ridgefield again, and the social scene became increasingly lively as pioneering poets affiliated with *Others* "mingled with anarchists, self-styled nature lovers, and artists taking a break

from the city," including Man Ray (fig. 205).[35]
Orrick Johns, Mina Loy (1882–1966), Marianne
Moore (1887–1972), Maxwell Bodenheim (1893–
1954), Robert Alden Sanborn (188?–1962), Conrad
Potter Aiken (1889–1973), Mary Carolyn Davies,
Horace Holley (1887–1960), and Skipwith Cannell
(1887–1957) were among the writers who gathered
at Ridgefield on Sundays with picnic lunches and,
at times, manuscripts. Having worked mostly in
isolation, they appreciated these opportunities to
come together and talk shop. Among the first and
most significant contributors to *Others,* and a reg-
ular visitor to Ridgefield, was William Carlos
Williams (1883–1963), the doctor-poet from near-
by Rutherford, New Jersey, whom Kreymborg
characterized as "artist, scientist, and madman."[36]
Williams frequented Kreymborg's home "to help
with the magazine which had saved my life as a
writer."[37] In his memoirs, Williams recalled having
"arguments over cubism which would fill an after-
noon. It seemed daring to omit capitals at the head
of each poetic line. Rhyme went by the board. We
were, in short, 'rebels.'"[38] Williams, along with
Malcolm Cowley, Johns, and Bodenheim, was
part of the magazine's revolving editorship.[39] In
1917 Williams captured the beauty of the local sur-
roundings in the following excerpt from his poem
"January Morning":

> Who knows the Palisades as I do
> knows the river breaks east from them
> above the city—but they continue south
> —under the sky—to bear a crest of
> little peering houses that brighten
> with dawn behind the moody
> water-loving giants of Manhattan.[40]

With the success of Man Ray's exhibition of
drawings and paintings at the Daniel Gallery in
November 1915—six paintings were sold to the
Chicago-based collector Arthur J. Eddy (1859–

205. The *Others* group, 1916. Photograph. In front, from left: Alanson Hartpence, Alfred Kreymborg, William Carlos Williams, Skip Cannell; in back, from left, Jean Crotti, Marcel Duchamp, Walter Arensberg, Man Ray, Robert Alden Sanborn, Maxwell Bodenheim. From the Poetry Collection of the Lockwood Memorial Library, State University of New York, Buffalo.

1920)—he and Lacroix moved from Ridgefield to New York. As he expressed to his wife, Man Ray desired to be spared a third winter in the country, exclaiming that he had had "enough of this back-to-earth life—no more woodchopping or melting snow for water, for me."[41] Nevertheless, Man Ray had laid the modernist foundations for his future work as he developed the theoretical, formalist basis for his paintings as two-dimensional arrangements. Furthermore, Man Ray's desire, sparked during these years, to work from the imagination paved the way for his increasingly conceptual approach to art making from 1917 onward.

.    .    .

During the 1920s and beyond, another, less cohesive group of artists, writers, and musicians succeeded the circle of Man Ray, Kreymborg, and the *Others* coterie. Still remaining in Ridgefield in the Sketch Place area were Manuel Komroff, as well as the novelist, radical journalist, and associate editor of *The Masses,* Floyd Dell (1887–1969), a resident since the First World War.[42] They were joined by the Impressionist painter William Tisch (1879–1972), a commercial artist who often created *plein air* landscape watercolors "without any distraction" of his hometown, in which he had settled in 1925.[43] Tisch's house was built by his close friend the Cubist painter, muralist, and designer Robert J. Martin (1888–1971).[44] Residing in James Maxfield's former home was the sculptor, architectural decorator, and interior designer Leif Neandross (1896–?), son of the aforementioned Sigurd.[45] Others who were in Ridgefield included several former students of Robert Henri who were associated with the Society of Independent Artists: Powers O'Malley (1870–1946), the prolific *plein air* landscape painter Walter Farndon (1876–1964),

and Charles Duncan (1892–1952).[46] A frequent visitor to the area, as remembered by Tisch, was the pioneering modernist John Marin (1870–1953), who spent his youth in nearby Weehawken and moved in 1920 to Cliffside Park, a few miles southeast of Ridgefield.[47]

The attractions of Ridgefield remained unchanged for many years: primarily the availability of inexpensive studio space amidst a town replete with farmland and beautiful wooded hillsides but within an easy commute to New York City. Gradually, however, the redevelopment of Ridgefield and proliferation of large homes erased most traces of the bucolic colony, as hills were leveled, cottages and trees bulldozed. A few residents today, especially artists such as landscape painter and book designer Maria Pia Marrella, are, however, aware of the area's illustrious past and summon forth memories as they view the town's panoramic vistas:

> You're above the fray. We get great sunsets. I don't think I could leave because of this view. You get reminded of what it must have been like at the turn of the century.[48]

.    .    .

During the late nineteenth and early twentieth centuries, Ridgefield, New Jersey, was a surprisingly vital, episodic crucible for new developments in the arts, a rustic retreat where idealists came together to conceive the future social and aesthetic orders. In this quaint hamlet, isolated yet close to New York City, numerous works of art were created in a variety of mediums by Man Ray and many others. These surviving artifacts attest to the Ridgefield colonists' little-known yet critical contributions to the world of literature and the arts, which merit further research.

# DOCUMENTS

## A.

## A PRIMER OF THE NEW ART
## OF TWO DIMENSIONS

Statement prepared for inclusion in an article by John Weichsel, "New Art and Man Ray," *East and West* 1, no. 8 (November 1915), pp. 245–246, and revised for publication in Man Ray, *A Primer of the New Art of Two Dimensions* (New York: privately printed, 1916); see fig. 155.

The conscious individual striving to experience all the sensations of life, is forced by his physical and temporal limits to receive them in a more concentrated intellectual form. This concentration of life is offered by the expressive arts.

But growing intellectual experience demands proportional creative powers. While the individual passively receives sensations from the arts, an active mastery of all life is beyond him as much as is an actual participation in that life itself. The greater the horizons of his appreciation, the more concentrated are his creations. That is, as the lens sacrifices actual space in order to focus the details of space within its limits, so the individual condenses the time and space element to recreate life. This leads his medium of expression to a static condition implying the unities of time and space. A concrete or plastic form being conceivable in an instant of time fulfills the first condition. Two dimensions or a flat space being comprehensible from one point of view meets the second need.

Beginning then with all the expressive arts as already concentrated parallels of life, the conscious individual seeks to contain them for unlimited self-expression in this simple plastic medium. It is impossible because each of the expressive arts, the dynamic as well as the static, has a characterizing static factor containable in a flat plane.

Music finds its origin in the contact of points, lines and planes in instruments. In musical notation these contacts are plastically expressed by points and lines, which to the musician are symbols for sound. In themselves, points and lines are static and can therefore be projected onto a flat plane to give musical quality.

In literature, idea and matter are plastically expressed by written words possessing distant individual forms. Likewise, plastic forms of two dimensions contain a literary quality for the individual familiar with literature.

In dancing, rhythm is the essence. It determines the relations of a series of gestures and combines them into an expressive unity. Such gestures are individual forms as much as are words, rhythm, likewise, gives relationship to plastic forms. By rhythm, then dancing finds its parallel in the static plane.

All architecture is based on the principle of proportion or scale, a purely plastic element adaptable to the flat plane and fully expressive of the architectural sense of the mind.

Painting, as an illusion of Matter, is materially identified by the color and the texture of pigment; these qualities cultivated in themselves replace the illusion of matter by parallel realizations of matter and satisfy the tactile sense. So the essence of painting is preserved in the flat plane.

The final expression in sculpture is attained by the creation of values. On a flat plane the contrast of absolute plastic values produces the same sensations as the opposition of planes in a space of three dimensions, and so the essence of sculpture is adequately represented by the new medium.

In the essences of the first three arts mentioned, that is lines and points, form, and rhythm, the process of their construction gives the dynamic element while the other three, proportion, texture and color pigment, and values, in terms of their content, supply the static element of the arts. The combination of these essences into a unit frees them from the incompleteness of the symbolism they separately possess, for by mutual dependence they become entirely self-expressive and parallel to life. . . . The conscious individual who attains realization by this medium is not merely a painter any more than he is merely a colorist or a draftsman. He is an artist selecting the experiences of his life and simplifying them to an intelligible unit. Art is man's simplest concrete expression of his greatest intellectual experience. Every individual is an artist in a different degree of evolution.

## B.
### TEXTS FOR THE REVOLVING DOORS

Five of the following texts—those for *The Meeting, Shadows, Mime, Decanter,* and *The Dragonfly*—were first published in Man Ray's one-issue review *TNT* (see fig. 197). The entire series of ten collages was published with their accompanying texts in the Surrealist periodical *Minotaure* 7 (1935), p. 66. Presented here are the complete texts, preserved in a typewritten document inserted into an album Man Ray kept during his years in Hollywood (now in the library collection of the J. P. Getty Museum, Los Angeles).

THE REVOLVING DOORS:

The concern of a period of time often leads to the disappearance of material space. That is what the images in two dimensions shown here tend to prove; by a mutual action, they give birth to a series of events escaping from the control of all diversion.[1]

I. Mime: The two manners of creating a flame-like effect: by a radiation of bands of the spectrum starting from a common center and contained within a sector, and the other, by concentric bands of the spectrum. The center for both is the same, giving a personal interest. Armbands carry out the intention to the surrounding space. The mood interpreted may be characterized as a laughing one.

II. Long Distance: In the same way that the augmentation of the number of cylinders gives the motor a soft character, two eyes can unify between them what, to a single eye, would look like several fragments. Parting from an arbitrarily selected point as the source of these diverse notions, the

two eyes tend to share the same point of view. The intervening atmosphere can be considered as agent of the achievement of monochrome.

III. Orchestra: Taking their departure from the least indication of a motif, a succession of planes proceeds from an intensity of projection connected with the total volume of accumulated prisms. Although carrying in itself all the augmentations of original desire, this is a hyperbolic ambition ending in the routine of the movement.

IV. The Meeting: Three beings meeting in one plane are contrasted, a yellow concave, a red convex, and a spiral blue. There is a mutual affection of color over the areas that two or three occupy together, resulting in a modification of their color but not in their form. Still it is possible to see the areas held in common as distinct additions. As in the other scenes the lines form a not too literal boundary for the planes.

V. Legend: If one takes an umbrella in section, where one takes off the tip and where one turns it around on its curve, a container presents itself with an increase of color containing the handle. Between the drawn forms anonymous forms produce themselves which are left transparent, or which are filled with hues that can remain after the others have made their choice. (Note that the anonymous forms are also important.)

VI. Decanter: In this case the retort is tilted purely in a spirit of enjoyment; the mold that is produced by the contents is quite adventitious, but carried out with all the deliberation of a preconceived design. It acquires courage from its sudden change of function: built to reject, it becomes an instrument of acceptance.

VII. Jeune Fille: In another case the color is used exclusively like opaque medium. Thus, the greatest precautions are necessary when a method of logical procedure must be developed. It is not permitted to let two tones that present any kind of affinity to be next to each other. In this manner the nature of the subject allows itself to become enveloping, with a clarity of intention that compensates for all original uncertainty. The inevitable consequence is a projection into space itself . . . an equivalent for light.

VIII. Shadows: If three beams of light be thrown on an object from different angles, or if the object were turned on three different angles simultaneously in relation to a single beam of light, the resulting shadows would assume various proportions although their character remain the same. In the same way, if a form be invested with three colors at the same time and viewed from different angles, three distinct characters would result. They could be seen, however, only by imagination.

IX. Concrete Mixer: Grating beyond any need, three funnels will receive only a liquid and will determine the color by their relative positions. All existing residue distributes itself impartially on the three and touches spherical proportions. The wooden planks criss-cross as long as there is some work to do, and supply an appropriate sourdine to an operation otherwise too discordant.

X. The Dragonfly: The lozenges of different-colored wills to ascension are a fairly accurate record of the creature's struggle. The silver is a convention for what is unfulfilled. If the creature consulted its will only, it was bound to be dashed against the unknown. The base is always there for preservation.

MAN RAY
*New York, 1916–17.*

C.
CARD FILE

Man Ray kept a card file of the works he produced in New York and Ridgefield, so as to maintain a permanent record of the various paintings, sculptures, drawings, and other works of art he left in storage (either at the Daniel Gallery or with his sister, Elsie Siegler) before leaving for Paris. In most cases, the artist attached a small photograph of the work to the card; when photographs were not available, he usually made a small thumbnail sketch, providing just enough information to identify the work visually.

These cards served a variety of purposes; primarily, they were used to keep an accurate record of the location and exhibition history of a given work of art, but on other occasions, a selection of cards was sent to prospective clients interested in the possible acquisition of a certain work or works of art. Thus, in 1922, he sent a number of these cards to Ferdinand Howald, who, by prior arrangement with the artist, was allowed to select certain paintings and drawings for inclusion in his growing collection of American art. "The packet of indexed photos I sent you," Man Ray wrote to Howald, "represents all the pictures I left at Daniel's that still belong to me."[1] These cards were probably returned to the artist at a later date.

The resultant assembly of index cards, then, represents the first attempt to establish a catalogue raisonné of the works produced in this period. Each card, therefore, was assigned a number—from 1 to 141—preserving the order in which these cards were left by Man Ray himself at the time of his death. A complete inventory of these cards and their texts is provided in Francis M. Naumann, "Man Ray and America: The New York and Ridgefield Years, 1907–1921" (doctoral dissertation, City University of New York, 1988), appendix G. All citations to the card file provided in the present text are to that publication.

At the time of Man Ray's death, this card file was left in the possession of his widow, Juliet Man Ray, who generously provided me with a photocopy of each card (from which the appendix in my dissertation was compiled). After the main portion of the estate was sold in 1995, the card file disappeared. As the present publication was going to press, this valuable archival document suddenly reappeared at the Galerie 1900–2000 in Paris (consigned from the collection of Lucien Treillard).

## 1890

August 27: Born Michael [Emmanuel] Radnitzky in Philadelphia, Pennsylvania. His father, Melach, and mother, Manya, are recent émigrés from Russia, and Emmanuel is their first child. (They will go on to have three more children: Samuel in 1893; Devorah [Dora] in 1895; Elka [Elsie] in 1897.) Melach works as a tailor in a garment factory.

## 1897

Melach, who now goes by the name Max, secures a higher-paying job in a garment factory in Manhattan. The Radnitzky family moves into a three-room apartment in the Williamsburg section of Brooklyn.

## 1898

February 15: The battleship *Maine* is blown up in Havana harbor. A reproduction of the ship appears in the local newspaper, and eight-year-old Emmanuel makes a drawing based on the image. It is his first work of art.

## 1904–1908

Attends Boys' High School, Brooklyn. He especially excels in mechanical drawing classes and decides that, upon graduation, he will study to become an architect. In his senior year, he executes a series of sketches that serve as illustrations for the school newspaper and yearbook.

## 1908–1910

Upon graduation, sets up a studio in his parents' living room. Paints portraits of friends and relatives and Impressionist-inspired scenes of Prospect Park. Takes several different jobs in Manhattan, ending up doing layout and lettering in an advertising office on Fourteenth Street. On lunch hours, visits the Metropolitan Museum and sees various galleries; sees Rodin's watercolors at Stieglitz's Little Gallery of the Photo-Secession (or 291, as it was better known, from its street address on Fifth Avenue) and attends the first exhibition of "the Eight," or so-called Ashcan Group, at the Macbeth Gallery.

1910

October 2: Takes classes at the Art Students League, New York, until May 25, 1912; enrolls in the classes of George B. Bridgman, who taught anatomy; Edward Dufner, who taught illustration and composition; and Sidney E. Dickinson, a well-known portrait painter.

October 28: Applies for admission to the National Academy of Design, New York; takes classes there for about a year.

1912

Spring: In accordance with a suggestion provided by his brother, Sam, the Radnitzky family changes its name to Ray. Emmanuel stops signing his paintings with the monogram *ER* and begins signing them "Man Ray."

Fall: Enrolls in art classes at the Ferrer Center, or Modern School, a progressive educational institution located at 63 East 107th Street in Harlem. Fellow students are Samuel Halpert, Adolf Wolff, and Max Weber. Among the teachers are Robert Henri and John Weichsel, a critic who lectures on modern art and aesthetics. Wolff offers Man Ray the keys to his studio on West 35th Street. Man Ray begins working for the McGraw Book Company designing maps and atlases, a job he keeps for the next six years.

With Samuel Halpert, Man Ray visits an artists' colony in Ridgefield, New Jersey. He decides to begin sharing rent on a small shack with Halpert.

December 28, 1912–January 13, 1913: "Exhibition of Works by Artists of the Modern School," Ferrer Center. No catalogue known (but from reviews, it is known that Man Ray was represented with a painting entitled *A Study in Nudes*).

1913

February 17–March 15: Sees "International Exhibition of Modern Art" at the 69th Regiment Armory on Lexington Avenue at 25th Street in New York. Better known as the Armory Show, it was the largest exhibition of modern art ever held in New York, and Man Ray was overwhelmed. A few months later, makes his first Cubist painting, *Portrait of Alfred Stieglitz* (Yale University Art Gallery, New Haven).

Spring: A few weeks after seeing the Armory Show, moves out of his parents' home to live in the small shack that he rents with Halpert in Ridgefield. In Ridgefield, he meets the poet Alanson Hartpence, who will later introduce him to Charles Daniel, a saloonkeeper who eventually opens a gallery and shows Man Ray's work. In Ridgefield, he also meets Manuel Komroff, Hippolyte Havel, Max Eastman, and the poet Alfred Kreymborg.

April 23–May 7: Is represented by ten works in "Exhibition of Paintings and Water Colors at the Modern School," Ferrer Center. Catalogue introduction by Max Weber.

May 9: Man Ray's letter to the editor concerning a review by Arthur Hoeber appears in the *New York Globe and Commercial Advertiser*.

August 27: Meets Adon Lacroix, a Belgian poet then living with Adolf Wolff.

September: With another couple, Man Ray and Adon Lacroix go on a three-day camping trip to

the Ramapo Hills in Harriman State Park on the New York/New Jersey border. The excursion is very important for Man Ray, for he will come to the realization that he no longer needs to paint from nature.

First issue of *The Glebe* a magazine edited by Alfred Kreymborg and published in Ridgefield, appears. Man Ray designs the magazine's logo, which appears on the cover.

Fall: "Travail," his first published poem, appears in *The Modern School,* a magazine published by the Ferrer Center.

1914

May: Two of his drawings are reproduced as part of the cover design for *The International,* a socialist review.

May 3: Marries Adon Lacroix in Ridgefield. Their witnesses are Alanson Hartpence and Helen Slade.

Publishes *Adonism,* a collection of poems that he hand-prints and publishes on his own printing press.

1915

January: "Impressions of 291," Man Ray's homage to Stieglitz and his gallery, appears in *Camera Work.*

*A Book of Divers Writings,* by Adon Lacroix, designed, calligraphed, and hand-printed by Man Ray in Ridgefield.

February 16–March 7: "An Exhibition of Paintings by Elmer Schofield and an Exhibition of Paintings Representative of the Modern Movement in American Art," Memorial Art Gallery, Rochester, New York. Man Ray is represented by two works:

*Still Life* and *Madonna* (Columbus Museum of Art, Columbus, Ohio).

March 14: "Man Ray and Adon La Croix, Economists," a full-page article by Alfred Kreymborg emphasizing the ability of these two artists to live so frugally, appears in the *Morning Telegraph.*

March 23–April 24. "Exhibition of Paintings, Drawings and Sculpture," Montross Gallery, 550 Fifth Avenue, New York. Man Ray is represented by *War* (Philadelphia Museum of Art) and *The Rug* (private collection), as well as an unidentified landscape; also reproduced in the catalogue is his ink portrait of Adon Lacroix.

March 31: Date given to the first and only issue of *The Ridgefield Gazook,* entirely written and designed by Man Ray.

June 15: Marcel Duchamp arrives in New York. Man Ray will meet him for the first time on a trip that he takes to Ridgefield with his patron Walter Arensberg in the fall.

November: "New Art and Man Ray," an article by John Weichsel, appears in *East and West.* Shortly after the article appears, Man Ray writes to Weichsel saying that "as a whole the article is stimulating, and really helpful in sensing my place in art-movements. It satisfies one's curiosity and gives a chance for mental exercise."

Until November 23: Man Ray's first one-person show is held at the Daniel Gallery, 2 West 47th Street, New York. Thirty works by the artist are listed in the accompanying catalogue, six called simply "Study in Two Dimensions," and three "Wall Decoration." The painting *Dance* (called "Dance Interpretation") is reproduced in the cata-

logue and is discussed by several reviewers. Shortly after the show closes, the Chicago collector Arthur Jerome Eddy purchases six paintings for two thousand dollars.

December: Man Ray and Adon Lacroix move to a studio on Lexington Avenue near Grand Central Station in Manhattan.

"Three Dimensions," a poem by Man Ray, appears in *Others.*

Begins initial sketches for *The Rope Dancer Accompanies Herself with Her Shadows* (Museum of Modern Art, New York).

### 1916

January 2–18: "Special Exhibition of American Art of Today," Daniel Gallery. Man Ray is represented by the painting *Elderflowers* (see fig. 105).

March 13–24: Shows ten paintings and three drawings in "Forum Exhibition of Modern American Painters," Anderson Galleries, 15 East 14th Street, New York. Catalogue includes forewords by the organizers of the exhibition and explanatory notes by the artists, as well as an essay entitled "What Is Modern Painting?" by Willard Huntington Wright.

April 6: Writes to the critic Hamilton Easter Field asking for information about an "Amberwax" preparation he had described in an article.

Closing May 14: Shows a work entitled *Barnes* in "Annual Exhibition of Water Colors," Daniel Gallery.

May 17–June 15: Shows *Nativity* in "Philadelphia Exhibition of Advanced Modern Art," McClees Galleries, Philadelphia.

Summer [?]: Hand-letters and prints *A Primer of the New Art in Two Dimensions,* an important formalist tract.

December: Shows five works in "Exhibition of Small Paintings on View during December at the Daniel Gallery" and designs cover of the catalogue (see fig. 128).

### 1917

Until January 16: Has second one-person show at Daniel Gallery. According to the catalogue, which includes an introductory statement by Adon Lacroix, nine works are shown, including *Ballet-Silhouette* (Peggy Guggenheim Collection, Venice), which is reproduced.

January: Hand-prints *Visual Words, Sounds Seen, Thoughts Felt, Feelings Thought,* a collection of Adon Lacroix's writings.

February 10–March 10: Shows two drawings and a work entitled *Transmutation* in "Exhibition of Modern Art, Arranged by a Group of European and American Artists in New York," Bourgeois Galleries, 668 Fifth Avenue, New York.

April 10–May 6: Shows *The Rope Dancer Accompanies Herself with Her Shadows* (called "Theatre of the Soul" in the catalogue) in "First Annual Exhibition of the Society of Independent Artists," Grand Central Palace, Lexington Avenue and 46th Street, New York.

July 31: Writes to the collector John Quinn to ask if he would consider purchasing one of his paintings. (Quinn declines.)

1918

Beginning March 16: Shows a landscape in "Exhibition [of] Contemporary Art," Penguin Club, 8 East 15th Street, New York.

April 20–May 12: Shows *Narcissus* (or *The Ship "Narcissus"*) in "Second Annual Exhibition of the Society of Independent Artists," 110–114 West 42nd Street, New York.

1919

November 17–December 1: "Man Ray: An Exhibition of Selected Drawings and Paintings Accomplished during the Period 1913–1919," Daniel Gallery. Eighteen works are included in the show, including the ten panels of *The Revolving Doors,* as well as a number of more recent airbursh paintings. Reviews are mixed.

1920

January: At the invitation of Katherine Dreier, he and Duchamp are founding members of the Société Anonyme, Inc., the first museum in America devoted to the display and promotion of modern art.

February 1–February 29: Has five paintings in "Exhibition of Paintings by American Modernists," Museum of History, Science, and Art, Exposition Park, Los Angeles, California. Catalogue includes a foreword by Stanton Macdonald-Wright.

April 30–June 15: His *Lampshade, Portmanteau,* and *Danger/Dancer* are shown in "[First] Exhibition of the Société Anonyme," Galleries of the Société Anonyme, 19 East 47th Street, New York. No catalogue or checklist. Flyer lists Brancusi,

Bruce, Daugherty, Duchamp, Gris, Picabia, Man Ray, Ribemont-Dessaigne, Schamberg, Stella, Van Gogh, Villon, Vogeler.

Closing November 16: Shows *Anpor,* an airbrush, in "Opening Exhibition 1920–1921," Daniel Gallery.

November 1–December 15: Shows *Danger/Dancer* in the "[Fifth] Exhibition of the Société Anonyme," Galleries of the Société Anonyme. No catalogue or checklist. Exhibition included works by Bauer, Derain, Hartley, Van Heemskerck, Kandinsky, Mense, Man Ray, Schwitters, Stella, Walkowitz.

December 1: Writes to Francis Picabia and Tristan Tzara sending his contributions to "Dadaglobe," an international Dada magazine planned by Tzara but never published.

1921

January 15: *Lampshade* is shown in "[Seventh] Exhibition of the Société Anonyme," Manhattan Trade School for Girls, New York. Exhibition included works by Brancusi, Kandinsky, Mense, Man Ray, Ribemont-Dessaigne, Stella, Villon.

January 18: *Lampshade* is again shown in "[Eighth] Exhibition of the Société Anonyme," Colony Club, New York. Exhibition included works by Bauer, Brancusi, Braque, Bruce, Daugherty, Derain, Gris, Hartley, Kandinsky, Mense, Picabia, Man Ray, Ribemont-Dessaigne, Schamberg, Stella, Van Everen, Van Gogh, Villon, Vogeler.

February 17: "[Twelfth] Exhibition of the Société Anonyme," Civic Club, New York. Exhibition included works by Bauer, Braque, Kandinsky, Molzahn, Man Ray, Ribemont-Dessaigne, Schwitters, Villon, Vogeler.

March 7–26: *Portrait of a Sculptor* (which is actually a portrait of Berenice Abbott) is shown in the "Fifteenth Annual Exhibition of Photographs," John Wanamaker's, Philadelphia. Man Ray is awarded a prize of ten dollars, his first official recognition as a photographer.

April: First and only issue of *New York Dada* appears, edited by Man Ray and Marcel Duchamp.

April 16–May 15: Shows *War (A.D.MCMXIV)* in "Exhibition of Paintings and Drawings Showing the Later Tendencies in Art," Pennsylvania Academy of Fine Arts, Philadelphia.

June 6–30: Shows his photograph of an eggbeater (entitled *La Femme*) and an assembly of light reflectors, glass, and clothespins (called *L'Homme*) in "Salon Dada International," Galerie Montaigne, Studio de Champs Elysées, Paris.

June 8: Prepares an elaborate letter to Tristan Tzara, to which he attaches a nude photograph of the Baroness Elsa von Freytag-Loringhoven. In the letter he writes, "Dada cannot live in New York. All New York is dada and will not tolerate a rival—will not notice dada." Attaches the fragment of a filmstrip to the letter and signs it: "Man Ray / directeur du mauvais movies."

July 15: Departs for Europe. Gets money for his trip from Ferdinand Howald, who advances him five hundred dollars against future purchases. Arrives in Le Havre July 14 (Bastille Day) and takes the train to Paris, where he is met by Duchamp.

August–November: Resides temporarily in Duchamp's sister's studio, 22 rue de la Condamine.

November 3–December 5: Shows *The Rope Dancer Accompanies Herself with Her Shadows* at "Exhibition of Paintings by Members of the Société Anonyme," Worcester Art Museum, Worcester, Massachusetts.

December: Moves into the Hôtel des Ecoles on the rue Delambre, the same hotel in which Tristan Tzara is a resident.

December 3–31: Has thirty-five works, many from his years at New York and Ridgefield, in "Exposition dada Man Ray" at Librairie Six, 5 avenue Lowendal, Paris. Catalogue includes notes by Louis Aragon, Hans Arp, Paul Eluard, Max Ernst, Man Ray, Georges Ribemont-Dessaigne, Philippe Soupault, Tristan Tzara.

1921–1922

Winter: One night, in a makeshift darkroom in his room at the Hôtel des Ecoles, he discovers a photographic process that will change his life. While making contact prints from plate glass negatives, he accidentally develops a sheet of light-sensitive paper that earlier had been exposed to light. The result is a photogram, which is not flat and opaque but retains a three-dimensional effect. It is so different from anything he has seen in photography that he eventually decides to name the new process after himself, and thus the rayograph is born.

# NOTES

In the notes, because it is so frequently cited, Man Ray's autobiography, *Self Portrait* (Boston: Atlantic–Little, Brown; London: André Deutsch, 1963) is abbreviated *SP.* A second edition was published posthumously (Boston: Little, Brown, 1988); it includes a foreword by Merry A. Foresta and many more illustrations than the original edition. Unless otherwise noted, all citations are to the first edition.

## PREFACE

1. Quoted in "A Charmed Life: The Paris Apartment of Juliet Man Ray," *Architectural Digest,* December 1986, pp. 142–143.
2. *SP,* p. 33.
3. Karen Anhold Rabbito, "Man Ray in Quest of Modernism," *Rutgers Art Review* 2 (January 1981), pp. 59–59.
4. Carl Belz, "The Role of Man Ray in the Dada and Surrealist Movements," Ph.D. dissertation, Princeton University, 1963; Roland Penrose, *Man Ray* (Boston: New York Graphic Society, 1975); Arturo Schwarz, *Man Ray: The Rigour of Imagination* (New York: Rizzoli, 1977).
5. Jules Langsner, ed., *Man Ray,* Los Angeles County Museum, Lytton Gallery, Los Angeles, 1966, p. 28.

## CHAPTER ONE
### Youth and First Artistic Impulses (1907–1911)

1. *SP,* p. 4.
2. Ibid.
3. Ibid. The *Maine* was destroyed by an explosion on February 15, 1898, an incident that helped precipitate the Spanish-American war. Since Man Ray's birthday was in August, the box of crayons was probably given for another occasion.
4. "This Is Not for America," interview with Arturo Schwarz, *Arts* 51, no. 9 (May 1977), p. 117 (first published in Schwarz, *New York Dada: Duchamp, Man Ray, Picabia* [Munich: Prestel, 1973], pp. 79–100).
5. *SP,* p. 76.
6. First quoted by Harriet and Sidney Janis, "Marcel Duchamp: Anti-Artist," *View,* ser. 5, no. 1 (March 1945), p. 24.
7. Man Ray's parents may have considered "Michael" a more common and hence more acceptable name for a legal document. The artist's original last name has been identified variously, most often given as Radenski (see, for example, Catherine Turril, "Man Ray," in William Innes Homer, ed., *Avant-Garde Painting and Sculpture in America, 1910–25* [Wilmington: Delaware Art Museum, 1975], p. 116). Arturo Schwarz was the first to publish Man Ray's original birth date and name (see Schwarz, "Nota Biografica," in *Man Ray, Carte Varie e Variabili* [Milan: Gruppo Editoriale Fabbri, 1983], p. 32). To the reasons provided by Schwarz for concluding that Michael Radnitzky is Man Ray, it can be added that Man Ray's mother was indeed named Minnie, and his father, Max, was also a "Vest Maker," precisely the information provided on Man Ray's birth certificate (a transcription of which is preserved in the Department of Records, City Archives, Philadelphia, Pennsylvania).

Throughout his life, Man Ray preferred not to make his original last name known. This has caused at least one critic to accuse the artist of anti-Semitism (see George Mellyt, "Man Ray's Camera Obscura," *Interview,* October 1988), which I have argued was not the case (see Naumann, "Man

Ray: An American Artist in Pursuit of Liberty," in *Man Ray and America,* Haggerty Museum of Art, Marquette University, Milwaukee, Wisconsin, October 21–December 31, 1989, pp. 11–15, an essay that was revised and expanded in Naumann, "Man Ray in America," in *Man Ray in America: The New York, Ridgefield, and Hollywood Years,* Francis M. Naumann Fine Art, New York, October 27, 2001–January 55, 2002).

8. Information provided the author in an interview with Man Ray's sister Dorothy Ray Goodbread, October 9, 1983, Rydal, Pennsylvania.

9. Man Ray to Sam Ray, undated but, based on internal evidence, written ca. summer 1907 (Papers of Helen Ray Faden, South Pasadena, Florida). Rose is Man Ray's cousin Rose Levinson (later Rose Bloom).

10. *SP,* p. 9; the artist attended Boys' High School in Brooklyn, New York (information provided by Dorothy Ray Goodbread, relayed to the author by Naomi Savage, November 1986).

11. Man Ray, *Alphabet for Adults* (Beverly Hills: Copley Galleries, 1948).

12. Florence Blumenthal (Man Ray's niece), "End of a Story," unpublished and undated typescript, p. 5 (Papers of Joan Hofheimer, Bethesda, Maryland). In his autobiography, Man Ray did not provide the name of the institution that offered him a scholarship in architecture; he did so in his conversations with David Savage (relayed to the author on November 20, 1986).

13. *SP,* p. 10. Even though Man Ray's name change would not take place until the spring of 1912 (see note 23 below), in order to avoid confusion, from this point onward in the present text I have taken the liberty of referring to the artist as Man Ray.

14. The remark about portrait painting was made in conversation with Arturo Schwarz (see Schwarz, *Man Ray: The Rigour of Imagination* [New York: Rizzoli, 1977], p. 25).

15. *SP,* p. 27.

16. Ibid., pp. 24–27. If we adhere strictly to the chronological sequence of events as they are presented in Man Ray's autobiography, then this incident took place sometime in 1912, after Man Ray had already begun attending classes at the Ferrer Center (for he explains that the model was employed there during the week). Since the precise order of events is often presented out of sequence in this section of the autobiography, this incident could very well have occurred a few years earlier, even while the artist was still attending classes in high school, that is, as early as 1908.

17. Man Ray often expressed his opinion on this subject. See especially his comments in "It Has Never Been My Object to Record My Dreams" (New York: Julien Levy Gallery, 1945), n.p. (reprinted in Arturo Schwarz, ed., *Man Ray: 60 Years of Liberty* [Paris: Eric Losfeld, 1971], p. 24) and his article "Is Photography Necessary?" *Modern Photography* 21, no. 11 (November 1957), p. 85.

18. "This Is Not for America," p. 119. These academic institutions are described but left unnamed in Man Ray's autobiography (*SP,* pp. 12–16); they are identified by Carl Irvin Belz in his unpublished dissertation, "The Role of Man Ray in the Dada and Surrealist Movements" (Princeton University, 1963), pp. 3–4. Belz gained this information through interviews conducted with the artist. In a questionnaire circulated by the Museum of Modern Art, the artist states the names of these institutions and gives the dates of his attendance as follows: "National Academy: 1907; Art Students League: 1910" (Artists' Files, Department of Painting and Sculpture); although this document is undated, it was probably completed by the artist in 1954, the year in which the museum acquired *The Rope Dancer Accompanies Herself with Her Shadows* (fig. 159). For more specific information on the times of his attendance at these schools, see notes 19 and 20 below.

19. *SP,* p. 13. Man Ray (still under the name Emmanuel Radnitzky) applied for admission to the National Academy of Design on October 28, 1910. At that time, the school was still located on 109th Street and Amsterdam Avenue. It is not known precisely whose class the artist attended; at that time, instructors at the Academy were Charles Hinton, Francis Coates Jones, A. L. Kroll, George Maynard, Charles Yardley Turner, and Douglas Volk (information provided by Abigail Gerdts, Academy archivist).

20. Bridgman went on to publish many handbooks on drawing and drawing technique, most notably *The Human Machine: The Anatomical Structure & Mechanism of the Human Body* (Pelham, N.Y.: Bridgman Publishers, 1939). Bridgman taught a number of different day courses, but his night class—which Man Ray says he attended—was entitled "Evening Life." From December 1911 through January 1912, Man Ray also studied with Edward Dufner, who during the day taught "Antique Drawing" and in the evenings offered "Illustration and Composition" (it is not known exactly what class Man Ray attended; information provided by Lawrence Campbell, editor of League publications). On the Art Students League in these years, see Marchal E. Landgren, *Years of Art: The Story of the Art Students League of New York* (New York: Robert M. McBride, 1940).

21. *SP,* p. 13.

22. Quoted from comments provided in a questionnaire circulated by the Whitney Museum of American Art, New York (Museum Archives), completed by the artist on March 23, 1956.

23. Removing the *ny* (or "New York") from "Manny," as a friend of mine, Will Koenig, recently observed. According to Carl Belz, Man Ray adopted this new name in 1910 ("Role of Man Ray," p. 4). The change must have occurred somewhat later, however, for a number of paintings that are clearly dated 1911 continue to bear the monogram signature *ER* (several landscapes formerly in the collection of Man Ray's sister Dorothy Ray Goodbread, now in the San Lee and Jules Brassner Col-

lection, Tokyo Fuji, Art Museum, Japan, are inscribed in this fashion). On April 8, 1912, Sam Ray wrote in his diary: "These days the letterman calls 'ray,' no matter who the mail is for. Too hard to say the old name; argument in my favor" (Samuel Ray, "The Diary of a Bad Boy," Papers of Helen Ray Faden, Pasadena, Florida).

## CHAPTER TWO
## The Ferrer Center: Formulating the Aesthetics of Anarchism (1912)

1. *SP*, pp. 19–20. On the Ferrer School, see Paul Avrich, *The Modern School Movement: Anarchism and Education in the United States* (Princeton: Princeton University Press, 1980), and Ann Uhry Abrams, "The Ferrer Center: New York's Unique Meeting of Anarchism and the Arts," *New York History* 59, no. 3 (July 1978), pp. 306–325. A major portion of the present chapter was previously published as Francis M. Naumann, "Man Ray and the Ferrer Center: Art and Anarchy in the Pre-Dada Period," *Dada/Surrealism* 14 (Iowa City, 1985), pp. 10–30; reprinted in Rudolf E. Kuenzli, ed., *New York Dada* (New York: Willis Locker & Owens, 1986), pp. 10–30.

2. *SP*, p. 23.

3. Noteworthy exceptions are William Innes Homer, *Robert Henri and His Circle* (Ithaca: Cornell University Press, 1969), pp. 179–182, and Avrich, *Modern School*, pp. 45–153.

4. On Bellows's association with anarchists and anarchism, see Charles H. Morgan, *George Bellows, Painter of America* (New York: Reynal, 1965), pp. 153–154, and Avrich, *Modern School*, p. 149. In 1917 Bellows so sympathized with the American war effort that he volunteered for service in the Tank Corps and devoted his artistic efforts to illustrating the atrocities of the European conflict (see *George Bellows and the War Series of 1918* [New York: Hirschl & Adler Galleries, March 19–April 16, 1983]).

5. Emma Goldman, *Living My Life* (New York: Alfred A. Knopf, 1931), pp. 528–529 (quoted in Avrich, *Modern School*, p. 149).

6. *SP*, p. 23. Man Ray thought of illustrating his autobiography with one of these drawings but told Ariel Durant that he had decided against it, for fear that it might offend her or her husband (see Will and Ariel Durant, *A Dual Autobiography* [New York: Simon & Schuster, 1977], pp. 83, 390).

7. The basis for establishing the identities of these figures is primarily circumstantial, although their indistinctly rendered features bear a vague resemblance to photographs of these artists from this period; see the photograph of Henri instructing art students in a night class at the New York School of Art, 1907 (reproduced in Homer, *Robert Henri*, fig. 19), where, coincidentally, Henri strikes a pose remarkably similar to the position given in the Man Ray drawing; a photographic portrait of Wolff appears in an article by André Tridon, "Adolf Wolff: A Sculptor of To-Morrow," *Interna-*

*tional* 8, no. 3 (March 1914), p. 86. Wolff's politics and art will have a profound effect on the ideas and work of Man Ray in this period, a topic that will be discussed at greater length below.

8. *SP*, pp. 22–23.

9. See Adolf Wolff, "The Art Exhibit," *Modern School* 4 (Spring 1913), p. 11.

10. On the early appreciation of Cézanne in America, see John Rewald, *Cézanne and America: Dealers, Collectors, Artists, and Critics* (Princeton: Princeton University Press, 1989).

11. Adolf Wolff, "Art Notes," *International* 8, no. 1 (January 1914), p. 21.

12. *Exhibition of Paintings and Water Colors at the Modern School*, 63 East 107th Street, New York, April 23–May 7, 1913, n.p. (a copy of this rare catalogue is preserved in the Papers of Forbes Watson, Archives of American Art, microfilm roll no. D57, frames 474–476).

13. *The Copper Pot* may refer to the large brass bowl filled with dried foliage, a motif that became a trademark of Alfred Stieglitz's 291 Gallery, which Man Ray had begun to frequent at this time (see next chapter and William Innes Homer, *Alfred Stieglitz and the American Avant-Garde* [Boston: New York Graphic Society, 1977], p. 46; for an illustration of this vessel, see p. 198, fig. 93).

14. *SP*, p. 14.

15. Avrich, *Modern School*, p. 90.

16. Manuel Komroff, "Art Transfusion," *Modern School* 4 (Spring 1913), pp. 12–15.

17. Max Weber, untitled introduction to the Modern School catalogue (see n. 12 above).

18. Quoted in Lloyd Goodrich, *Max Weber* (New York: Whitney Museum of American Art, 1949), p. 46 (also cited in Avrich, *Modern School*, p. 155).

19. Man Ray's letter was dated May 3 [1913] and appeared in the *New York Globe and Commercial Advertiser* on May 9, 1913, p. 10. He was responding to Hoeber's article "Art and Artists," the *New York Globe and Commercial Advertiser*, May 2, 1913, p. 10.

20. See Francis M. Naumann and Paul Avrich, "Adolf Wolff, 'Poet, Sculptor and Revolutionist, but Mostly Revolutionist,'" *Art Bulletin* 67, no. 3 (September 1985), pp. 486–500.

21. Although it was not until August of 1914 that the Panama Canal was informally opened, the United States had been engaged in its excavation since 1906.

22. *Mother Earth* 9 (1914), nos. 6 (August), 7 (September); while Man Ray only designed these two covers for the magazine, the masthead he designed for the title was retained throughout the duration of its publication.

CHAPTER THREE
Stieglitz, Ridgefield, and the Assimilation of a
Modernist Aesthetic (1913: Part 1)

1. In his autobiography (*SP,* p. 18), Man Ray said that the Cézanne watercolor show was the first exhibition he saw at 291, but, a few sentences further on, he also reported having seen an exhibition of Rodin watercolors, the last of which was held at the gallery in the spring of 1910 (although Rodin drawings were periodically exhibited in group shows at the gallery). Rodin's drawings and their influence on Man Ray's work are discussed below.

2. Man Ray, "Impressions of 291," *Camera Work* 47 (dated July 1914, published January 1915), p. 61.

3. Even though Man Ray describes Stieglitz's preparation of this portrait in some detail in his autobiography (*SP,* pp. 19–20), it is not known for certain if Stieglitz can be credited as author of the photograph reproduced here. I discovered this print in the artist's studio in 1981 and believed at that time that it was a self-portrait. Since Man Ray did not securely determine his authorship by means of a signature or a studio stamp on the verso of the print (as was his custom), then it is logical to assume that this photograph may have been taken and printed by another photographer. I have suggested Stieglitz's authorship primarily on the basis of Man Ray's description, which very closely matches that of the image. The negative for this portrait is not preserved in the artist's estate, nor is it documented in the "master set" of Stieglitz prints housed in the collection of the National Gallery of Art, Washington, D.C. Primarily for stylistic reasons, the current leading experts on Stieglitz—Peter Bunnell and Sarah Greenough—are hesitant to assign a secure Stieglitz authorship.

4. Exactly when this photograph was taken is also open to question. My estimate of ca. 1915 is based on the fact that it was likely in that year—when Man Ray was preparing for his first exhibition at the Daniel Gallery—that he approached Stieglitz for technical information about how to take photographs of his paintings.

5. *SP,* p. 181.

6. Ibid., p. 18.

7. This watercolor is clearly signed and dated at a later date—probably many years later—for the artist did not use the name Man Ray until sometime during the spring of 1912 (see ch. 1, n. 23), and the calligraphic style of the inscription is more typical of works dated in the 1950s and 1960s. With this much of a time removal, it is likely that Man Ray guessed at the early date, imagining that, because of its subject, the work must have been made while he was still living at home. The style, however, is one that is more consistent with other drawings and watercolors made at the end of 1912 or the beginning of 1913.

8. *SP,* p. 18.

9. Nine drawings by Rodin are reproduced in a special issue of *Camera Work* devoted to his work, no. 34–35 (dated April–July 1911).

10. *Modern School* 5 (Autumn 1913), p. 17; this issue also contained Man Ray's poem "Travail."

11. Until now, the date of Man Ray's move to Ridgefield has always been given as 1913, but there is some evidence that he took his first trip out to the artists' colony somewhat earlier, probably in the closing months of 1912. His winter landscapes are dated 1913 (see figs. 48, 49), but they must have been completed in the early months of that year. Works made after the fall of 1913 (see figs. 82–89) are strikingly different in style and approach. Finally, to the end of his life, Man Ray kept a sketchbook (now lost) that was prominently inscribed: "Man Ray 1912 / Ridgefield N.J." (see below).

12. *SP,* p. 30.

13. Margaret Johns, "Free Footed Verse Is Danced in Ridgefield, New Jersey," *New York Tribune,* July 15, 1915, sec. 3, p. 20.

14. The photograph of Man Ray in Ridgefield that is reproduced here (fig. 47) was once in the collection of his brother, Sam, and is inscribed on its verso: "Bro Man / Winter 1913" (Papers of Helen Ray Faden, Pasadena, Florida).

15. *SP,* p. 33; quoting from the same passage, Arturo Schwarz concluded that this painting disappeared (*Man Ray: The Rigour of Imagination* [New York: Rizzoli, 1977], p. 31).

16. See, for example, Halpert's *Brooklyn Bridge,* 1913 (Whitney Museum of American Art, New York), reproduced in Lloyd Goodrich, *The Decade of the Armory Show, 1910–1920* (New York: Whitney Museum of American Art, 1963), p. 10. For more on Halpert's work of this period, see John Weichsel,

"Samuel Halpert's Paintings," *East and West,* January 1916, pp. 310–313, 316, and Diane Tepfer, *Samuel Halpert: A Conservative Modernist,* Federal Reserve System, Washington, D.C., April 9–May 31, 1991. On Marquet, see Francis Jourdain, *Marquet* (Paris: Cercle d'art, 1959), Marcell Marquet, *Marquet* (Paris: Laffont, 1951; Hazan, 1955) and François Daulte, *L'Oeuvre de Marquet* (Lausanne: Spes, La Bibliothèque des Arts, 1953).

17. This painting was formerly in the possession of Dorothy Ray Goodbread, Rydal, Pennsylvania, but it is now in the collection of Jules and San Lee Brassner (on long-term loan to the Tokyo Fuji Art Museum, Japan). For reasons that are unclear, Schwarz reproduces the same still life with Japanese figurine (fig. 55), but he gives it a date of 1910 (Schwarz, *Man Ray,* fig. 5, p. 18). Although the painting is not dated, the date of 1910 is untenable. On the basis of subject and style, the date provided here—ca. 1913—is more probable.

18. Alfred Kreymborg, *Troubadour: An Autobiography* (New York: Liveright, 1925), p. 201.

19. Quoted from C. Lewis Hind, "Wanted, a Name," *Christian Science Monitor,* ca. November–December 1919 (exact date unknown; clipping preserved in the scrapbooks of Katherine Dreier, Collection of the Société Anonyme, Beinecke Library, Yale University, New Haven; reprinted with slight variations in Hind, *Art and I* [New York: John Lane, 1920], pp. 180–185). Despite the early date of this statement—made only five years after the event referred to—it is unlikely that the artist totally ceased artistic production for a period of six months simply because he needed the time to contemplate what he had seen at the Armory Show. It is at best an exaggeration, meant only to emphasize the importance of this event.

20. For the identification of this and all other works exhibited in the Armory Show, see Milton W. Brown, *The Story of the Armory Show* (Greenwich: New York Graphic Society, 1963), pp. 217–301, 2nd revised edition (New York: Abbeville, 1988), pp. 244–327, and Brown, *Armory Show: 50th Anniversary Exhibition, 1913/1963* (Utica: Munson-Williams Proctor Institute, 1963), pp. 182–208.

21. In the 1910 exhibition of Matisse's drawings at 291, Stieglitz supplemented the show by displaying black-and-white photographic reproductions of paintings, including, among others, *Harmony in Red* (see William Innes Homer, *Alfred Stieglitz and the American Avant-Garde* [Boston: New York Graphic Society, 1977], p. 61).

22. See the catalogue that accompanies the exhibition *Inheriting Cubism: The Impact of Cubism on American Art, 1909–1936,* essay by John Cauman, Hollis Taggart Gallery, New York, November 28, 2001–January 12, 2002.

23. On the influence of Cubism in Weber's work of this period, see Homer, *Alfred Stieglitz,* p. 130, and Percy North, *Max Weber: American Modern* (New York: Jewish Museum, 1982), pp. 36–37. These historians fail to note that there is documentary evidence to prove that Weber actually met Picasso and visited him in his studio in 1908, a fact supported by a note from Picasso to Weber, dated November 10, 1908, wherein Picasso expresses his regret at having missed Weber's visit to his studio but also arranges for another appointment on the following day (this note is reproduced and translated in Sandra E. Leonard, *Henri Rousseau and Max Weber* [New York: Richard L. Feigen, 1970], p. 33 and plate 14, p. 81). Later, reproductions of Picasso's work in American newspapers and magazines can be seen to have influenced the early Cubist compositions of both Max Weber and Man Ray (see the discussion of this topic in chapter 6 of the present study, particularly as it pertains to sources for Man Ray's *Five Figures* [fig. 120]).

24. See, for example, Weber's *Bathers,* 1909 (Baltimore Museum of Art, Cone Collection) and *Summer,* 1909 (Collection of Mr. and Mrs. Solomon K. Gross, New York). On Weber's claim to have been the first to import Cézanne, see Lloyd Goodrich, interview with Max Weber, November 9, 1948, Archives of American Art (reported in Homer, *Alfred Stieglitz,* p. 130).

25. This drawing currently carries Man Ray's signature and the date "1913." On the verso of a photograph taken in 1963, however, no date appears on the image and the year "1912" is written on the verso. Naomi Savage (who owns this photograph) explains that although this date was provided by the artist himself (when assembling works for an exhibition in Princeton), since he later inscribed the drawing "1913," the earlier date was probably provided in error.

26. *Camera Work,* special number (dated August 1912).

27. As suggested by Arturo Schwarz, *Man Ray,* p. 30; note that this does not rule out the possibility of his experimentation with Cubism at an earlier date, as I have suggested above.

28. Brown, *Story of the Armory Show,* p. 112.

29. These phrases are excerpted from four pages of text in Man Ray's handwriting that are dated "Nov. 4, 1912" (Papers of Helen Ray Faden, Pasadena, Florida). For reasons that are unclear, in the biography of Man Ray by Neil Baldwin (*Man Ray: American Artist* [New York: Clarkson N. Potter, 1988], pp. 35–36), this passage is referred to as "the artist's secret diary" and interpreted as referring to Adon Lacroix, whom Man Ray would not meet until August of the following year.

## CHAPTER FOUR
## New Words for New Images: Adon Lacroix and the Modern Poetry Movement (1913: Part 2)

1. Man Ray, "Travail," *Modern School* 5 (Autumn 1913), pp. 20–21. The depressing tone of this poem is uncharacteristic of writings produced after his meeting with Adon Lacroix in the summer of 1913 (discussed below).

2. Margaret Johns, "Free Footed Verse Is Danced in Ridgefield, New Jersey," *New York Tribune,* July 25, 1915, sec. 3, p. 2. It is curious that this journalist does not mention Man Ray by name, for he ran his own printing press and, by the time this

article appeared, had already issued several publications of his and Adon Lacroix's writings (figs. 99, 132). On the *vers librists,* see also Alfred Kreymborg, "Vers Libre and Vers Librists," *Morning Telegraph,* August 8, 1915, p. 50.

3. According to Kreymborg, Man Ray accepted the term "with gusto," but Halpert disliked the word because of its religious connotation (see Alfred Kreymborg, *Troubadour: An Autobiography* [New York: Liveright, 1925], p. 202).

4. Kreymborg mistakenly implies that once the printing press had broken, the Bonis took over publication of *The Glebe* from its very first issue (ibid., p. 210). This error is repeated in the standard source on the history of the little magazine: (Frederick J. Hoffman, Charles Allen, and Carolyn F. Ulrick, *The Little Magazine: A History and Bibliography* (Princeton: Princeton University Press, 1946), p. 46. The most current and reliable source of information on *The Glebe* is provided by Jay Bochrer in *American Literary Magazines: The Twentieth Century,* Edward E. Chielens, ed. (Westport, Conn.: Greenwood Press, 1992), pp. 135–139.

5. On the last page of *Adonism,* a booklet of poems published in 1914 (fig. 99), Man Ray wrote: "Publisher of 'The Bum' and other original papers." Kreymborg is quoted from *Troubadour,* p. 202.

6. *SP,* p. 32.

7. The alternate title by which this work is known today—*A Tree Grows in Brooklyn*—was suggested by Man Ray himself when he saw the painting on display in his exhibition at the Princeton Art Museum in 1963 (the comment was recalled by his niece Naomi Savage). *A Tree Grows in Brooklyn* is the title of a novel by Betty Smith published in 1943 (which in 1945 was made into a popular movie by Elia Kazan).

8. See n. 2 above.

9. See William H. Gerdts, "The American Fauves, 1907–1918," in *The Color of Modernism: The American Fauves,* Hollis Taggart Galleries, New York, April 29–July 26, 1997, pp. 5–22.

10. Man Ray provided the exact date of his meeting with Adon Lacroix in a brief statement that he provided for the editors of *Minotaure* 3/4 (October–December 1933), p. 112.

11. This is how Man Ray explained the creation of this painting in his autobiography (*SP,* pp. 39–40), but when he filled out a questionnaire for the Whitney Museum in March of 1957, he wrote of this painting: "Living in the country near Ridgefield, N.J., this picture was painted (1913) at night by the light of an oil lamp which accounts for the dominance of yellow in the face. However, this should not be considered accidental, and I have used the same colors in later portraits painted in normal daylight! The stylization of the face is an obvious attempt to break away from academic drawing" (Artists' Files, Whitney Museum of American Art, New York). Despite Man Ray's explanation of how this painting came into being, it may have been based on the photograph of a woman sleeping that appeared in the local newspapers; a copy of this unidentified clipping is attached to the verso of the painting (opposite).

12. From 1910 through 1916, Mitchell Kennerley was publisher of the magazine *The Forum.* His identity was not provided by Man Ray in his account of this sale (*SP,* p. 40), though he supplied the publisher's name in the Whitney questionnaire referred to in the previous note. For a recent biography of this publisher, see Matthew Bruccoli, *The Fortunes of Mitchell Kennerley* (New York: Harcourt Brace Jovanovich, 1986).

13. *SP,* p. 44; this remark can be attributed to Man Ray's description of his state of mind in the fall of 1913, for his account continues: "I seethed with projects to paint; I must find more time to myself. There were so many immediate distractions: my job, chopping and storing wood for the approaching winter, getting warm clothes." The "approaching winter" was later identified as that of 1913–1914 (p. 45).

14. Ibid., *SP,* p. 54. I originally believed, based on the sequence of events related in Man Ray's autobiography, that this important camping trip took place in the fall of 1914, a conclusion that was reported in nearly all of my published writings on the artist (see especially Naumann, "Man Ray, 1908–1921: From an Art in Two Dimensions to the Higher Dimension of Ideas," in *Perpetual Motif: The Art of Man Ray* [Washington, D.C.: National Museum of American Art; New York: Abbeville Press, 1988], pp. 50–87, and Naumann, "Man Ray's Early Paintings, 1913–1916: Theory and Practice in the Art of Two Dimensions," *Artforum* 20, no. 9 [May 1982], pp. 37–46). My conclusions changed when I examined a watercolor that Man Ray made during this trip (fig. 80), which is inscribed on its verso "September 1913."

15. *SP,* p. 42.

16. I have in mind paintings such as *Paysage, No. 2* of 1911 (Herbert and Nannette Rothschild Collection) and *Landscape (Paysage, No. 1)* of 1912 (Philadelphia Museum of Art), both of which were included in the Armory Show. Paul Wescher was the first to suggest that *The Village* is best compared to paintings by Roger de la Fresnaye ("Man Ray as Painter," *Magazine of Art* 46 [January 1953], p. 32). But Wescher cited as an example only de la Fresnaye's well-known *Conquest of the Air,* a painting that Man Ray could not have known at this time (the definitive version of this work is now in the collection of the Museum of Modern Art, New York; for its exhibition history and provenance, see Germain Seligman, *Roger de la Fresnaye* [Greenwich: New York Graphic Society,

1969], cat. no. 137, p. 156). For a list of the works by de la Fresnaye exhibited in the Armory Show, see Milton W. Brown, *The Story of the Armory Show* (Greenwich: New York Graphic Society, 1963), p. 259.

17. *SP,* p. 45.

18. Ibid., p. 55.

19. In this period the painting was in the collection of Leo and Gertrude Stein in Paris; when reproduced in the Picasso/Matisse issue of *Camera Work* (August 1912), it was identified only by the caption "Spanish Village."

20. Kreymborg, *Troubadour,* p. 201.

21. When I was compiling information for my dissertation on Man Ray, his widow, Juliet, told me that this painting was never returned from the Man Ray exhibition held at the Centre Georges Pompidou in 1981. This painting, however, does not appear among the works listed as having been shown in this exhibition (see Jean-Hubert Martin, ed., *Man Ray,* Centre Georges Pompidou, December 10, 1981–April 12, 1982).

## CHAPTER FIVE
## Approaching the Art of Painting in Two Dimensions: The Paintings, Drawings, and Watercolors of 1914

1. Arturo Schwarz, *Man Ray: The Rigour of Imagination* (New York: Rizzoli, 1977), p. 31.

2. *SP,* p. 46.

3. Ibid., pp. 51–52.

4. See Francis M. Naumann, "Man Ray: *Hills,*" *Masterworks of American Art from the Munson-Williams-Proctor Institute* (New York: Harry N. Abrams, 1989), p. 117.

5. *SP,* p. 46.

6. See, for example, Schwarz, *Man Ray,* p. 32, and Marcel Jean, *The History of Surrealist Paintings* (New York: Grove Press, 1960), p. 60. In describing this painting, Schwarz mistakenly attributes the statement "In a picture, is it not above all the signature that counts?" to Man Ray, when, in fact, it is only a remark made by Jean in discussing the painting.

7. *SP,* p. 57.

8. There is no proof that these works were completed in the order given here; they are placed into this sequence entirely on the basis of style, progressing from those images strongly dependent upon a naturalistic portrayal of their chosen subjects to those that appear to have been more consciously "abstracted" or stylized.

9. *SP,* p. 45.

10. The original plaster sculptures by Wolff were reproduced in *Vanity Fair,* October 1914, p. 54.

11. Gelette Burgess, "The Wild Men of Paris," *Architectural Record* 27, no. 5 (May 1910), pp. 400–414; on the importance of this article, see Edward Fry, "Cubism, 1907–08: An Early Eye Witness Account," *Art Bulletin* 47, no. 1 (March 1966), pp. 70–73.

12. C. Lewis Hind, "Wanted, a Name," *Christian Science Monitor,* ca. November–December 1919 (exact date unknown; clipping preserved in the scrapbooks of Katherine Dreier, Collection of the Société Anonyme, Beinecke Library, Yale University, New Haven; reprinted with slight variations in Hind, *Art and I* [New York: John Lane, 1920], pp. 180–185).

13. For reviews of this exhibition and an account of its organization, see Marius de Zayas, *How, When, and Why Modern Art Came to New York,* ed. Francis M. Naumann (Cambridge: MIT Press, 1993), pp. 55–64.

14. Questionnaire completed by the artist on March 23, 1957 (Artists' files, Whitney Museum of American Art, New York).

15. There were others as well: another for the two reclining figures in the foreground (Collection Silvo Perstein, Antwerp) and a lost painting for the masked figure on the right (reproduced in the Artist's Card File, document C, no. 52).

16. *SP,* p. 75. The decision to consciously renounce the influence of primitive art must have occurred around 1915 (according to information supplied in the Whitney questionnaire [see n. 14 above], for the artist said that the influence of primitive art lasted only from 1913 through 1915.

17. Gail Levin, "American Art," in William Rubin, ed., *"Primitivism" in 20th Century Art,* vol. 2 (New York: Museum of Modern Art; Boston: New York Graphic Society, 1984), p. 462.

18. Frank Stephens, "A.D. 1914," *Mother Earth* 9, no. 8 (October 1914), p. 254.

19. Interview with Arturo Schwarz, quoted in Schwarz, *Man Ray,* p. 32.

20. *SP,* p. 49.

21. Although both catalogues were published in 1916, I believe Man Ray used earlier sketches, for both of these images appear to have served as preparatory studies. The subtitle came from the Artist's Card File, document C, no. 48.

22. Statement by the artist published in Mary Lawrence, ed., *Mother and Child* (New York: Thomas Y. Cronwell, 1975), p. 64. My interpretation of this painting and its preparatory drawing is based on the artist's description of *Madonna* provided in this statement.

23. Paul Wescher, "Man Ray as Painter," *Magazine of Art* 46, no. 1 (January 1953), p. 33.

24. For reviews of this exhibition and reproductions of works by Picasso and Braque that were included in the show, see de Zayas, *Modern Art,* pp. 28–40.

25. *SP,* p. 18.

26. See the artist's description of this project in his interview with Pierre Bourgeade, *Bonsoir, Man Ray* (Paris: Pierre Belfond, 1972), pp. 49–50.

27. On the relationship of American *trompe l'oeil* painting to Cubist collage, see Francis M. Naumann, "Illusion and Reality: The Origin and Development of Collage and Assemblage in American Art," in *Collage and Assemblage* (Jackson: Mississippi Museum of Art, 1981), pp. 1–14.

CHAPTER SIX
The Art of Painting in Two Dimensions, Part 1:
The Paintings, Drawings, and Watercolors of 1915

1. The title is often misread as *diverse* rather than *divers,* but we can be fairly certain that Man Ray intended the dual reading, for readers were expected to "dive" into the text, just as he and his wife—as creative artists—were in the process of diving into unexplored areas of creativity. In 1986 *A Book of Divers Writings* was reprinted by Luciano Anselmino, Milan (two hundred numbered examples, the first five of which contain an original drawing made for the 1914 publication.) Considering the availability of this reprint, it is remarkable how often this publication has been improperly identified.

2. Quoted in Alfred Kreymborg, "Man Ray and Adon La Croix, Economists," *Morning Telegraph,* March 14, 1915, p. 7. I am grateful to Billy Kluver and Julie Martin for having drawn this bibliographic citation to my attention. (The article is reproduced here as fig. 134).

3. *SP,* pp. 44, 50.

4. Biographical information on Charles Daniel and his gallery was derived from Elizabeth McCausland, "The Daniel Gallery and Modern American Art," *Magazine of Art* 44, no. 7 (November 1951), pp. 280–285, as well as from notes compiled by Virginia Zabriskie of three visits with Daniel, dated June 20, 1961, April 26, 1966, and April 23, 1970 (archives of the Zabriskie Gallery, New York; I am indebted to Virginia Zabriskie for having provided me with access to this material).

5. Man Ray listed the people who acquired all twenty copies of this publication (including one that he retained for himself) on the verso of a card in his Card File, document C, no. 72 (verso).

6. Kreymborg, "Man Ray and Adon La Croix, Economists." Kreymborg discusses the articles he wrote for this newspaper in his autobiography (*Troubador: An Autobiography* [New York: Liveright, 1925], pp. 214–215), but he does not identify the articles themselves, many of which contain important firsthand accounts of contributions made in the worlds of both art and literature. He published fifteen articles in all, on subjects as varied as life in Greenwich Village and the publication of Gertude Stein's *Tender Buttons* (a full list of these articles was published in Francis M. Naumann, "Man Ray and America: The New York and Ridgefield Years, 1907–1921" [doctoral dissertation, City University of New York, 1988], p. 117, n. 17).

7. *SP,* p. 55; he would later describe this phase of his work as "my Romantic-Expressionistic-Cubist period" (*SP,* p. 65).

8. *Exhibition of Paintings by W. Elmer Schofield and a Collection of Paintings Representative of the Modern Movement in American Art,* Memorial Art Gallery, Rochester, New York, February 16–March 7, 1915 (Man Ray's entries were cat. nos. 64 and 65).

9. *Post Express,* February 17, 1915; *Madonna* was also repro-

duced, along with James Doherty's [Daugherty's] *Subway Station,* in the *Rochester Democrat,* February 18, 1915. This information was supplied in a letter from Janet Otis, archivist of the Memorial Art Gallery, to Catherine Glasgow, assistant curator at the Columbus Museum of Art, dated March 17, 1982 (Museum Archives, Department of Twentieth Century Art, Columbus Museum of Art; copies of this correspondence were kindly provided for me by E. Jane Connell, associate curator).

10. *Exhibition of Paintings, Drawings, and Sculpture,* Montross Gallery, New York, March 23–April 24, 1915.

11. Quoted in William B. McCormick, "Cubists and the Other Obscurationists Have Their Inning This Month," *New York Press,* February 1, 1914, sec. 4, p. 8. On the Montross Gallery, see Judith Zilczer, "'The World's New Art Center,' Modern Art Exhibitions in New York City, 1913–1918," *Archives of American Art* 1, no. 3 (1974), pp. 4–5.

12. *SP,* p. 56. The paintings Man Ray showed were cat. nos. 45, 46, and 47; reproduced in the catalogue was the artist's *Portrait of Adon Lacroix* (cf. figs. 132 and 134).

13. The original ink sketch for this publication was formerly in the collection of Arnold Crane, Chicago, but it was lost or discarded upon the conclusion of an exhibition in 1990. It was from this example that the review was reprinted in 1970 by Mazzotta (Milan), as part of their series of facsimile Dada documents. Since there are no known copies of the original review in existence, it is my contention that it was probably never printed and never circulated.

14. For a detailed account of this incident, see Paul Avrich, "Lexington Avenue," ch. 6 in *The Modern School Movement: Anarchism and Education in the United States* (Princeton: Princeton University Press, 1980), pp. 183–216.

15. Artist's questionnaire, dated June 19, 1954 (Museum Archives, Department of Painting and Sculpture, Museum of Modern Art, New York).

16. Wassily Kandinsky, *Uber das Geistige in der Kunst,* original German edition 1912, first published in English under the title *The Art of Spiritual Harmony* (London and Boston, 1914). The present quotation is taken from Rose-Carol Washton Long, "Kandinsky's Vision," in Long and John Bowlt, eds., *The Life of Vasilii Kandinsky in Russian Art: A Study of "On the Spiritual in Art"* (Newtonville: Oriental Research Partners, 1980), p. 50.

17. Albert Gleizes and Jean Metzinger, *Cubisme* (Paris: Eugene Figuiere, 1912); first English edition *Cubism* (London: T. Fisher Unwin, 1913); the present quotation is taken from the English edition, p. 28.

18. *SP,* p. 30.

19. This painting went by various titles. In Man Ray's card file of works from this period, he simply entitled it "Nativity" but later added the notations "also called 'Black Widow'" (Artist's Card File, document C, no. 87). In the price list of works included in the Forum Exhibition (see next chapter), it was entitled "Invention-Nativity."

20. This watercolor is reproduced in Arturo Schwarz, *Man Ray: The Rigour of Imagination* (New York: Rizzoli, 1977), fig. 7.

21. On the founding of the magazine, see Kreymborg, *Troubadour*, pp. 218–223.

22. *SP*, p. 41, and "This Is Not for America," interview with Arturo Schwarz, *Arts* 51, no. 9 (May 1977), p. 117.

23. *Others* 1, no. 6 (1915), pp. 107–108. Although this issue is not dated, it followed the November 1915 issue and preceded the first issue of 1916, meaning that it likely appeared in December. Man Ray's poem was probably written at some point earlier in the year, possibly during the summer months.

24. *Third Exhibition of Works by Contemporary French Artists,* Carroll Gallery, New York, March 8–April 3, 1915. The two works by Duchamp were cat. nos. 16 and 17.

25. William B. McCormick, "Present Cubist Show Is Most Representative Yet," *New York Press,* March 21, 1915, sec. 5, p. 9.

26. *SP*, p. 56.

27. "Interview with Man Ray," in Jean-Hubert Martin, ed., *Man Ray Photographs* (London: Thames and Hudson, 1982), p. 35.

28. Willard Huntington Wright, "Modern American Painters and Winslow Homer," *Forum* 54, no. 6 (December 1915), p. 669.

29. Dr. John Weichsel, "New Art and Man Ray," *East and West* 1, no. 8 (November 1915). Due to the rarity of this magazine (it is only known in a microfilm copy housed in the collection of the New York Public Library), the articles written by John Weichsel for this short-lived review have been overlooked by art historians. He wrote not only on Man Ray but also on Elie Nadelman (August 1915), Jerome Myers (December 1915), Samuel Halpert (January 1916), Adolf Wolff (February 1916), and a number of artists who would be less known in years to come. I learned about the existence of this magazine from Diane Tepfer, who had known about the article on Halpert (see her *Samuel Halpert: A Conservative Modernist,* Federal Reserve System, Washington, D.C., April 9–May 31, 1991, p. 17, note 1). For more on Weichsel, see Gail Stavitsky, "John Weichsel and the People's Art Guild," *Archives of American Art Journal* 31, no. 4 (1991), pp. 12–19.

30. Man Ray to John Weichsel, November 3, 1915 (Papers of John Weichsel, Archives of American Art, Smithsonian Institution, Washington, D.C. [hereafter referred to as AAA], microfilm roll N601, frame 401).

31. Memoirs of Charles Daniel, unpublished typescript, p. 31 (Archives of American Art, Smithsonian Institution, Washington, D.C., microfilm no. 1343).

32. *SP*, p. 59.

33. The first quotation is taken from A.v.C., "Man Ray's Paint Problems," *American Art News* 54, no. 6 (November 13, 1915), p. 5; the second from Francis J. Ziegler, "Widely Different Phases of Modern Art," *Philadelphia Record,* 1915 (more precise date unknown; clipping preserved in the papers of Willard Huntington Wright, Princeton University). See also the anonymous review of this exhibition in the *New York Times,* "The Paintings of Man Ray," November 21, 1915,

magazine sec., p. 22, and James Britton, "Daniel's 'Modernists'," *American Art News* vol. 14, no. 4 (October 30, 1915), p. 7.

34. "Current News of Art and the Exhibitions," *New York Sun,* November 14, 1915, sec. 3, p. 7.

35. For an excellent biography of Wright, see John Loughery, *Alias S. S. Van Dine* (New York: Scribner's, 1992).

36. Milton W. Brown, *American Painting from the Armory Show to the Depression* (Princeton: Princeton University Press, 1955), p. 90. *Modern Painting* was simultaneously released in New York and London by the John Lane Company.

37. Almost immediately upon publication, Wright's book was acclaimed for its intelligent appraisal of the most recent tendencies in modern painting (see the review by Andre Tridon, "America's First Aesthetician," *Forum* 55, no. 1 [January 1916], pp. 124–128). On Wright's emphasis of Synchromism, see Brown, *American Painting,* p. 90.

38. Wright's article appeared in the same issue of *The Forum* as Tridon's review of his book (see previous note); the section on Man Ray appeared on pp. 32–35.

39. H. R. Poore, *Pictorial Composition and the Critical Judgment of Pictures* (New York and London: G. P. Putnam, 1903); Denman Ross, *A Theory of Pure Design: Harmony, Balance, Rhythm* (New York: Peter Smith, 1907); Arthur W. Dow, *Composition: A Series of Exercises in Art Structure for the Use of Students and Teachers* (New York: Doubleday Doran, 1899, 1913).

40. Wright, *The Creative Will: Studies in the Philosophy and the Syntax of Aesthetics* (New York and London: John Lane, 1916).

41. See Wright, "The Lesser Moderns," ch. 14 in *Modern Painting,* pp. 305–326; on Kandinsky, see pp. 308–315.

42. Wright, *Creative Will,* pp. 15, 81.

43. For more on Eddy and his collection, see Paul Krutky, "Arthur Jerome Eddy and His Collection: Prelude and Postscript to the Armory Show," *Arts* 61, no. 6 (February 1987), pp. 40–47.

44. In 1937 four of these paintings were sold from the estate of Arthur J. Eddy by his son (see *Art Auction by Order of Jerome O. Eddy, Shull Valley, Arizona, Son of Late Arthur J. Eddy, Extraordinary Collection of One Hundred and Ten Modernistic Paintings and Antique Oriental Rugs,* Williams, Barker & Severn, Auctioneers, Chicago, January 20 [1937]). The four paintings were identified in the auction checklist as follows (from an annotated copy of this catalogue in the Archives of the Art Institute of Chicago; my own comments to these annotations follow in parentheses): lot 129, "Wrestlers," identified as by "Many [sic] Ray" and "purchased by K[atherine] K[uh]" (probably *The Lovers*); lots 153 and 154, both called "Figures" (either this or the preceding entry was *Five Figures,* later given by Katherine Kuh to the Whitney Museum, while the other is *Figures in a Landscape*); lot 160, "Man with Scythe" (this work is doubtlessly *The Reaper,* which Katherine Kuh later sold to the artist).

45. *SP,* pp. 60–61.

46. Marius de Zayas, *How, When, and Why Modern Art Came to New York,* introduction and notes by Francis M. Naumann (Cambridge: MIT Press, 1994), p. 93.

47. Schwarz, *Man Ray,* p. 134, n. 1.

48. Carl Belz, "Man Ray and New York Dada," *Art Journal* 23, no. 3 (Spring 1984), p. 210.

49. "French Artists Spur on an American Art," *New York Tribune,* October 24, 1915, sec. 4, p. 2.

50. For an analysis of these mechanical portraits, see William Camfield, *Francis Picabia: His Art, Life, and Times* (Princeton: Princeton University Press, 1979), pp. 83–87; William I. Homer, "Picabia's 'Jeune fille americaine dans l'état de nudite' and Her Friends," *Art Bulletin* 57, no. 1 (March 1975), pp. 110–115; Dickran Tashjian, *Skyscraper Primitives: Dada and the American Avant-Garde, 1910–1925* (New York: Harry N. Abrams, 1994), pp. 50–61.

51. All quotations are from *SP,* pp. 65–66.

52. Ibid., p. 65.

CHAPTER SEVEN
The Art of Painting in Two Dimensions, Part 2:
The Paintings, Drawings, Watercolors, and Collages of 1916

1. Willard Huntington Wright, "Art, Promise, and Failure," *Forum* 55, no. 1 (January 1916), pp. 29–42.

2. *SP,* p. 67.

3. The exhibition catalogue included an introductory essay by Willard Huntington Wright, forewords by the exhibition's organizers, and brief statements by each of the artists in the show (*The Forum Exhibition of Modern American Painters,* Anderson Gallery, March 13–25, 1916). On the historical significance of the Forum Exhibition, see Milton W. Brown, *American Painting: From the Armory Show to the Depression* (Princeton: Princeton University Press, 1955), pp. 65–67; Anne Harrell, *The Forum Exhibition: Selections and Additions* (Whitney Museum of American Art at Philip Morris, New York, May 18–June 22, 1983), pp. 4–15; and Christopher Knight, "On Native Ground: U.S. Modern," *Art in America* 71, no. 9 (October 1983), pp. 166–174.

4. A complete checklist of this exhibition with the prices that were assigned for individual works is preserved in the Papers of the Forum Exhibition, Archives of American Art, Smithsonian Institution, Washington, D.C.; I am grateful to Anne Harrell for having drawn this list to my attention.

5. Reported in *SP,* p. 68.

6. Anonymous, "The Season's Art Sensation," *World Magazine* (April 3, 1916), p. 9.

7. Willard Huntington Wright, "The Forum Exhibition," *Forum* 55, no. 4 (April 1916), pp. 457–471.

8. As he later explained to Arturo Schwarz, *Man Ray: The Rigour of Imagination* (New York: Rizzoli, 1977), p. 32. Letter from Man Ray to Hamilton Easter Field, April 6, 1916 (Papers of Hamilton Easter Field, Archives of American Art, Smithsonian Institution, Washington, D.C.; microfilm roll no. N68–2, frame 40).

9. I am grateful to Professor William Camfield for having alerted me to the existence of this pamphlet in the archives of the Philadelphia Museum of Art. And I owe a further debt of gratitude to Anne d'Harnoncourt and Marge Klein for having arranged for photographs of this important document to be made and sent to me.

10. Dow was Weber's teacher of design at Pratt Institute around the turn of the century, and his theories of composition had a significant influence on the artist's subsequent work (see Alfred Werner, *Max Weber* [New York: Harry N. Abrams, 1975], pp. 29–31). In the fall of 1914, O'Keeffe studied with Dow at Teachers College, Columbia University, and, as influential as his theories of composition may have been, she later confessed that at the time she could not afford to purchase his book on the subject (see William Innes Homer, *Alfred Stieglitz and the American Avant-Garde* [Boston: New York Graphic Society, 1977], pp. 235–236). On the influence of Dow's writings among the early critics and theorists of abstraction, see Marianne W. Martin, "Some American Contributions to Early Twentieth-Century Abstraction," *Arts* 54, no. 10 (June 1980), pp. 158–165.

11. Arthur Wesley Dow, "Modernism in Art," *American Magazine of Art* 8 (January 1917; from a paper presented at the Annual Meeting of the College Art Association, Philadelphia, held in April 1916). See also Dow, "Talks on Appreciation of Art," *Delineator,* January 1915, pp. 14–15.

12. Published by G. P. Putnam's Sons, New York and London. George Lansing Raymond occupied the chair of oratory and aesthetic criticism at Princeton University from 1880 to 1905. His writings on comparative aesthetics were published in eight separate volumes between 1886 and 1900 (brought together and republished in a uniform edition in 1909). Professor Raymond's theories were provided renewed interest in 1914–1915, upon the publication of a two-volume compilation containing extracts from his most important writings in poetry and aesthetics. See E[dward] A[lden] J[ewell], "Raymond, George Lansing," *Dictionary of American Biography,* vol. 7 (New York, 1963; original ed. vol. 15, 1935), pp. 407–408.

13. Willard Huntington Wright, "Synthesis of the Arts," note no. 130 in *The Creative Will: Studies in the Philosophy and the Syntax of Aesthetics* (New York and London: John Lane, 1916), pp. 176–177.

14. Dow, "Modernism in Art," p. 116.

15. *SP,* p. 17.

16. See the catalogue *Exhibition of Pictures by Jean Crotti, Marcel Duchamp, Albert Gleizes, Jean Metzinger,* Montross Gallery, New York, April 4–22, 1916. For a historical account of the exhibition, see William A. Camfield, "Jean Crotti and

Suzanne Duchamp," in William Camfield and Jean-Hubert Martin, eds., *TABU DADA: Jean Crotti and Suzanne Duchamp, 1915–1922,* (Bern: Kunsthalle; Philadelphia: Philadelphia Museum of Art, 1983–1984), pp. 12–15, and Francis M. Naumann, *New York Dada, 1915–23* (New York: Harry N. Abrams, 1994), pp. 10, 43–44, 101–102.

17. "A Complete Reversal of Art Opinions by Marcel Duchamp," *Arts and Decoration* 5 (September 1915), p. 428.

18. *SP,* p. 82.

19. Crotti displayed the work in this fashion for a journalist named Nixola Greenley-Smith, "Cubist Depicts Love in Brass and Glass: More Art in Rubbers Than in Pretty Girl," *Evening World* (April 4, 1916), p. 3.

20. S[teven] N[ash], "Symphony Orchestra," in Steven A. Nash, ed., *Albright-Knox Art Gallery: Painting and Sculpture from Antiquity to 1942* (New York: Rizzoli, 1979), p. 532.

21. From an interview with George and Richard Hamilton, "Marcel Duchamp Speaks," BBC broadcast, 1959, quoted in Arturo Schwarz, *The Complete Works of Marcel Duchamp* (New York: Harry N. Abrams, 1969; 2d rev. ed., 1970), p. 23.

22. From Duchamp's notes for *The Large Glass,* ca. 1912–1915, first published in a facsimile edition by Duchamp, *La Mariée mise à nu par ses célibataires, même,* Paris, 1934; reprinted with an English translation by Arturo Schwarz, ed., *Marcel Duchamp: Notes and Projects for the Large Glass* (New York: Harry N. Abrams, 1969), n. 3, pp. 36f. On Duchamp's interest in the fourth dimension, see Linda Dalrymple Henderson, "Marcel Duchamp and the New Geometries," *The Fourth Dimension and Non-Euclidean Geometry in Modern Art* (Princeton: Princeton University Press, 1983), ch. 3, pp. 117–163, and Craig Adcock, *Marcel Duchamp's Notes from the Large Glass: An N-Dimensional Analysis* (Ann Arbor: UMI Research Press, 1983).

23. The year 1916 is usually given for *The Rope Dancer,* for that is the date inscribed directly on the canvas (just below the artist's signature in the lower right corner of the painting). In a questionnaire prepared for the Museum of Modern Art, however, Man Ray explained that he actually began this picture in 1915, just after moving from Ridgefield to New York (Artists' Files, Department of Painting and Sculpture, Museum of Modern Art, New York). Although this questionnaire is undated, it was probably filled out in the late fall of 1954, shortly after the museum acquired the painting (see letter from Alfred Barr to Man Ray, August 26, 1954, Barr Archive, Museum of Modern Art, New York).

24. *SP,* pp. 66–67.

25. Questionnaire, fall 1954 (see n. 23 above).

26. As noted in the same passage from his autobiography cited above (*SP,* p. 66). On the historical precedents to this theme in German painting of the early twentieth century, see Janice McCullagh, "The Tightrope Walker: An Expressionist Image," *Art Bulletin* 56, no. 4 (December 1984), pp. 633–644.

27. Man Ray is clear about sequence in the statement he pre-

pared for the Museum of Modern Art: "*After* finishing the painting," he wrote, "the idea still obsessed me, and I made a fine-line drawing called Ballet-Silhouette" (emphasis added; see n. 23 above). Later, however, in an interview with Arturo Schwarz, he begins his account of how *The Rope Dancer* came into being with a description of this drawing, implying by chronological sequence that the drawing may have preceded the making of the painting (see "This Is Not for America," interview with Arturo Schwarz, *Arts* 51, no. 9 [May 1977], p. 118). On this drawing see also Lucy Flint, "Silhouette," no. 43 in Flint, *Handbook: The Peggy Guggenheim Collection* (New York: Harry N. Abrams, 1983), p. 94. Originally, I, too, had assumed that *Ballet-Silhouette* served as a preliminary study for the painting (see "Man Ray: Early Paintings, 1913–1916: Theory and Practice in the Art of Two Dimensions," *Artforum* 20, no. 9 [May 1982], p. 39). The same assumption guides the analysis of the drawing by Angelica Zander Rudenstein ("Silhouette," *Peggy Guggenheim Collection, Venice* [New York: Harry N. Abrams, 1985], pp. 481–485).

28. Questionnaire, Museum of Modern Art (see n. 23 above).

29. William S. Rubin, *Dada and Surrealist Art* (New York: Harry N. Abrams, 1968), p. 60.

30. See "Revolving Doors" (prepared by Lesley Baier and Anna Chave), in Robert L. Herbert et al., *The Société Anonyme and the Dreier Bequest at Yale University: A Catalogue Raisonné* (New Haven: Yale University Press, 1984), p. 567.

31. "Revolving Doors," p. 567.

32. *SP,* p. 68.

33. Quoted in Roland Penrose, *Man Ray* (Boston: New York Graphic Society, 1975), p. 56.

34. In 1935 the artist affixed a rubber ball to the fingertips of a wooden mannequin's detached hand and entitled the resultant assemblage *Main Ray,* an obvious pun characteristic of the kind of title the artist frequently assigned to his sculptures in this period. On Man Ray's playful manipulations of language, see Robert Pincus-Witten, "Man Ray: The Homonymic Pun and American Vernacular," *Artforum* 13, no. 8 (April 1975), pp. 54–59.

35. On this exhibition, see William A. Camfield, *Francis Picabia: His Art, Life, and Times* (Princeton: Princeton University Press, 1979), pp. 68–69.

36. Schwarz, *Man Ray,* p. 37.

37. Although the catalogue indicates only a closing date, January 16, 1917, the show probably ran no more than a few weeks, as was customary at the time. Moreover, another exhibition was up at the gallery through the month of December, a show in which Man Ray not only participated but for which he even provided a design for the cover of the catalogue (see figs. 128, 129). Finally, the first newspaper reviews of the show only began to appear around January 7, 1917, indicating that it probably opened at around that time.

38. Quoted in Schwarz, *Man Ray,* p. 136.

39. *SP,* p. 71.

40. Marcel Duchamp, "The Creative Act," delivered as a talk in Houston, Texas, at a meeting of the American Federation of the Arts, April 1957 (frequently reprinted; first published in *Art News* 56, no. 4 [Summer 1957], pp. 28–29).

41. Willard Huntington Wright, "Modern Art: Walkowitz, Monet, and Burlin," *International Studio* 60 (November-February 1916–1917), p. cxxxii.

42. Henry McBride, "Modern Art of Berlin and Man Ray," *Sun* (January 7, 1917), sec. 4, p. 12.

43. "This Is Not for America," interview with Arturo Schwarz, *Arts* 51, no. 9 (May 1977), p. 119.

44. Ibid.

45. Ibid.

## CHAPTER EIGHT

## The Art of Painting in More than Two Dimensions: The Paintings, Drawings, Watercolors, *Cliché Verre,* and Airbrush Compositions of 1917–1919

1. *SP,* p. 71.

2. Although this statement is unsigned, it was probably written by the gallery's owner, Stephan Bourgeois, a French dealer who had helped in the organization of the Armory Show and who in 1914 opened a gallery in New York devoted to the showing of American and European modern art (see *Exhibition of Modern Art, Arranged by a Group of European and American Artists in New York,* Bourgeois Galleries, New York, February 10–March 10, 1917).

3. The society was organized in the fall of 1916 in meetings held at the home of John Covert, who served as the organization's first secretary. Man Ray was listed as one of the society's twenty founding directors on an announcement that was circulated to the public in January of 1917 (a copy of this four-page document was brought to my attention by Garnett McCoy). On this exhibition and the public's critical response, see Francis Naumann, " 'The Big Show': The First Exhibition of the Society of Independent Artists," part 1, *Artforum* 17, no. 6 (February 1979), pp. 34–39, and 2, "The Critics," *Artforum* 17, no. 8 (April 1979), pp. 49–53, and Naumann, "The Independents," *New York Dada, 1915–23* (New York: Harry N. Abrams, 1994), ch. 8, pp. 176–191. Most of the foregoing account is derived from these sources.

4. See Rudi Blesh, *Modern Art USA: Men, Rebellion, Conquest, 1900–1956* (New York: Alfred A. Knopf, 1956), p. 71.

5. *SP,* p. 71.

6. From a questionnaire circulated by the Museum of Modern Art, New York (Artists' Files, Department of Painting and Sculpture); although undated, this questionnaire was likely completed in the mid-1950s (see ch. 7, n. 23). In a questionnaire filled out for another museum, the artist was even more emphatic in expressing his opinion of juries: "Unless uncon-ditionally invited," he wrote, "I have never submitted a work to an exhibition where a jury functioned, nor entered a work in competition for a prize; therefore no honors!" (Artists' Files, Whitney Museum of American Art, New York, dated March 23, 1956).

7. Frederick James Gregg, "A New Kind of Art Exhibition," *Vanity Fair,* May 1917, p. 47.

8. Quoted in Arturo Schwarz, *Man Ray: The Rigour of Imagination* (New York: Rizzoli, 1977), p. 39.

9. The painting was reproduced in both the French and English editions of this book (see Albert Gleizes and Jean Metzinger, *Du Cubisme* [Paris: Eugène Figuière, 1912] and *Cubism* [London: T. Fisher Unwin, 1913], p. 123).

10. By 1917 both versions of the *Chocolate Grinder* had been given at least two public showings in New York (in the Third Exhibition of Contemporary French Art at the Carroll Gallery in March 1915 and at the Exhibition of Modern Art at the Bourgeois Gallery in April 1916). One of Man Ray's visits to the Arensberg apartment is recalled in his autobiography (*SP,* p. 70). These two paintings are visible in photographs of the Arensberg apartment taken by Charles Sheeler in 1919 (see Naumann, *New York Dada,* pp. 26–27).

11. See Schwarz, *Man Ray,* p. 38, and Jean-Hubert Martin, *Man Ray,* Centre Georges Pompidou, Paris, December 10–April 12, 1982, cat. no. 15, p. 5. Even though this painting was reproduced with the title *The Ship "Narcissus"* in Georges Ribemont-Dessaigne's monograph on the artist (*Man Ray* [Paris: Librarie Gallimard, 1924], p. 29), apparently neither one of these authors realized it.

12. *SP,* p. 82.

13. Schwarz, *Man Ray,* p. 39.

14. Ibid.

15. See, for example, *SP,* p. 145, and Man Ray, "Photography Can Be Art," in Jean-Hubert Martin, ed., *Man Ray Photographs* (New York: Thames and Hudson, 1981), p. 34.

16. We know the title Man Ray originally gave this work from information provided in the Artist's Card File (document C, no. 105). On Evreinof, see Michael T. Florinsky, ed., *McGraw-Hill Encyclopedia of Russia and the Soviet Union* (New York: McGraw-Hill, 1961), p. 617, and Henry Wadsworth Longfellow Dana, "Yevreinov, Nikolai Niko-layevich," *Columbia Dictionary of Modern European Literature,* Horatio Smith, ed. (New York: Columbia University Press, 1947), pp. 880–881.

17. All quotations that follow are taken from the text reprinted in *TNT.*

18. From Man Ray's Card File (see document C, no. 105).

19. See André Breton, ed., "Le Suicide est-il une solution?" *La Révolution Surréaliste* 2 (January 15, 1925), p. 12.

20. See the description of this painting by Arturo Schwarz, who concluded that its title "relates to the spiritual crisis that he [Man Ray] suffered in 1917" (*Man Ray,* p. 40), as well as the analysis by Roland Penrose, who believed that this painting

was "a witness to the reality of his [Man Ray's] state of despair" (*Man Ray* [Boston: New York Graphic Society, 1975], pp. 48–50).

21. As reported by Penrose (*Man Ray*, p. 50), who does not, however, provide a specific credit reference for his quotation of the artist's words (they were taken from a letter from Man Ray to Dominique de Menil, October 20, 1973; quoted in *Gray Is the Color*, Rice University, Houston, October 19–January 19, 1974, p. 130).

22. Quoted, without acknowledging a source, by Schwarz (*Man Ray*, p. 40). A few years after this image had become identified with the general theme of death, Man Ray incorporated this aerograph in a 1926 photograph that he entitled *Suicide* (reproduced in Martin, *Man Ray Photographs*, p. 45). In this image, the artist carefully positioned a model before the picture in such a way that her features are reflected into the glass directly over one of the two ovoid shapes (or "Entities," as they were identified above), while at point-blank range she aims a revolver into the center of the composition. Although this photograph may represent only the fanciful staging of an idea, the actual possibility of suicide continued to fascinate the artist, as it did many of the Surrealists. And in a particularly low period of his life, brought on by poor health and continued bouts of insomnia, Man Ray later confessed that on at least one occasion he actually did seriously consider the possibility of taking his own life (*SP*, p. 249).

23. See "Interview with Man Ray," in Martin, *Man Ray Photographs*, p. 37 (the name of the person who conducted this interview with Man Ray is unknown and not provided in the publication). Man Ray frequently spoke out against the notion of placing so much reliance on the opinions of critics: "I had never paid much attention to criticisms," he wrote. "If I had taken them at their word I would probably never have accomplished anything. If fact, if I had any doubts about my work, adverse criticism convinced me I was on the right track" (*SP*, pp. 337–338). While living in Hollywood, the artist published a brief essay that was devoted to precisely this subject (see Man Ray, "Art in Sanity," *California Arts and Architecture* 58 [January 1941], pp. 19, 36–37).

24. Man Ray to John Quinn, July 31, 1917, and Quinn to Man Ray, August 6, 1917 (Quinn Papers, Manuscript Division, New York Public Library).

25. Although it had only gained prominence during the twentieth century, the *cliché verre* technique had been employed in producing works of art by a number of important French artists in the nineteenth century (see Aaron Scharf, *Art and Photography* [Baltimore: Penguin Books, 1968], p. 33).

26. In his card file of works from this period, Man Ray called these works "silverprints" (see document C, no. 122). In his card file, he listed the titles of five works, one of which was called "Harbor." Knowing this, it may be that the most abstract of these images (fig. 181) was derived from a scene of boats in a harbor.

27. *Exhibition [of] Contemporary Art*, Penguin Club, New York, beginning March 16, 1918 (cat. no. 16), and *The Second Annual Exhibition of the Society of Independent Artists*, New York, April 20–May 12, 1918 (cat. no. 614).

28. See the Artist's Card File, document C, no. 122. The photograph reproduced here (fig. 187) is taken from the card file.

29. *SP*, p. 73.

30. In both subject matter and composition, the aerograph (not reproduced here) is very similar to the painting (fig. 180). On *Seguidilla*, see Judith Zilczer, "From Mechanical Drawing to Mechanized Dance: Man Ray's 'Seguidilla,'" *Drawing* 11, no. 6 (March-April 1990), pp. 125–128.

31. *SP*, p. 85. It is difficult to determine with certainty the precise date of Man Ray's move to this basement studio. Most biographers have assumed that it took place in 1919, coincident with his split from Adon Lacroix. This year is established on the basis that in his autobiography the artist noted that he and his wife had been together for six years (*SP*, p. 80). Calculated from the time of their meeting in 1913, this would date their separation to sometime in 1919. However, if we can trust a date of 1918 given to a painting depicting a corner of the artist's studio interior (fig. 193), a date provided by Man Ray himself (see document C, no. 114), this move may have taken place somewhat earlier, for this painting clearly exhibits the dress form he mentions having encountered for the first time during the course of this move (*SP*, p. 92).

32. *SP*, p. 86.

33. Schwarz, *Man Ray*, p. 50.

34. As noted by William Camfield, *Francis Picabia: His Art, Life, and Times* (Princeton: Princeton University Press, 1979), p. 108.

35. "This Is Not for America," interview with Arturo Schwarz, *Arts* 51, no. 9 (May 1977), p. 120.

36. Henry McBride, *Sun*, March 9, 1919, sec. 6, p. 12.

37. Although this questionnaire is not dated, Man Ray provided the following information at the close of his remarks: "The thoughts expressed here apply only to the period above, and do not necessarily express my attitudes today—1954" (document preserved in Artists' Files, Department of Painting and Sculpture, Museum of Modern Art, New York).

38. John Elderfield, *The Modern Drawing: 100 Works on Paper from the Museum of Modern Art* (New York: Museum of Modern Art, 1983), p. 118.

39. *SP*, p. 76.

40. Man Ray made a drawing that shows exactly how these works were to be displayed; see *Man Ray: Paintings, Objects, Photographs*, Estate Sale, Sotheby's London, March 22–23, 1995, lot no. 77.

41. Man Ray's account of this incident is provided in *SP*, p. 76; for the texts Man Ray supplied, see document B in the present text.

42. Hamilton Easter Field, "Man Ray at the Daniel Gallery," *Brooklyn Daily Eagle*, November 30, 1919, p. 4.

43. Cortissoz, "Random Impressions in Current Exhibitions," *New York Tribune,* November 23, 1919, sec. 4, pp. 11, 13.

44. C. Lewis Hind, "Wanted, a Name," *Christian Science Monitor,* ca. November–December 1919. (exact date is unknown; clipping preserved in the scrapbooks of Katherine Dreier, Collection of the Société Anonyme, Beinecke Library, Yale University, New Haven; reprinted with minor variations in Hind, *Art and I* [New York: John Lane, 1920], pp. 180–185). In a mildly favorable review of this exhibition, Man Ray was proclaimed to be "a master of his instrument" (see "Art Notes," ed., *New York Times,* November 26, 1919, p. 12, col. 7).

45. Quoted in Margery Rex, "If You Feel Like a Feather After a Party, You're a Tactilist," *New York Evening Journal,* February 11, 1921. In January 1921 a public argument took place in the Paris press between Picabia and Marinetti over exactly who it was that invented the concept of "tactilism"; Marinetti said that it was Boccioni in 1912, and Picabia argued that it was first conceived by the American sculptor Edith Clifford Williams in New York in 1916. In the American press, their exchange was billed as a struggle between Dadaism and Futurism (see, for example, "Tactilism Greeted by Dadaist Hoots," *New York Times,* January 17, 1921, p. 15; "Dadaists War on 'Tactilism,' Latest Art Form," *Chicago Tribune,* January 17, 1921; "Dadaists and Futurists," *New York Times,* January 18, 1921, p. 10; "Picabia and Marinetti Disagree on 'Tactilism,'" *New York Herald,* January 20, 1921; and "Fighting for the Last Word in Art," *Literary Digest,* February 19, 1921, p. 31).

### CHAPTER NINE
### From an Art in Two Dimensions to the Higher Dimension of Ideas (1920–1921)

1. C. Lewis Hind, "Wanted, a Name," *Christian Science Monitor,* ca. November-December 1919 (exact date unknown; clipping preserved in the scrapbooks of Katherine Dreier, Collection of the Société Anonyme, Beinecke Rare Book and Manuscript Library, Yale University, New Haven, Connecticut; reprinted with minor variations in Hind, *Art and I* [New York: John Lane, 1920], pp. 180–185).

2. Exactly when Man Ray chose to categorize these works as "Objects of Affection" is uncertain. He first assembled photographs and prepared brief texts for a publication by this title in 1944. (The book was never published, but several variant maquettes were prepared.) In a catalogue for an exhibition held at the Museum of Modern Art in 1961, the artist published a text entitled "Preface from a Proposed Book: One Hundred Objects of My Affection" (William C. Seitz, *The Art of Assemblage* [New York, 1961], pp. 48–49). This preface was not included, however, in the earliest appearance of these objects in book form: *Oggetti d'affezione* (Turin: Giulio Einaudi editore, 1971; including a brief introductory comment by the artist, with black-and-white reproductions

of 119 objects dating from 1917 through 1968). After the artist's death, a catalogue raisonné of the objects was prepared by Philippe Sers, *Man Ray: Objets de mon affection* (Paris: Philippe Sers, 1983), which lists 187 separate objects.

3. In 1957, when *Boardwalk* was included in a Dada exhibition at the Galerie de l'Institut in Paris, a group of students invaded the exhibition and fired some shots directly at the assemblage, striking it twice. (The holes have never been repaired, officials reasoning, apparently, that they are an important part of this work's history.) Man Ray recalled the episode in his autobiography (*SP,* p. 391).

4. "The Nude-Descending-a-Staircase Man Surveys Us," *New York Tribune,* September 12, 1915, sec. 4, p. 2.

5. This note is reproduced in facsimile in Marcel Duchamp, *A l'Infinitif* (New York: Cordier & Ekstrom, 1966); reprinted with an English translation by Arturo Schwarz, ed., *Marcel Duchamp: Notes and Projects for the Large Glass* (New York: Harry N. Abrams, 1969), n. 58, pp. 94–97.

6. Arturo Schwarz, *Man Ray: The Rigour of Imagination* (New York: Rizzoli, 1977), p. 158.

7. Man Ray, "Objects of My Affection," *Oggetti d'affezione* (see n. 2 above).

8. Man Ray, "Preface from a Proposed Book" (see n. 2 above).

9. Arturo Schwarz, "Interview with Man Ray," in *New York Dada: Duchamp, Man Ray, Picabia* (Munich: Prestel Verlag [for the Stadtische Galerie im Lenbachhaus], 1973, p. 100); this interview was reprinted—excluding (curiously and without explanation) this important statement Man Ray made about his objects—in "This Is Not for America," *Arts* 51, no. 9 (May 1977), pp. 116–21.

10. *SP,* pp. 68–69, 81. Duchamp's impressions of Man Ray's studio were recalled by Man Ray in an interview with Carl Belz in 1962 (see Carl Belz, "Man Ray and New York Dada," *Art Journal* 23, no. 3 [Spring 1964], p. 208, and n. 12, p. 213).

11. *SP,* p. 101.

12. "This Is Not for America," p. 121.

13. "Dadamade," July 8, 1958, original handwritten text reproduced in *Dada: Dokumente einer Bewegung,* Kunstverein für die Rheinlande und Westfalen, Düsseldorf, 1958, n.p., and reprinted in *SP,* p. 389.

14. It is not known exactly when Howald purchased his first painting by Man Ray from the Daniel Gallery. We know from the ledger books he kept, however, that by 1921 he owned at least three paintings by the artist: two still lifes (figs. 111, 112) and the *Madonna* (fig. 127), purchases he had made from Daniel in 1918 and 1919 (information provided by the Columbus Museum of Fine Arts, Columbus, Ohio).

15. Man Ray described this exchange with Howald in his autobiography (*SP,* p. 103).

16. "A New Method of Realizing the Artistic Possibilities of Photography," *Vanity Fair,* November 1922, p. 50.

17. Man Ray to Ferdinand Howald, April 5, 1922 (University Libraries, Ohio State University, Columbus, Ohio).

18. Marcel Duchamp to Man Ray, undated but, based on inter-

nal evidence, written in the spring of 1922 (Humanities Research Center, University of Texas at Austin); published in Francis M. Naumann, ed., *Affectionately, Marcel: The Selected Correspondence of Marcel Duchamp* (Ghent and Amsterdam: Ludion Press, 2000), pp. 106–107.

19. See "Interview with Man Ray," in Jean-Hubert Martin, ed., *Man Ray: Photographs* (New York: Thames and Hudson, 1982), p. 35.

20. *SP*, p. 340.

## AFTERWORD
## Artists and Art Colonies of Ridgefield, New Jersey

1. The epigraph is from *SP*, 2d ed., pp. 33–34.

2. For histories of Ridgefield, known originally as the English Neighborhood, see *A History of the Borough of Ridgefield* (Ridgefield: Ridgefield Exchange Club, 1964); "From a Village in Ridgefield Township to the Borough of Ridgefield," *Ridgefield Centennial* (Bergen Newspaper Group, 1992), pp. 3–31; the entire May 27, 1942, issue of the *Bergen Bulletin;* and "Early History of Ridgefield Pictured by Historical Society Members," unidentified newspaper clipping dated February 1, 1908, Ridgefield Public Library Archives. For Ridgefield as an artists' colony, see Peter J. Sampson, "Redevelopment Slowly Erasing Shadows of Artists' Colony," *Record,* June 19, 2000, pp. L1, L6; William H. Gerdts, *Painting and Sculpture in New Jersey* (Princeton: Van Nostrand, 1964), pp. 215–219; Lucy D. Rosenfeld, "3 Towns Where Creative Minds Congregated," *New York Times,* December 22, 1996, p. 13. William H. Gerdts, *Art across America: Two Centuries of Regional Painting, 1710–1920,* vol. 1 (New York: Abbeville, 1990), pp. 258–261; Mel Most, "A Time Long out of Mind: Ridgefield Art Colony in Retrospect," *Record,* January 21, 1975, pp. A11, A13; Sheila Magee, "Town's Past . . . Art Thrived in Borough," *Record,* May 16, 1967, pp. C1, C3; and "Ridgefield Home of Many Noted Authors and Artists," *Bergen Bulletin,* May 27, 1942, p. 14. See also Richard Burdi, "An Art Colony and More," and Lila Locksley, "A Bohemian Heaven on the Palisades," both unidentified newspaper clippings, Ridgefield Public Library Archives.

3. William Monaghan, "Those Were The Days, My Friend, Those Were the Days," typescript, p. 1, Ridgefield Public Library Archives.

4. The author is grateful for information on the little-known Maxfield received from David Dearinger, chief curator, National Academy Design Museum, in an e-mail of August 24, 2001, containing the text for the entry on Maxfield that will appear in the Museum's collection catalogue, to be published in early 2003. See also *Who Was Who in American Art,* vol. 2 (Madison, Conn.: Soundview Press, 1999), p. 2225. On Maxfield in Ridgefield, see "Ridgefield Home of Many Noted Authors and Artists" and Most, "Time Long out of Mind." Maxfield's home was acquired by the sculptor, architectural decorator, and interior designer Leif Neandross (as discussed later in this essay), who sold it to the current owner, Mike Merse (interview, May 15, 2001).

5. Lolita L. W. Flockhart, *A Full Life: The Story of Van Dearing Perrine* (Boston: Christopher Publishing House, 1939), pp. 77, 101. Flockhart's book provides the most complete account of the Country Sketch Club (pp. 76–88, 94–130, 147, 155–156). For recent accounts, see Arleen Pancza, "Van Dearing Perrine and the Country Sketch Club," in *Van Dearing Perrine: First Decade on the Palisades, 1902–1912* (New York: Graham Gallery, 1986), pp. 12–15, and Gerdts, *Art across America,* pp. 258–260.

6. Flockhart, *Full Life,* p. 94.

7. Charlotte Leon Mayerson, ed., *Shadow and Light: The Life, Friends, and Opinions of Maurice Sterne* (New York: Harcourt, Brace & World, 1952), p. 38. Sterne became best known for his figurative studies on the island of Bali from 1912 to 1915, which show the influence of the work of Gauguin and Cézanne. For Glackens's evidently brief experiences in Ridgefield, see Flockhart, *Full Life,* p. 137.

8. Flockhart, *Full Life,* pp. 83, 87, 99, 114–123. See also *Who Was Who in American Art,* vol. 2, p. 2410, vol. 3, pp. 3499, 3507, 3645.

9. Flockhart, *Full Life,* p. 106.

10. Quoted in Pancza, "Van Deering Perrine and the Country Sketch Club," p. 12.

11. Quoted in Flockhart, *Full Life,* p. 115.

12. "The Country Sketch Club," *Art Collector* 9 (June 1, 1899), p. 230.

13. Ibid.

14. Ibid.

15. John I. H. Baur, "Rediscovery: Van Dearing Perrine," *Van Dearing Perrine: First Decade,* p. 7.

16. See Pancza, "Van Dearing and the Country Sketch Club," pp. 13–14. Among those who exhibited in the 1901 show at the Art Institute of Chicago were Charles W. Hawthorne, Jonas Lie, Alfred H. Maurer, Ernest David Roth, Paul Goeble, Albert L. Groll, G. Glenn Newell, and Maurice Sterne.

17. See "Ridgefield Home of Many Noted Authors and Artists," *Bergen Bulletin,* May 27, 1942, p. 14, and *A History of the Borough of Ridgefield,* p. [6]. See also *Who Was Who in American Art,* vol. 1, p. 586, vol. 2, pp. 2225, 2394, 2469, vol. 3, pp. 2895, 3132.

18. Emma Goldman, *Living My Life* (New York: Dover, 1970), p. 471; Most, "Time Long out of Mind"; Monaghan, "Those Were the Days," p. [2].

19. Gerdts, *Painting and Sculpture in New Jersey,* p. 215; Orrick Johns, *Time of Our Lives: The Story of My Father and Myself* (New York: Stackpole Sons, 1937), p. 225.

20. Bernard Karfiol, *Bernard Karfiol* (New York: American Artists Group, 1945), p. [8].

21. *SP*, 2d ed., p. 33.

22. Ibid, p. 34.

23. On Halpert, see Diane Tepfer, "Edith Gregor Halpert and The Downtown Gallery Downtown, 1926–1940: A Study in American Art Patronage," Ph.D. dissertation, University of Michigan, 1989, p. 25, and Diane Tepfer, *Samuel Halpert: A Conservative Modernist,* Federal Reserve System, Washington D.C., 1991, pp. 10, 17. I am grateful to Diane Tepfer for an advance copy of her publication *Samuel Halpert 1884–1930 Art and Life* (New York: Millenium Partners, 2001), p. 9 and plate 7, p. 30 discussion of *Interior with Man Ray,* 1913–1915. In an e-mail of August 9, 2001, Tepfer stated that Halpert never mentioned Man Ray or Ridgefield in his writings that are included in her publication (e.g., Halpert's autobiographical letter of November 14, 1915, to John Weichsel). On Halpert's influence in Ridgefield, see Francis M. Naumann, "Man Ray, 1908–1921: From an Art in Two Dimensions to the Higher Dimension of Ideas," in Merry Foresta et al., *Perpetual Motif: The Art of Man Ray* (New York: Abbeville, 1988), pp. 55–56.

24. Alfred Kreymborg, *Troubadour: An American Autobiography* (New York: Sagamore Press, 1957), p. 200.

25. *SP,* 2d ed., p. 35.

26. See Francis M. Naumann and Paul Avrich, "Adolf Wolff, 'Poet, Sculptor, and Revolutionist, but Mostly Revolutionist,' " *Art Bulletin* 67 (September 1985), pp. 486–500, and Francis M. Naumann, "Man Ray and America: The New York and Ridgefield Years, 1907–1921," Ph.D. dissertation, City University of New York, 1988, op cit, pp. 6,8, 17–19.

27. On *The Glebe,* see Kreymborg, *Troubadour,* pp. 151–158, and Neil Baldwin, *Man Ray: American Artist* (New York: Da Capo Press, 1988), pp. 32–35. See also Naumann, "Man Ray and America," pp. 5–6.

28. See Naumann, "Man Ray and America," pp. 10–16, and Baldwin, *Man Ray: American Artist,* pp. 39–40.

29. Alfred Kreymborg, "Man Ray and Adon La Croix, Economists," *Morning Telegraph,* March 14, 1915.

30. *SP,* 2d ed., pp. 43–44, Johns, *Time of Our Lives,* p. 225, and Naumann, "Man Ray and America," pp. 10–11.

31. Baldwin, *Man Ray: American Artist,* p. 33; and Man Ray, *SP,* 2d ed., p. 40.

32. *SP,* 2d ed., p. 50 and pp. 45, 47–49, 52–53, 55, 56, 65, 69.

33. Johns, *Time of Our Lives,* p. 224.

34. *SP,* 2d ed., pp. 48, 55; Robert Carlton Brown, *Let There Be Beer* (New York: Harrison, Smith & Robert Haas, 1932), pp. 189, 195ff. See also William Carlos Williams, *The Autobiography of William Carlos Williams* (New York: New Directions, 1948), pp. 137–138.

35. Baldwin, *Man Ray: American Artist,* p. 44.

36. Kreymborg, *Troubador,* p. 243. See also Man Ray, *SP,* 2d ed., p. 40, and Neil Baldwin, *To All Gentleness: William Carlos Williams, the Doctor Poet* (New York: Atheneum, 1984), pp. 78–80.

37. Williams, *Autobiography of William Carlos Williams,* p. 135.

38. Ibid, p. 136.

39. Naumann, "Man Ray and America," pp. 19–20.

40. A. Walton Litz and Christopher MacGowan, eds., *The Collected Poems of William Carlos Williams,* vol. 1 *1909–1939* (New York: New Directions, 1986), pp. 102–103.

41. *SP,* 2d ed., p. 57.

42. See "Ridgefield Home of Many Noted Authors and Artists"; Gerdts, *Painting and Sculpture in New Jersey,* p. 218; Most, "Time Long out of Mind"; Monaghan, "Those Were the Days," p. [2]; and Burdi, "An Art Colony and More," p. 15.

43. David S. Heeren, "Ridgefield Art Colony Recalled In Octogenarian's Reminiscences," and Bill Dalton, "Painter Rich in Memories: Art Was His Life Style," unidentified clippings, Ridgefield Public Library Archives.

44. Burdi, "An Art Colony and More," p. 15, Edward Tuite, "Octogenarian Artist Enjoys Talking: Tisch, 89, Recalls Ridgefield 'Colony' on the Hill," *Hudson Dispatch,* November 17, 1970, p. 2; Monaghan, "Those Were the Days," p. 3, also mentions Carol Ruggles, a composer, on p. 7; and Heeren, "Ridgefield Art Colony Recalled," also mentions Anton Rovinsky, pianist, as a resident.

45. Most, "Time Long out of Mind," and "Personality Profile— Leif Neandross," *Society News* 16 (New York: General Society of Mechanics and Tradesmen of the City of New York), January 1, 1975, pp. 4–7.

46. Gerdts, *Painting and Sculpture in New Jersey,* p. 218, and *Who Was Who in American Art,* vol. 1, pp. 979, 1086.

47. David S. Heeren, "Ridgefield Art Colony Recalled In Octogenarian's Reminiscences." See also Lucy D. Rosenfeld, "3 Towns Where Creative Minds Congregated," p. 13, and *John Marin: The Weehawken Sequence* (Jersey City: Jersey City Museum, 1985), essay by Robert Ferguson.

48. Sampson, "Redevelopment Slowly Erasing Shadows of Artists' Colony."

## DOCUMENT B
## Texts for *The Revolving Doors*

1. This introductory text appeared in *Minotaure* and is here translated from the French: "Le souci d'une période du temps conduit souvent à l'effacement de l'espace matériel. C'est ce que tendent à prouver les images en deux dimensions ci-contre que, par une action mutelle, donnent naissance à une série de faits échappant au contrôle de toute diversion."

## DOCUMENT C
## Card File

1. Letter from Man Ray to Ferdinand Howald, May 28, 1922 (Papers of Ferdinand Howald, University Libraries, Ohio State University, Columbus, Ohio).

To date, the most extensive general bibliography on Man Ray and his writings is found in Arturo Schwarz, *Man Ray: The Rigour of Imagination* (New York: Rizzoli, 1977), pp. 338–358. With the exceptions of sections III and IV below, the present compilation is intended to concentrate specifically on the writings that pertain to Man Ray's New York and Ridgefield years.

## I. WRITINGS BY MAN RAY

## A. Books, Pamphlets, and Magazines

*Adonism.* Ridgefield: Printed by the artists, 1914.

*A Book of Divers Writings* [with Adon Lacroix]. Ridgefield: Printed by the artist, 1915; rpt. Milan: Luciano Anselmino, 1976.

*The Bum.* Ridgefield: Printed by the artist, ca. 1913.

*New York Dada.* Ed. New York: Privately printed, 1921.

*Ogetti d'affezione.* Turin: Einaudi, 1970.

*A Primer of the New Art of Two Dimensions.* New York: Printed by the artist, 1916.

*Revolving Doors.* Paris: Editions Surrealistes, 1926; rpt. Turin: Galleria Il Fauno, 1972.

*The Ridgefield Gazook.* Ridgefield: Printed by the artist: 1915. Rpt. in *Dada Americano,* ed. Arturo Schwarz. Milan: Mazzotta, 1970.

*Self Portrait.* London: Andre Deutsch, 1963.

*TNT.* Ed. with Henri S. Reynolds and Adolf Wolff. New York: Printed by the artist, 1919.

*Visual Words, Sounds Seen, Thoughts Felt, Feelings Thought.* Poems by Adon Lacroix (1916); layout by Man Ray. New York: Printed by the artist, 1917.

## B. Articles, Poems, and Published Statements

"Art in Sanity." *Arts and Architecture* 58, no. 1 (January 1941), pp. 19, 36–37.

"Autobiographie." Text for the catalogue of the exhibition *Max Ernst, Man Ray, Dorothea Tanning.* Tours: Musée des Beaux-Arts, November 10–December 16, 1956. Rpt. in English, "An Autobiography," in the catalogue *An Exhibition Retrospective and Prospective of the Work of Man Ray.* London: Institute of Contemporary Arts, March 31–April 25, 1959. Rpt. in Italian in the catalogue *Man Ray: Oggetti del mio affetto.* Milan: Galleria Schwarz, March 14–April 3, 1964.

"Bi-lingual Biography." *View* 5, no. 1 (March 1945), pp. 32, 51.

"Chessmen by Man Ray." Leaflet describing Man Ray's chess sets. Hollywood: Privately printed, 1945.

"Dadaism." Text for the catalogue of the exhibition *Schools of Twentieth Century Art.* Beverly Hills: Modern Institute of Art, April 22–May 30, 1948.

"Dadamade." Text in *Dada Dokumente einer Bewegung.* Dusseldorf: Kunstverein für die Rheinlande und Westfalen, Dusseldorf Kunsthalle, September 5–October 19, 1958; rpt. in Italian in *Quinta Parete,* no. 4 (Summer 1972).

"Editor of the *Globe.*" *New York Globe and Commercial Advertiser.* May 9, 1913, p. 10.

"I Have Never Painted a Recent Picture." Text written for the catalogue *Man Ray.* Los Angeles: Los Angeles County Museum of Art, 1966, pp. 28–31.

"Impressions of 291." *Camera Work* 47 (July 1914), p. 61.

"L'inquietude." Visual poem for the catalogue of the exhibition *Salon Dada International.* Paris: Galerie Montaigne, June 6–30, 1921, p. 1.

"Is Photography Necessary?" *Modern Photography* 21, no. 11 (November 1957), pp. 82–87, 122, 124.

"It Has Never Been My Object to Record My Dreams." Text for the catalogue for the exhibition *Man Ray: Objects of My Affection.* New York: Julien Levy Gallery, April 1945.

"Pensées sur l'art." Text prepared for the catalogue *Exposition dada Man Ray.* Paris: Libraire Six, December 3–31, 1921.

"Photography Can Be Art." In Jean-Hubert Martin, *Man Ray: Photographs.* New York: Thames and Hudson, p. 34.

"Photography Is Not Art." *View* 3, no. 1 (April–October 1943). Rpt. in Jean-Hubert Martin, *Man Ray: Photographs.* New York: Thames and Hudson, pp. 30–33.

"Les Portes tournantes." *Minotaure* 7 (1935), p. 66.

"Preface from a Proposed Book *One Hundred Objects of My Affection.*" Text in the catalogue *The Art of Assemblage* by William C. Seitz. New York: Museum of Modern Art, 1961, pp. 48–49.

"Three Dimensions." *Others* 1, no. 6 (1915), p. 108.

"To Be Continued Unnoticed." Text for the catalogue of the *Man Ray* exhibition. Beverly Hills: Copley Galleries, December 14, 1948–January 9, 1949.

"Travail." *Modern School* 5 (Autumn 1913), pp. 20–21.

Untitled statement. *The Forum Exhibition of Modern American Painters.* New York: Anderson Galleries, March 13–26, 1916, n.p.

"What I Am" (in cooperation with Erik Satie). Text in the catalogue *An Exhibition Retrospective and Prospective of the Work of Man Ray.* London: Institute of Contemporary Arts, March 31–April 25, 1959. Also in *Man Ray,* Los Angeles County Museum of Art, Los Angeles, 1966, 20.

## C. Interviews

Anonymous. "Interview with Man Ray." In Jean-Hubert Martin, *Man Ray: Photographs.* New York: Thames and Hudson, 1982, pp. 35–39.

Bouregade, Pierre. *Bonsoir, Man Ray.* Paris: Belfond, 1972.

Breton, André, ed. "Recherches sur la sexualité: Part d'objectivité déterminations individuelles, degré de conscience." *La Révolution Surréaliste* 11 (March 15, 1928), pp. 32–40.

Schwarz, Arturo. "Interview with Man Ray." In Schwarz, *New York Dada: Duchamp, Man Ray, Picabia.* Munich: Prestel, 1973, pp. 79–100. Rpt. (with the last response deleted), "An Interview with Man Ray: 'This is Not for America.'" *Arts* 51, no. 9 (May 1977), 116–121.

## II. WRITINGS ON MAN RAY

## A. Books

Alexandrian, Sarane. *Man Ray.* Paris: Filipacchi, 1973.

Anselmino, Luciano. *Man Ray opera grafica.* Turin: Luciano Anselmino, 1973 (later released as vol. 1 in a two-volume set published by the Studio Marconi, Milan; see below: Pilat).

Baldwin, Neil. *Man Ray: American Artist.* New York: Clarkson N. Potter, 1988.

Belz, Carl. "The Role of Man Ray in the Dada and Surrealist Movements." Doctoral dissertation, Princeton University, 1963.

Butor, Michel, and Maxime Godard. *L'Atelier de Man Ray.* Paris: Edizioni Essegi, 1987.

Bramly, Serge. *Man Ray.* Paris: Pierre Belfond, 1980.

Foresta, Merry. *Perpetual Motif: The Art of Man Ray.* Washington, D.C.: National Museum of American Art; New York: Abbeville, 1988. With contributions by Merry Foresta, Stephen C. Foster, Billy Kluver, Julie Martin, Francis Naumann, Sandra S. Phillips, Roger Shattuck, and Elizabeth Hutton Turner.

Janus. *Man Ray.* Milan: Fratelli Fabbri, 1973.

———, ed. *Man Ray: The Photographic Image.* Woodbury: Barron's, 1980.

———, ed. *Man Ray: Tutti gli scritti.* Milan: Feltrinelli, 1981.

Martin, Jean-Hubert. *Man Ray: Photographe.* Paris: Philippe Sers, 1981. Published in English, *Man Ray: Photographs.* New York: Thames and Hudson, 1982.

Masini, Lara Vinca. *Man Ray.* Florence: Sansoni, 1974.

Penrose, Sir Roland. *Man Ray.* Boston: New York Graphic Society, 1975.

Perl, Jed. *Man Ray.* New York: Aperture, 1979.

Pilat, Bianca Maria. *Man Ray opera grafica,* vol. 2. Milan: Studio Marconi, 1984.

Ribemont-Dessaignes, Georges. *Man Ray.* Paris: Librairie Gallimard, 1924.

———. *Man Ray.* Paris: Villa Arson, Centre National des Arts Plastiques, Ministere de la Culture, 1984.

Schwarz, Arturo. *Man Ray: The Rigour of Imagination.* New York: Rizzoli, 1977.

Sers, Philippe, and Jean-Hubert Martin, eds. *Man Ray: Objets de mon affection.* Paris: Philippe Sers, 1983.

Soby, James Thrall, ed. *Photographs by Man Ray: 105 Works, 1920–1934.* Hartford: James Thrall Soby, 1934; rpt. New York: Dover Publications, 1979.

## B. Articles

A.v.C. "Man Ray's Paint Problems." *American Art News* 14, no. 6 (November 13, 1915), p. 5.

Alloway, Lawrence. "Some London Exhibitions: Man Made Objects." *Art International* 3, no. 4–5 (1959), p. 61.

Amaya, Mario. Foreword. *Man Ray: Inventor/Painter/Poet.* New York: New York Cultural Center, December 19, 1974–March 1975.

"Art Notes: Man Ray's Exhibition." *New York Times,* November 26, 1919, p. 12.

Belz, Carl. "Man Ray and New York Dada." *Art Journal* 23, no. 3 (Spring 1964), pp. 207–213.

Cocteau, Jean. "Lettre ouverte a Man Ray, photographe americain." *Les Feuilles Libres* 26 (April–May 1922).

Copley, William. "Man Ray: The Dada of Us All." *Portfolio 7* (1963), pp. 14–23, 111. Rpt. in *Man Ray: Inventor/Painter/Poet.* New York: New York Cultural Center, December 19, 1974–March 2, 1975, n.p.

De Gramont, Sanche. "Remembering Dada: Man Ray at Eighty." *New York Times Magazine,* September 6, 1970, pp. 6–7, 25–26, 30, 31, 34.

Duchamp, Marcel. "Man Ray." *Collection of the Société Anonyme: Museum of Modern Art 1920.* New Haven: Yale University Art Gallery, 1950.

Fagiolo, Maurizio. "L'occhio obbiettivo." *Data* 2, no. 3 (April 1972), pp. 54–55. Rpt. in *Man Ray: Opere 1914–1973.* Rome: Il Collezionista d'Arte Contemporanea, October 24–December 8, 1973.

Glueck, Grace. "An Angel for the Biennale." *New York Times,* October 17, 1965.

"The Good Old Dada Days." *Time,* June 28, 1954, p. 74.

"Grandada." *Time,* May 17, 1963.

Hind, Lewis C. "Wanted, a Name." *Christian Science Monitor,* newspaper clipping, scrapbooks of Katherine Dreier, Beinecke Rare Book and Manuscript Library, Yale University, date unknown (ca. November–December 1919). Rpt. in Hind, *Art and I.* New York: John Lane, 1920, pp. 180–185).

Janus. "In Man Ray's Century." In Jean-Hubert Martin, *Man Ray: Photographs.* New York: Thames and Hudson, pp. 26–30.

Kramer, Hilton. "His Heart Belongs to Dada." *Reporter* 28 (May 9, 1963), pp. 43–46.

———. "Man Ray: Faithful Disciple." *New York Times,* January 12, 1975, p. 23.

———. "Photography Was Man Ray's Greatest Success." *New York Times,* May 1, 1977, pp. 29, 34.

Krauss, Rosalind. "Objects of My Affection." In *Man Ray: Objects of My Affection.* New York: Zabriskie Gallery, 1985, n.p.

Kreymborg, Alfred. "Man Ray and Adon La Croix, Economists." *New York Morning Telegraph,* March 14, 1915, p. 7.

Lacroix, Adon. Untitled preface. *Exhibition of Paintings & Drawings by Man Ray.* New York: Daniel Gallery, until January 16, 1917.

Langsner, Jules. "About Man Ray: An Introduction." In *Man Ray.* Los Angeles: Los Angeles County Museum of Art, 1966, pp. 9–18.

———. "Art News from Los Angeles." *Art News* 52, no. 2 (April 1953), p. 44.

"Man Ray." *Informations et Documents* 39 (January 1, 1956), pp. 59–65.

Martin, Henry. "Man Ray: Spirals and Indications." *Art International* 15, no. 5 (May 20, 1971), pp. 60–65.

Martin, Jean-Hubert. Introduction. In Jean-Hubert Martin, *Man Ray: Photographs* (New York: Thames and Hudson, 1982), pp. 6–14.

Miller, Lee. "My Man Ray." An interview with Mario Amaya. *Art in America* 60, no. 3 (May–June 1975), pp. 54–61.

Melville, Robert. "Man Ray in London." *Arts,* June 1959, pp. 45–47.

Molderings, Herbert. "Photography as Consolation." In Jean-Hubert Martin, *Man Ray: Photographs.* New York: Thames and Hudson, 1982, pp. 14–15, 25.

Naumann, Francis. "Dada (freedom) + Surrealism (pleasure) = Man Ray." *Man Ray: An American Surrealist Vision.* André Emmerich Gallery, New York, November 6–December 20, 1997. Rpt. in Japanese in *Man Ray: Liberty and Pleasure.* Itochu Gallery, Yumi Kawanabe, Japan, February 27–April 17, 1998.

———. "Man Ray and the Ferrer Center: Art and Anarchy in the Pre-Dada Period." *Dada/Surrealism* 14 (1985), pp. 10–30. Rpt. in *New York Dada,* ed. Rudolf E. Kuenzli. New York: Willis Locker & Owens, 1986. Rpt. with minor changes in Italian, "Man Ray e il Centro Ferrer: Arte e anarchia nel periodo Pre-Dada." *Volonta* 2 (1986), pp. 80–102.

———. "Man Ray, 1908–1921: From an Art in Two Dimensions to the Higher Dimension of Ideas." *Perpetual Motif: The Art of Man Ray.* Washington, D.C.: National Museum of American Art; New York: Abbeville Press, 1988, pp. 50–87. Published simultaneously in Italian by Mondadori, Milan; in French by Gallimard, Paris; and in German by Stemmle, Dusseldorf.

———. "Man Ray." *The Advent of Modernism: Post-Impressionism and North American Art, 1900–1918,* ed. Peter Morrian, Judith Zilczer, and William C. Agee. Atlanta: High Museum of Art, 1986.

———. "Man Ray: A Painter Worth Knowing." *Guardian,* London, February 7, 1995.

———. "Man Ray: An American Artist in Pursuit of Liberty." *Man Ray in America: Paintings, Drawings, Sculpture, and Photographs from the New York/Ridgefield (1912–1921) and Hollywood (1940–1950) Years.* Francis M. Naumann Fine Art, New York, October 27, 2001–January 5, 2002.

———. "Man Ray: An American Artist in Pursuit of Liberty." *Man Ray in America.* Patrick and Beatrice Haggerty Museum of Art, Marquette University, Milwaukee, October 20, 1989–December 4, 1989.

———. "Man Ray: *Black Tray,* 1914." *The Advent of Modernism: Post-Impressionism in North American Art, 1900–1918,* ed. Peter Morrian, Judith Zilczer, and William C. Agee. Atlanta: High Museum of Art, 1986.

———. "Man Ray: Early Paintings, 1913–1916: Theory and Practice in the Art of Two Dimensions." *Artforum* 20, no 9 (May 1982), pp. 37–46.

———. "Man Ray: *Hills,* 1914." *Masterworks of American Art from the Munson-Williams-Proctor Institute.* New York: Harry N. Abrams, 1989, pp. 116–117.

———. *Man Ray: The New York Years, 1913–1921.* Zabriskie Gallery, New York, November 29, 1988–January 6, 1989.

O'Doherty, Brian. "Man Ray: The Forgotten Prophet." *New York Times,* May 3, 1963, p. 37.

"The Paintings of Man Ray." *New York Times,* November 21, 1915, magazine sec., p. 22.

Paule, Tilley. "How Man Ray Put Magic into Photography." *Observer,* April 27, 1975, pp. 29–30, 32.

Penrose, Sir Roland. Foreword. In Man Ray, *Revolving Doors.* Turin: Galleria Il Fauno, 1972.

Pincus-Witten, Robert. "Man Ray: The Homonymic Pun and American Vernacular." *Artforum* 13, no. 8 (April 1975), pp. 54–59.

Rabbito, Karin Anhold. "Man Ray in Quest of Modernism." *Rutgers Art Review* 2 (January 1981), pp. 59–69.

Raynor, Vivien. "Tribute to Man Ray at the Zabriskie Gallery." *New York Times,* February 19, 1982, sec. C, p. 26.

Reed, Muriel. "Who Is This Man, Man Ray?" *Réalitiés* 168 (November 1964), pp. 60–63.

Richter, Hans. "Private Notes for and on Man Ray." In *Man Ray.* Los Angeles County Museum of Art, Los Angeles, 1966, pp. 39–41.

Rose, Barbara. "Man Ray: The Photographer as Genius." *New York Magazine,* August 6, 1973, p. 52.

Rubin, William. "Man Ray." *Art International* 7, no. 6 (June 25, 1963), pp. 66–67.

Russel, John. "The Whole Man Ray at Cultural Center." *New York Times,* December 20, 1974, p. 20.

Saarinen, Aline B. "The Establishment Was the Enemy." *New York Times,* May 12, 1963, book review section.

Waldberg, Patrick. "Bonjour Monsieur Man Ray!" *Quadrum* 7 (1959), pp. 91–102.

———. "Man Ray avant Man Ray." *XXᵉ Siècle* 45 (December 1975), pp. 10–18.

———. "Les objets de Man Ray." *XXᵉ Siècle* 31, (December 1968), pp. 65–80.

Watt, Alexander. "Dadadate with Man Ray." *Art and Artists* 1, no. 4 (July 1966), pp. 32–35.

Wescher, Paul. "Man Ray as Painter." *Magazine of Art* 46, no. 1 (January 1953), pp. 31–37.

Whitman, Alden. "Man Ray Is Dead in Paris at 86; Dadaist Painter and Photographer." *New York Times,* November 19, 1976, p. 24.

## III. WRITINGS OF RELATED INTEREST
### (containing specific references to Man Ray)

### A. Parts of Books

Avrich, Paul. *The Modern School Movement: Anarchism and Education in the United States.* Princeton: Princeton University Press, 1980, pp. 153–161.

Durant, Will, and Ariel Durant. *A Dual Autobiography.* New York: Simon and Schuster, 1977, pp. 83, 390.

Jean, Marcel. *The History of Surrealist Painting.* New York: Grove Press, 1960, pp. 59–64.

Kreymborg, Alfred. *Troubador: An Autobiography.* New York: Liveright, 1925, pp. 199–203.

Rubin, William S. *Dada and Surrealist Art.* New York: Harry N. Abrams, 1968, pp. 58–63.

Tashjian, Dickran. *Skyscraper Primitives: Dada and the American Avant-Garde, 1910–1925.* Middletown: Wesleyan University Press, 1975, pp. 62–70.

Waldberg, Patrick. "Bonjour Monsieur Man Ray." In *Les Demeures d'Hypnos.* Belgium: Editions de la Difference, 1976, pp. 126–39.

## B. Articles

"America's Rebellious Painters and New Style." *New York Globe and Commercial Advertiser,* November 22, 1920.

Britton, James. "Daniel's 'Modernists.'" *American Art News* 14, no. 4 (October 30, 1915), p. 7.

Cole, Robert J. "Studio and Gallery." *New York Evening Sun,* January 9, 1917, p. 8.

Cortissoz, Royal. "Random Impressions in Current Exhibitions." *New York Tribune,* November 23, 1919, sec. 4, pp. 11, 13.

"Current News of Art and the Exhibitions." *New York Sun,* November 14, 1915, sec. 3, p. 7.

"Exhibitions Now On." *Art News,* March 18, 1916.

"Last Week: Forum Exhibit of Modern American Painters." *New York Tribune,* March 20, 1917.

McBride, Henry. "Modern Art of Berlin and Man Ray." *New York Sun,* January 7, 1917, sec. 5, p. 12.

———. "News and Views of Art, Including the Clearing House for Works of the Cubists." *Sun and New York Herald,* May 16, 1920, sec. 3, p. 8.

McCausland, Elizabeth. "The Daniel Gallery and Modern American Art." *Magazine of Art* 64, no. 7 (November 1951), pp. 280–285.

"Somewhat Humorous." *Boston Evening Transcript,* February 10, 1917.

"Spring Watercolors." *New York Times,* April 23, 1916, magazine section, p. 14.

Wolff, Adolf. "The Art Exhibit." *Modern School* 4 (Spring 1913).

———. "Art Notes." *International* 8, no. 1 (January 1914), p. 21.

Wright, Willard Huntington. "Art, Promise, and Failure." *Forum* 55, no. 1 (January 1916), pp. 29–42.

———. "The Forum Exhibition." *Forum* 55, no. 4 (April 1916), pp. 457–471.

———. "Modern American Painters—And Winslow Homer." *Forum* 54, no. 6 (December 1915), p. 669.

———. "Modern Art: Walkowitz, Monet and Burlin." *International Studio* 60 (November 1916–February 1917), p. cxxiii.

Young, Mahonri Sharp. "Ferdinand Howald and His Artists." *American Art Journal* 1, no. 2 (Fall 1969), pp. 119–128.

Ziegler, Francis J. "Widely Different Phases of Modern Art." Unidentified newspaper clipping [ca. 1915], Papers of Willard Huntington Wright, Princeton University.

## IV.   EXHIBITION CATALOGUES, 1921–1987

[N.B. For exhibitions prior to 1921, see the Chronology; the catalogues listed here are only for one-man exhibitons.]

Galerie Surrealiste, Paris. *Tableaux de Man Ray et objets des iles.* March 26–April 10, 1926.

Frank Perls Gallery, Hollywood. *Man Ray Exhibition of Paintings, Watercolors, Drawings, Photographic Compositons.* March 1–26, 1941.

Pasadena Art Institute, Pasadena. *Man Ray: Retrospective* Exhibition: Paintings, Drawings, Watercolors, Photographs: 1913–1944. *September 19–October 29, 1944.*

Julien Levy Gallery, New York. *Exhibition Man Ray.* April 1945. Copley Galleries, Beverly Hills. *Man Ray* (accompanied by the publication *To Be Continued Unnoticed*), December 14, 1948–January 9, 1949.

A L'Etoile Scellée, Paris. *Man Ray: Non-Abstractions.* April 24–May, 1956.

Institute of Contemporary Arts, London. *An Exhibition Retrospective and Prospective of the Works of Man Ray.* March 31–April 25, 1959.

Galerie Rive Droite, Paris. *Man Ray.* October 16–November, 1959 (traveled to Alexander Iolas, New York, November 1959).

Princeton University, Art Museum, Princeton. *Man Ray.* March 15–April 15, 1963.

Galleria Schwarz, Milan. *Man Ray: Oggetti del mio affetto.* March 14–April 3, 1964.

Los Angeles County Museum of Art, Los Angeles. *Man Ray.* 1966.

Galerie Europe, Paris. *Man Ray: Objets de mon affection* (exhibition and catalogue organized by Marcel Zerbib), 1968.

Galerie Alphone Chave, Vence. *40 Oeuvres invendables de Man Ray.* April 5–May 9, 1969.

Hanover Gallery, London. *Man Ray.* 1969.

Cordier & Ekstrom, New York. *Man Ray: A Selection of Paintings.* January 14–February 7, 1970.

Galleria Milano, Milan. *Man Ray: Disegni, Rayografie, fotografie, incisione, edizioni numerate, duecentoventi opere: 1912–1971.* June 4, 1971.

Galleria Schwarz, Milan. *Man Ray: 60 Years of Liberties.* Paris: Eric Losfeld, 1971.

Musee Boymans–van Beuningen, Rotterdam. *Man Ray.* September 24–November 7, 1971 (traveled to Musée National d'Art Moderne, Paris, January 7–February 28, 1972).

Galleria Civica d'Arte Moderna, Comune di Ferrara, Palazzo dei Diamanti. *Man Ray.* May 20–July 25, 1972.

Gissi Galleria d'Arte, Turin. *Man Ray.* 1972.

Il Collezionista d'Arte Contemporanea, Rome. *Man Ray: Opere 1914–1973.* October 24–December 8, 1973.

Galleria Il Fauno, Turin. *Man Ray.* April 1974.

New York Cultural Center, New York. *Man Ray: Inventor/Painter/Poet.* December 19, 1974–March 2, 1975 (traveled to Institute of Contemporary Arts, London, April–June 1975, and with some variation to Rome [see next entry]).

Assessorato Antichita Belle Arti e Problemi della Cultura, Palazzo delle Esposizioni, Rome. *Man Ray: Occhio e il suo doppio.* July–September 1975.

Kimmel/Cohen Photography Arts, New York. *Man Ray: Vintage Photographs, Solarizations and Rayographs.* April 19–May 21, 1977.

Frankfurter Kunstverein, Frankfurt. *Man Ray: Inventionen und Interpretationen.* October 14–December 23, 1979 (traveled to Kunsthalle, Basel, January 20–February 24, 1980).

Birmingham Museum of Art, Birmingham. *Man Ray: Photographs and Objects.* February 1–March 9, 1980 (traveled to Columbia Museum of Art, Columbia: April 13–May 25, 1980; Columbus Museum of Art, Columbus: June 22–August 3, 1980; Hunter Museum of Art, Chattanooga: September 7–October 19, 1980).

Virginia Zabriskie Gallery, New York. *Man Ray: Publications and Transformations.* February 10–March 13, 1982 (traveled to Meredith Long & Company, Houston, April 6–May 1, 1982).

Centre Pompidou, Paris. *Man Ray.* December 10, 1981–April 12, 1982 (organized by Jean-Hubert Martin).

Galleria d'Arte Niccoli, Parma. *Man Ray: Assemblages, dipinti, fotografiel, disegni: dal 1912 al 1972.* 1982 (with texts by Flavio Caroli and Giuseppe Bonini).

Padiglione d'Arte Contemporanea, Milan. *Man Ray: Carte varie e variabili.* December 1, 1983–January 9, 1984.

Virginia Zabriskie Gallery, New York. *Man Ray: Objects of My Affection.* January 23–February 23, 1985.

Museo Regionale di Palazzo Bellomo, Siracusa. *Man Ray: Disegni.* June 29–July 28, 1985.

G. Ray Hawkins Gallery, Los Angeles. *Cafe Man Ray.* January 18–March 1, 1986.

Lunds Konsthall, Lunds. *Man Ray.* July 7–August 31, 1986.

Galleria Vivita 1, Florence. *Man Ray.* December 13, 1986–February 28, 1987.

## V. ARCHIVAL SOURCES

Archives of American Art, Smithsonian Institution, Washington, D.C.

Beinecke Rare Book and Manuscript Library, Yale University, New Haven, Connecticut. Archives of Katherine Dreier and the Société Anonyme.

Bibliotêque Literaire Jacques Doucet, Universites de Paris, Paris. Tristan Tzara and Francis Picabia Dossiers.

City of Philadelphia, Department of Records, City Archives, Philadelphia.

Columbus Museum of Art, Columbus, Ohio. Department of Twentieth Century Art.

Museum of Modern Art, New York. Artists' Files, Department of Painting and Sculpture.

New Jersey State Health Department, State Registrar, Trenton, New Jersey. Search Unit.

New York Public Library, New York. Rare Book and Manuscript Division. Papers of John Quinn.

Ohio State University, University Libraries, Columbus, Ohio. Library for Communication and Graphic Arts.

Virginia Zabriskie Gallery, New York. Daniel Gallery File.

Whitney Museum of American Art, New York. Artists' Files.

# INDEX

*Artwork by Man Ray unless otherwise noted; page numbers in italics indicate illustrations.*

## ABOUT THE AUTHORS

Francis M. Naumann is an independent scholar, curator, and art dealer, specializing in the art of the Dada and Surrealist periods. He is author of numerous articles and exhibition catalogues, including *New York, Dada 1915–25* (Harry N. Abrams, 1994), considered to be the definitive history of the movement, and *Marcel Duchamp: The Art of Making Art in the Age of Mechanical Reproduction* (Ludion Press, 1999; distributed by Harry N. Abrams, New York). In 1996 he organized "Making Mischief: Dada Invades New York" for the Whitney Museum of American Art; in 1997, "Beatrice Wood: A Centennial Tribute" for the American Craft Museum in New York. He has worked for the last three years on a monograph of the American painter Wallace Putnam (1899-1989), which was published by Harry N. Abrams in the spring of 2002. He is currently the owner and operator of his own gallery in New York City.

Gail Stavitsky is chief curator at the Montclair Art Museum, where she has been the primary author of many exhibition catalogs, including *Will Barnet: A Timeless World* (distributed by Rutgers University Press, 2000) and *Precisionism in America 1915–1941: Reordering Reality* (Harry N. Abrams, 1994).